*Money and Materiality in the
Golden Age of Graphic Satire*

Money and Materiality in the Golden Age of Graphic Satire

AMANDA LAHIKAINEN

UNIVERSITY OF DELAWARE PRESS

NEWARK

ISBN 978-1-64453-269-0 (casebound)
ISBN 978-1-64453-268-3 (paperbound)
ISBN 978-1-64453-270-6 (epub)
ISBN 978-1-64453-271-3 (web PDF)

LCCN 2021057001

A British Cataloging-in-Publication record for this book is available from the British Library.

References to internet websites (URLs) were accurate at the time of writing. Neither the authors nor University of Delaware Press are responsible for URLs that may have expired or changed since the manuscripts were prepared.

♾ The paper used in this publication meets the requirements of the American National Standard for Information Sciences—Permanence of Paper for Printed Library Materials, ANSI Z39.48-1992.

Composed in De Vinne, Miller, and Franklin Gothic
Calligraphic ornaments by Robert Slimbach
Book design by Robert L. Wiser, Silver Spring, MD

udpress.udel.edu

Distributed worldwide by Rutgers University Press

Manufactured in the United States of America

For Isobelle and Aila

TABLE OF CONTENTS

ACKNOWLEDGEMENTS

IN ITS MOST BASIC SENSE, this book is about the tension between abstract ideas and the material world. It shows how graphic satire and paper money offered an opportunity for Britons to navigate this boundary at the end of the eighteenth century. Persistent questions about abstract ideas, materiality, art, fact, and value animate the following pages. Many colleagues and friends spent time discussing these ideas and such conversations continue to sustain a number of fascinating questions. From the early days of graduate school to the numerous invited lectures that helped improve the project, I am thankful to Theresa Choi, Pannil Camp, Nina Dubin, Amy Richards Duncan, Jason Duncan, Niall Ferguson, Liz Graves, Yi Gu, Alfred Haft, Divya Heffley, Adrian Johns, William Keach, Nico Kuhlmann, Nathan Lahikainen, Julie Anne Lambert, Carol Leary, Noel Leary, Josh Louria, David Mallen, Sturt Manning, Jack Mockford, Joseph Monteyne, Elise Morrison, Dietrich Neumann, Aida Ramos, Amelia Rauser, Joseph Roach, Bret Rothstein, Hope Saska, Suzanne Scanlan, Eleanor Shevlin, Allison Staag, Michael Smith, Phil Timmons, Michael Yonan, and Mike Zamojski. I would like to give special thanks to Craig Hanson. Craig has been a generous colleague from even before my move to Grand Rapids, Michigan. His intellectual curiosity continues to inspire.

Douglas Fordham, Richard Taws, and Ian Haywood were kind enough to read early sections of the text and helped move the project forward. Along with the admirable work of Hiroki Shin, their scholarship also helps animate the following pages. I am also thankful to Aaron Graham and John Bloxham for their support and friendship. Daniel Wagner provided extensive and exciting conversation, particularly about the place and importance of David Hume and John Searle in Western philosophy. Moving way back in history, I realized recently that I have been using a loaned copy of John Searle's book. Ajume Wingo first loaned me a copy of *The Construction of Social Reality* nearly twenty years ago. He can finally have it back now.

It was a delight to work with the Coins and Medals department at the British Museum. I am grateful to have worked with Thomas Hockenhull, even if remotely, on parts of this project. I found his support and enthusiasm, like that of Catherine Eagleton before him, so encouraging and collegial. Staff at the Huntington Library, The Lewis Walpole Library, The Department of Prints and Drawings at the British Museum, and the Kluge Center at the Library of Congress also helped with this research. I am especially grateful to Mary Lou Reker, Travis Hensley, Jason Steinhauer, and Martha Kennedy.

It is unclear what would have become of this project without the Art Department at Aquinas College. Joe Becherer, Chris LaPorte, Ron Pederson, Steve Schousen, and especially Dana Freeman, all helped to create a collaborative and supportive academic department. Beyond the department, which welcomed me in 2012, I am also grateful for the faculty research mini-grants at Aquinas, and to the economists former Provost Stephen Barrows and President Kevin Quinn (who fortunately both enjoy discussing economics with those who have less knowledge of the field).

I am thankful for a publication grant from the Historians of British Art. Parts of this book appeared in previously published articles and I would like to thank the journals *Art History* and *Studies in Romanticism* for their permission to reprint sections of these publications. The anonymous peer reviewers for these articles and for this book provided much needed criticism, refinement, and energy. Panels at various conferences including the College Art Association, Historians of British Art, American Society for Eighteenth-Century Studies, and Historians of Eighteenth-Century Art & Architecture energized many conversations.

Dean and Elizabeth Lahikainen have been supportive of this project in many ways over the years and I am grateful for their love and support. Tommy Urban encouraged the project from the start, read multiple drafts, and enthusiastically engaged me in conversation about the fields of anthropology and philosophy. His insight has taught me a lot over the years and I am glad to be married to him. I will leave the last word of thanks to K. Dian Kriz in order to recognize the fact, and value, of her as a colleague and mentor.

LIST OF TABLES AND ILLUSTRATIONS

Table 1. Consumer price inflation from 1751–1850. Jim O'Donoghue, Louise Goulding, and Grahame Allen, "Consumer Price Inflation since 1750," *Economic Trends* 604 (March 2004): 44. © Crown Copyright. Published with the permission of the Controller of Her Majesty's Stationery Office (HMSO). Table design concept courtesy Mike Zamojski.

Table 2. John Searle's hierarchical taxonomy of (certain types) of facts. Reproduced from John Searle, *The Construction of Social Reality* (New York: The Free Press, 1995). Courtesy of Simon & Schuster. Table design concept courtesy Mike Zamojski.

Figure 1. William Holland, *Political Hocus Pocus! or John Bull brought to believe anything!!*, June 14, 1802. Hand-colored etching, 9¾ × 13¾ in. (249 × 349 mm). London: British Museum. © Trustees of the British Museum. Photo: © British Museum.

Figure 2. Anonymous, *Political Bank*, satirical banknote, undated (likely after 1790). Engraving, 3^{15}⁄$_{16}$ × 8¼ in. (100 × 210 mm). Washington, DC: Library of Congress (Prints and Photographs Division). Photo: Library of Congress. LC-DIG-ds-05071.

Figure 3. James Gillray, *The Gout*, May 14, 1799. Hand-colored etching and Aquatint, 10¼ × 14 in. (260 × 355 mm). London: British Museum. © Trustees of the British Museum. Photo: © British Museum.

Figure 4. James Gillray, *The Apotheosis of Hoche*, January 11, 1798. Hand-colored etching, 19⅞ × 15⅜ in. (505 × 390 mm). Washington, DC: Library of Congress (Prints and Photographs Division). Photo: Library of Congress.

Figure 5. Bank of England £1 note, 1813. 4¾ × 8 in. (122 × 205 mm). London: British Museum. © Trustees of the British Museum. Photo: © British Museum.

Figure 6. James Gillray, *Midas, Transmuting all into ~~Gold~~ Paper*, March 9, 1797. Hand-colored etching, 13⅞ × 10 in. (354 × 254 mm). London: British Museum. © Trustees of the British Museum. Photo: © British Museum.

Figure 7. Thomas Rowlandson, *The Bank*, January 1792. Etching, 6¼ × 9¼ in. (159 × 235 mm). London: British Museum. © Trustees of the British Museum. Photo: © British Museum.

Figure 8. Scottish satirical bank note protesting the option clause from 1764. Image © National Museums Scotland.

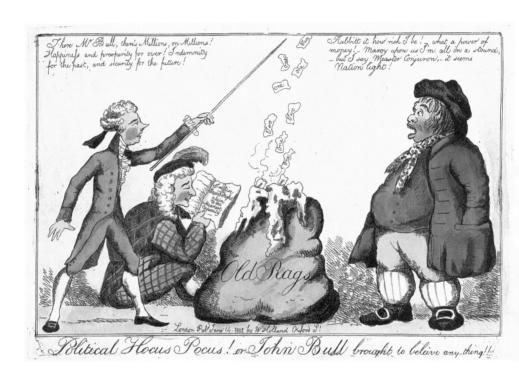

**Figure 1. William Holland, *Political Hocus Pocus!
or John Bull brought to believe anything!!*, June 14, 1802.**

The Inflation of Georgian Graphic Satire

"**W**HAT A POWER OF MONEY!" cries John Bull, embodiment of the British nation, in William Holland's etching *Political Hocus Pocus! or John Bull brought to believe anything!!* (**Figure 1**). With an open mouth, exaggerated profile, and sweaty bands of hair stuck to his ruddy cheeks, John Bull hardly inspires confidence for viewers of this clever satire, despite his wise claim that money holds a special kind of power. To the left of Bull stands Prime Minister William Pitt—his visual opposite. Pitt stands shorter and is at least one third the width of Bull; he holds a comically long wand that matches the angle of his long pointy nose and the slenderness of his long pointy shoes. Lines comprise Pitt and curves comprise Bull, communicating the types of money they each prefer by echoing the flimsy lines of paper money and firm curves of gold coin. Here, the wand held by Pitt acts as an engraver's burin, and with the movement of his wrist and arm, engraving leads to the creation of value: once unengraved rags below become engraved money above.

Holland likens the sack of old rags to a witch's cauldron; rags bubble up over the side in viscous form, releasing steam along with banknotes. Although gullible, Bull finds the notes "nation light." "Nation" is used here as an adverb, likely meaning "very, extremely," and modifies the adjective "light," contrasting notes with coins. "Nation light" could also be a reference to clipped or forged coins known as "light money," casting coin as a similarly

problematic currency. "Nation light" as mentioned in the text resonates with the image in several additional ways. It contrasts the weight of rags, a raw material, with the lightness of paper, a finished product. It also contrasts the weight of coin, made with its own raw material, with the lightness of paper, the secondary product of an already undesirable raw material, old and worn cloth rags. These comparisons all chip away at the value of Pitt's banknotes. Bull's hands are stuffed in his pockets, likely holding the gold coins he covets. It is unlikely that he could grow comfortably fat on beef and beer purchased with airy, "conjured" paper notes. The process of printing itself is called into question, and yet inspires awe in Bull, who opens his mouth in surprise.

These embedded, polysemous contrasts provide the main point of the satire. The image contrasts left with right, linear with round, "the government" with "the people" (Pitt versus Bull), raw material with finished product, valuable raw material with discarded raw material, paper with coin, light with heavy, easy with hard, fake with real, light with dark, and pink with blue. These dichotomies form the context for, and help to define, the subject of the satire: paper money. Through the deployment of such dichotomies—visual and conceptual—the print attacks the idea that paper banknotes could ever have value, especially in comparison to other mediums of currency with perceived high intrinsic value like gold or silver. *Political Hocus Pocus!* contributed to debates on the value of paper money five years into the Bank Restriction, a period lasting from 1797 to 1821, when the Bank of England's promissory notes were no longer convertible into cash.[1] Like many satires during the golden age of caricature in Britain, this one retained its effective bite, offering a witty and ironic commentary on a pressing concern of the day. Despite all of Bull's oafishness, and nearly grotesque appearance, viewers of this satire are meant to side with him in opposition to the prime minister, who acts as a magician by conjuring featherlike banknotes from a sack of old rags. Pitt seems here to connote every negative value in British culture. Working against the narrative of a kindly, benevolent, polite, enlightened, and rational eighteenth-century Britain that saw increasing gender equality, this satire reminds viewers of what Simon Dickie has identified as the "[v]iolence, intolerance, and schadenfreude [that] were all tolerated as unavoidable side effects of British liberty, if not its very foundation."[2] Viewers are encouraged not to trust the new, low-denomination paper notes distributed by the Bank of England, but to perceive them as old rags produced from a sack with a magic wand. If Bull could be convinced that Pitt's "paper millions" represent "Happiness and prosperity for ever!" then he could be swindled into believing anything at all.

The following chapters will argue that Bull was correct in proclaiming "what a power of money!" with implications reaching well beyond a conception of money as a medium of exchange for buying things and influence. In a series of case studies analyzing late Georgian satires, *Money and Materiality*

in the Golden Age of Graphic Satire explores the culture of paper money during the period and the role that material qualities played in constructing its value. Seeing, hearing, smelling, and touching played a role in valuation and the satires analyzed in the following chapters draw attention to each of the senses. Bull helps to illustrate for viewers that visual culture played an important role in helping people assess the political economy of paper money. He stares in awe at the sack of old rags, commenting on the trust individuals were willing to place in it over the long nineteenth century.

Political Hocus Pocus! categorizes paper money as a political trick. It labels printing as "easy" compared to the "hard" labor required for mining and minting coin. Henry Dundas, the figure sitting between Pitt and the sack of old rags reading from a book, indicates a different kind of trick. The book's cover reads "A Treatise on Second Sight plain to the Meanest Capacity," which is possibly a reference to Theophilus Insulanus's *A treatise on second sight: dreams and apparitions* from 1763. Dundas was accused of having second sight, or the ability to see the future, by Thomas Paine in the 1790s (Dundas was a Scottish politician and this ability was generally associated with the Scottish). While Bull's mental capacity is called into question here, so is the physical reality of the banknotes, which are likened to a dream or apparition from the future. This image takes up the unstable sign of paper money and transforms its promise into something ridiculous—in this case, the promise of one easy solution to all past and future problems. It is as if Holland is recalling a quote by Thomas Paine from years earlier: "Bank paper . . . is no more national wealth than newspapers are . . . [A]n increase of promissory notes, the capital remaining unincreased, or not increasing in the same proportion, is no increase of wealth. It serves to raise false ideas which the judicious soon discover, and the ignorant experience to their cost."[3] The literacy and numeracy required to read banknotes, and possibly spot a forgery, might be part of the magic for Bull, who does not read banknotes in the same way that Dundas reads the book in his hands.

The satire invites comparison of these two types of printing on paper, banknotes and books. Years later, in 1837, Thomas Carlyle would make a similar comparison commenting on the simultaneous growth of "bank-paper" and "book-paper": "[S]hall we call it, what all men thought it, the new Age of Gold? Call it at least, of Paper; which in many ways is the succedaneum of Gold. Bank-paper, wherewith you can still buy when there is no gold left; Book-paper, splendent with Theories, Philosophies, Sensibilities,—beautiful art, not only of revealing Thought but also of so beautifully hiding from us the want of Thought! Paper is made from the rags of things that did once exist; there are endless excellences in Paper."[4] Paper is for Carlyle a succedaneum, a thing that replaces another.[5] It is a mere substitute for gold, yet a replacement that still has qualities despite being in second-run, reused form. Further in the same passage, Carlyle asks of

the 1770s and 1780s which wisest *philosophe* could have predicted the "event of events," or the French Revolution of 1789, knowing that paper would play an important political and financial role in France. Although Carlyle was concerned specifically with Revolutionary France and Anglo-American literary mass culture, his observation is also pertinent for British art.[6] Carlyle made connections between artistic literary production and economic circumstances like inflation, as Lothar Müller has observed.[7]

Taking up this logic, *Money and Materiality in the Golden Age of Graphic Satire* investigates the inflation of two types of paper during the Georgian period: an understudied archive of satirical prints that imitate banknotes and graphic satires like *Political Hocus Pocus!* that target money. The archive under discussion is greatly expanded from traditional studies of graphic satire to include imitation banknotes, prints that take the form of actual banknotes for various purposes, and a more specific category of these imitations: satirical banknotes. Satirical banknotes are satires that take the form and often the size of paper money to satirize a variety of subjects, including paper money itself. Given the high cost of paper and its limited supply in the period under discussion here, the widespread existence of these objects becomes all the more fascinating. They existed from about 1760 onward. They proliferated after 1800 and although they declined along with the Georgian tradition of graphic satire, they never disappeared entirely.

Today, paper is something we tend to take for granted. In order to demonstrate it as a naturalized idea, the book *White Magic* by Lothar Müller opens with a gripping thought experiment in which a microbe outbreak eliminates all the paper in the entire world.[8] Interweaving this "microbe experiment" with discussions of paper by French philosophers Paul Valéry and Jacques Derrida, Müller sets the prologue for his global history of the paper age, from first-century China to the present. By engaging paper in turns as a product, a means of storage, and a metaphor, he accounts for its complexity and surprising cultural entanglements. He sees paper as both a metaphorical resource and material for reflection, as did graphic satires from the period under discussion here.

This period is roughly between 1780 and 1840, with the publication of *Punch* taken as a convenient marker of the end of this tradition.[9] I follow Diana Donald and Amelia Rauser in identifying a change in graphic satire around 1780 in London's print culture, especially regarding the use of caricature strictly defined as loading the features of an individual.[10] Satirical prints by William Hogarth, who died in 1764, as well as the macaroni print craze of the 1770s following the fashion of the eighteenth-century Grand Tour, are just two of the important contributions to graphic satire not discussed here given the emphasis on paper money.[11] Several terms characterize sections of the period: "the paper age" or "the papered century" for the whole of the eighteenth century and onward; "the golden

Amanda Lahikainen

age of caricature" and "Georgian" referencing the reign of George III between 1760 and 1820; and "Romantic," preferred by literature scholars, for roughly the first half of the nineteenth century. The often-identified stars of the tradition of graphic satire did not live to see *Punch*. James Gillray passed away in 1815, while his friend Thomas Rowlandson passed in 1827. Isaac Cruikshank's son, George Cruikshank, who continued this tradition further into the nineteenth century than the rest, died in 1878 but had actually abandoned the tradition long before his death. While all the terms I have mentioned are awkward, I use them despite their shortcomings and applaud recent scholarship that is beginning to rethink satire from the 1820s and 1830s on its own terms. "The golden age of graphic satire" in this title references the single-sheet intaglio print that dominated after 1780 and became something else by the Victorian period, as discussed further in the Epilogue. This phrase "golden" takes on a slightly new connotation here by playing with its literal reference to gold bullion.

Money and Materiality in the Golden Age of Graphic Satire sheds new light on how a strong culture of paper money developed at the turn of the "papered" century in Britain, especially after the specie crisis of 1797 and the introduction of fiat money. Satirists exploited these monetary problems to great effect, lampooning individuals as well as political, economic, and social issues, including the sign of paper money itself. Paper money, in turn, represented debt and wealth, freedom and tyranny, and prosperous trade and bankruptcy. Satirists variously cast paper money as a placeholder for gold, a fictitious French idea, excrement, a symbol of social relations, a false promise, a symbol of death, the cause of many deaths, a social evil, and, in the case of later imitation banknotes, objects indicating real wealth. As a set of evidence, imitation notes contribute to our understanding of how paper became a carrier of financial value in Britain and of the numerous ways individuals conceived of and imitated paper currency.

Forgery, a capital offense, became a critical issue during the Bank Restriction period. When low-denomination banknotes of one and two pounds were issued for the first time after 1797, they were accepted despite the risk of forgery and utterance. Utterance is the crime of passing or trying to pay with a fake banknote, as opposed to actually forging them. As described in an editorial in the *Times* on December 8, 1792, "certain printshops . . . abound with the most scandalous and libellous caricatures."[12] The number of forgeries rose each year between 1806 and 1820, and between 1816 and 1820, an average of twenty-seven thousand forged notes were presented to the Bank of England each year; many blamed this on the circulation of small-denomination notes.[13] Forgery was a central concern to the whole paper money system, most famously satirized by George Cruikshank and William Hone in their *Bank Restriction Note*, which is discussed in Chapter Four. By the early nineteenth century, in addition to forged notes, tens of thousands of imitation banknotes circulated alongside

the newly introduced low-denomination paper notes in England—the same one- and two-pound notes that float out of Pitt's sack in *Political Hocus Pocus!* They were labeled by a variety of names, variously called "flash notes," "puff notes," "skit notes," "jokers," and "fleet notes."[14] The *Political Bank* (**Figure 2**), discussed in the next chapter, exemplifies this type of note. The volume of imitation notes helped employ "Bank Agents," such as William Spurrier, who worked for the Bank of England detecting and prosecuting money forgers.[15] While this book focuses on paper, coins were also subject to forgery and used for political satire in this period.

During the Bank Restriction period, Britain experienced literal monetary inflation, an inordinate rise in prices or "undue increase in the quantity of money in relation to the goods available for purchase."[16] The makers, publishers, and consumers of imitation banknotes experienced this inflation. Robert Hume emphasizes that between 1760 and 1790 inflation started "to add up to something" and that during the Napoleonic era "raging inflation was a huge problem."[17] Analysis of the purchasing power of the pound, or consumer price inflation, shows that prices rose about 140 times between 1750 and 2003.[18] While most of that inflation happened after World War II, ten of the years between 1780 and 1841 (inclusive) saw inflation rates above 10 percent. The highest inflation in any year between 1750 and 2003 occurred in the year 1800, with an annual inflation rate of 36.5 percent (**Table 1**). It is no coincidence that imitation and satirical banknotes like the *Political Bank* proliferated after 1800. The main argument here intervenes in scholarship on "the golden age of caricature," in particular the admirable work of Donald and Rauser, calling for more sustained attention to inflation and overall economic context.[19]

The growth of credit and debt—themselves subject to changing forms of representation and changing norms of regulation—furthered innovation and reinvention in the visual culture of late eighteenth- and early nineteenth-century London. James Baker makes a related argument when he stresses the nexus and "embeddedness" of making, selling, and consuming satirical prints in London as crucial to understanding them.[20] In satire, the bodies of caricatured individuals literally inflated as if pumped up with air or gas. Many satirists experimented with visual space, embracing distortion, contradiction, ambiguity, color, and vitriolic politics. James Peller Malcolm, whose 1813 history of caricature in Britain was the first in the field, noted the "degree of levity, and mirth-exciting fancy" in the caricatures of the previous twenty-five years. He wrote: "This branch of the art was unknown till about the period I have mentioned: and the facility with which these persons exercise a species of allegory peculiar to themselves is equally original."[21]

The period under discussion was subject to the literal and metaphorical inflation of both graphic art and paper money. This inflation included an increase in the number and types of circulating paper and corresponding

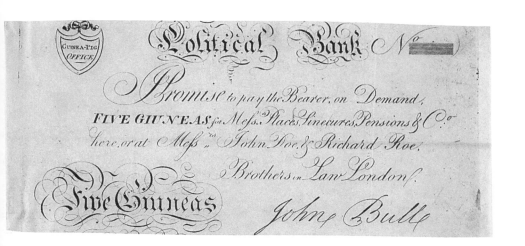

Figure 2. Anonymous, *Political Bank*,
satirical banknote, undated (likely after 1790).

Composite Price Index: Annual Percentage Change

YEAR	%	YEAR	%	YEAR	%	YEAR	%
1751	-2.7	1776	-2.2	1801	11.7	1826	-5.5
1752	4.7	1777	0.4	1802	-23.0	1827	-6.5
1753	-2.7	1778	4.0	1803	-5.9	1828	-2.9
1754	5.1	1779	-8.5	1804	3.2	1829	-1.0
1755	-6.0	1780	-3.4	1805	16.2	1830	-3.6
1756	4.2	1781	4.1	1806	-4.4	1831	9.9
1757	21.8	1782	2.1	1807	-1.9	1832	-7.4
1758	-0.3	1783	12.0	1808	3.4	1833	-6.1
1759	-7.9	1784	0.6	1809	9.7	1834	-7.8
1760	-4.5	1785	-4.0	1810	3.2	1835	1.7
1761	-4.5	1786	0.0	1811	-2.9	1836	11.0
1762	3.9	1787	-0.6	1812	13.2	1837	2.5
1763	2.7	1788	4.0	1813	2.5	1838	0.7
1764	8.9	1789	-1.3	1814	-12.7	1839	7.3
1765	3.5	1790	1.8	1815	-10.7	1840	1.8
1766	1.2	1791	0.1	1816	-8.4	1841	-2.3
1767	5.8	1792	1.5	1817	13.5	1842	-7.6
1768	-1.1	1793	2.8	1818	0.3	1843	-11.3
1769	-8.2	1794	7.7	1819	-2.5	1844	-0.1
1770	-0.4	1795	11.6	1820	-9.3	1845	4.9
1771	8.5	1796	6.4	1821	-12.0	1846	4.0
1772	10.7	1797	-10.0	1822	-13.5	1847	12.0
1773	-0.3	1798	-2.2	1823	6.8	1848	-12.1
1774	0.9	1799	12.3	1824	8.6	1849	-6.3
1775	-5.6	1800	36.5	1825	17.4	1850	-6.4

Table 1. Consumer price inflation from 1751–1850.

change in relative value, as well as the metaphorical inflation of visual and conceptual extremes in graphic satire. That is, this was inflation as a change in monetary value and as a metaphorical challenge to representation.

The present study widens the field of analysis for graphic satire to include economic context, addressing the idea of a crisis in representation, or in sign-making, itself. Some of the objects under discussion here are the lowest form of ephemera. Like Richard Taws in *The Politics of the Provisional*, my aim is not to "reinforce the distinction between . . . institutionally valorized art and a diverse field of images conventionally understood to be outside the sphere of art."[22] Satire draws heavily from all areas of culture. Mark Hallett notes in *The Spectacle of Difference*: "Satire, alongside its polemical bite, was distinguished by its wide-ranging engagement with, and adaptation of, a variety of representational materials."[23] In some sense, the monetary drama that satirists explored is the familiar philosophical debate between idealism and realism.

During the Bank Restriction, caricature inflated beyond its limits, reaching a point at which people and things could not be further exaggerated, and experienced a resulting deflation. Caricature's bombastic and swollen quali-ties reached a peak, and the use of incongruity humor, fueled by political dichotomies and conceptual opposites, also reached an apogee. Two strategies of visual inflation and their respective limits are exemplified by two satires by James Gillray, who learned to engrave copper plates while an apprentice for the banknote manufacturer Ashby & Company.[24] One tends toward simplicity and the other toward complexity, but both are extreme or inflated, and make for good comparison.

In *The Gout* of 1799 (**Figure 3**), Gillray reached the limits of swelling bodies in visual space. *The Gout* is particularly representative of the condensing and distillation associated with modern cartoons. Here it is included as an example of the literal inflation and exaggeration of bodies and things, which defined caricature during the golden age. Both the foot and toes of this poor sufferer of gout inflate in size and are further exaggerated by color, espe-cially red on the ball of the foot. The pain associated with this disease is anthropomorphized as a devilish creature that bites and claws the foot. Additional simplification of this image and its lines would make it harder for a viewer to identify the objects and ideas being represented.[25]

In the other extreme, *The Apotheosis of Hoche* (**Figure 4**) approaches the limits of an elaborate and detailed composition. Gillray has the French General Louis Lazare Hoche playing a guillotine lyre amid a chorus of cherub revolutionaries. He floats to heaven in a fantastic parody of the genre of apotheosis. Countless details fill the entirety of the frame in this rather large satire. While this print deserves a book of its own for full explanation, suffice it to say that if Gillray had included further references and charac-ters, he would have risked losing his parody of Michelangelo altogether. Inflation in the sense indicated by *The Gout* and *The Apotheosis of Hoche*

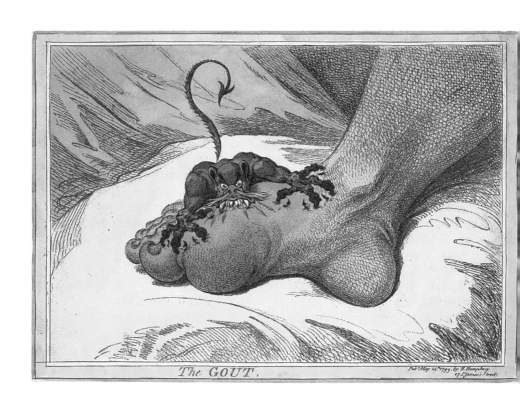

The GOUT.

Figure 3. James Gillray, *The Gout*, May 14, 1799.

Figure 4. James Gillray, *The Apotheosis of Hoche*, January 11, 1798.

refs to visual strategies of exaggeration in opposite extremes that typify caricature in this period.

To reiterate, this exaggeration is tied structurally to literal monetary inflation. Imitation banknotes as a phenomenon appeared at this time and were structurally related to this change in graphic satire. Caricature of the inflated kind, for Donald, stems from two key moments in history: Wilkes and Liberty propaganda in the 1760s and the Fox-North coalition in the early 1780s. These were moments when it became widely known that prints could be useful in politics.[26] Donald and I are in agreement as to the "intimate relationship between satire and social reality."[27] Donald is credited with making it a "fait accompli" that satirical prints are treated as objects worthy of study and as objects that embody a democratic form of art. According to Baker, the ideas she made standard in the scholarship are that Georgian satirical prints: had a broad cultural impact; served chiefly to comment, court controversy, and provoke; and existed in a multi-class discursive arena exemplified by the printshop window.[28] I discuss a lack of knowledge of the printshop window viewers, and the problematic characterizations associated with them, in the last chapter. As to the broad cultural impact of Georgian graphic satire, I do engage with this assumption and extend this to a more global context by tracing the influence of satirical prints in the United States and Japan in the Epilogue.

In addressing their impact in London, my treatment of these objects is largely driven by close visual analysis and what we can make of the evidence they directly present. Satires commented and provoked, advertised, and enabled artists and publishers to make a living. They engaged a market largely comprised of elite buyers and readers with private jokes and even weaponized support (here I reference the pension that Gillray received from the government between 1797 and 1801).[27] The number of graphic satires and printshops selling caricatures increased at this time, paralleling the increase in the number of circulating banknotes from the Bank of England and country banks. Anyone on the street could stop and peer into the windows of printshops to see graphic satires, including pickpockets who notoriously targeted distracted individuals standing outside. As far as imitation banknotes are concerned, it is important to keep their numbers in view. They existed on a small scale, but there were at least over ten thousand of them circulating by the early nineteenth century.

Over a century of work went into acculturating Britons to paper currency. Many factors collectively contributed to its eventual acceptance as a suitable method of payment starting in the late seventeenth century with the English Financial Revolution, including the establishment of the Bank of England in 1694, the passage of numerous laws legalizing and regulating networks of paper credit, the consistent shortage of small change, the need for fairly consistent wartime funding, economic expansion, and even the influence of the Scientific Revolution.[30] As the dominant fiscal military

Amanda Lahikainen

state in Europe by the early nineteenth century, Britain relied on public credit and debt to build an empire and the audiences for caricature were subject to related structural changes, especially during the Restriction period. Patrick O'Brien lists the astonishing growth of public debt at the time: over the long eighteenth century, it increased from a nominal capital of under £2 million in the reign of James II to reach an astronomical level of £854 million or 2.7 times the national income when Lord Liverpool's administration returned the monetary and financial system to the gold standard in the aftermath of the Napoleonic Wars.[31]

A massive network of institutions, individuals, and material embodiments of value changed the way Britons lived their lives during this period. That change has less readily come into art historical focus, especially with regard to the connections between paper money, aesthetics, and graphic satire. Recent publications in eighteenth-century French art history, notably by Richard Taws and Nina Dubin, place works of art within their economic and social contexts, revealing the important connections these objects have to the credit economy, especially the role of paper in material life.[32] In the context of Revolutionary France, Taws especially acknowledges the importance of "circulation" for a broad range of provisional images and objects that gathered meaning in ownership, transmission, and viewing by a critical mass of individuals; he links paper money and caricature as mediums of "change and exchange."[33] Historian Tamara Hunt argues that caricature in this period "came to visually express new concepts of Britishness."[34] While the controversies, signs, and countless other factors that presumably shaped British identity (or shape any identity for that matter) are up for further debate, I hope this discussion demonstrates that money belongs on that list of things.

This study resonates with the work of several art historians, especially Mark Hallett, K. Dian Kriz, Joseph Monteyne, and Todd Porterfield, who have engaged with graphic satires as important works of art that helped to shape the way their viewers thought and felt, not simply as illustrations of, or witnesses to, the period.[35] Along similar lines, Ian Haywood used art historical methodology for writing about the intervisual and discursive qualities of paper money satires in his article "Paper Promises: Restriction, Caricature, and the Ghost of Gold," and in a subsequent version of that work in the book *Romanticism and Caricature*, and dedicated an entire monograph to close readings of just a handful of satires.[36] This body of material demands that increasingly sophisticated questions be asked about graphic satires, and paper money is one of the topics that has provided rich questions and answers.[37]

While the French Revolution has been well studied in relation to the golden age of graphic satire, its role as an inflator of satire cannot be stressed enough. It sets the 1790s apart from other decades, building on changes evident after 1780. Donald rightly notes that it is no accident that,

in the 1790s, "Gillray's penchant for savage personal caricature and for grotesque flights of fancy reached its apogee" and that caricature played an "astonishingly important role" in ideological battles.[38] While Donald and, to some extent, Rauser indicate that developments in incongruity theory played a role in the development of caricature, they do not sufficiently integrate this observation into visual analysis. As a result, humor is occasionally a structural blind spot.[39] Even Vic Gatrell, who offers "a history of humor and laughter" and notes how cultural norms for laughter are dependent upon time, sex, class, and place, does not use a methodology that engages in the visual analysis of individual images.[40]

While this book does not presume to provide a comprehensive exploration of the interplay between graphic satire and money from 1780 to 1840, there are a few characteristics of that interplay that are clearly important. They constitute the organizational structure of the book and include: engagement with value, social reality, and institutional facts; openness to interpretation and semiotic play; changing definitions as a result of moments of crisis; the tendency to readily adopt the character assessments of individuals; subjective and collective intentionality; the scale of shadow economies; peculiar requirements for form and norms of materiality; reliance on authorship and individuals; the tendency to create and perpetuate false dichotomies; and the use of incongruity humor. The following chapters explore these phenomena and their consequences, giving value to graphic art and money in late eighteenth- and early nineteenth-century Britain.

The first chapter begins with a close look at a Bank of England banknote from the early nineteenth century. A discussion then follows asking what money is and how it is defined, and laying out the theoretical paradigm governing the interpretation of money that follows in this book. That is, money is an institutional fact. A key moment in this chapter explores the fact/value dichotomy in relation to our understanding of money by thinking through the problem of why "fact" and "value" both, surprisingly, fail as a definition of "money." Comparison of the Bank of England note to the *Political Bank*, closes the chapter by emphasizing a satire that reflects on and criticizes money as an institutional fact.

Emphasizing crisis, the second chapter gives a close reading of James Gillray's *Midas, Transmuting all into ~~Gold~~ Paper* (1797) as a satire on a new kind of social relation, or medium for money, and contextualizes the note within the specie crisis of 1797. The chapter includes an early historical account of satirical banknotes in Britain, and their scope, mostly in London but with important mention of Scotland and Ireland. It makes clear the importance of the French Revolution in understanding paper money, inflationary excess, and satire during this time. This discussion offers the most obvious account of how a crisis in money constituted a crisis in representation that fueled satirists.

The third chapter discusses subjectivity and trust. Opening with *Jew —— Depreciating Bank Notes* (1811), the chapter shows money as a social relation in images of exchange and the role that Jewish stereotypes played in satirizing money. With visual analysis of satires that show people exchanging money, we see how money was bound up with the mutual gaze. Following the definition of money as outlined in the first chapter, and understanding collective intentionality, we see how satires used that gaze in their images to indicate the complexity of money as an institutional fact. The discussion widens to include evidence for the "femininity" of banknotes and their relationship to a particular type of novel that was popular in the eighteenth century, the it-narrative. The chapter ends by trying to understand the role of signatures on the back of banknotes as they related to users of paper money and how those users thought of themselves as part of the economy. This chapter identifies the effect of complex networks of consumers, exchanging both paper money and caricature, on subjectivity and social reality.

The fourth chapter, on imitation, analyzes several skit notes that imitate the immaterial. As a social relation, the physical object of embodied money is already a representation of something else. In that sense, it is immaterial, yet its embodiment can be imitated and parodied. Using Charles Sanders Peirce's distillation of three types of signs and his notion of growing symbols, we can see paper money as a new and unstable symbol for Britons. This chapter begins and ends with discussion of the run of satirical banknotes published by John Luffman and later by S. W. Fores, especially *William Pittachio* (1807 and 1818). One section in this chapter discusses forgery and state injustice, showing how imitation played a lethal role by perpetuating charges of utterance, and another shows how it served as a platform for protesting the social ills of slavery. This chapter ends by contextualizing *William Pittachio* with later works in the history of art. Joseph Kosuth's *One and Three Chairs* (1965) provides the central point of comparison, but John Haberle's painting *Imitation* (1887) is also discussed at length.This discussion aims to show their undeniable semiotic similarities and connections to abstract ideas. Analysis of satirical prints reveals their complex engagement with imitation and the difficulty of isolating the effects of their semiotic play. By meditating on their own medium, some satires displayed self-awareness of the problems that come with imitating the immaterial that are more familiar to us in the modern period.

Picking up on this theme of handling banknotes and looking closely at caricatures, the fifth chapter, on materiality, analyzes the satire *A Whole Family Lost* (1814). This chapter explores the entwined status of material as fact and value. It demonstrates that for many Britons in this period, the value of money stemmed from the material that embodied it. The discussion begins by thinking through what has been labeled the turn toward materiality in art historical scholarship. While materiality in some form has been

part of art history since at least the time of Aby Warburg, the turn referenced here indicates more recent scholarship. The importance of materiality for users of paper money in Britain becomes clear with close readings of graphic satires that show Britons yearning for specific types of sensory input with their money. Materiality carries a semantic thickness, with a capacity to produce meaning beyond the images or pictures a material object may depict, or the medium of that object. While the myth of intrinsic value often protected coins from attack—hiding the market forces that actually determined their value—paper was more prone to criticism. In contrast to coins, paper cannot be melted down and resold as gold or silver; as a commodity it had far less value than metal. Numerous satires exemplify this attack and offer information about attitudes toward the materiality of paper money and the tendency to anthropomorphize it. This chapter also questions the longstanding dematerialization principle, which maintains that money consistently trends toward being less physical, and why it continues to inform modern understandings of money.

In the final chapter, I return to the theme of inflation by reflecting on the deflation of eighteenth-century graphic satire with close visual analysis of a *Punch* magazine cover from 1841. Linking such deflation directly with the stability of the British pound, we see it in terms of the satirical practices in use during the golden age of caricature and a nuanced reformulation of its demise. The *Punch* cover takes up themes in print culture used before the eighteenth century, such as the Punch and Judy show. The comparison of the cover and earlier examples of print culture offers examples of both continuity and change regarding many of the themes in this book, especially critical reflexivity, the gaze, collective intentionality, the genre of printshop viewing scenes, and the history of laughter.

An epilogue extends these questions beyond Britain. In two parts, it traces the problems inherent in introducing paper as a medium for money in two different countries that produced sophisticated satires of money. First, the Panic of 1837 in the United States allows for discussion of the problematic dichotomy of gold versus paper and strategies for understanding and critiquing value in the American context. Second, in a related but wholly separate discussion, analysis turns to several satires produced in Japan when trading with Britain developed after the Anglo-Japanese Treaty of Amity and Commerce of 1858 and through the modern period. This discussion indicates not only the legacy of the British satirical tradition there, such as *Japan Punch*, but also humorous reactions to inflation using incongruity and monetary dichotomies.

While some scholars, Eirwen Nicholson in particular, have found graphic satire in this period overvalued, this study aims to show the depth of inquiry this material can sustain.[41] The entanglement of graphic art and paper money, and the mutual pressure the two exerted on each other, shows us how much more there is to learn about graphic satire at this time, in

keeping with Vic Gatrell's characterization of satirical prints as "abundant but woefully under-explored."[42] Paper money's relationship to satire is one that deserves more attention and analysis and may further art history's view of graphic satire in the same way that the economic turn in the study of English literature and theory has changed the way historians of literature interpret novels.[43]

Value in graphic art, in money, in relationships, and in print culture does not simply appear; it is created, shared, contested, and made the subject of politics. Although the case studies in this book are grounded in late eighteenth- and early nineteenth-century Britain, the lessons they record have resonance today when it comes to the politicization of money and its embodiment in a medium, including cryptocurrencies like Bitcoin and Litecoin, and local currencies like the Bristol pound (U.K.) and BerkShares (U.S., Massachusetts), as well as Facebook's Libra. For instance, difficulties with the digital currency Bitcoin parallel those of other monetary mediums. Created in 2008 and controlled by an algorithm that protects the currency from theft or inflation, Bitcoin—like so many currency innovations before it—was designed to escape the control of any one political entity, government, or country. In some sense, it is a deeply democratic form of global money not controlled by a government and open to anyone with a computer. Yet, this currency has been criticized as co-opted by Chinese influence. In mid-2016, over seventy percent of Bitcoin transactions were processed by just four Chinese companies. This, in turn, gave those companies rights to change its software, making other users of the currency nervous about its intended neutrality.[44] Money is always political, not just in the sense of how it is spent or how it is managed by a controlling party or a government, but also in the sense of its very constitution.[45] Chapter One explores the definition of money and its constitution in more depth.

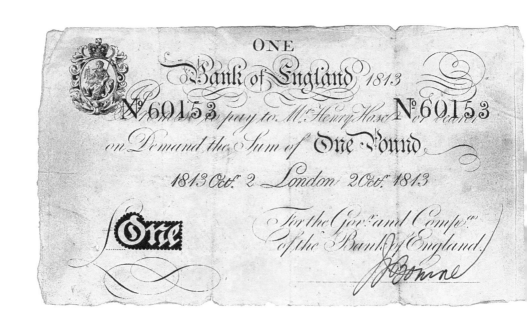

Figure 5. Bank of England £1 note, 1813.

Money, Fact, and Value

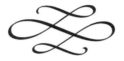

AS AN OBJECT THAT FITS easily into one's hands, the one-pound Bank of England note in **Figure 5** dating to 1813 records that it had been folded vertically and horizontally for transport. The fold marks compartmentalize its major constituent parts: vignette, sum block, signature, decorative scrolls, and textual promise to pay. The number that records it as a unique and traceable object in the world appears twice across the written promise: 60153. The year appears three times. The sum block and elegantly exaggerated pound sign claim the bottom left plane of the image; a floating decorative scroll design matches the pound sign to balance the design in the upper right corner. The name of Henry Hase, who was chief cashier of the bank between 1807 and 1829, appears in the writing alongside the anonymous "bearer" of the note, a known person listed next to an unknown carrier of the note. Why did this little piece of printed paper have value? What made it usable money? These deceptively simple questions quickly lead to the broader and more theoretical question: what is money, exactly?

Both the definition of money and the grounding of money's value have long been debated. In nineteenth-century Britain, for example, four popular answers to the question of what grounded money's value were: labor, gold, the quantity of money in circulation, and prices.[1] The definition of money was, and is, also up for debate. Even today, economists do not agree on a definition—on how money works, how it should be counted (monetary aggregates), or what types of credit instruments qualify as money. This disagreement remains, despite the consistent notion that money has three basic functions: as a means of payment, store of value, and unit of account.[2]

The following discussion will provide the framework for understanding money that is used in this book. This approach draws on several fields of study. It does not presume in any way to offer a comprehensive view of money or its historiography. After briefly discussing some problems related to defining money, it will offer a definition central to understanding satires of money. This in turn will help to explain why representation of the mutual gaze was a key move for satirists. The following discussion relies on the philosophy of John Searle and the entwined notions of fact and value. The work of Bill Maurer and Geoffrey Ingham is also quite influential in the following orientation of money, fact, and value.

As mentioned above, it is hard to avoid the three basic functions or definitions of money that stem from the neoclassical model in economics. Historically, however, two different answers have tended to explain what money is, or where moneyness is located.[3] The first theory understands money as a commodity and the second theory understands it as claims and credits. The theory of commodity money focuses on money as a medium of exchange and store of value, while the theory of credit money focuses on it as a unit of account.[4] The first tends to locate money in the real world, while the second tends to locate it as a value existing within social relations. There are fundamental tensions here between material things and abstract ideas, and between fact and value. State theories of money—arguing that nation states invent, enforce, and control money—are a variant of the credit theory. In Britain during the late Georgian period, we see the physical coercion of the state in monetary sovereignty, discussed in relation to forgery and lethal money in Chapter Four. Satirists consistently challenged exactly what the sign of money might symbolize and the people most closely associated with it (the monarchy and government). As in much of the historiography on money, we might not be able to find a clearly articulated and comprehensive monetary theory in the satires of this period, but there is evidence that satirists acknowledged and probed both types of theories.

A key distinction used in economics is real versus nominal value, or goods and services versus money (which is subject to inflation). "Real" is used as a term to describe the production of goods and services, output, employment, or the real interest rate, as opposed to trading on financial markets.[5] In part stemming from this distinction, in the field of economics there is little consensus regarding the extent to which money is related to the real economy. A standard macroeconomics textbook describes this as money neutrality, or the veil theory of money. It is a result of the classical economic model associated with Adam Smith: "Economists say that there is *money neutrality*, or simply that money is neutral, if a change in the nominal money supply changes the price level proportionally but has no effect on real variables."[6] Economists also debate the non-neutrality of money.[7] This comes largely from integration with the second major paradigm in the field, that of Keynesianism. As a term, "Keynesian" indicates a follower of

the British born economist John Maynard Keynes, who lived from 1883 to 1946 and is largely credited with founding modern macroeconomics.[8] While classical economists agree with Keynesians that money is neutral, they disagree on the length of time it remains so. Keynesians believe money is only neutral in the long run and, hence, favor monetary stimulus and government intervention in the economy.[9]

Geoffrey Ingham criticizes the neoclassical approach to understanding money, claiming its "logical preconditions" as a medium of exchange put economists at a disadvantage for describing the object of their inquiry. In his view, neoclassicism's methodology cannot account for the complex historical social relations that gave rise to monetary systems.[10] Carl Wennerlind notes the "seeming aversion to the study of money among microeconomists" and identifies this phenomenon in relation to both microeconomics and macroeconomics: "Many macroeconomists argue that money is a veil that has little or no significance for the determination of real variables, while microeconomists infrequently discuss money, as their theoretical foundation does not specify money as a necessary institution."[11] The broader point achieved by citing classical and Keynesian approaches to money shows the disagreement that prevails in the discipline and, further, that money's definition affects the assumptions and questions used in those different approaches.

Recent literature across many disciplines in the humanities and social sciences has argued for a more nuanced and social definition of money.[12] Following this challenge to previous scholarship, this book treats money as a medium or symbol for social relations and as the social relation itself.[13] Matthew Rowlinson notes that although money acts as a symbol and requires symbolic authority, it is not only a symbol. He writes, "the different material objects and social practices in which money is embodied at any given time and place support an array of different symbolic meanings."[14] Ingham, following Searle, moves beyond the claim that money represents a social relation; rather, he claims that it is a social relation: "all forms of money are social relations."[15] At its base, money is a social connection or implicit agreement between people. It structures different kinds of relationships. Economist Narayana Kocherlakota has even argued that "money is equivalent to a primitive form of memory," an essential aspect to forming any relationship.[16] Once money is seen as constituted by social relations, the conventional distinction between money and credit becomes problematic, and, according to one scholar, not merely anachronistic but "based on a conceptual confusion."[17] Economist Glyn Davies identified the origin of money as developing from multiple social needs, not all economic, and therefore drew attention to relationships first and foremost in exchange.[18] This has been recognized by sociologists, anthropologists, philosophers, historians, political scientists, and literary historians (see Chapter Five on materiality).

As a contested sign that operates in diverse mediums and cultures, money is hardly a neutral object that adds up to its face value. Rather, money offers a complex site for the creation of meaning.[19] Any system that relies on collective belief, as both coin and paper money do, is necessarily representing a social relation, described by Niall Ferguson as "trust inscribed," by Geoffrey Ingham as "structural properties of society," and by John Searle as the "construction of social reality."[20] We can then start to see why there is such variety in terms of the medium of money across cultures. People on the island of Yap in the South Pacific, for instance, used stone discs weighing as much as a car as currency.[21]

The cultural need to stamp metal with the signs of government, as the Tories did to their captured Spanish dollars in 1797, indicates a need for symbolic authority in helping to smooth out social relations between people. As Kevin Gilmartin has noted, the struggle against the system and its financial instruments "was in many ways a struggle over how people should be linked with one another in society."[22] In his 1832 history of the Bank of England written from the perspective of the "Old Lady of Threadneedle Street," the economist William Reid acknowledged that "a great advantage of the rag trade, [is] that it requires little or no capital to begin with. A good name is better than riches to a rag merchant."[23] The "rag trade" was a common slang term for banking, and banknotes themselves were often referred to disparagingly as "rags," such as those depicted in *Political Hocus Pocus!* (Figure 1). Reid explained that the opinion of a banker's character and his reputation for honoring debts are more important than owning capital itself. Thus, Reid's observation admits that social relationships structure or give value to money. In 1778, Richard Price wrote about the social nature of paper's "imaginary value," that it owes "its currency to opinion."[24] Reid and Price correctly hinted at the fact that paper money derives its value from opinion and not solely from its convertibility into specie.

This difficulty of defining and valuing money contributed to satires like *Political Hocus Pocus!* that linked money to magic. Money carries a power so strange—so odd—that it was routinely attributed to things like magic, necromancy, ghostliness, and "second sight."[25] When satirists engaged with this kind of association, they challenged money's status as a thing in the world. And by probing its definition they also probed the distinction between fact and value. Was money something like a brute fact? Or was it purely invented, and something that held its value completely removed from the material world? Satirists hinted at such questions in their images. In order to understand satires of money or other works of art representing money, we must also understand the fact/value distinction and how this dichotomy breaks down. I suggest here that money cannot be defined without it.

In philosophy, particularly analytic philosophy, much has been written about the breakdown of the fact/value dichotomy.[26] Classical and medieval philosophers such as Plato, Aristotle, and St. Thomas Aquinas saw an

essential connection between fact and value not only in ethics, but also in aesthetics. However, the influential modern philosopher David Hume famously denied that a rational connection is to be discovered between factual claims and value claims—thus divorcing fact from value.[27] Hilary Putnam has argued that the dichotomy of facts versus values has "corrupted our thinking about both ethical reasoning and description of the world," especially in economics and the social sciences. He argues, unwittingly using language relevant for the practice of visual analysis in art history, that "evaluation and description are interwoven and interdependent."[28] That is, bringing value to an object and describing the object are entwined practices.

We cannot adequately understand the graphic satires examined here without a clear picture of fact and value in relation to money. At its most fundamental level, money is a social relation. One can ask more specifically, what kind of social relation is it? The most compelling answer is that money is an institutional fact. This term institutional fact might appear distilled and self-explanatory, and in some sense, it is, but it comes from a specific place in the history of analytic philosophy. An institutional fact is an objective fact in the world, but one that is only brought into being by human agreement. Together, these institutional facts build social reality, or the social rules that we internalize and follow.

Philosopher John Searle, who is central to many developments in analytic philosophy, brings particular clarity to fact and value. In *The Construction of Social Reality*, Searle delineates things that exist only when we say they do. These include marriage, property, government, and money.[29] He demonstrates that money is an "institutional fact," not a "brute fact."[30] It exists within human institutions and not independent of them. For example, marriage is not real in the way that, for instance, temperature is. Temperature is a good example of a brute fact. No amount of arguing or redefining will move mercury on a thermometer. Yet, the definition of marriage is subject to argument and definition in terms of nature, process, and documentation. In his own way, Georg Simmel attempted to identify this when he said that money carries "the psychological fact of objective value" and not objective value itself.[31]

In *The Construction of Social Reality*, Searle develops a taxonomy of facts. In this hierarchy of certain types of facts, he separates mental, intentional, collective, functional, agentive, status-driven, and nonlinguistic facts.[32] See **Table 2** for an explanation of how money is defined in relation to each of these categories. One can see, at the fourth level of the chart and below it, that collective social facts are divided to include the assignment of function, which is a brute fact. Function is then divided into non-agentive and agentive. The distinction pertains to the difference between what might be called natural functions existing in the world and not determined by human agents, and those functions that are determined by human agents.

His example of a screwdriver, however, does involve this assignment of function. As an object in the world, a screwdriver might be used for something else, like picking ice, but in this specific case it matches exactly with other parts created by humans called screws. On the next level, this assignment of function to the screwdriver is also causal, as opposed to relating to status in society. In this line of the chart, Searle equates status function with institutional facts, and he uses money as an example of this type of status function. In other words, money might be a brute material in the real world, but its function and agency exist in the minds of observing subjects and is based on the collective agreement and collective intentionality of its use and value. These distinctions help us refine our understanding of how objects affect our world and sense of self.

Key to this discussion of money, and the Bank of England note highlighted here, is the notion of collective intentionality. In Searle's model, subjectivity requires an orientation to others: "It is indeed the case that all my mental life is inside my brain, and all your mental life is inside your brain, and so on for everybody else. But it does not follow from that that all my mental life must be expressed in the form of a singular noun phrase referring to me. The form that my collective intentionality can take is simply 'we intend.'"[33] This collective intentionality is part of subjectivity and the relation of the self to the broader culture. In the following pages, I use the terms "institutional fact," "human agreement," "collective intentionality," and "social reality" in reference to the tradition of graphic satire. I also take the term "collective intentionality" as inseparable from subjectivity and notions of the self; this is central to understanding the mutual gaze in satires and is discussed further in Chapter Three.

The word value itself, as a noun, always indicates *relative* importance. It is defined as "worth or quality as measured by a standard of equivalence." Even in art, where value means "due or proper effect or emphasis" and "relational tone," the word indicates relational qualities in a picture.[34] Value does not exist in isolation. It arises from estimation, opinion, comparison, liking, usefulness, importance, and equivalence. Monetary value is the equivalent monetary worth of a specified sum that might be expressed as "fact" or a number, but it is a number that arises from the act of valuation. Monetary value and other types of value, such as sentimental and social values, are not easily separated. They exist relative to other things, people, and relations between people.

In order for money to be used as payment, the value of a medium of exchange needs social acceptance and explication. Language and taxonomy thus contribute to how materials are valued. In Searle's language, this means the use of performative utterances in the creation of institutional facts. For example, defining a one-pound Bank of England note as a "hand-signed engraving" is peculiar even today, despite that this describes its medium in the late Georgian period far better than "banknote."

Facts

Brute Physical Facts
*There is snow
on Mt. Everest*

Mental Facts
I am in pain

Intentional
I want a drink of water

Nonintentional
I am in pain

Singular
*I want a drink
of water*

Collective = Social Facts
*The hyenas are
hunting a lion*

Assignment of Function*
*The heart functions
to pump blood*

All Others
*The hyenas are
hunting a lion*

Nonagentive Functions
*The heart functions
to pump blood*

Agentive Functions
This is a screwdriver

Casual Agentive Functions
This is a screwdriver

Status Functions = Institutional Facts
This is money

Linguistic
That is a promise

Nonlinguistic
This is money

**Functions are always ultimately assigned to brute phenomena,
hence the line from the assignment of Function to Brute Physical Facts.*

Table 2. John Searle's hierarchical taxonomy of (certain types) of facts.

Yet, the one-pound note (Figure 5), which qualifies as a "speech act" of sorts claiming, "I promise to pay . . . ," has a different exchange value than other hand-signed engravings.[35]

Another way in which Searle explains institutional facts is with logical structure, or claims in the form of a logical proof. According to Searle, constitutive rules are a key element in creating social reality. Constitutive rules take this form: "X counts as Y in context C." Or in a similar logical form, "We declare that X is Y (in context C)."[36] Here is one example: "A person born on American soil counts as an American citizen" (this is an example used by Searle and A. P. Martinich).[37] The notion of nationalism is an institutional fact, and not one that stems from any connection to geography or literal soil in the United States. Another example is "this dollar bill counts as five US dollars (in countries that accept the currency of the United States)."

That this Bank of England note is only intelligible in light of its function in certain social relations can be shown where such relations are removed. Money does not matter in isolation. An example that never fails to articulate this collective belief is the desert island test. What can be done with a dollar bill alone on a desert island? You might be able to burn it, or save it. Alone on an island, you could not buy a meal with it. It would otherwise not have a function or any value beyond individual mental belief. Money's value only arises within human institutions, and is thus an institutional fact.

Satirists toyed and played with the definition and creation of institutional facts in British culture. They probed not just money, but marriage and government as well. In several instances, satirists intended to challenge belief in institutions and in this way they participated in Enlightenment cultures of questioning and criticism.[38] While some satirists during this period ridiculed money in ways that fell flat, others created satires that managed to ask, in ways still relevant today, questions about fact and value in relation to money. Understanding how money operates as an institutional fact that dissolves the fact/value dichotomy and derives its meaning within a social world allows us to unpack satires that target money and see how objects help to build our social reality.

Scholarly books including Marc Shell's *Art & Money*, and the edited volumes *Art and Money* and *Show Me the Money*, show that money and art are themselves social realities.[39] An astute comment in the introduction to *Show Me the Money* acknowledges the way that things build social reality: "cultural and aesthetic artefacts . . . do not merely reflect, or even simply interrogate, the realities of financial exchange, but also play an active role in constituting those realities."[40] Yet, books discussing art and money have struggled to adequately articulate institutional facts. Peter Stupples notes in his introduction to *Art and Money* that art and money are "spheres of social activity that carry symbolic values," but he then limits the categories used to define them by saying that art and money "come together whenever

the values of both are exchanged within a market." Exchange value, however, is only one of the ways in which they relate.[41]

In the case of imitation banknotes, Ian Haywood did not go far enough when he noted that "the fake banknote . . . shadowed, mirrored and exposed the new credit economy throughout its history."[42] The fake banknote may have shadowed, mirrored, and exposed the credit economy, but it also called such realities into question. Satirists needled the fact/value distinction, and forced Britons to question their participation in institutional facts. In the period 1780–1840, artistic and economic values were bound up to the point where graphic satire and money constituted the same object, for instance, the imitation banknote *Political Bank* signed by John Bull (Figure 2). Its anonymous printmaker called into question the value of paper money, the relationships that create its value, and the networks of people that "promise to pay" and view satire. The *Political Bank* takes aim at the very formula "We declare that X is Y (in context C)." The satire indicates that social reality is necessary for both the satire's joke and its subject, money. In this satirical banknote, both graphic art and money partially constitute social reality, as they did for Britons engaging with new forms of paper in this period. J. P. Malcolm hinted at this notion in relation to the world of sign-making within these satires. He wrote that the caricaturist "nearly creates a new order of beings and things."[43]

Graphic art, like money, exists in the form of a physical object and also draws on the world of ideas and abstraction. Like money, it is traded, discussed, bought, and sold, and like money, it stores both cultural and monetary values. Graphic art probes fact and value; it also offers up both facts and values to its viewers. Mapping it onto the first level of Searle's hierarchy, one can also see how caricature is difficult to characterize as a brute fact or a mental fact. It served as both. A caricature pasted onto the wall of a home is not something imagined by people, it is a real object. Yet, it plays with distinctions of meaning operative in the mental realm and impossible without it. It was the case that William Pitt was tall and lanky, but his exaggerated representation as such in caricatures helped to produce mental facts related to humor and political opinion in viewers of such caricatures. In a sense, graphic satire is a collective social fact; many Britons accepted it as a type of graphic art that commented on people, politics, and society. While various arguments were voiced for and against satires, such as from William Makepeace Thackeray who wrote in 1840 of the notion of bright, enchanted printshop windows with grinning and laughing viewers, to Vicesimus Knox's moral outrage at satire "leveling high characters,"[44] there was a general sense that graphic satire in society existed, that it was a fact. Even the "haughty art critics" who became "irritated when people talk of the composition or the stance of figures in a mere caricature," as a contemporary wrote of Georgian graphic satire in 1801, bestowed this kind of acknowledgement upon it.[45] Despite the variety of approaches

to establishing its function, graphic art operated as an institutional fact similar to money, even if it held a status as low art.[46] Money and graphic art do not create their own value, networks of people do.

Famously, for instance, Hone and Cruikshank's *Bank Restriction Note* protesting the death penalty as punishment for forging or passing counterfeit paper money imagined a different ethical future for Britons. It demonstrated that money is constituted politically and subject to ethical norms, but it was not the only satirical banknote to do so. The *Political Bank* deserves closer attention in this context. Despite his distaste for paper money, Bull signed the *Political Bank*, worth five guineas, sometime during the 1790s. This anonymous satirical note housed in the Library of Congress is drawn on the imaginary "political bank." Instead of listing an actual bank, satirical use of the term "political" replaces what would normally be a place name or recognizable bank (for instance, "Bristol" bank or Bank of England). The note thus highlights the political and economic relations supporting paper money. It satirizes unfair payments in the form of sinecures and undue pensions. John Doe and Richard Roe, both placeholder names used in eighteenth-century law, stand in for real people and, like this note's publisher, remain fully anonymous. This satirical note lists three fake names and three political appointments. Without real people to establish a network of relationships and eventual payment, this note ensures no chain of accountability in the payment of five guineas. The creators of this note also risked the crime of uttering, as someone might mistake this as a real banknote and pass it either wittingly or unwittingly as a forgery. Yet, the "guinea pig office" vignette gives the note a whimsical and humorous tone, and could be an example of an early use of the term "guinea pig" to refer to the subject of a scientific experiment. This satire engages in contemporary debates about corruption and the ethical and political nature of money, or its social reality.[47]

Like Bank of England notes issued after 1855, this note does not promise to pay anyone in particular; rather it just promises to pay the bearer. The note indicates that people who are paid for not working gain their wealth from the deep reserves of political relationships and the paper promises that service them. By drawing the note on the "political bank," the maker of this note revealed an astute understanding of paper money as a social and political phenomenon. In the *Political Bank*, perhaps John Bull ran out of real guineas and could only back his paper money with guinea pigs—a real world item with use value, not value based on human agreement. Like Bitcoin, the *Political Bank* demonstrates the instability of trust, neutrality, and anonymity where money is concerned.

This satirical banknote, like *Political Hocus Pocus!*, shows that paper money can disguise political motivations driving the economy and, in that sense, how history unfolds. Money acted in the period examined here as a veil to hide the politics behind sinecures, pensions, laws, governments, and

Pitt's own machinations. Like John Bull, a symbol of the nation, Doe and Roe could represent anyone. Britons constituted Bull in the same way that their trust in each other constituted the value of paper money. Britons who were willing to trade paper money for goods and services created its value. Money is ultimately a human agreement and therefore a deeply political phenomenon requiring political acts.[48] It is a social relation subject to all the same problems and triumphs that occur between humans in groups. In sum, money is an institutional fact that constitutes our social reality.

The Bank of England pound note operated in a contested cultural context of growing belief in systems of paper money. Far from a stable entity, this object was a sign open for interpretation by its users. The role of economic crisis and warfare in ushering new monetary mediums into circulation, as shown in the next chapter, seems the best place to start uncovering the cultural substrate of paper money's value on a large scale in late eighteenth-century Britain.

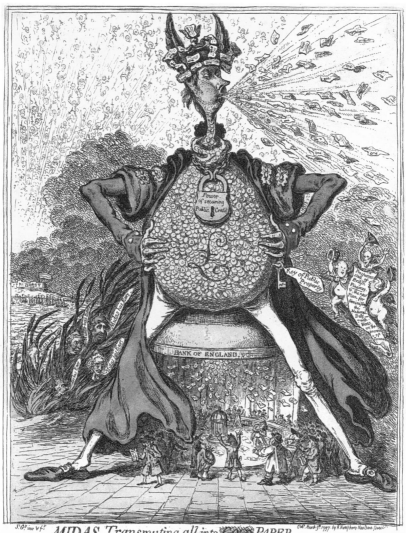

**Figure 6. James Gillray, *Midas,
Transmuting all into ~~Gold~~ Paper*, March 9, 1797.**

CHAPTER TWO

Crisis

GʀᴏᴛᴇsQᴜᴇ ᴀɴᴅ ɢʀᴀɴᴅ, King Midas inflates beyond recognition and spews paper money in James Gillray's satire *Midas, Transmuting all into* ~~*Gold*~~ *Paper* (**Figure 6**). In what might be one of the more famous satires of Prime Minister William Pitt, *Midas* responds to the specie crisis of 1797, when the Bank of England stopped converting paper money into cash.[1] Pitt, cast as Midas, has asses' ears under his "regal cap" of low-denomination incontrovertible paper money notes. Gillray delights in dichotomies and humorous contrasts. The left and right juxtapose French and British, and Whig and Tory. Further pushing this geometric logic, an X formed by Pitt's limbs compartmentalizes disparate groups of people and things: dagger-wielding revolutionaries in the upper left quadrant and paper money in the upper right, different factions of Parliament in the left and right of center, and a large diverse crowd under the Bank of England rotunda at the bottom, including John Bull. The Whigs are blown by "the Wind from the opposite Shore" of Brest, the westernmost French military port that stood a short distance from Britain's southern shore. France had suffered multiple failed paper money currencies by 1797, and these were listed for contemporary Britons in the *Times* as *assignats, territorial mandats, rescriptions, bons, ordonnances,* and *inscriptions.*[2] This satire represents the "inflationary excess" experienced during the French Revolution and then applies it to Britain.[3]

Multiple crises manifest in Gillray's ironic treatment of the Midas myth: an Order of Council stopping payments in specie, the French Revolution and the potentially destabilizing effects of the resulting power shift at home,

a shortage of bullion due to funding the war against France, runs on the bank, the instability of the Bank of England and public credit in general, and a crisis directly relating to the representation, or medium, of money. As a somewhat new medium for money, paper appears as a new kind of social relation for Britons.

Just days before Hannah Humphrey published this hand-colored etching, the *Telegraph* reported: "Every man who read the proclamation was struck with this enormity in it, that for the first time in the history of this country a proclamation violated public credit, and compelled the Bank to stop payment."[4] Faced with a lack of specie and fear of a French invasion, the British government was forced to act. On February 27, 1797, King George III delivered a message to the House of Commons expressing concern about the demands of specie in the face of recent runs on the Bank of England. The Order of Council, later the Bank Restriction Act, was immediately agreed upon and the Bank of England stopped converting banknotes into gold specie on demand. During February and March, some Bank of England notes were refused by customers, while others signed resolutions to support the bank. In March, Parliament passed an act enabling the bank to issue notes of small value (one and two pounds) until May 1 to offset the general shortage of specie, and the country banks were permitted to do likewise; new copper coinage was also minted in low denominations of farthing, halfpenny, penny, and two penny pieces.[5]

Some viewers of this satire were no doubt reminded of the forged assignats produced by Britain between 1793 and 1795 as a furtive means of further debasing France's economy, but in this print, Gillray reveals the fear that British banknotes might meet with the same desperate fate as French paper money.[6] Supposedly a temporary measure, the Bank Restriction lasted until 1821.[7] The connection here between liberty and the convertibility of paper money into cash—and the negative association of paper money with Republican France—cannot be stressed enough. The stoppage of payments was cast as an act of tyranny as large as Pitt's body in *Midas*. The *St. James Chronicle or the British Evening Post* quoted Charles James Fox, the Whig opposition leader, speaking about convertibility in terms of liberty, itself now under threat from the Restriction: "Credit never rose under absolute Government; we have founded our happiness upon our civil and political Liberty."[8] Thus, in *Midas*, the Whigs wear Phrygian caps, the caps worn by freed slaves in ancient Rome and by French Revolutionaries.

Gillray reverses the touch of King Midas in text and image and uses the satire's title to make this reversal obvious by scratching out the word "gold." Pitt grips his bulging belly of gold with both hands; his vomiting and incontinence produce paper money. Bills spew from his mouth and the Bank of England rotunda serves as his latrine. The large pound sign on Pitt's engorged stomach asserts that the British currency is made of gold coins

Amanda Lahikainen

and not paper money. The satire visually delights in what is supposed to be missing. Gold shines out to the viewer in the center of the print with bright yellow color and drowns out the rest of this carefully divided image. This bizarre fantasy of distortions makes it unclear if gold is the solution to a problem, or the problem itself. It is safe to say that here Gillray produced and responded to a taste for gold in the current climate.

Around the larger message of Pitt as a hoarder of gold in this satire, Gillray added several key points. Pitt, Scottish politician Henry Dundas, Member of Parliament William Wyndham Grenville, and William Windham often appear together in his satires. Windham, the Secretary-at-War, serves as a significant detail here. Floating to the right, he holds the most powerful weapon for waging a war behind his ear: the pen. Writing on paper in this context secures credit and the "Prosperous state of British Finances" listed on the scroll in front of him. British finances were not prosperous; therefore his use of the term is ironic. Printing paper money and hand-signing it with a pen was a solution to funding the nation, and yet it ironically admitted defeat—Britain did not have the money to fight a war. Yet, paper money worked. Windham's pen points directly to the key of public property hanging from Pitt's little finger. Paper is the only remaining medium of money the public is able to obtain, and its proliferation terrifies the crowd below.

Below, Bull watches his own economy, and the space that symbolizes it, transform before his eyes into a new social relation. Gillray carefully etched a representation of Sir John Soane's Bank of England rotunda, the one that dates to 1794, by including the large circular desk surrounding the cupola in the center. In Gillray's *Midas* fantasy, people crowd behind the long circular desk inside, and around the outside of the rotunda, collapsing the distinction between interior and exterior. Gillray extends the collective space of the rotunda to include a crowd on the street, confirming that this crisis has affected everyone. In 1841, this room was described as a neoclassical work of art, and a temple for public participation in the economy: "Here, on former days, people of all classes and nations used to assemble, to buy and sell stock; and as the dome is a powerful reverberator of sound, the hum of conversation, and the din of voices, were at once confounding and astounding to the stranger . . . It was a public room, devoted exclusively to the convenience of all who chose to make use of it."[9] An accompanying etching, by Thomas Shepherd and engraved by Harden Sidney Melville, brings the molding, arches, cupola, and caryatids into close view. Light enters into the space used by both men and women. In their description, they emphasize the "recipients of the dividends frequently attend in person, ladies as well as gentlemen acting as their own agents in the all-important matter of receiving money."[10] As a counter to this sunny view, we can see that Thomas Rowlandson satirically adapted a view of Sir Robert Taylor's earlier rotunda

in 1792, when it was used as a stock exchange, observing the baser instincts of people (**Figure 7**). He included the warning on the wall: "No Clerk to act as broker."

The rotunda was later used by the Bank of England to pay dividends on the national debt, of the kind that two men hold in *Midas* on the bottom right corner. On the left, a person likely meant to represent a Jew holds a paper labeled "scrip" and walks off on his own, not participating in the frenzy like the others. "Scrip," sometimes described as substitute money, dates to the eighteenth century in Britain and stands for "subscription receipt." The *Oxford English Dictionary* cites Francis Grose's *Classical Dictionary of the Vulgar Tongue* from 1796 (the year before this satire was published), which defines "scrip" as a phrase often heard in Exchange Alley in London meaning "the last loan or subscription." In any case, this person does not leave with gold, even if the paper he holds was issued at a favorable exchange rate. This contrasts with a satire made by William Dent in 1793, where Pitt is the one taken advantage of by Jews in *Two to One, an attempt to outwit the young pawnbroker*.[11] Gillray's depiction indicates that not even those stereotypically associated with wealth, Jews, have it at this moment in 1797.

After analyzing some of the earliest examples of satirical banknotes and the context of their emergence, this chapter demonstrates that paper money cannot be decoupled from the French Revolution and ensuing specie crisis of 1797. Subsequent debate dominated political and social discussions in Britain. The Bank Restriction period lasted between 1797 and 1821, which overlapped, as Ian Haywood has pointed out, with a large slice of the Romantic period.[12] Gillray, Isaac Cruikshank, and many other satirists were at their best and most "inflated" during the decade of the 1790s. The term crisis implies a turning point, or decisive stage, in the progress of something, especially in, as it was in the 1790s, "times of difficulty, insecurity and suspense in politics or commerce."[13] The word has long been associated with disease and a sudden variation in the progression of illness, such as Pitt's disorder in *Midas*, wherein his body produces paper when it should be producing gold. Crisis aptly describes the trouble with specie in 1797; it also helps to articulate why graphic satire at this time exploded like the paper money from Pitt's mouth. This chapter will suggest that satirists, keenly aware of their own historical context, were fueled by a crisis in representation. Multiple crises structurally disrupted politics, economics, and graphic art.

Early Satirical and Imitation Banknotes

The earliest satirical banknotes appeared in Scotland. A change in the redeemability of banknotes resulted in the production of one of the first such notes in 1764.[14] There are several examples in the National Museums

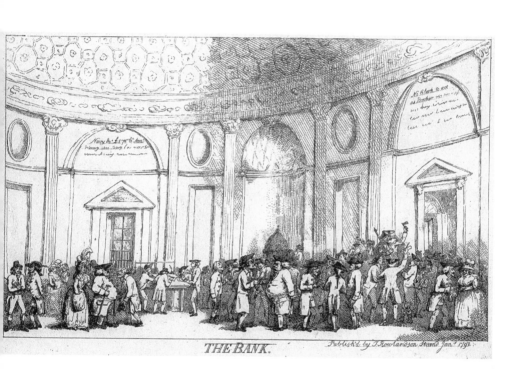

Figure 7. Thomas Rowlandson, *The Bank*, January 1792.

Figure 8. Scottish satirical bank note protesting the option clause from 1764. The following denominations survive from this period: 1 shilling, 1 penny, 3 pence, and 1 pound.

Scotland from that year, including the one pictured in **Figure 8**.[15] One nine-teenth-century volume queries its status as a real note. The author acknowledges it was in fact issued, but is not sure if it was issued in all seriousness or as a joke.[16] Other versions of this same note were signed with fake names, like "cash" and "credit," indicating its status as "propaganda"—the official cataloging term used by the National Museums. These names compare well to later fictitious signatories, such as "Solomon," whose name appears frequently on later satirical banknotes in facetious reference to the tenth-century king of Israel who built the First Temple in Jerusalem, as well as to Jews more generally.

The Scottish satirical banknote responds to the option clause. In the history of banking, an option clause was a way that a bank could legally suspend the redeemability of its liabilities, including paper money, provided it paid an interest penalty.[17] In more general terms, an option clause is meant to prevent runs, or raids, on a bank. In another satirical banknote from 1764, bankers Daniel McFunn, Duncan Buchanan & Co. promise to pay one penny or "three Ballads six Days after a Demand" in the option of the directors. The "ballads" are likely the offer of a satirical song as payment. The swarming wasps that surround the text on the note may indicate a criticism of the increased number of banks issuing notes, but as with so many satirical banknotes, this one's intentions are difficult to recover. A column that repeatedly discussed old banknotes in *The Scottish Antiquary, or, Northern Notes & Queries* states with frustration: "How far these notes may have been used by—say the itinerant singers and sellers of ballads of the Glasgow of that day, or how far they were jokes the signatures we find attached to them leave it doubtful."[18] Apart from the reasonable interpretation that these satires engaged the option clause with irony, it is not clear which side of the debate they targeted. Many scholars have argued that such option clause notes were willingly accepted by the public, despite objections to the prohibition of the clause.[19]

These were just one type of imitation banknote. It is helpful to identify the different types, about which so much is still unknown. Imitation banknotes are prints resembling banknotes with a political, satirical, or fantasy theme. They were also called skits, jokers, flash notes, fleet notes, and puff notes. The term "skit" was likely coined by Maberley Phillips, an early donor to the coins and medals department at the British Museum.[20] They were sometimes called "flash notes," as some flash before your eyes, or "fleet notes," given their association with Fleet Prison, a notorious London prison that mainly housed debtors and people who had gone bankrupt in the eighteenth century. The term "puff" has several fascinating eighteenth-century associations, including with fluffy pastry, advertisements, hot air, and inflation.[21] "Puff" had associations with paper money much earlier in the century, with hot air, breath, farting, and wind all being used to satirize loss of value. One example of this from earlier in the eighteenth century is a satirical medal

from the South Sea Bubble of 1720, which shows a man creating credit from wind by blowing paper credit instruments from a pair of bellows (**Figure 9**).[22] As a verb, one of the definitions of "puff" means to "cause (something) to swell by directing air into it; to blow out or up, to inflate; to distend by inflation," and although it is not entirely clear, it is likely that inflation in the monetary sense is one strong association for the satirical term "puff," meaning an imitation banknote devoid of value.[23] "Puff" also betrays the close relationship that graphic satire and its subgenre of imitation banknotes shared with advertisement throughout the period.

The British Museum holds the largest collection of imitation banknotes, around 150 of them dating before 1870. Around 120 distinct imitation banknote designs survive in various collections.[24] Even assuming a conservative print run of two hundred copies per plate for the surviving examples, these imitation notes circulated in the tens of thousands. Note that Eirwen Nicholson argues for an initial print run of one hundred to as much as six hundred for political prints in the eighteenth century.[25] While this number of imitation banknotes is small in comparison to the 270 million small-denomination Bank of England notes circulating between 1797 and 1821, it is still significant and invites investigation.[26]

The majority of imitation and satirical banknotes appeared after 1780 in England. Judging from the largest extant collection, a group of imitation banknotes dating from the 1780s and 1790s in the British Museum coins and medals department mentioned above, most imitation notes listed the following denominations: two, three, four, and five pence, and five half-pence. A few outliers have higher denominations (for example, five guineas and ten pounds), and others list goods such as tea and engraving. As the list makes clear, though, most of the notes have small denominations, making their creators less amenable to prosecution, and many include obviously fake names.

These objects invite comparison to the parallel cultural form of the mock playbill so prevalent in the eighteenth and nineteenth centuries. Two playbills from this period, discussed by James Gregory, focus on popular political topics in the manner of the graphic satires; they address the famous Westminster election of 1784 and Napoleon's threatened invasion of England around 1803 (in this latter squib, Napoleon is the new star of a farce, but this will be his first and last appearance on stage).[27] These playbills used complex references to theater and current politics to advocate a political position and create humor, and served as an important tool for early nineteenth-century radicals advocating reform. Like these mock playbills, imitation banknotes took up a familiar form and played with the message and semiotic structure of it. One significant difference, although the archive for these two forms of parody is admittedly incomplete, is that the mock playbills played a larger role in electioneering than did satirical banknotes.[28]

Figure 9. Christian Wermuth, Satirical Medal, 1720.

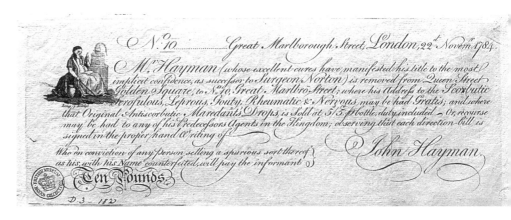

Figure 10. Imitation banknote in the form
of an advertisement for Maredent's Drops, 1784.

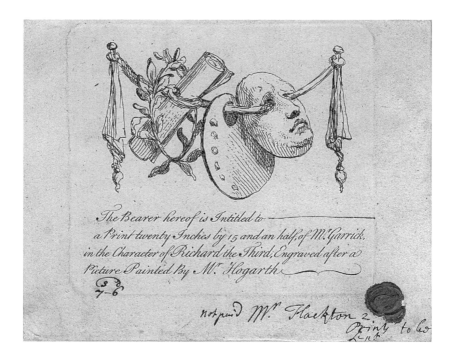

Figure 11. William Hogarth, *Mask and Pallet*, February 1745.

These notes took three general forms: advertisements and trade cards, satires, and forged notes. With the exception of forged notes, most imitations in this genre circulated without the intention to bear credit. Some notes are intentionally nonsensical and often frustrate the three categories.[29] An early note from 1784 (**Figure 10**) exemplifies an early form of imitation and advertisement, complete with a numbering system at the top left, a vignette presumably showing the chemist John Hayman, who signed at the bottom, a written description of his products, a reward of ten pounds to those willing to reveal imitators of Maredent's Drops, and a signature. Another note from 1782 signed by M. Norton advertising the same product is discussed in Chapter Three. Other notes seem to be an exercise in eccentricity. For instance, the mock notes issued by Fort Montague Bank in Yorkshire, for the tiny denomination of five half-pence, were likely issued as a souvenir for people visiting a tourist attraction—a kind of personal paper money.[30]

A similar instance occurred in Australia with "Tommy the Banker." This self-proclaimed banker, Thomas Wright, issued his own notes in small denominations of one, ten, and twenty pounds drawn on the "Defiance Bank" in 1835, as well as numerous other fake banks including: Sydney Bank, Parramatta Trading Bank, and the variously spelled Austilin, Austilian, or Austiln Bank. Such imitation banknotes strike a blend between advertisement, forgery, and joke (at least for those who were wary of Wright's scheme). He cashed some of these notes as an investment in their value and his own reputation, but went to prison anyway in 1839 for fourteen years.[31] Sociologist Viviana Zelizer has shown that when money becomes more prominent in social life, people segregate, differentiate, label, decorate, and personalize it to meet their complex social needs. They transform money by earmarking it to fit a variety of values and social relations.[32] Imitation banknotes follow this logic and are still produced today.

A near precursor to these, William Hogarth's subscription ticket *Mask and Pallet* for *Garrick in the Character of Richard III* (**Figure 11**), an etching from 1745, also takes the form of a promise to pay. Ronald Paulson has discussed at length the mask and pallet's connections to theater and friends of Hogarth at the time.[33] The bottom half is clearly a promissory note and form of paper credit. It reads: "The Bearer hereof is Intitled to ————— a Print twenty Inches by 15 and an half, of Mr. Garrick, in the Character of Richard the Third, Engraved after a Picture Painted By Mr. Hogarth." This ticket acts as an advertisement for the artist, a promissory note for further work, a receipt, and a record of an exchange only partially completed. The engraving acts as a social promise and agreement in much the same way as paper money. It is modeled after such money, but this promise has exchange specificity.

Although the supply of money had been inadequate over the whole of the eighteenth century, the problem of small change became an even bigger problem in England after the Bank Restriction. On December 19, 1789, the

National Assembly in Paris issued paper currency called *assignats* (1789–97) redeemable on the monetary value of state lands and plundered church property. Both assignats and the specie crisis of 1797 rivaled the South Sea Bubble of the 1720s in terms of attracting popular attention and criticism of paper credit instruments in the British press.[34] As Richard Taws notes, assignats were materially unstable and the ultimate sign of both value and worthlessness.[35] Despite the long tradition of paper credit, targeted by Augustan satirists, there is no evidence that paper money itself was used as a platform for satire in England until the 1780s and 1790s.[36] This innovation in satirizing credit indicates a change in the status and visibility of paper money in England at the end of the eighteenth century. During the specie crisis of 1797, the Bank of England stopped redeeming its notes for gold and started issuing paper money in small denominations. That year, for the first time, low-denomination notes of one and two pounds entered the credit economy, drastically increasing the social reach of paper money issued by the Bank of England and country banks. No longer the business-to-business convenience it had been in Adam Smith's time, paper money came into common use by butchers and pastry cooks.

In Ireland, fake banknotes appeared at least as early as the French Revolution. A reference found in the Charles Haliday manuscript collection explains that, in Ireland, satirical banknotes containing the pretend signatures of French Revolutionaries had an immediate, negative effect on banks' business. Not all individuals who encountered these fake notes signed by Robespierre and Marat were able—or willing—to understand them within a humorous framework. Richard Hayes's description of this reads: "An odd circumstance occurred in the North of Ireland which may serve to show the pains taken to seduce the people of this country. Shortly after a Bank had been opened in a large commercial town in Ulster, a number of notes were issued made payable to Thomas Paine, Dumouriez, Robespierre, Marat, &c., which were put into circulation among the loyal inhabitants of that town . . . the result of their conference was that no one would accept in payment a Note from that Bank, which thus suffered severely from its Republican humour."[37] Satirical notes such as the ones in this anecdote indicate the fluid nature of political and financial capital. This observation offers evidence that the networks of satirical prints in Britain emerged and spread before British money was in use in Ireland after the Acts of Union in 1800.

The high cost of paper, and its rarity across Europe at this time, indicates the extent to which imitation banknotes became important to their publishers. James Baker has done some fascinating research into the conditions of production of late Georgian satirical prints, including paper. Before the 1840s and the mechanized production of paper, papermaking was more directly tied to labor.[38] As the craft involved picking rags, preparing them with water, and then sizing the sheets, there were just not enough people making paper around London. It had to be imported. As it was a luxury good

subject to tax and wartime blockade, even importation was not always a solution that could satisfy market demand. In a telling example, Baker records the cost of printing five hundred copies of a sermon in 1796 by Thomas Spilsbury: four pounds, four shillings for four reams of "fine wove paper" and eighteen shillings for printing, labor, ink, and depreciation of machinery. The cost of paper in this example is 82 percent of the total cost of production.[39]

Most of the single-sheet engravings in the genre of satirical banknotes appeared early in the nineteenth century. Small-denomination notes of one and two pounds formed one of the conditions of possibility for the popularity of satirical currency in England, especially the run by John Luffman discussed at length in Chapter Four. Reports of "Mock Bank Notes" appeared periodically in newspapers during the Restriction period, such as the *Manchester Mercury* in 1812: "House of Commons, Wednesday. The Chancellor of the Exchequer rose to bring forward his motion for regulating, with a view to suppress, the circulation of Local Tokens. He said that considerable mischief had been done, and gross imposition practiced on the people by the circulation of Mock Bank Notes, which by having the words applicable to the note in white letters upon a black ground, in imitation of real notes, could not be discovered without close inspection."[40] William Cobbett (1763–1835), a widely read radical journalist in this period, cited the *Courier* in April of 1811:

Mock Bank Notes. A number of mock notes, for a penny, fabricated obviously imitation of the one pound bank of England, are at present in circulation. After the words, "for the Governor and Company of the," the words *"King's Bench and Fleet"* are inserted in an upper line, in very small characters, and the remainder of the sentence concludes "Bank *in* (instead *of*) England." The hackney-coachmen are the principal *putters off* of these notes. A person who asks change of a two pound note from one of these gentry particularly at night, rarely escapes being cheated.

Cobbett began attacking paper money after 1800, writing about the topic in 1810 and 1811 in his *Weekly Political Register* (which he wrote in Newgate Prison while serving a two-year sentence for seditious libel). The reference to Fleet Prison, where many imitation notes were printed illegally, appears in many of the imitation banknotes. Cobbett states further that anyone who puts faith in "the Old Lady," the Bank of England, will deservedly "be caught in their own trap; choaked in their own halter."[41] Clearly an increase in banks and in paper money in the form of low-denomination notes, as well as changes in the redeemability of those notes, fueled the production of satirical banknotes by the early nineteenth century. The reasons to imitate paper money are clearly multifold and increasingly made sense to printmakers as paper money became more widely used. Additional contextual factors enabled paper money to become a platform for ridicule, of itself and other political questions.

The Bank Restriction Act of 1797 and Semiotic Instability

William Pitt served as British prime minister from 1783 to 1801 and again from 1804 to 1806. Satirists held him responsible for the sizable debt incurred to fund the wars against France, as the national debt during nine years of war with France increased by £336 million, while the actual cash taken in by the government was only £223 million.[42] In 1795, James Aitken created an etching in which the national debt, along with "Imperial Loan" and "New Loan," appeared on the saddle of John Bull while Pitt, riding Bull like a horse, whipped him with war and taxes.[43] That same year, a number of images of Pitt as a locust, or of him eating money for dinner and guarding the treasure chest of the country, appeared.[44] By 1797, he embodied public credit, marking a change from an allegorical female Whig in service of the public to a tyrant in danger of destabilizing the national finances.[45] Once Pitt took control of the circulation of money in coin, Gillray and Cruikshank visually inflated his body to the size of a giant.

The relationship between gold and paper, and the meaning of paper notes (in this case shares of stock), repeats a trope in circulation during the South Sea Bubble of 1720.[46] Drawing inspiration from the frontispiece to *Arlequyn Actionist* (1720), Gillray turns Pitt's paper money into excrement in *Midas, Transmuting all into ~~Gold~~ Paper*.[47] *Arlequyn Actionist* was republished in the famous Dutch volume on the bubble *Het Groote Tafereel Der Dwaasheid (The Great Scene of Folly)* and represents stock shares as excrement. On the platform in the upper right-hand corner, Scottish economist John Law, squatting over the edge, imbibes coin from a funnel and through this process excretes a paper inscribed with his name, written as "*Laauw*" (lukewarm). Below, a man eagerly reaches up to pull the dispensed share. Two other gentlemen in the center of the stage also eat coin and excrete stock: the bare cheeks on the left deliver "Z:Z," for the South Sea Company's shares Zuid Zee, and the exposed posterior on the right delivers "Missisippi," or shares in the French Mississippi Company, which Law had founded. Another paper note just behind "Missisippi" reads "*al Wint*" (all wind) drawing on the metaphors of farting, blowing wind, and excretion. A monkey in the foremost center of the print holds a paper inscribed "nothing" (*Nul*) directly comparing this paper to the bags of coin in front of him, one of which reads "I have the money" (*ik heb de peon*).[48] As was the case in the 1790s, bodily processes and individuals provided the framework for representing the forces of financial loss and negation. In borrowing from this tradition, Gillray turned Pitt into John Law. He also equated paper money with lower bodily functions and assessed its value as nothing.

This section traces the representation of paper money in several satires of Pitt during the first few months of the Bank Restriction period. Crucial to understanding these caricatures, yet often left out of their discussion, are the

Amanda Lahikainen

definitions of paper money held by the individuals depicted. Debate about the definition of paper money underscores the impossibility of semiotic closure for representations of paper money in satire and the meaning of paper money itself. These images reveal the semiotic instability of paper money, variously cast as trust in the government or in the Tories, as a placeholder for gold, as a revolutionary fiction, or as all of those combined. Visualizing debt via the caricatured body of a prominent politician proved an effective strategy for challenging belief in England's system of currency and for demonstrating anxiety surrounding public credit. Satirists claimed to deliver the truth about state finances and to unmask the prime minister's corrupt actions. Several of Gillray's caricatures in particular play with traditional dichotomies and attitudes toward debt in surprising ways. For example, Pitt serves as a monetary radical in well-known caricatures of the specie crisis. Pitt's changing portrayal demonstrates several reversals in financial imagery, from allegory to representing personal identity, from Whig to Tory, from public to private, from British to French, and from female to male.

These changes indicate the fragility of the credit-debt continuum at this time. In Gillray's *The Giant-Factotum amusing himself* (1797), Pitt's swollen body straddles the speaker's chair in Parliament, balancing paper on his right hip with coin on his left. His red freckled cheeks and nose are flushed from the excesses of alcoholic and financial indulgence. In a grotesque turn, the royal coat of arms replaces Pitt's genitals, blurring the lines between the king's power and his own. The satire addresses semiotic instability; the viewer is left to interpret the money stuffed into Pitt's pockets as either arbitrary or indispensable for fighting the war against France. Trust in Pitt has been disavowed by his large size, but as the Tories literally kiss his shoes, the Whigs get trampled. This formulation of Pitt's body must have been quite successful, since Cruikshank's *Billy a Cock-Horse or the Modern Colossus amusing himself* (**Figure 12**) adopted it from Gillray's more compelling design published a few months prior. Cruikshank, however, took the trope of Pitt as a factotum a step further by accusing him not only of war mongering, but also of financial wizardry to advance the war and profit from it.[49] Pitt wears two saddlebags labeled "Resources for Prosecuting the War" and "Remains of the Gold & Silver Coin" in the image. In one bag, five denominations of "British Asignats" protrude: 20s, 40s, 10s, 5s, and 2.6. Pitt's left riding boot literally serves as a spur in Charles James Fox's side as blood pours forth. By accusing Pitt of paying for the war with worthless French paper money, Cruikshank envisioned the Bank Restriction Act of 1797 as a result of Pitt's inability or refusal to repay his treasury bills in specie.

Pitt became a tyrant in the eyes of the caricaturists and was treated as such by the Whigs. Early on in the Parliamentary debates on a paper money currency, Fox stressed the necessity of institutions, such as a senate, with large numbers of people for distributing power. Otherwise, corruption would ensue:

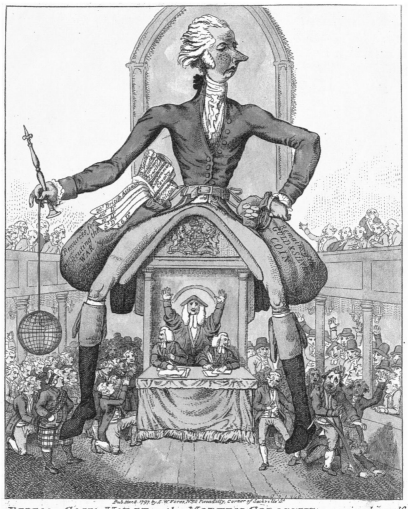

Figure 12. Isaac Cruikshank, *Billy a Cock-Horse
or the Modern Colossus amusing himself*, March 8, 1797.

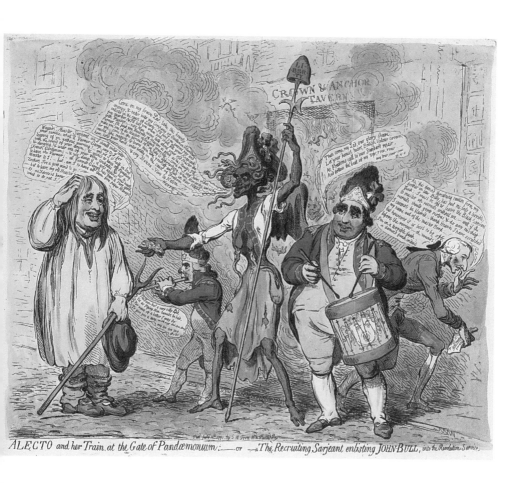

Figure 13. James Gillray, *Alecto and her Train, at the Gate of Pandaemonium: or The Recruiting Sarjeant enlisting John Bull into the Revolution Service*, July 4, 1791.

"[i]t has been proved that the stability of credit has always been better maintained in republics, than in those governments where it merely depended on an individual, or on a small body of men."[50] For the caricaturists, this individual was Pitt, and following the Whig line of reasoning, they located this fear of tyranny in his body, stressing the fragility and corruption of Pitt's administration.

In the seventeenth and early eighteenth centuries, the other side of debt—namely, credit—had always been represented as an allegorical female figure, as Lady Credit or Fortuna, in both graphic satire and pamphlets written mainly by Whig authors.[51] Certainly, no one visual formula existed for the representation of credit or debt at the end of the eighteenth century. Gillray reinvented Lady Credit in a number of satires in the 1790s, notably as a fabulous French hag in *Alecto and her Train, at the Gate of Pandaemonium: or The Recruiting Sarjeant enlisting John Bull into the Revolution Service* (**Figure 13**). In this satire, Alecto extends a fist full of assignats with her right arm. She offers Bull a choice between two possible types of economies: that of the immaterial wealth associated with paper money and that of material, land-based wealth represented by Bull's pitchfork. *Alecto* contrasts well with the emblem of credit in a Josiah Wedgwood cameo dating from between 1789 and 1795, which displays public credit or faith as a triumphant woman holding a horn of plenty. By the specie crisis of 1797, with its implementation of fiat currency, circulation of small-denomination banknotes, and increased demand for trust in paper, satirists replaced Lady Credit with Pitt, making caricature central to the representation of debt.

Like the fears voiced in Parliament and written in newspapers at the time, *Billy a Cock-Horse* asserts that British paper money could follow the same fate as French assignats. A Mr. Hobhouse stated outright in Parliament that he was "afraid that bank paper would fall into as low a condition as even assignats or mandats."[52] Because assignats and *mandats* were forced currencies, any indication that paper notes might be forced on Britons met with vigorous opposition. The Marquis of Lansdown objected to the language used in the original Order of Council ordering the Bank of England to stop issuing cash as payment, specifically the term "required": "it was a word unknown to the law, and which ought not to have been used; it was an importation from France. Requisition carried with it the idea of terror, which could only be carried on by force. It ought to have been a recommendation."[53] With comments such as these, the association between Pitt and French despotism makes sense, as does his body swelling in size while his perceived power grew. The Whig-leaning *Morning Chronicle* claimed "there is a similitude in the *Arret* and the *Order* of Council so striking as to make the heart of every loyalist shudder."[54] Such pronouncements indicate that Pitt also risked association with Revolutionary France in the contemporary press and faced accusations that his support of the

Amanda Lahikainen

Bank Restriction bordered on anti-loyalist or radical behavior. One author in the *Morning Chronicle* sarcastically made the case for Pitt as a French Revolutionary: "What followed was all quackery and patchwork; the Revolution took place [in France]; and CLAVIERE prevailed over the wiser suggestion of M. de TALEYRAND, in substituting Assignats as a Circulating Medium. Mr. PITT's own confidential advisers can tell him the rest."[55] This association of Pitt with French finances, however, was not the initial point made by Gillray after the Order of Council.

In his first satire on the Bank Restriction, Gillray once again confronted Bull with the prospect of accepting paper money in *Bank Notes, Paper Money; French Alarmists, o the Devil, the Devil! ah! poor John Bull!!!* (1797, see a copy in **Figure 14**). But instead of *Alecto* as a terrible hag offering paper notes, Pitt offers them instead. Here, paper money is depicted as a social relation, directly tied to the government, the Tories, and Pitt himself. The print divides down the center with Tories on the left and Whigs on the right, fighting over Bull's allegiance. The Whigs offer him gold, the Tories offer him paper. Pitt dons a quill in his hair, indicating his literal involvement in writing paper credit. Gillray highlights the yet unresolved relationship between the Chancellor of the Exchequer and the Bank of England.[56]

Perhaps to a surprising degree, the satire correctly reveals the politicization of paper money along these lines. Fox laid out a statement on February 27, 1797, against issuing paper money, calling it "a very alarming proposition."[57] Fox's body language in the print reveals alarm as he throws up his hands and encroaches on Bull to warn him. In Parliament the very next day, Fox stated outright that Pitt "has destroyed the credit of the bank. There is no gentleman so ignorant of the principles of paper credit, as not to know that the whole source of the validity of this species of currency is derived from the circumstance of it being convertible into gold and silver."[58] The satire allows for this conversion since the cash backing the banknotes sits just under the desk, but it also challenges the connection between the notes and the cash just like it challenges the Bank Restriction Act itself. The Marquis of Lansdown's complaint appears in the center of the print as a statement posted to the end of the desk. The Bank of England had been ordered by Parliament and Pitt to stop paying in specie and this came dangerously close to tyranny at home.

Gillray imbued this representation of paper money with a sense of risk. Bull's understanding of the paper money boiled down to his political allegiances and trust in politicians. He opted for the political party more likely to honor its agreements and actively shoring up the nation against France. In this image, Fox characterizes paying debt with paper as paying off the material with the immaterial, exclaiming: "Don't take his damn'd Paper John! Insist upon having Gold to make your Peace with the French when they come." In this satire, Fox and Irish Whig Richard Brinsley Sheridan want coin to give to the French. Accordingly, Bull would rather take a note

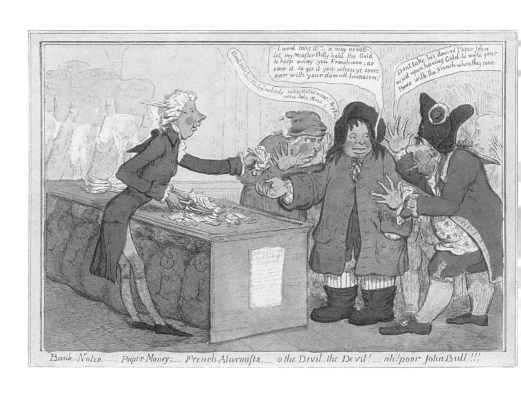

Figure 14. After James Gillray, *Bank Notes, Paper Money;*
French Alarmists, o the Devil, the Devil! ah! poor John Bull!!!, March 1, 1797.

from Pitt, who keeps the coin locked behind his desk and out of French hands. He replies, "I wool take it!—a may as well let my Measter Billy hold the Gold to keep away you Frenchmen, as save it to gee it you when ye come over with your damn'd Invasion!"

If Diana Donald is right that Bull represents imagined public opinion in the 1790s, then Gillray is presenting a fantasy of every Briton accepting paper money. She writes, "Rather than being part of an allegory of the nations, or the embodiment of an authentic British consciousness, John Bull is now in the 1790s a materialization of *public opinion* as imagined, shaped and manipulated by those who control the levers of political power."[59] Gillray had to contend visually with the "general eagerness to display this CONFIDENCE in the STABILITY of the BANK" and the various resolutions around London "instantly filled with signatures" to support the Bank of England, described in the Tory *Oracle and Public Advertiser* on February 28.[60] Several newspapers recorded this phenomenon on their front pages that week. Hiroki Shin has observed how significant this declaration movement was for maintaining trust in the financial system.[61]

A meeting was held at the Mansion House the day prior "to consider of a general Resolution to promote the universal Circulation of Bank of England Notes instead of specie," and the resolution was unanimously accepted by merchants and bankers with the Lord Mayor presiding.[62] The *Times*, the *Morning Chronicle*, and the *Oracle and Public Advertiser* all printed a short explanation of the resolution, the resolution itself, locations where one could go to sign it, and its signatories (although the Whig-leaning *Morning Chronicle* claimed the names were too numerous to be copied in time for their print).[63] The *Oracle* republished the resolution on March 8 with additional names beyond the "three thousand and twenty-three" already signed. The *Observer* printed a similar resolution from the Newcastle Upon Tyne banks: "We the undersigned do hereby declare that we will receive the Notes of all the Banks in Newcastle upon Tyne, on payment of rent and in other transactions as usual."[64] *The True Briton* reported this support of accepting banknotes in North Shields, South Shields, and Durham.[65] Gillray quite studiously represents Bull as accepting paper money from Pitt, like the Britons who signed the resolution to support the Bank of England, but he denies comfort in taking the notes since Bull is an idiot. Bull's acceptance of the note is a sign of trust in the currency, but his interpretation of paper money is suspect due to his low intellect.

Aside from using the French Revolution to politicize paper money, Gillray's satire also calls into question the value of banknotes, as did the debates in Parliament. Parliamentarians debated how far and to what extent paper money should be used in Britain, and what paper money represented, with most individuals falling into one of two groups: calling it equal to cash, or calling it simply a promise. Here the debate discussed in Chapter One on the two main theories of money, described by Joseph

Schumpeter as the commodity theory or the claim theory, becomes obvious in historical context. Parliamentary conversations reveal a basic divide—a debate that never became comfortable or acceptable for Britons, even throughout the nineteenth century.[66] The Whigs were associated with the principles of the French Revolution. The Tory attitude toward debt and paper money was more closely aligned with the main principle behind assignats than that principle was with the Whigs. According to the Tory view, there need not be metallic money backing up all paper credit. The biting humor of Gillray's *Bank Notes, Paper Money* comes from the irony of who is painted as a French Republican (the Whig Fox) and who acts as the French Republicans acted (the Tory Pitt). This contradiction stems from two differing definitions of banknotes.

Fox could admit no other definition of paper money than that it represented gold or silver in the Bank of England. He insisted that: "The use of paper, then, must always be secondary to the precious metals, must flow from credit, and credit must in its nature arise out of the opinion that the paper was issued in due and discreet proportion to the fund of specie."[67] Simply put, the Whigs had a conservative definition of paper money. Thomas Paine was even more skeptical of paper money than Fox and Sheridan were. He outright objected to the idea of them *tout court* in 1787, claiming that Bank of England paper had no more value than newspaper and that paper money served to raise false ideas in the mind.[68] He stated in *The Decline and Fall of the English System of Finance* (1796) that paper money might produce a political revolution in government and attributed the impending downfall of the economy to cheap credit traded in paper.[69] Sheridan, who had never heard "such nonsense" from the Tories before, claimed that "[a]ccording to one of these orators, a forced paper currency was better than specie, and our commerce would increase in proportion as we violated the principles of honesty in paying our public debts."[70] This contrasts nicely with Sheridan's Jacobin plot in an earlier satire by Gillray.[71] In *The Dagger Scene*, Sheridan is represented as saying he planned for bankruptcy as an easy solution to debt: "O Charley, Charley! farewell to all our hopes of Levelling Monarchs! farewell to all hopes of paying off my debts by a general Bankruptcy! farewell to all hopes of plunder!" When Gillray included Edmund Burke's speech "where French principles are introduced, you must prepare your hearts for French Daggers!" he might have specified that one of these French principles was indeed defaulted finances.[72]

According to Burkean Whigs, the conversion of land into cash was partly to blame for the trouble with the value of paper money. Keep in mind that fiscal policy and church property figure prominently in Burke's *Reflections*, and that he understood property to be the foundation of virtue, manners, and chivalry—all of which made commerce possible. Burke warned in *Reflections* that "the mutual convertibility of land into money, and of money into land, had always been a matter of difficulty," and later wrote that

"[t]o establish a current circulating credit upon any *Land-bank*, under any circumstances whatsoever, has hitherto proved difficult at the very least. The attempt has commonly ended in bankruptcy."[73] Assignats, in the words of John G. A. Pocock, serve as the "central, the absolute and the unforgivable crime of the Revolutionaries" in Burke's *Reflections*.[74]

Pitt, however, did not expect the bank to hold enough reserves to meet every note upon demand at any given moment, and accounted for other kinds of property, particularly land, as collateral for paper money. This claim was perfectly clear to those who understood the growth of capital, such as Whig William Pulteney, who wondered why the notes existed at all, but to extend credit beyond specie: "[t]he Bank had not always beside them the cash for all the notes they issued; for if they had, why issue notes at all?"[75] Dent, who supported Pitt's ministry broadly, noted that the scarcity of cash was "partly real and partly ideal," admitting that the difficulty in defining exactly what paper money was could be attributed to it being an idea and a matter of faith—in the terms suggested earlier, a matter of human agreement.[76] In fact, Pitt sidestepped the entire question of specie. Concerned with properly managed debt for the Bank of England and not physical money, he appealed for the abstract negotiations of multiple kinds of debt on a balance sheet:

This was a question which had for its object the ultimate security of the funds of the bank, and not whether the demands against it were to be paid at a particular day or hour. It was a question with reference to the solvency and solid capital of the bank. It was not a question, whether the bank contained actual specie equal to those demands; but whether they had good debts due to them, or property of any other description, which might be finally available to them in the liquidation of the debts owing to the public.[77]

When the Government inquired into the high price of gold bullion in 1810 (and after), this same debate continued. Albert Feavearyear noted Tory Robert Peel's definition of the pound sterling, in agreement with the economist David Ricardo, that "No one had ever been able to give any satisfactory definition of a pound sterling except that it was a piece of gold of a certain weight. He ridiculed the ideas of Thomas Smith who, in evidence before the Committee, had attempted to develop his conception of an 'abstract' pound."[78] This led to the passing of Peel's Act in 1819, returning British currency to the gold standard, and the resumption of gold payments by the bank in 1821.

The abstract nature of money was communicated in satiric representations of paper money and also in titles such as Gillray's "ministerial Conjurations for supporting the war," suggesting, among other things, that Pitt somehow conjured up magical ways of financing the country much in the way the monied interest did.[79] In this way, several satires in the 1790s adopted a Burkean, or Whig, line of reasoning by representing paper money as suspect.

The problem of representation in regard to paper money might be interpreted within "English Romanticism's obsession with imagination" and the fact that, for better or worse, to think about money requires imagination.[80] Money is a sign subject to interpretation, trust, and authorship. Gillray used his powers of imagination to depict Pitt as a kind of "philosopher's stone" in *Midas* by combining several earlier sources representing him as the alchemist, the tyrant, the colossus, and the money devil—ironically showing him as the reverse of Midas.[81] The Bank of England may have been consistently caricatured as a Whig institution early in the century, but in this image, Pitt serves as the referent for public credit and the Bank of England, visualized as his Tory institution.[82] Here, Pitt hoards the specie rather than safeguarding it as he does in *Bank Notes*.

Midas envisions that paper money, like excrement, has no value, employing a strategy for materializing the ideas of loss, negation, and nothingness. In fact, Pitt's expulsion of paper money resonates with the Scottish financial wizard John Law's paper schemes, which were well known in the 1790s and refreshed in the minds of those who read *Reflections*.[83] Each emission of a banknote in the image makes the one before it less and less valuable. *Midas* visualizes the opposite of what Burke bragged about seven years earlier in *Reflections*:

At present the state of their [France] treasury sinks every day more and more in cash, and swells more and more in fictitious representation. When so little within or without is now found but paper, the representative not of opulence but of want, the creature not of credit but of power, they imagine that our flourishing state in England is owing to that bank-paper, and not the bank-paper to the flourishing condition of our commerce, to the solidity of our credit, and to the total exclusion of all idea of power from any part of the transaction. They forget that, in England not one shilling of paper-money of any description is received but of choice; that the whole has had its origin in cash actually deposited; and that it is convertible, at pleasure, in an instant, and without the smallest loss, into cash again.[84]

Here, Burke refers to paper money as "fictitious representation" and attacks the idea of arbitrary power. He also alludes to exchanging notes for cash as a freedom, and the "exclusion of [. . .] power from any part of the transaction." It is no wonder that satirists seized on Pitt in order to represent the Bank Restriction Act, since Pitt put an end to this freedom by using a power later referred to as unconstitutional. Britons did not choose the Order of Council and they were not able to convert their paper into cash in 1797. "Fictitious representation" might as well describe the representation of paper money in *Midas*, also indicated in the *Morning Chronicle*, published on the same day as *Midas*: "It seems to be the intention of Mr. Pitt to render the Circulating Medium like the Representatives of the Commons, not an actual but a virtual Representative—paper without

money, Representatives without constituents."[85] The scroll reading "Prosperous state of British Finances & the new plan for diminishing the national debt" held by Grenville and Dundas in the satire ironically indicates that this situation is anything but prosperous.

Gillray gives visible form to what Fox called "the Minister's strange and monstrous paradoxes on the subject of French finances."[86] The poem below explains the reference to the legend of Midas in Ovid's *Metamorphoses* and that the five Whig heads appearing from the Sedges "whisper'd out his [Pitt's] infamy whenever they were agitated by the wind from the opposite shore [France]." Yet, the convergence of dagger-bearing revolutionaries with paper money at the top of the satire threatens to overwhelm the association of the Whigs in the grass with France, associating Pitt's paper with them instead. Gillray played with the associations of paper money with characteristic ambiguity by hinting at Pitt's strange "paradoxes." Pitt had, after all, ironically embraced the tactics of assignats in order to defeat the spread of French aggression.

Haywood interprets *Midas* in terms of capital punishment: to touch paper money, especially the low-denomination one-pound notes floating around in this satire and in real life, "will bring death" by capital punishment. In this way, he argues, Pitt intentionally ensures the compliance of the Bank of England in devastating the lower classes with state coercion. In his reading, Bull, who stands outside the Bank of England with his hands and fingers spread wide apart in surprise and dismay, is "incongruous" in the face of financial decisions made by the government and the bank.[87] Along similar lines, David Taylor reads Georgian satires as needing to separate those who don't understand from those who do, and to distinguish those who revel in the material world as opposed to the intellect.[88] Applying Taylor's general logic to *Midas*, Bull represents those who are excluded from graphic satire's ideal audience and therefore stands incongruous next to individuals with more financial imagination. He displays a kind of shock at Pitt's one-pound notes with his left hand outstretched, yet he holds dividends, another form of paper value, in his right hand. He appears torn between disbelief in and the instability of paper instruments on the left, and belief in and the stability of them on the right. The paper energy triumphed in Gillray's *Midas* is as unstable as the sign of paper money is itself. Bull's participation in the institutional fact of paper money remains ambiguous. Could Pitt's innovations represent Burke's "good" capitalism and prosperity, or must they indicate the bad French side, a "ruinous, inflationary, 'dangerous' supplement" supplanting real wealth?[89]

Only a few select writers, like Henry Thornton, insisted on the benefits of a system of paper credit: "The nature of the institution of the Bank of England is then explained; the necessity of maintaining the accustomed, or nearly the accustomed, quantity of its notes, however great may be the fluctuation of it cash, is insisted on; and the suspension of its cash payments is shewn to have

resulted neither from a deficiency in this resources, not from a too great extension of its loans to government, nor from rashness or improvidence in its directors, but from circumstances which they had little power of controlling."[90] Networks of people also embraced the necessity of paper. The resolution published in the *Times* on February 27, 1797, resolved to "support the universal circulation of the bank of England notes instead of specie" and more than seven hundred people signed it. In some sense, the real value of money was in these newspaper pages and discreet conversations between people as direct expressions of human agreements and institutional facts.

By May, a few months after the Order of Council, Pitt was relieved of his duty to embody the national credit in graphic satire. Gillray re-envisioned public credit in *Political Ravishment, or The Old Lady of Threadneedle Street in danger!* (**Figure 15**), a satire famous today for the first appearance in print of the nickname "The Old Lady of Threadneedle Street."[91] In Gillray's progression from *Bank Notes* to *Midas* to *Political Ravishment*, Pitt first hides and protects gold from the French, then swallows and becomes constituted by it, before finally chasing after it in a sexually aggressive way. As he promotes, regurgitates, and ignores the paper money in these images, he demonstrates the anxiety it created for Britons at the time. He also indicates a progression of meaning, where the trust in paper money is taken as a social relation, subject to trust in government, then the money itself is taken as the untrustworthy vomit and excrement of a tyrant, and then as the legitimate—yet threatened—sartorial facade of the Bank of England. Of course, the choice of clothing makes sense for banknotes, as in *Political Ravishment*, Gillray has returned them to cloth rags. Such a progression indicates a significant change had taken place in just three months.

This semiotic instability appeared after the specie crisis in *Days of prosperity; or Congratulations for Johon Bull!!!* (1798). The image celebrates John Bull, who is dressed up in a new suit made of paper money and two pence buttons. His cravat and ruffles are made of one- and two-pound banknotes and the cockade in his hat is made of one-pound notes. Pitt compliments Bull, saying, "Bless me, Master Bull, why I scarcely know you, you look so well and so prosperous! I told you times would mend—What a fine new Coat! smart Cockade! light Ruffles! beautiful buttons! And such a rotundity! positively you must be bled a little, or youll get too corpulent!" and Bull responds, "I feel as if it were puff'd up with Copper, little Spangles [seven-shilling pieces], Peaper and Promises!"[92] The satire seems to indicate prosperity and promises kept. Yet, there is some doubt. The absurdity of Bull's sartorial display could equally indicate his imminent deflation, leaving behind mere rags, copper, and broken promises. His puffing might not indicate the good health of the nation. *Days of prosperity* and its predecessors reveal the instability of a society confronted with large-scale changes in social relations, a shift that can also be seen in imitation and satirical banknotes from the 1780s and 1790s.

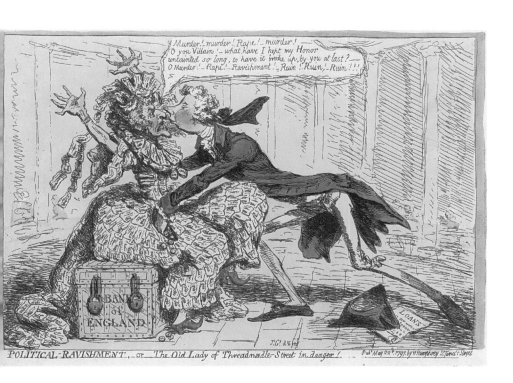

Figure 15. James Gillray, *Political Ravishment,*
or The Old Lady of Threadneedle Street in danger!, May 22, 1797.

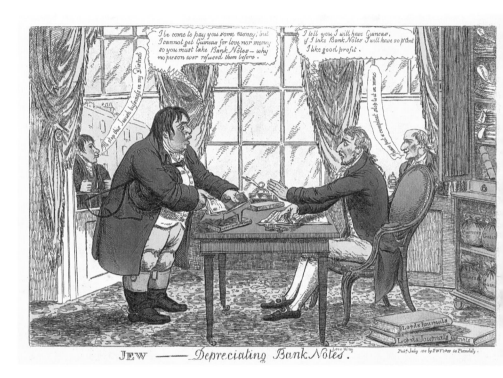

Figure 16. Charles Williams, *Jew —— Depreciating Bank Notes*, July 1811.

CHAPTER THREE

Subjectivity and Trust

REVOLUTIONARY FRANCE made several failed attempts at issuing paper money in the eighteenth century, creating continued inflation and financial hardship for citizens. The same situation often applied to British users of paper money—a fact famously demonstrated by what became known as the Lord King affair. In response to the depreciation of banknotes in 1809, Lord Peter King, a member of Parliament, gave a notice to his tenants that he would only accept rent payment in guineas, Portugal gold coin, or banknotes "of a sum sufficient to purchase the weight of standard gold requisite to discharge the rent."[1] This worked out to nearly a 20 percent increase in the rent price. He published his reasons for refusing to take banknotes for their face value: "On every sound principle of law and equity, the landlord is entitled to receive the real intrinsic: value of the stipulated sum, in good and lawful money; or at least in currency equal in value to the currency at the date of the contract. He is strictly in law entitled to the legal gold coin of the realm."[2] Satirists delighted in the scandal. Responding directly to this affair, Charles Williams and S.W. Fores portrayed paper money's value through the relationship between Lord King and John Bull in the satire *Jew —— Depreciating Bank Notes* (**Figure 16**). Williams, the artist, and Fores, the publisher, released several satires in the early nineteenth century demonstrating the conflict and agreement that creates the value of money.

Here, King, hoarding coins and other paper instruments in his cabinet (leases, annuities, and mortgages), firmly denies Bull the right to pay with a fist full of banknotes pulled from his red wallet. He holds up his left hand in a firm gesture of denial saying, "I tell you I will have Guineas, if I take

Bank Notes I will have 20 p cent I like good profit." One party takes the acceptance of a banknote as a given ("why no person ever refused them [banknotes] before") while the other will not even consider taking a banknote at face value and defines it instead as a financial instrument. Constitutive rules have broken down. For Lord King, X does not count as Y in context C.[3]

The suspense over the definition of Bull's banknotes, and therefore the relationship between Britons and their elected government, offers sufficient tension to carry the satire. The satire also imbricates the subjectivities of Bull and a member of Parliament. Williams and Fores could, for instance, have inserted violence into this scene or crafted some other such artistic solution. The satire reveals that King cannot be trusted, and that the mutual recognition between the two actors in this drama is uneven. They hold different norms for collective intentionality and ethics about monetary exchanges. Although not at first glance a compelling visual organization for a satire—one person sitting behind a desk while the other approaches to complete a business transaction—the artistic framing of this encounter likely offered its viewers a moment of dramatic action. King and Bull stare directly at each other with wide open eyes and in so doing acknowledge that much more is at stake here than simply the rent.

In addition to envisioning paper money as a relationship, *Jew —— Depreciating Bank Notes* further observes that money behaves like gossip. The Member of Parliament Lord Stanhope and Prime Minister Spencer Perceval watch the interaction between Bull and King with disapproval from two open windows. Perceval whispers an anti-Semitic statement secretly in the back, "I'll stop this Jewish business in my District." Stanhope says, "I have put a compleat stop to it in mine."

These two politicians take information out of its original context and act on it in a way that changes the relationships between other people; in this way, gossip and money converge to have a real-time effect on the value of paper. Joseph Roach has observed that "[m]oney, so often the subject of gossip, also behaves like gossip."[4] He further notes that money has a way of "blinding individuals to the full efficacy of their separate contributions" to the credit economy.[5] In this way, the private actions of Bull and King affect the whole country. Like the "widening circle of official associates, detectives, and informants" used by the Bank of England agent William Spurrier to detect utterers and forgers in Birmingham, it is not only the physical object of money that circulates in society. The way money is talked about and accepted has its own circulation.[6] Although King as a landlord was responding to the depreciation of banknotes, the satire recognizes that his action contributed to depreciation as well. The relationship between landlord and tenant becomes the subject of gossip here and spreads beyond the confines of a private office, influencing the relationships between other people, unconnected to the exchange, and how they value paper money. In response to the King affair,

Parliament passed two major acts in 1811 and 1812 that effectively made Bank of England notes legal tender and stabilized banknote and coin depreciation.[7] They had to address trust in paper as well as the value of paper.

The exchange between Stanhope and Perceval also demonstrates how both incongruity and superiority play a part in the satire's construction of humor. While suspense and incongruity supply its dramatic action, part of its humor also comes from its anti-Semitism, which was typical for many of the graphic satires in this period. One of the three major theories of humor, the superiority theory of humor posits that humor comes from a feeling of superiority in the laughing subject.[8] Although King is not a Jew, the satire likens him to the discredited Jewish financier John King in text (the title) and image (his beard).[9] Jews were routinely associated with duplicity and the debasement of currency, from counterfeiting to coin clipping, throughout the eighteenth century. Jews were also known for the rag trade in both the United States and Britain, collecting and selling secondhand clothes, many of which were purchased in bulk by paper producers.[10] This satire forms part of what Frank Felsenstein identified as "an aggressive strain of anti-Semitism that runs through eighteenth-century English popular culture."[11] On the Bank of England notes, Britannia links users directly, presumably, to their national identity.[12] Lord King has denied his Britishness by charging extra for paper money and is thus given a new identity, that of a Jew. This cultural context does not allow for a flexible notion of identity; rather, it creates a false dichotomy, suggesting that King cannot be both British and Jewish.[13]

Thomas Rowlandson captured many of these associations in his 1801 etching *A Jew Broker*. Indicators of Jewishness in this satire include a long beard, hat, paper money folded into a wallet in his left pocket, and a sign saying "Duke's Place," which was the location in North London of the Great Synagogue built between 1788 and 1790. Most contemporary representations of Jews bear some resemblance to Shakespeare's Shylock, the moneylender in *The Merchant of Venice*, and this satire is no exception.[14]

Paper money not only empowered users in eighteenth- and nineteenth-century Britain to own something, but it also structured the relationships between, and the subjectivity of, the people who exchanged money. In this way, subjectivity arises from engagement with others and with culture, or physical extensions of culture. As an institutional fact, it takes the form of "I intend only as part of our intending."[15] As discussed in the first chapter, part of subjectivity is collectively defined—not just "I" but "we." Analysis of *Jew —— Depreciating Bank Notes* shows the importance of subjectivity and trust in representations of paper money exchanges that, along with the things that mediate and define this subjectivity and trust, form the focus of this chapter. Using paper money, and to some extent looking at graphic satire, does not make sense in a vacuum and is difficult to explain without this notion of collective intentionality. Social reality both constitutes and

affects relationships and subjectivities. Satirists took up this realization for humorous ends. And even Edmund Burke, who had little patience for paper money, knew that collective intentionality formed the basis for culture: the "little platoon we belong to in society, is the first principle (the germ as it were) of public affections" and the "interest of that portion of social arrangement is a trust in the hands of all those who compose it."[16] Many satires use the mutual gaze to comment on paper money exchanges. Close visual analysis of these satires reveals how money and graphic art both reflect and produce social reality, and how both can only exist in the symbolic world of collective engagement and intentionality.

Acceptance of a paper note implied trust in the bearer of the note, in the issuer of the note, in neighbors and friends to accept the note *in the future*, and in the self as a performing member of this network of anonymous paper exchanges. Accepting banknotes after the Bank Restriction Act forced individuals to perform outward signs of trust and trustworthiness— to express collective intentionality and admit ethical expectations in a social relation—in depersonalized monetary exchanges. In a sense, the satires here operate in agreement with the often-cited quote from Hegel: self-consciousness "exists only in being acknowledged."[17] Both paper money and graphic satire circulated information easily and quickly and, both "like" and "as" currency, they demanded a kind of trust from the viewing audience, at least regarding the accuracy of events and individuals ridiculed.[18] Graphic satires and imitation banknotes demonstrate the importance of faith and trust in identifiable individuals for eighteenth-century British users of paper money. They also further evince the "embeddedness of key political and moral ideals in the bodies and identities of individuals" in several discourses starting in the 1770s.[19] On the large scale of public finances and on the small scale of purchases, paper money demanded that individuals subject themselves and their material wealth to the promises of other Britons, of government, and of its print culture. That demand changed the orientation of these citizens to each other and to themselves.

Money as a Social Relation in Satires of Exchange

Satirists responded to the basis of paper money's value by representing it as a force in defining symbolic, political, economic, and professional relationships. By stressing the mutual gaze between people exchanging money, they exposed the ethical questions at stake with money as an institutional fact. We have already looked at James Gillray's first response to the specie crisis of 1797 in *Bank Notes, Paper Money* (Figure 14), in which he presents paper money as a material sign of the fragile trust existing between John Bull, who embodies the people of the nation, and Prime Minister William Pitt. Pitt's caricatured body represents the system of paper money itself and therefore makes it difficult to isolate the trust that Bull places in him.

Trusting the paper money in the image means trusting the Bank of England, the Tory government, the prime minister himself, and the king. On the other side of the desk stand the Whig opposition leaders Charles James Fox and Richard Brinsley Sheridan, who warn Bull not to take the paper money. Fox exclaims: "Don't take his damn'd Paper John! Insist upon having Gold to make your Peace with the French when they come." Since Fox and Sheridan are represented as French Revolutionaries, Bull would rather take a note from Pitt, who keeps the coin locked behind his desk and out of French hands.

In *Bank Notes, Paper Money*, the notes symbolize and provide a test for the political and economic relationship between Pitt and the nation. If Britain is going to move forward in funding the fight against Revolutionary France, then Britons need to accept the paper printed by the government. Refusal of the notes would compromise Bull's national identity. His acceptance of them stands as a symbol of his trust, albeit reluctant, in the government's paper system. Those struggling against the system of paper money complained that it resulted in increases in the number of poor people, parliamentary and political corruption, public debt, and, especially, taxation. Poet Percy Bysshe Shelley and activist William Cobbett attacked economist Thomas Robert Malthus in their critique of paper money. In their view, Malthus wrongly blamed the evils of the poor on population increase when he should have blamed taxation, paper money, and the national debt.[20] Other satires of exchange delight in this conflict.

Williams and Fores address the problem of exchange in *Bankers Stopping Payment* (**Figure 17**) and *The Card Party or the Utility of Paper* (1808). The country bankers in *Bankers Stopping Payment* tell a gentleman, "I am sorry to inform you we have just stopp'd Payment!!" He replies, "Pray doant stand upon Compliments with I—I have had a long walk, and will sit here till you begin again." An ambiguous paper credit instrument on the desk reads "Small Stock & Co please pay to my charge £50-0-0- S. Simple." It is probably a check, but possibly a bill of exchange or deposit receipt. S. Simple, the apparent drawer on this note, sits resolutely in the chair with a trustworthy spaniel at his side; he personifies a local version of Bull. All items on the desk indicate a lack of real money: an empty coin shovel, paper credit, a bank ledger, and a pen with ink. All that remains is the relationship between Simple and three elderly bankers whose wide eyes indicate alarm and concern. Eye contact between each of them forms several lines that lead directly to Simple's head and, along with the edge of the desk, complete a wedge shape that culminates in his eyes. This emphasis on wide eyes (even the dog mirrors them) highlights the personal connections and imbricated subjectivities in this exchange. At stake here is trust in a relationship mediated by mutual recognition.

Satirists remained interested in visualizing the exchange of paper credit despite the variety of more interesting topics available to them. Again in 1808,

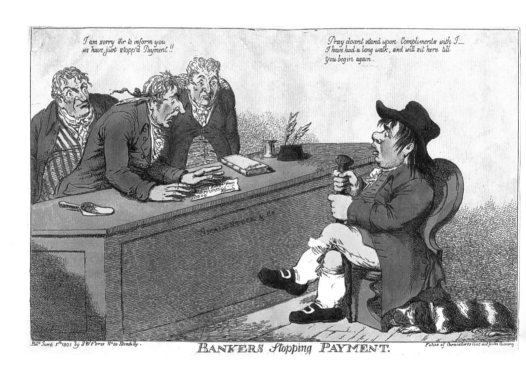

Figure 17. Charles Williams, *Bankers Stopping Payment*, June 5, 1805.

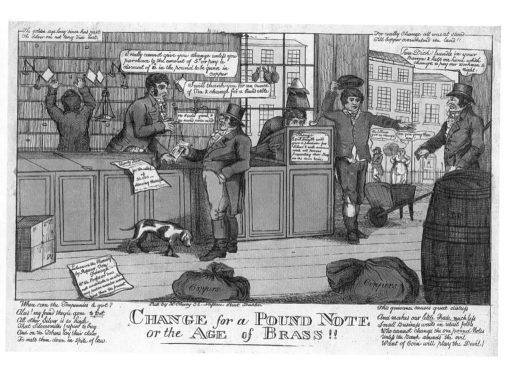

Figure 18. William McCleary, *Change for a Pound Note or the Age of Brass!!*, 1810–15.

Fores and Williams produced *The Card Party or the Utility of Paper*, in which a woman asks indignantly of a man, "Have you no gold sir?" The man replies with a smile, "in the little houses I frequent we always make use of paper."[21] Here, two different cultural norms come to a head as these card players are forced to agree on a form of payment, and consequently on the level of trust in their relationship. Many exchange satires serve particular ends, such as targeting Pitt or Lord King, but the subject of exchange seems too persistent to explain them away by classifying them as personal satire or caricature. The subject likely compelled satirists because they enjoyed probing institutional facts and the fragility of the human agreements that create them. As discussed in the first chapter, money is an "institutional fact" (existing within human institutions) and not a "brute fact" (existing independently of human institutions). In late eighteenth-century Europe, paper currency made this structure of belief ever more apparent because the difference between coin and paper remained a crucial distinction, even though this very structure also maintained the value of coin.

A satire by William McCleary, who famously published pirated copies of London satires in Dublin, shows a shopkeeper refusing to give change for a banknote around the year 1811. *Change for a Pound Note or the Age of Brass* (**Figure 18**) demonstrates the absurdity of challenging paper money—a system clearly more practical than that which required barrels full of copper coins. A gentleman in the corner makes obvious this fact as he requests a wheelbarrow to carry home all the change he needs to pay his workmen. In response to his customer saying, "I will thank you for an ounce of tea & change for a Pound Note," the shopkeeper (or banker) stares directly back at his customer saying, "I really cannot give you change unless you purchase to the amount of 5s or pay a discount of 10% in the pound to be given in copper." The brass referenced here is low-value, base metal coinage, although it could also reference some surviving brass money coined by James II, also called gun money, which circulated until the 1860s in Ireland.[22] Most currency worth over five pence had disappeared by this time, leaving large quantities of lightweight counterfeits or tokens made of mixed metal including brass. *Change for a Pound Note* also exemplifies Gresham's law in economics that when two commodity-based forms of money circulate together at the same face value, bad money will drive out the good.[23] That is, the more valuable commodity will disappear from circulation. By 1811, silver coins, hardly minted at all in the eighteenth century, had disappeared onto the Continent and into secret hiding places in people's homes. Gresham's law also states that newly minted coins eventually drive out the worn and older ones—it is also a law of aesthetics.

A man in the back of *Change for a Pound Note* references the past ages of gold and silver, saying, "the golden age long since has passed, the silver one not long is last." Text at the bottom references the "evil want of coin"

Amanda Lahikainen

and the trouble it causes small business.[24] This satire has much in common with *Jew —— Depreciating Bank Notes*, including the theme of the depreciation of paper money, the importance of eye contact in monetary exchanges, and the general skepticism of paper as currency. A man hiding behind the change counter is afraid to accept paper money. The myth of intrinsic value protected coins from attack, hiding the market forces that actually determine their value. Paper was more prone to criticism. So compelling is this myth that it appears repeatedly in the historiography. Marc Shell, in agreement with Karl Marx, enforces the dichotomy of paper versus gold, categorizing coin as a symbolic commodity, and paper as purely symbolic: "In the institution of paper money, sign and substance—paper and gold—are clearly disassociated." In short, "paper money differs from coined money in an intellectually significant way."[25] The belief that paper money has "intellectual significance" and Shell's denial of its status as a traded commodity subject to shortage and production just like metal reveals the extent to which the value of coins has been naturalized over time.

The "Circulation" of Feminine Banknotes

Satires of exchange visualize money as a social relation. In so doing, they acknowledge that agreements between people structure different kinds of relationships and institutional facts. Satirists probed the ethical dimension of the mutual gaze and human agreements in these images. They also imagined paper money creating many kinds of relationships, especially sexual and criminal ones. Satirists were animated by ideas about gender in representations of exchange and of money. This section will bring to light some evidence for the gendering of banknotes as feminine. Recall from the Introduction how Pitt's gentle wand waving in *Political Hocus Pocus!* (Figure 1) participated in this association. This provides contrast to "John Bullion" and what Ian Haywood called Bull's personification: the "moral gold standard, the 'real value' of the national character."[26] Close readings of several satires, such as *Men of Pleasure in Their Varieties*, show that banknotes both reflected and produced associations with female sexual organs, male impotency, female prostitution, softness, and gossip. That is to say, paper money was often feminized.

One compelling reason for the feminization of banknotes is that the French were cast as helpless, feminized fops in British satire—the French used paper money first and badly.[27] Another association has to do with circulation. Banknotes are commodities used by people and circulate in a society. As mentioned earlier, money is often the subject of women's gossip, and also behaves like gossip due to quick circulation.[28] It is no coincidence that Jews, so tied to moneylending, were also associated in popular culture with libidinal excess and sexually transmitted diseases spread by prostitutes.[29] Consider money's place in the eighteenth-century tradition of the "it-narrative."

Also called novels of circulation, it-narratives or object narratives are short stories that take up objects as protagonists. They constitute a genre in British literature that was quite popular in the eighteenth century and lasted well into the nineteenth century. Taken together, it-narratives explore the ways in which circulation, mobility, and travel were affecting culture by subverting the traditional relationship between people and things. For example, rather than presenting a novel about a person carrying money around, an it-narrative might relay a story from the perspective of the money itself doing the speaking and traveling. Such novels often engaged a satirical position and gave voice to a variety of objects, including pets, dolls, furniture, and clothing. One very popular subject object was money, in the form of both paper and coin.

Ann Louise Kibbie identifies nine it-narratives targeting money dating between 1709 and 1794. These stories personify guineas, shillings, rupees, pennies, sovereigns, bank tokens, and banknotes.[30] This tradition was also very strong in the late eighteenth-century United States.[31] In the 1770s, paper money was drawn into this standard conceit in London. Thomas Bridges's *Adventures of a Bank-Note* (1770–71) narrates in the first person the life of a twenty-pound banknote. It is a satire on Robert Walpole, who had been dead for thirty-five years already at its publication. The narrative itself is based on circulation, a longstanding metaphor for currency, as the banknote passes from one customer to the next.[32] The question asked by Bridges's banknote, and often cited in relation to this narrative, stresses this circulation: "Who would not be a banknote to have such a quick succession of adventures and acquaintance?"[33] Although personified as a male, this banknote is especially garrulous, a quality associated with gossiping women. One of the reasons that money worked so well for this genre was that it suited the popular themes of loving and leaving, and enabled the authors to satirize the culture of commerce and luxury.[34] In the space of five pages, this twenty-pound banknote passes "from a milliner, to a bishop's wife, to the bishop, to a bookseller, to a printer, to a pastry cook, and to a seller of dead dogs."[35]

Bridges's banknote clearly has male desire for the female body. At one point, "he" is tucked into the breasts of a virgin, who was impregnated out of wedlock, and delights in his position: "O reader, think (if thou has any sensation) of my happy situation! Dissolv'd in pleasure, I lay gasping and panting like a great carp in a fishmonger's basket, placed in a vale between two snowy mountains . . . casting my eyes down to the valley that leads to. . . ."[36] The banknote is a ribald man, but he cannot escape close connection to a loose woman. Bonnie Blackwell rightly notes that circulation dictates a loose sexual character, as a virtuous woman would have few adventures to recount, and that the value of both paper money and women decreases with "fondling" and "possession" by many consumers.[37] Taking the idea of circulation further, graphic satirists delighted in the substitution of prostitutes

Amanda Lahikainen

with banknotes, and their work displays the same "credo of the it-novel" by representing highly sexualized women via metonymy.[38]

In a licentious satire *Men of Pleasure in Their Varieties* (**Figure 19**), Richard Newton carefully uses paper money as a euphemism for sexual organs and prostitution. Two of the four sections show a man pulling paper money out of his wallet to pay for a sexual exchange with a prostitute. In the section detail "A good customer," a man puts a ten-pound note on the table, saying, "There's a ten pound note, Maria: I cannot be as liberal as I used to be for money is very scarce." The third section, "A Sham Arrest," shows a man ready to pay some "Abraham Newlands" to keep a woman out of prison. Abraham Newland was chief cashier of the Bank of England from 1782–1807 and his name became a common shorthand for the bank's notes.[39] Paper money's limp placement just above the waist of the gentleman indicates his flaccid member "peeping out of his pocket book already." Historically, paper was not the best form of payment, already highlighted by the Lord King affair. The Court of Common Pleas stated in 1801 that a tender of banknotes in payment was not generally a good tender though the legislature had declared it to be good under particular circumstances, such as to prevent arrest.[40] Using paper money made sense in desperate or unsavory situations, like keeping someone out of jail or paying for sex. In *Men of Pleasure*, the paper money represents sex only symbolically, as the man is prepared to identify what he thinks the prostitute's worth is, presumably at least forty pounds as the text indicates. In this image, paper money stands in for sex and is the sex.

Another satire imagines paper money as having female subjectivity. Rowlandson delights in two "Abraham Newlands" lounging in a parlor (1799). The title *A brace of Abraham Newlands* is handwritten on the back. The women are presumably banknotes, and they are available for sexual acts that may require both sitting and lying. They stand as a typical example of Rowlandson's delight in the female body. The obvious connotations here are that money is female, youthful, sexual, easy, cheap, promiscuous, faint, pretty, and passive. The cultural connections between sexual availability and money are also indicated in *Symptoms of Crim Con!!! or a Political visit to the Heiress in Threadneedle Street* (**Figure 20**). Similar connotations appear variously in Bridges's *Adventures of a Bank-Note*.

Scholarship analyzing monetary it-narratives, which Blackwell's edited volume *The Secret Life of Things* does very well, has yet to sufficiently stress the vastness and unknowability of networks of exchange, and how these multiple, mobile, and ephemeral networks become a complex system.[41] Several authors have suggested such models for understanding money. For instance, Elinor Harris Solomon suggests that money evolves in a messy process of trial and error, carrying the burden of history, and that "one cannot predict" the future of such a system.[42] Bill Maurer rightly suggests thinking about the development of money in terms of additions

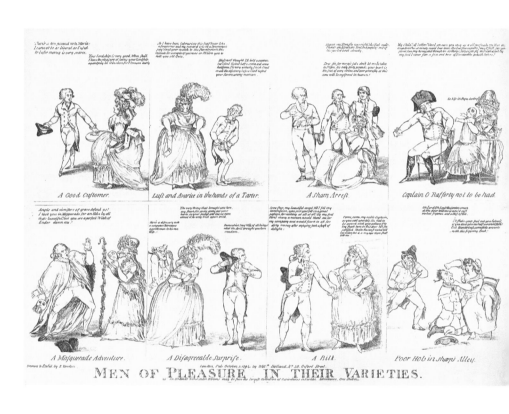

Figure 19. Richard Newton, *Men of Pleasure in Their Varieties*, October 1, 1794.

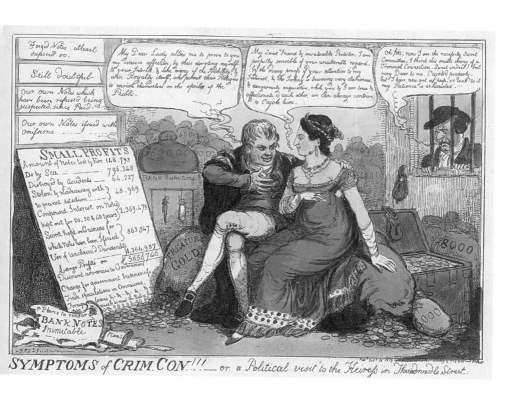

Figure 20. Isaac Robert Cruikshank, *Symptoms of Crim Con!!!*
or a Political visit to the Heiress in Threadneedle Street, **February 12, 1819.**

to an old system, and not linear progressions to new systems.[43] Maurer's observation is particularly relevant for paper money. In the eighteenth century, many Britons understood paper money as a replacement for gold and other forms of cash metal in Britain. Money was a symbol that grew and changed over time. The way symbols grow in a culture was also observed by the philosopher Charles Sanders Peirce, and is addressed further in the next chapter.

Networks of exchange are an essential aspect of the material culture of money. Peter de Bolla noted the efficacy of such a system when discussing debt in Britain, stating that the monetary system is the product of knowledge of the system itself. He writes: "The greater the awareness of the productivity of the circulation of paper money the greater the incentive to participate in the capitalist exchange of interests."[44] Individuals are able to imagine networks of exchange animating money, and this imagining partly constitutes money and debt. In a related observation about literature, Christopher Flint has argued that object narratives on the nature of money parallel the textual commodification of literary forms in which they appear, that they fuse linguistic and material exchange.[45] Similar to how the debt referenced by de Bolla is synchronous with the circulation and exchange of money, reading about circulation and exchange happens at the same time as the circulation and exchange of literature.

Satires personifying money move their narratives forward with an acknowledgement that circulation cannot ever be fully accounted for on the small scale, the only scale possible for an object-narrator. The satirical target of Bridges's *Adventures of a Bank-Note* is a network of credit made up of stereotypes and regular types, including the henpecked husband, the scoundrel baronet, and the naive country gentleman.[46] Contributing to popular culture, satirists characterized paper money as feminine and associated it with the idea of a desirable female body circulating in a vast network of unknowable people. They could not resist the association between circulation and prostitution in relation to paper money. This network of circulation, a complex system knowable to individuals only in the abstract, formed the target of satirical banknotes.

Bawdy and licentious prints themselves were also feminized. For instance, Joseph Monteyne notes that a satire from 1756 equates "indecent prints" in printshop windows "with the strolling bodies of London's prostitutes."[47] Monteyne lists two cases from 1772 and 1782 in which magistrates issued orders for prints of this kind to be taken down from printshop windows.[48] Compare this to the machismo of bullion. Richard Newton's choice of associating hard metal gold coins with constipation in *The Inexhaustable Mine* (1797) indicates the polarization of forms of money along the lines of gender. Newton represents gold as something hard and immovable, traits associated with manliness. That is, the opposite of the easy flow of paper seen in Gillray's *Midas*.

Amanda Lahikainen

In his personification of the Bank of England, Gillray furthered this casting of banknotes as feminine by turning them into a dress for the bank, but with a somewhat grotesque innovation. As discussed in Chapter Two, Gillray re-envisioned public credit and debt in *Political Ravishment, or The Old Lady of Threadneedle Street in danger!* (Figure 15), the first appearance in print of the nickname "The Old Lady of Threadneedle Street." He personified the Bank of England as a haggard and ugly woman clad in flowing paper money. Banknotes constitute this old woman's dress while she sits on a large chest—filled with gold, we assume—protesting the violent courtship of Pitt. While frightened for her honor, this "old lady" appears quite stylish in her dress made of the newly circulating one-pound notes. Rather than disintegrating into the mist, as they did in *Midas*, these notes maintain solid visual form and nestle into her bosom much like the banknote in Bridges's it-narrative from two decades prior.

The print appeared after fierce debates in the House of Commons and Lords about government financial conduct took place. Although Pitt's demeanor indicates going in for a long, soft kiss, the word rape appears in the old lady's speech bubble. She cries out with both hands in the air: "Murder! murder! Rape! murder! O you Villain! what have I kept my Honor untainted so long, to have it broke up by you at last? O Murder! Rape! Ravishment! Ruin! Ruin! Ruin!!!" She refers to public credit as her untainted "Honor," indicating chastity in addition to honorable action in matters of finance. Here, Gillray has given subjectivity and authenticity to the Bank of England, and by this time the bank was sufficiently naturalized to enable its caricature in the proper sense of loading the features of an "individual" institution. The fact that Pitt ignores the woman's dress and heads right for what lies underneath—the gold coin in the private regions of the bank—indicates that the notes on the dress are merely placeholders for gold. As we know, the prime minister did not actually agree with this definition of paper money and stated plainly in parliamentary debates that paper was a perfectly reasonable medium for money. Gillray here picks up a long-standing association between females and paper money, and uses incongruity to take the sexual appeal out of banknote circulation. The old lady's banknotes now define the Bank of England and they are no longer sexy. Pitt finds them appealing, but Gillray has decided they have circulated too much and are worn out, thus letting irony take over. Only Pitt could want someone so unattractive and take her without asking.

The Endorsement of Contingent Subjects and Signatures

A problem arises when the dynamic of mutual recognition expands and circulates beyond known networks of people. While mutual recognition had always been part of the dynamic of paper credit, the influx of small-denomination notes after 1797 meant that notes circulated faster and

more widely. The practice of endorsement, recording the name of the giver and/or receiver on the back side of a banknote, confirms this anxiety. In different ways, satirical representations of debt and credit lay bare the importance of trust networks in producing modern subjectivity. (If everyone paid their debts then money would theoretically disappear from the world.[49]) Signing the back of notes continued in the Bank Restriction Period, quite apart from any legal need for the signatures.[50] Endorsement might have helped recover loss in cases of forgery or misplaced notes, but it also offered peace of mind to users. This practice worked against the anonymity of unlimited bearers.

Two crucial aspects of the practice of endorsement for paper banknotes are the author-function and the signature itself—that is, both recognition of the signature as an extension of a person and the form of the signature itself. In surprising ways, the concept of authorship is as central to paper money as it is to works of art or the spread of print culture. Randall McGowen presents some compelling arguments for the importance of knowing the hand of the person signing banknotes early in the eighteenth century, which, he explains, took place "in a more intimate world."[51] Generally speaking, McGowen demonstrates it was the person and not the paper that mattered in detecting forged paper money. Signing banknotes and promissory notes turned those objects into currency. That is, a signature as a kind of authorial practice produced value. What made monetary transactions possible was the conviction that one had adequate knowledge of the person with whom one dealt.[52] Familiarity with the person as accessed through their signature—an extension of that person—helped individuals assess character and reputation.[53] In a related article, Natasha Glaisyer argues for the importance of signatures in early eighteenth-century England in the context of books about interest rates and how well they could be trusted.[54] Anyone trustworthy must also have a trustworthy signature, and a beautiful one: "And so long as the production of financial instruments depended upon the name and worth of the person presenting them, a good hand was a necessary sign that that person was one who had the credit to present such a note."[55] This supported the trade in books teaching the art of writing, which specifically mention the importance of writing financial instruments.[56]

Authorship during this period carried beyond the importance of a signature line on paper money. It also applied to faith in the government and the individuals tied to the government or to a bank more generally, but a signature applied to a thing changes its status and ties it to the self. Of course, many scholars have argued that things generally, without a signature, are tied to subjectivity. A number of researchers in a variety of fields have theorized "things," how objects and their ownership relate to subjectivity.[57] Money is a thing that relates to subjectivity and imitation banknotes played with this realization.

Imitation banknotes were produced before 1780 in Britain but flourished after 1800. Their circulation in the marketplace, like representations of paper money in caricature, could have concurrently produced the distrust of paper currency and naturalized it as a means of exchange. A comparison of two imitation banknotes from 1797 exemplify the difference between a satirical note and a standard imitation note, two largely different types of notes circulating in and around London in the last two decades of the eighteenth century. A satirical banknote for the sum of three pence from the "Bank of Hereford" is as hard to take seriously as the fake names and playful referents it used to ridicule the contingent subjects of credit. It reads:

I promise to pay Mr Puffer or Bearer on Demand the Sum
of Three Pence, Value, Received.
For Wig, Bag, Tail & Self, J. Rogers.[58]

"Mr Puffer" could refer to forgers, makers of satirical or imitation banknotes, or those who puff up their wallets with fake banknotes, or it could allude to any of the other associations mentioned earlier in terms of light pastry, advertisement, hot air, or inflation. In a reversal of association, it could refer to something that is certainly not coin.

Another imitation banknote for two pence issued by "Farnham New Bank" serves as more of an advertisement:

I Promise to pay the Bearer on demand the sum of Two Pence payable
at the Goat's head, Farnham and the Spur Inn, in the Borough, Southward.
For Wilkins, W. Trimmer, M. Page & co.[59]

The playful references to puffing, wig, and tail contrast in the first note sharply with Wilkins, Trimmer, and Page, indicating that the latter note is likely an advertisement. The satire plays with the tenuous legitimacy of paper currency to gain attention in the marketplace. Both notes quoted here connect their value to several individuals. Importantly, the latter note references material goods and services, for instance a stay in the Spur Inn, and does not indicate a value "Received" like the satirical note does. This advertisement might parallel changes in banking. For example, McGowen uses a forgery case from 1794 to illustrate that increasingly the name of a bank would grow in importance relative to the names of the individuals passing its notes.[60]

In many cases it is difficult to tell the difference between imitation and satirical notes before the turn of the century, a fact that calls into question the usefulness of these categories in this period. A close look at the grotesque note *Emetic Court Bank Dublin* (1794) reveals that it might act as an advertisement, not simply a satirical banknote.[61] Certainly, it associates paper money with vomiting in the same vein as *Midas* by depicting the man

in the upper left corner vomiting into a bowl. And the mismatched sums of "three pence" and "five guineas" seem to indicate its satirical intent. The "three pence," however, seems to be a reward for tracking down "Mr Rhubarbs" or going to "No. 12 Pill Road London" in person, while the sum block of "five guineas" indicates an upward limit for the price of emetic agents: "Salve from One Guinea pr Box to Five Guineas." The nonsensical names at the bottom right foreclose any good answer to the question of whether the note should be categorized as advertisement or satire. It works against anonymity by listing plausible individuals like "James," but mostly draws attention by listing absurd names like "Salts" and "Bark."

The satiric pretentions of the *Scale de Cross* banknote (**Figure 21**) are not obvious now, and were not in the past either. It was passed off as a forgery in 1787. Hugh Peel, a horse dealer, was arrested, imprisoned, and later sentenced to twelve months in prison in connection with the forgery charge.[62] This particular note might have served as a simple private joke; it may also have advertised either the bank or the printer who made it. Marcus Wood has paid careful attention to the connection between advertisement and satire, including ephemera like mock funeral processions and wills, noting that the "rise of the satiric print in the latter half of the eighteenth century is closely related both in formal and economic terms to the rise of advertising forms outside the press."[63] Imitation banknotes are no exception to this. The large-scale growth of the advertising industry from 1780 to 1820, paper availability, and the growth of the press all overlap with the production of imitation banknotes, helping to make odd hybrid-parodies like the *Scale de Cross* banknote possible and available.

It is worth considering the fact that imitation banknotes, like caricature, did not become popular until after 1780 in England. This is puzzling because paper money had been used since the seventeenth century and the Bank of England was established in 1694. Beyond their shared moment of historical emergence, there are several important similarities between caricature and imitation banknotes. First, both types of prints underscore a similar cultural need. Early imitation notes betray people's desire for knowing what lies beneath the surface in an economic exchange, a need to know the character and credibility of those from whom they accept a paper note. This is the type of truth caricaturists loved to promise their viewers, such as Pitt in *Bank Notes* offering paper money, backed by gold, as a social contract with Bull. Second, the two types of prints both copy the form and employ the features of their target. In this way, fake banknotes work like a caricature to unmask anonymous users of money, often with irony. For example, John Graspall's promise to pay Mr. Sippi Round O Winter on the first of April in the satirical banknote *Canterbury Bank* (1791) is possibly an April Fool's Day joke.

Haywood claims that caricature was an ideal medium to engage with paper money on account of the "maverick and ungovernable aesthetics" of both

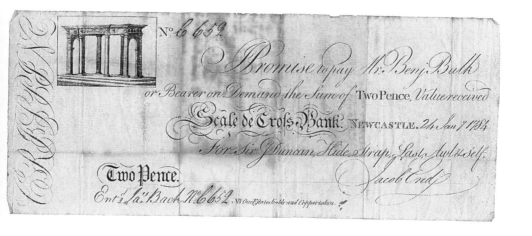

Figure 21. Anonymous, *I Promise to pay Mr. Benj Bulk . . . ,*
Scale de Cross satirical banknote, 1784.

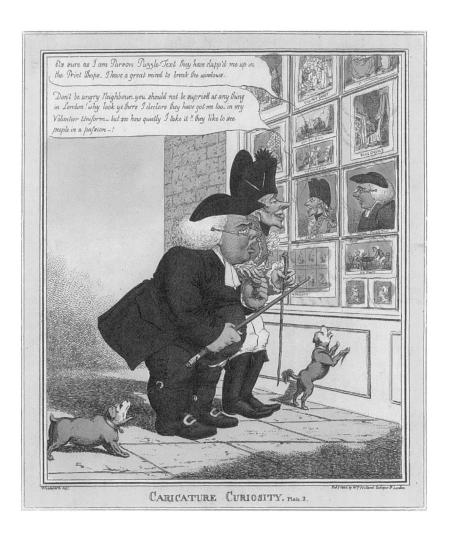

Figure 22. George Moutard Woodward, *Caricature Curiosity*, 1806.

printed materials. Caricature also had potential for acculturating individuals to new economic exchanges, confronting them with semiotic instability and contingency while naturalizing the form of paper money.[64] In contrast to finding simply a "fertile cultural climate for its own paper economy of 'fake' or falsifying representations," graphic satire could also encourage belief in the value of paper, while unable to erase the semiotic instability of paper money. Imitation banknotes worked with and against belief in paper, offering entertainment, skepticism, and advertisement. In contrast to most imitation banknotes after 1797, for instance, John Jenkinson's 1785 advertisement for his teas indicates a fully positive engagement with the form of paper money, despite its underlying assumption of deceit: "I John Jenkinson of Greek Street, Soho, do make Oath that the Teas sold by me shall be pure and unadulterated."[65] Satire and advertisement are "linked dialogically in the late Georgian period" and imitation notes offer a subgenre indicating this.[66]

The successful exchange of real banknotes enabled by the recognition of signatures on their reverse share an affinity with the act of recognizing an individual's caricature in satire of the kind that developed into a distinct genre of printshop window scenes in the early nineteenth century. *Caricature Curiosity* (**Figure 22**) especially illuminates the act of viewing caricature and its relationship to "the self" by depicting two individuals who recognize themselves in the window of a printshop and reflect on the act of viewing themselves on public display. The two types presented, a parson and a military volunteer, are easily recognized by viewers of the satire. The artist draws on incongruity humor: one person is fat and the other thin. Their noses are exaggerated and also reflect the shape of their bodies, one round and the other pointy. Only the words and the dogs below them indicate their excitement, as they are otherwise too busy staring at the caricatures to react beyond the excessive lean of their bodies toward the glass panes. Just right of center, the volunteer stares directly into his own eyes. The tip of his nose nearly meets the represented tip of his nose in the caricature behind the glass. This representation of the volunteer is both an icon, as it reproduces him exactly, and symbolic. His hat and his uniform, and the humor created by exaggeration and incongruity, are signs created out of cultural consensus. Anyone can relate to his position and gaze.

Caricature Curiosity teaches contemporary viewers about the culture of printshop window fronts in 1806—the volunteer reminds the parson not to be surprised by anything in London, saying, "I declare they have got me too" and "they like to see people in a passion." The satire indicates that we do not always like what culture tells us about ourselves. The enraged and stationary parson says, "I have a great mind to break this window." To reiterate the opening section of this chapter, relationships help to structure subjectivity— the idea that "I intend" presupposes "we intend"—and objects are extensions of this model of shared social reality. These two men see themselves,

but they also see how others see them, and this in turn affects their state of mind and sense of self. They are presented as contingent upon how they appear to others. The act of viewing caricatures serves as an apt paradigm for imagining networks of paper credit. After all, imitation banknotes were produced in response to all the strange problems and advantages that arose in a complex system of paper credit. The subjectivity represented in *Caricature Curiosity* was also at stake in a similar way, with the practice of endorsing real banknotes and the ways in which a signature draws on the recognition of self and other.

Anxiety about anonymous paper money exchanges can be seen in several imitation notes, such as *Canterbury Bank*. Although Abraham Newland was a known entity, the rest of the individuals referenced by this bill remain absurdly undetermined and contingent, and along with them the value of paper is lost in a sea of spurious connections. The satirical note reveals a sense of anxiety regarding bills that had no stable referent for the individuals agreeing to a monetary exchange and, in turn, for the physical coin that the paper was supposed to represent. *Canterbury Bank* uses nonsensical references, including the animal "Ourang Outang," likely parodying the variety of users that might encounter paper money:

I promise to pay Mr Sippi Round O Winter or Bearer on demand Ten Farthings here or at Kirby & Mutton Bankers. St Cosmus & Damian in the Blean Kent.
For Janus, Nero, Judy, Trovel, Butt, Hobnail, Ipeaicuanha, Middlings, Miscrecordia, Ourang, Outang & Self.
John Graspall[67]

However, reference to Newland as a real person relieves the anxiety of not having a referent. In the left-hand corner, a man excretes, much like Pitt in Gillray's *Midas*, saying, "Ah woe is me Abraham Newland Alass They have put a Glister in my A . . . e." Dorothy George, who wrote the original catalog entries for graphic satires held at the British Museum, suggests in the entry for *Canterbury Bank* that the satire targets Pitt's idea of drawing on unclaimed dividends at the Bank of England, and that the ducks, meaning stock exchange defaulters, mentioned here are lame.[68] It is also possible that glister, as an alternative to glitter, refers to a shining coin. This reverses the standard association of gold with value.

A number of scholars have noted how the rise of finance capital, financial schemes, and the widespread use of paper money directly affected identity, and may have marked a change in subjectivity specific to the modern period.[69] This links paper money with the theme of alienation discussed at length by theorists of modernity. Paper credit connects its users in wide, unknowable networks of users who do not know each other personally, and participation in these networks contributed to the sense of alienation that is widely considered a major hallmark of modernity.[70] Lothar Müller

even suggests that paper money acquired modernity under Pitt's tenure as prime minister during the specie crisis of 1797.[71] Ian Baucom has noted that finance capital produced a discourse that forced members of society to believe in abstract and imaginary values and things—including abstract people.[72] Some satirical banknotes challenged, subverted, and worked against this notion of crediting abstraction. Others drew attention to the importance of a human referent in exchanges of paper money and to the tenuous subjectivity of the bearer of a paper note.

Slavoj Žižek attributes an aspect of modernity to a certain development in the exchange economy. He recognizes the use of paper money as a social practice that profoundly affects how people see themselves: "the subject has to relate to itself, to conceive of itself, as (to) an empty 'bearer,' and to perceive his empirical features which constitute the positive content of his particular 'person' as a contingent variable."[73] The word "Self" was routinely included on imitation banknotes in their long lists of jokes, animals, and nonsensical references. The "Self" who pretends to offer up three pence to the bearer perceives him or herself as merely a contingent variable. The unstable "bearer" draws attention to "Self," a superfluous term alongside the words "I promise" and the signature at the bottom of a note. Repeated textual inscriptions of "I" and "Self" on imitation and satirical notes, as well as lists of names, offer desperate, ironic assurances that trust in the signatory was not misplaced. In this way, banknotes mediated encounters between people, and were themselves social relations.

There is a similar dynamic described by theorists of imitation, from Rene Girard to Natasha Eaton, that imitation cannot be reduced to a two-way encounter, that it is necessarily mediated by something.[74] A compelling recent art historical treatment of this idea is Monteyne's *From Still Life to the Screen*, where he excavates the issue of self-recognition through representation. A group of prints showing representations of people looking in at printshop windows developed as a unique genre of printed imagery in London in the 1780s and 1790s. Monteyne treats the printshop window as cultural "screen," a concept he takes from Jacques Lacan and Kaja Silverman. The screen in this sense acts a mediator presenting "cultural norms assisting in the definition and identification of the self."[75] He understands art as a reflection and production of subjectivity.[76] The cultural screen posits that mediating objects affect subjectivity. If paper money acted as such a cultural screen for its users, then the reflection of self it offered helped to define such users as social beings in a vast network. The act of spending or accepting a banknote tied the user of paper money to participation in a system of collective intentionality. This collective intentionality makes money an institutional fact, as discussed in Chapter One. In the Searlian sense, the screen of shop window prints and the screen of paper money engaged with the formation of subjectivity despite being very unlike objects. These observations need not indicate that print, specifically paper money,

Figure 23. Anonymous, *I Promise a Reward of Five Guineas . . .*,
advertisement in the form of a mock banknote, 1782.

satires were the only objects related to subjectivity, nor that they somehow played a larger role in the construction of subjectivity than other things in society. Satires were parts of a much larger canvass of people and things that formed social reality for Britons.

In the case of imitation banknotes, the instinct to seek out an actual user of paper money directly turns up in one of the earliest such notes from the British Museum, dating to 1782 (**Figure 23**).[77] This note offers a reward of five guineas to "whosoever shall Discover any Person's Selling a Spurious Sort of Maredant's Drops & counterfeiting my Name." Signed "M. Norton," this sole signatory argues the "Purchaser may be fully satisfy'd by sending or bringing this Note to my House to be Check'd" on the "Least doubt of the Drops not being Genuine." The promise of direct social contact as proof of the quality of Norton's drops assures the consumer of an authentic private individual backing the reward of five guineas. The note also acknowledges that a paper promise will not sufficiently convince the public on its own and directly tackles the problem of imitation or fake products in the market-place with reference to a personal house call that would verify the product's authenticity. In fact, the advertisement itself might be taking up the problem of monetary forgery and connecting it with other types of brand name forgery. This early advertisement reveals a lack of confidence in paper. It takes the form of paper money, but does not fully trust it. The "NB" (*nota bene*) in the bottom left corner of the note invites clients to meet the maker of the drops (M. Norton) in person at his house. Norton's emphasis on a human connection indicates that he does not expect the form of his adver-tisement to sway potential customers. If this advertisement note cannot stand in for a social relation, then his customer should find him in order to create this relationship.

This advertisement's *nota bene* indicates that paper merely services credit, an agreement between people. By doing so, Norton's note validates the much older system of credit that existed long before paper money was exchanged. In the early modern period, for instance, debts would often be canceled against the debts of others, leaving a small remaining balance to be paid in money. Craig Muldrew explains this process as an exchange of credit based on monetary prices, but not necessarily upon physical money. Such agreements, often made verbally, relied on small credit networks among acquaintances.[78] Real banknotes also admitted of this with the practice of endorsement, which worked against the anonymity of the "or bearer" clause that made banknotes fully negotiable and ensured that any-one holding a note could use it as money. As discussed, users of paper notes often signed the back, leaving a record of the people presenting them for pay-ment and a trail of accountability.[79] The practice worked against the theo-retically unlimited number of bearers of a given note and helped to connect paper money to known individuals.[80] According to W. H. Wills, endorse-ment of notes continued into the 1850s.[81] The two imitation banknotes

Canterbury Bank and the advertisement for Maredant's Drops help contextualize satirical banknotes by providing insight into one kind of social relationship, an entrepreneurial one, that engravers hoped to form with users of paper money.

Fake banknotes helped naturalize the form of a banknote—a form that remained fairly unchanged until the early twentieth century (comprised of vignette, sum block, and text). But at the same time, fake notes often worked against the real banknote's ability to deliver a promise. Far from simply resembling "actual counterfeits," these notes indicate a skillful and, in some cases, witty engagement with the credit economy.[82] As prints circulating in the marketplace, imitation banknotes engaged the collective basis for subjectivity and its contingent nature, demonstrating and often creating the need for identifiable individual participants in exchanges in an increasingly expanding credit economy. They demonstrate the desire for confirmation of these participants in acts of collective intentionality and active valuation of the new symbol of paper money. Like the caricatures staring down their targets in *Caricature Curiosity*, banknotes and their imitators reflected and produced knowledge of the self and others in a complex system.

Swearing to Property

William Holland published a satire quite apt for summarizing a chapter discussing subjectivity and trust. *John Bull swearing to his Property!!* (**Figure 24**) shows us again the pairing of William Pitt and John Bull. In this satire on the income tax, Pitt threatens Bull with perjury as he swears under oath.[83] Holland has labeled a small stack of paper money "The Holy Bible." Paper money is thus compared to this most precious of books, which serves as a platform for Bull's swearing. In this satire, paper is a religious text, an ambiguous carrier of financial value, an embodiment of the speech act of "swearing to," and a complex social relation. The overall point of the Whiggish satire is that Pitt acts a thief, taking and spending Bull's money.

These two characters enact both an oath and an exchange while they stare into each other's eyes.[84] Their verbal and monetary exchange is intimate and involves a mutually recognized gaze. The paper money between them represents many things at once—something sacred or akin to the Bible, private property, thievery, trickery, taxation—and is a material embodiment of their relationship. The slope of Pitt's nose and finger form a perfect triangle pointing to Bull. Pitt's finger wag both admonishes Bull and hints at nose picking. In this sense, the government is picking poor Bull's nose and his pocket.

The paper money falls on the left-hand side of the print, indicating its new owner is Pitt. He has taken banknotes from Bull, who claims that he

Amanda Lahikainen

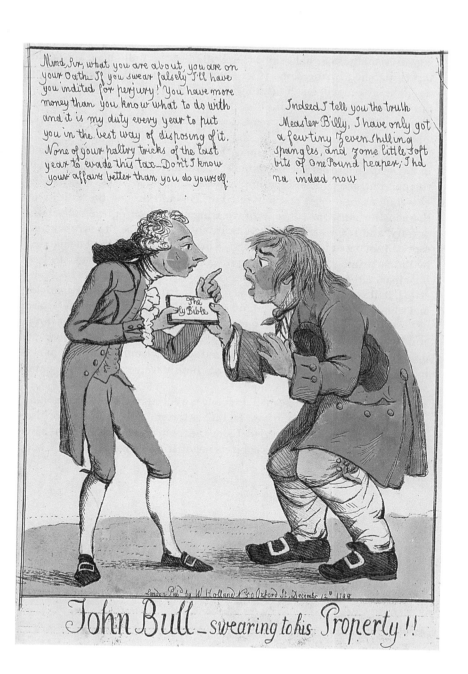

Figure 24. William Holland, _John Bull swearing to his Property!!_, December 12, 1798.

has no money left. Bull emphasizes truth ("I tell you the truth Measter Billy") while Pitt emphasizes his knowledge and control ("I know your affairs better than you do yourself"). The two parallel lines emphasize Pitt's control visually, as a slight slope from Pitt's head to Bull's head across the top is matched by the slope from elbow to elbow. Pitt literally has the upper hand and will enact taxation, portrayed as a form of legal robbery, but in a way that will hopefully go better than the previous income tax, which had been inadequately regulated and largely evaded during the previous tax assessment.

Part of the complexity of this image has to do with all the vectors implied in the relationship between Bull and Pitt, and the web of institutional facts surrounding them. These institutional facts included taxes, law, money, government, and even possibly religion. Holland probed the validity of these institutions. The concepts of swearing under oath, ethical obligation, perjury, and taxes are not purely brute facts, the value of currency and especially of paper money is not purely a brute fact, and the trust demanded by Pitt as prime minister was not purely a brute fact. These facts are not imaginary either—they are institutional. In *John Bull swearing to his Property!!*, Bull swears to his property as just "a few tiny seven shilling spangles and some little soft bits of one pound peaper." He emphasizes the literal size of the currency in the image, as opposed to its face value, by calling it "tiny" and "little." He also dwells on the softness of his paper money. He is no doubt trying to manipulate and discourage Pitt from taking his paper money with these adjectives. His words both devalue paper money and admit its value at the same time.

In this satire of exchange, paper money is a social relation. The relationship between the prime minister and Bull as the embodiment of the British nation is in process and entangled. Using the mutual gaze, Holland was sure to acknowledge these actors as subjects negotiating a collective, social, and ethical world.

Amanda Lahikainen

Imitation
and Immateriality

Uɴᴀᴘᴏʟᴏɢᴇᴛɪᴄ ɪɴ ɪᴛs ɪɴsɪsᴛᴇɴᴄᴇ on coin, John Luffman's satirical bank-note *William Pittachio* delights in imitation and semiotic confusion (**Figure 25**). Its text works against itself in the sense that it is an imitation of paper money protesting paper money. Number eight in a series of twenty-five satirical banknotes, *William Pittachio* is named for Prime Minister William Pitt and calls for the dissolution of his "Great Paper Manufactory," which refers to the widespread issue of paper money in Britain:

> I Promise to pay to the Right Honorable William Pittachio or Bearer, Tᴡᴏ Pᴇɴᴄᴇ, on the dissolution of his Great Paper Manufactory and the Circulation of Specie only.
>> London, the 1st day of August, 1807,
>> For Self, Silvertouch & Lovegold,
>> Brass Hatepaper.
> entd. George Pennypiece.

This note originally appeared in 1807, ten years after the initial stoppage of payments to the Bank of England. Pitt is still portrayed as the benefactor of the Great Paper Manufactory, as he was in James Gillray's images from 1797. The note blames him for the problem of paper money even though he

Figure 25. John Luffman, *I Promise to pay to the Right Honorable William Pittachio . . .* , satirical banknote, August 1, 1807.

had died the previous year, a sign of his importance during the Bank Restriction period. The focus on Pitt also indicates the way Britons sought out individuals to associate with the paper money system in the face of such a vast impersonal system of economic exchange. Like other satires of its time, this satirical banknote criticizes the government and its paper money, but it does not work against the authority of the king, who appears as a marker of stability. The head of George III on the "scarce British coin" replaces Britannia, directly representing gold. The fake signatories on this note are named for the desire for the feel of handling real metal, touching silver, loving gold, and preferring brass to paper. This satire adds to the paper manufactory it seems to condemn and draws attention to itself as a copy of multiplicities. While it is loosely based on the Bank of England note, there is no one banknote it copies. Part of its *raison d'être* is to comment on the idea of a banknote's reproducibility.

William Pittachio straddles and combines two genres of prints circulating during this period: imitation banknotes and graphic satires. Biting, conceptually daring satires are most often associated with Gillray and Thomas Rowlandson in the 1790s, so this particular work has not been singled out as a satire worthy of intense study by historians, numismatists, literary theorists, or art historians who have, on occasion, written about imitation banknotes.[1] In this chapter, though, *William Pittachio* sustains conversations about art and the history of money simultaneously, demonstrating its importance and clever disposition.

Although many imitation notes were not meant to pass as actual money, they were often mistaken for real banknotes and in that context became forgeries. Given the variety of paper credit instruments circulating in Britain, including Bank of England notes and notes issued by country banks, this confusion is not surprising.[2] *William Pittachio*'s small denomination satirizes the inflation of paper money, which had never been issued in denominations as low as one pound before 1797. Its promise of paying two pence might have been a defense against forgery; perhaps Luffman was prepared to pay that small sum if challenged by the government. The low denomination might also have helped to prevent illiterate or deceitful individuals from passing it off as actual currency. Robert Southey wrote from Bristol in 1801 that "market folk this day unanimously refuse to take the small Bank of England bills . . . you are always in danger of receiving forged ones."[3] *William Pittachio* shares its low denomination with other skits, flash, fleet, or puff notes in this period. Although it helps advertise its maker, this clever satire might also, in addition to engaging in the semiotic play discussed here, be a satire on imitation banknotes and the culture of monetary puffery and printers who copied money for various ends.

According to Charles Sanders Peirce, often considered an early theorist of analytic philosophy, there are three main kinds of signs: icon, index,

and symbol.[4] These can help to clarify three ways in which *William Pitta-chio* carries meaning. Peirce's system of categorization accounts for the sign, its object, and the interpretant or effect of the sign on one who sees or perceives it. Icons and indexes are directly imitative of the real world. An icon physically resembles what it stands for. All mimicry is iconic; for example a picture of fire is an icon for fire. An index is defined by some sensory feature or correlation in space and time. For example, smoke is an index for fire. A symbol gets its meaning from mental association and correlation with surroundings. Like the institutional facts under discussion in this book, symbols are defined by consensus or agreement. Language itself is symbolic and arbitrary; for example, the word "fire" is a symbol for fire. Symbols are the most abstract form of sign and are based on convention. They also act as social relations between people.

William Pittachio is an icon of a real banknote, physically resembling one. It has the feel and size of a banknote, which is supposed to be exchangeable for real guineas. It is also an ironic index for coin. Its form is associated with, and is thus an index for, gold. This meta-banknote takes the form of its own target. It is a paper note concerned with the subject of paper money and fits well with an observation made by Richard Price in 1778: "Paper, therefore, represents coin; and coin represents real value. That is, the one is a *sign* of wealth. The other is the *sign* of that *sign*."[5] Using Price's definition, this satire is a sign of a sign of a sign that depicts the original sign on its face. More specifically, it is a symbol of a symbol of a symbol. That is, it is an imitation of an original paper note, itself a sign of wealth or coin, that also depicts the coin. Luffman plays with these signs in order to draw attention to the original sign (wealth) and its absence. Imitation notes thus complicate and confuse the chain of signifi-cation, drawing attention to the complex structure of social trust that lies hidden within, and yet supports, systems of money. The satirical banknote is a *symbol* in the Peirceian sense: it gets its meaning from a cultural context in which paper and gold coin could arbitrarily take the form of money. This last category of sign directly ties together the realm of ideas with the material world. Symbols complicate imitation and the ways people make sense of associations. An extended quote from Peirce in his essay "What Is a Sign?" demonstrates how symbols are, in philosophical language developed much later, institutional facts. As mediators of the physical and mental worlds, symbols and institutional facts follow the same path to meaning:

Symbols grow. They come into being by development out of other signs, particularly from likenesses or from mixed signs partaking of the nature of likenesses and symbol. We think only in signs. These mental signs are of mixed nature; the symbol-parts of them are called concepts. If a man makes a new symbol, it is by thought involving concepts. So it is only out of symbols that a new symbol can grow. *Omne symbolum*

de symbolo. A symbol, once in being, spreads among the peoples. In use and in experience, its meaning grows. Such words are *force, law, wealth, marriage*, bear for us very different meanings from those they bore to our barbarous ancestors."[6]

William Pittachio represents the old symbol of coin, from which the new symbol of paper money grows. The coin in the corner is the iconic symbol of wealth and from it the new symbol of wealth and value emerges in the form of a paper note.

Imitation in this context resists obvious categorization. Jennifer Roberts has noted that in its insistence on exact resemblance and absolute singularity, paper money is subject to a paradox that sets printing against itself.[7] Although a copy, a paper banknote stretches the meaning of copy, which carries the idea that there is an original. In this sense, *William Pittachio* is a parody of a banknote and a simulacrum. In English, the word "simulacrum," which refers to something having the appearance of a certain thing without that thing's proper qualities, dates back to the sixteenth century. As Jean Baudrillard might have put it, it has references but no referents.[8] This relates to Peirce's idea of the index. Even the coin that is meant to stand in as the real form of money is "scarce." It is no longer around to provide the referent. The combination of these signs links them in the minds of their viewers, creating what Joseph Monteyne identifies as the change from object to thing, "the cultural resonances that exceed the object's simple materialization."[9] A symbol, again following Peirce, implies collectivity. That is, a symbol privately held in the mind of an individual is not actually a symbol. Symbols need to communicate between individuals.[10] Peirce lists varied institutional facts, such as law and marriage, as symbols, noting that they exist due to human agreement and convention. Wealth is also in his list of examples, identifying that the creation of value is symbolic and relative to culture. The real stuff of money lacks materiality altogether. Its origin is human agreement.

This chapter considers the complex role of imitation in satires of paper money, accounting for its variety of effects and productivity, beginning with the largest known set of satirical banknotes. It then turns to how paper money grew to symbolize death and state coercion with discussion of the most famous satirical banknote: George Cruikshank and William Hone's *Bank Restriction Note*. The following section, discussing a rare satirical banknote, attempts to unpack how the sign of paper money can symbolize slave labor and abolition. The chapter ends by considering opportunities that arise with the problem of imitating the immaterial, since as a social relation, money has no original embodiment and exists in the realm of ideas. The discussion ends by noting connections some satirical banknotes in this period share with conceptual art. By comparing satires of money to works of art that imitate the immaterial, we can see how the satires take up similar semiotic strategies and concepts seen in later periods of art history.

John Luffman and S. W. Fores

A little-known printseller and mapmaker named John Luffman (1766–1820) began publishing satirical banknotes based on the Bank of England note in 1803, six years after the start of the specie crisis. His satirical banknotes, including *William Pittachio*, reference events between 1803 and 1812. Like William Cobbett after him, he used paper money to represent debt, not wealth.[11] Samuel William (S.W.) Fores (1761–1838), printseller, playing-card maker, and stationer, purchased the plates for these satirical banknotes from Luffman in 1818.[12] Fores republished these notes in 1818 and 1819 toward the end of the Bank Restriction period, when the second Bullion Commission convened and payments in gold were reinstated with Peel's Act. With the second commission, Parliament finally agreed that the value of paper money was related to its volume in circulation, and initiated the resumption of gold payments.[13] The time was right for Fores to appeal, as Luffman had before him, to a general skepticism of paper and the reassurance of gold.

These prints remained topical throughout the Bank Restriction period and serve as the largest surviving set of satirical banknotes known to date. Like traditional graphic satire during this period, Luffman's run attacks a wide range of topics somewhat indiscriminately. The form of paper money—visual and material—was an unstable sign that served as an ideal platform for satirizing grievances of all kinds. As Richard Taws has noted about the assignat in France, caricature and the assignat were both subject to associations with authenticity and falsehood, and value and worthlessness.[14] Both paper money and graphic satire are forms of representation that are laden with political capital and are easily contestable. By imitating the Bank of England note, each one of these satirical banknotes challenged and disrupted the authority and authenticity of the government by calling into question the reliability and trustworthiness of its paper money. Such an act came with several attendant social and political ramifications, which Luffman and Fores gleefully drew upon.

Both publishers of this run of notes were interested in paper money and in making money. Fores rented out books of caricatures for an evening and boasted innovations including the "only Pocket Map ever published with the Names of the Streets" in his bilingual travel guide *Fores's New Guide for Foreigners* (1790). Like the radical publisher William Hone, who gave away a child's toy as a promotion with one of his prints, Fores was skilled at publicizing himself and even erected a fully assembled guillotine in his printshop to accompany a print of the martyrdom of the French king.[15] Maps aside, only a few of Luffman's satirical broadsheets and a set of his satirical banknotes survive. His broadsheets might indicate Tory leanings, but one of his banknotes refers to the radical reformer Sir Francis Burdett

as "A Patriot and an Honest Man." Another advertises his services as an engraver.[16]

Twenty-five of his distinct satirical banknote designs were issued between 1803 and 1819. The notes came in denominations, including pence, maravedis, Danish skillings, pennies, centimes, quatrini, farthings, and sous. Topics of the Luffman/Fores satirical banknotes include: the British Army, dress and foppery, elections, folly, labor, law, lottery insurers and swindlers, social justice, public virtue, prices, political parties, slavery, and thievery. Catholicism and Methodism are tackled along with the Magna Carta and the now obscure Four-in-Hand Club (which involved drunken gentlemen racing stagecoaches). These mock notes were signed with a number of fantastic names including John Bull, Solomon Snug-birth, Old Tom Puff, Hamlet, Simon Lostall, Alfred Trueblood, Horatio Hardbattle, Maria Crucifix, and Shirtless Raggedbottom. Other notes in this series were signed by "Moral rectitude," "public virtue," and "common sense," personifying these ideals as people who made promises to the public. These fake names indicate a form of satire that directly criticizes and rebukes, in the sense of offering morals, virtue, and common sense when it seems to be missing in the broader culture.

It is important to note that these satirical banknotes engage a long tradition of satire as an enforcer of norms and ideals. A common triad in literature describes different types of satire as Juvenalian, Horatian, or Menippean. These categories are named after the ancient authors Juvenal, Horace, and Menippus. Juvenalian satire is distinguished from Horatian satire by its abrasiveness and strong sense of condemnation. Horatian satire is lighter, prizing wit, humor, and mockery. Menippean satire targets paradigms or attitudes more so than individuals, and is typically found in narrative form rather than verse satire. The Luffman/Fores run of satirical banknotes takes a Horatian approach to satire, with occasional moments of Juvenal cruelty and judgment. For instance, note twenty-two is abrasive and preachy in the Juvenalian sense. It attacks female fashion, warning: "Cover yourself, lest Shame cover you."

In the political realm, two of Luffman's notes ironically tackle the most pressing issues of the time in the Horatian spirit: the union with Ireland and the wars with France. His Ireland note offers a poignant political dare to Britons in the early nineteenth century:

I promise to Pay to Rory O Bogg Esqr or Bearer, Two Pence, when the Union of the Kingdoms shall have produced a union of Civil & Religious principles. London. The 1st day of January 1819. For Self, Leinster, Ulster, Munster & Connaught.

Pat Potatoe

And Luffman takes the promise out of the promissory note in **Figure 26** by appealing to France as the longstanding foil for Britain:

Figure 26. S. W. Fores, *I Promise to pay to Monsieur Bonaparte . . .* , satirical banknote, November 17, 1818, originally by John Luffman in 1803.

I Promise to pay Monsieur Bonaparte, or Bearer, Two PENCE when the Gallic Flag shall triumph over the British, and the French become the Masters of the Sea.

London, the 17th day of November 1803.

For Self, St Vincent, Duncan, Nelson & Co

John Bull.

The circular emblem of a ship reading "Britain's Glory and its Pride" and the list of British worthies are patriotic, especially when juxtaposed to the two sarcastic claims about the Gallic Flag and the French becoming masters of the sea. The assertion that Napoleon might ever defeat Britain is treated as a boastful and ultimately unattainable challenge. Bull will likely not have to pay the comically low denomination of two pence. Instead of a banknote that functions based on belief in promises, this satirical banknote dares Napoleon to confront British naval power. In this way, Luffman's run of satirical banknotes worked to counter the promises that form the basis for paper credit.

Importantly, in this reference to failure, in the sense that this satirical note is premised on the failure of Napoleon to defeat the British, the Luffman/Fores prints imitate the Bank of England note and therefore also indicate that paper money issued by the government is also likely to fail. In fact, an 1812 act prohibiting the use of a design similar to Bank of England notes was aimed at suppressing the circulation of mock banknotes of the Luffman/Fores type.[17] When Luffman applied the irony and incongruity found in the golden age of graphic satire to his satirical banknotes, he also visited these irreverent approaches on the Bank of England. In employing irony and incongruity, the visual form of these mock banknotes ties together several important problems: the opposing ideals of stability and inimitability, and the low status of engraving as an art form.

All banknotes aim to achieve two design goals in order to become a stable currency: they need to be familiar enough for users to recognize them, and they need to be hard to forge or supply will overtake demand, causing depreciation. The Bank of England, in pursuit of stability and minimal printing costs, ignored pleas to increase the artistic quality of its notes, and this decision increased counterfeit productions. V. H. Hewitt and J. M. Keyworth identify the predominant characteristics of eighteenth-century Bank of England notes as their lack of ornament and austerity of design.[18] The Bank of England note's vignette, depicting Britannia, only underwent a few changes over the eighteenth century. She variously held a trident, a spear, an olive branch, and the English plant Honesty. Later, instead of dots around the seal, foliations and a crown framed her. The quality of paper had improved in 1724, but it wasn't until 1855 that the notes changed with electrotype letterpress technology.[19] In this new version, illustrator Daniel Maclise remade Britannia in a more pre-Raphaelite style.[20]

The sum block appeared in the early eighteenth century, consisting of the pound sign followed by Gothic block letters on a black background. A waved-line watermark appeared in 1801.[21] Otherwise, the design of the notes was mostly unchanged until 1914. The notes were simple, clearly organized, uncolored, and only printed on one side.

Because value was tied to an authorized visual and material form, changing the design would have meant risking the trust of users of the note. In 1817, there were as many as ten thousand engravers capable of reproducing a Bank of England note. Isaac Cruikshank referenced this in a satire from 1819 that depicted a mouse eating a paper labeled "Plans to render BANK NOTES Inimitable."[22] In another satire, George Cruikshank highlighted the fact that country banknotes were less susceptible to forgery, with Bull saying, "If the 'Govr & Compa' would only go to half the expence of Engraving their notes that some of the Provincial Bankers do, they would be more secure from imitation."[23]

The aesthetically flawed design of banknotes, and the ease with which they could be forged, were linked with the status of engraving as an art. The *Monthly Magazine* wrote in 1797: "[i]f a bank note were to be held up as a specimen of the state of the fine arts in England, what a lamentable state would they still appear to be in!"[24] As Sir Joshua Reynolds argued in his *Discourses*, the cultivation of the polite arts was long overdue in Britain in the mid-eighteenth century.[25] But Reynolds's push for artistic renaissance excluded engravers, indeed anyone engaged in solely commercial ventures; the new Royal Academy he directed limited its membership to painters, sculptors, and architects.[26] Accordingly, this led to the involvement of the Society of Arts in banknote design. This group was dedicated to both the applied and fine arts. It created its own committee in 1819 to examine the artistic quality of banknote specimens, the technology used to print them, and the level of communication between engravers. Many artists were dissatisfied with how the Bank of England had treated them, and the society wanted the bank to use better artists.[27]

While the use of skilled fine art engraving was identified as one of the ways to prevent forgeries, others thought it would be wasted on an ignorant public. C. W. Williams wrote in 1818 to the royal commission on preventing banknote forgeries: "To talk of taste, or the display of genius to the public, or to expect that such can be appreciated . . . would be to throw pearls to swine: it is to expect the admirers of the sports of Bartholomew Fair should become pit critics and literati." The art dealer R. H. Solly recognized Williams's comment as snobbery and thought the public would learn to appreciate good design if they were given examples of it. He lamented: "I understand that English art is not much respected on the continent. I hope foreigners do not take the Bank Note for a specimen of English art." Notable later Bank of England note designs by Augustus Applegath, Edward Cowper, Jacob Perkins, and J. C. Dyer using double-sided printing,

color, and new press technology all failed.[28] The resumption of cash payments by the bank in 1821 somehow eased the pressure to change the design of its notes, supporting the ideal of stability over that of inimitability and stifling the development of the art of engraving.

In addition to indicting public taste, Williams indicated that banknotes were beginning to penetrate society. Crucially, the specie crisis of 1797 led to the unprecedented flow of paper into Britain in new, low-denomination notes, increasing the social reach of the Bank of England note. A list of claimants for lost banknotes in the year 1799, analyzed by Hiroki Shin, indicates that the use of banknotes was extending beyond the professional classes of doctors and clergymen to a larger swath of society, including women. Shin lists, among other professionals, butchers, fishmongers, grocers, cheesemongers, innkeepers, miners, gardeners, pastry cooks, watermen, night watchmen, and soldiers as users of the notes.[29] By 1819, the Society of Arts acknowledged that currency in low denominations, both coin and paper, "circulates chiefly among the lower classes."[30] With this statement, the society acknowledged that, when large denominations were all that was available, paper money had been the purview of wealthy bankers and merchants. The newer small-denomination notes were useful for individuals previously excluded from this type of credit instrument.

Despite making extensive comment about money and finance, the Luffman/Fores satirical banknotes do not offer a coherent position. Several notes from the run seized upon issues related to money and circulation, while others more directly satirized the credit economy. They were able to effectively demonstrate paper money's contested status and create doubt as to paper's ability to carry value. In note number two, "Gristle Barebones" engages real and nominal value. He or she complains that the price of goods is too high and that he or she will pay two pence when roast beef is sold at four pence per pound. Note number four addresses the misuse of public funds, while notes fifteen, sixteen, and seventeen target the Old Price Riots at Covent Garden Theater. Note twenty-five implicates Nicholas Vansittart, Chancellor of the Exchequer from 1812 to 1823, who "took chief part in defeating the resolutions of the Bullion Committee."[31]

Two notes that address specie and paper money directly deserve careful attention as paper money propaganda: numbers eight (*William Pittachio*, Figure 25) and nineteen (**Figure 27**), the latter of which targets country banks by promising to pay broke bankers:

Messrs Fudge, Swindle and Nocash, BANKERS, or Bearer, TWO PENCE, when Country Banks shall have been abolished and when Sterling GOLD and SILVER, Only, shall again become the circulating medium of Old England.
 For Clodhopper, Bumpkin & Co.
 Zekel Hardbrass

Embracing one of the economic theories of the time, this note blames the country banks for devaluation of the pound. The pound's value fell in several waves between 1799 and 1817. There were eighty country banks in 1793 and nine hundred by 1815.[32] Other theorists blamed devaluation on the increased issuance of the Bank of England note.[33] *William Pittachio* and note nineteen could be seen as advocating different monetary theories, beyond having a shared primary target of valuing specie above paper.

Imitation as Forgery: "I can't tell Bad Good ones from Good Bad ones"

Reproducibility produces different interpretations in relation to print culture. Currency tends to go down in value with overproduction, but engraved copies as works of art can increase value with increased exposure to larger networks of consumers.[34] Engraving as art, or as currency, can grow the economy as well as flood and undermine it. Satirical banknote producers delighted in imitating something without a pure original, engaging imitation as a form of ridicule and a form of technical reproduction, even as they railed against the reproducibility and inflation of banknotes. Although paper money resists the standard language of copy and original, the legal ramifications for forgery, which includes parodies of paper money, were deadly.

Forgeries were often indistinguishable from real notes despite the numbering system designed to keep track of those notes. Though authenticity was difficult to achieve, it was the aim of printers, users, and forgers of paper money. In the satire *Johnny Bull and his Forged Notes!! or Rags & Ruin in the Paper Currency!!!* (**Figure 28**) poor John Bull admits serious confusion concerning forged notes, which are pasted into his front windows pages like graphic satires were in printshops of the time, and honestly states: "I can't tell Bad Good ones from Good Bad ones." Forged notes may have made some forgers wealthy, but they caused the government to punish the guilty and innocent alike. By the early nineteenth century, the foremost social problem relating to paper money was the capital offense of forgery. Between 1805 and 1829, 282 people were executed for forgery, despite the protest of some bankers and several pressure groups.[35] Printing banknotes was not the only prohibited activity. Merely passing—or uttering—counterfeit notes could lead to prosecution or execution. Bankers divided into groups: some issued petitions to stop the practice of execution and others formed associations to prosecute forgers as late as 1825. Bankers from the Bank of England were uniformly portrayed as asleep on the job, bloodthirsty, and eager to see people hanged. In response to unjust laws, two satires tackling the problem of forgery earned accolades from the public as clever forms of political protest. In these examples, satirical banknotes helped create new forms of money to enact social change.

Amanda Lahikainen

Cruikshank and Hone's *Bank Restriction Note* (**Figure 29**) and accompanying barometer (**Figure 30**) protested capital punishment for forging or passing counterfeit paper money. Cruikshank was the son of Isaac Cruikshank, one of the great talents from the Georgian period. He was one of the few satirists to bring the eighteenth-century tradition of caricature well into the nineteenth century, although by the 1820s he had abandoned biting satire and turned to book illustration. He had collaborated successfully with satirist, radical publisher, and bookseller Hone on many projects, including the *Reformists' Register* in 1817 and *The Political House that Jack Built* in 1819. Hone won a series of court cases against political censorship in 1817 that made him extremely famous and celebrated in England.[36]

In 1819, Hone and Cruikshank produced the first imitation banknote to protest an egregious social evil.[37] Cruikshank wrote in a letter that he saw two women hanging from a gibbet while walking down Ludgate Hill in December of 1818. Upon learning their offense, that they merely passed forged one-pound notes, he aspired to reveal the true character of the Bank of England note: it was a death sentence for Britons. His satirical pretensions were heightened by the fact that he knew of a recent competition to redesign the Bank of England note; this *Bank Restriction Note* could be his mock entry.[38]

The satire depicts the pound sign as a rope noose and shows Britannia literally devouring her own children in the vignette. It serves as an apt and grotesque metaphor for state execution, comparing hanging to cannibalism, which served as a popular theme used by satirists to imagine the French Revolution in the 1790s. Eleven bodies, including those of three women, hang faceless above the words "for the Govr and Compa: of the Bank of England." Nina Athanassoglou-Kallmyer refers to such immediacy as "primitivistic naiveté" and notes that such simple and crude figures may have influenced nineteenth-century painter Théodore Géricault.[39] The note is signed by the famous seventeenth-century hangman "John" Ketch, and the letters "AD LIB," meaning at one's pleasure, stand in for numbers on the banknote. The text lists three possible solutions to the problem of forgery: banknotes should be less easy to imitate, cash payments should resume, or the punishment for forgery should be changed. The political message possibly reached even those who could not read, as indicated by the accounts of crowds gathering for public readings outside Hone's shop. The *Examiner* claimed the note "ought to make the hearts of the Bank Directors ache at the sight," and Cruikshank regarded it as one of the most important etchings he ever made.[40] Netting Hone and Cruikshank around seven hundred pounds, the note was so popular that they designed a second version.[41] The bank restriction barometer (created under the pseudonym "Abraham Franklin") accompanied this print as an envelope or wrapper. It refers to paper money in shockingly Burkean terms, as fictitious capital and false credit. The barometer indicates only one direction with the continued use of paper money: despair and suicide.

All is not Gold that glitters.

Raised by the necessity of the times.
Ruind by our speculations.

Learn to be wise by others harm.
and ye will do full well.

Mind yourself!

N.º 19

Promise to pay to Mess. rs Fudge, Swindle and Nocash, BANKERS, or Bearer, TWO PENCE, when Country Banks shall have been abolished and when Sterling GOLD and SILVER, Only, shall again become the circulating medium of Old England.

London, the 1.st day of August, 1818.

For Clodhopper, Bumpkin & C.º

Zekel Hardbrass.

Two

Pence

Ent.d Roger Rustic. Sold by S. W. Fores, 50. Piccadilly.

Figure 27. S. W. Fores, *I Promise to pay to Messrs. Fudge, Swindle and Nocash . . .* , satirical banknote, August 1, 1818, originally by John Luffman in 1810.

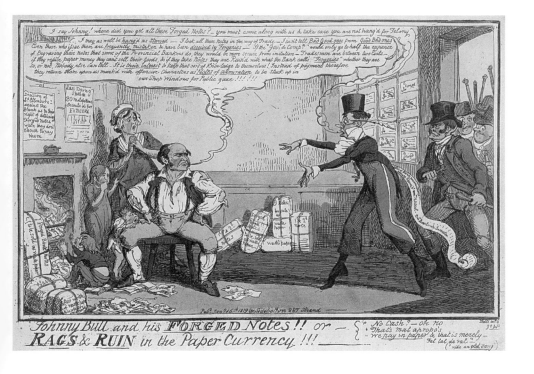

Figure 28. George Cruikshank, *Johnny Bull and his Forged Notes!!*
or Rags & Ruin in the Paper Currency!!!, January 1819.

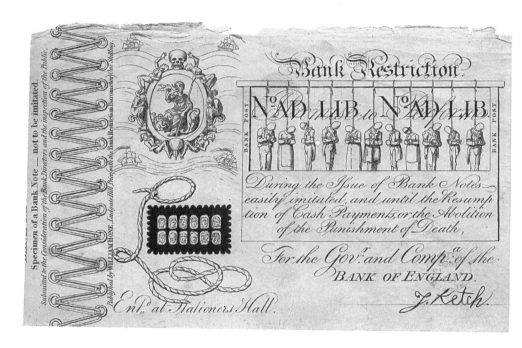

Figure 29. George Cruikshank and William Hone,
Bank Restriction Note, satirical banknote, January 1819.

Figure 30 (opposite). George Cruikshank,
The Bank Restriction Barometer, satirical print, 1819.

THE

BANK RESTRICTION BAROMETER;

OR, SCALE OF EFFECTS ON SOCIETY OF THE

Bank Note System, and Payments in Gold.

BY ABRAHAM FRANKLIN.

⁎ To be read from the words "BANK RESTRICTION" in the middle, upwards or downwards.

NATIONAL PROSPERITY PROMOTED,

10. The Number of useless Public Executions diminished.

9. The Amelioration of the Criminal Code facilitated.

8. The Forgery of Bank Notes at an end.

7. Manufacturers and Journeymen obtain Necessaries and Comforts for their Wages.

6. The Means of Persons with small Incomes enlarged.

5. A Fall of Rents and Prices.

4. The Circulating Medium diminished.

3. Fictitious Capital and False Credit destroyed.

2. Exchanges equalized, and the Gold Coin preserved, if allowed to be freely exported.

1. The Gold Currency restored.

Consequences, if taken off, will be as above:—viz.

➤ THE BANK RESTRICTION

Consequences of its Operation are as follow:—viz.

1. Disappearance of the legal Gold Coin.

2. The Issues of Bank of England Notes and Country Bank Notes extended.

3. Paper Accommodation, creating False Credit, Fictitious Capital, Mischievous Speculation.

4. The Circulating Medium enormously enlarged.

5. Rents, and Prices of Articles of the first Necessity, doubled and trebled.

6. The Income and Wages of small Annuitants, and Artisans and Labourers, insufficient to purchase Necessaries for their Support.

7. Industry reduced to Indigence, broken-spirited, and in the Workhouse; or, endeavouring to preserve independence, lingering in despair, committing suicide, or dying broken-hearted.

8. The Temptation to forge Bank of England Notes increased and facilitated.

9. New and sanguinary Laws against Forgery ineffectually enacted.

10. Frequent and useless Inflictions of the barbarous Punishment of Death.

GENERAL DISTRESS INCREASED.

Note.

In the Debate in the House of Lords, on the first day of the meeting of Parliament (21st January, 1819), LORD LIVERPOOL said, " About the Bank Prosecutions for the Forgery of their Notes, he had only to observe, that a Committee had been appointed, on the order of the other House; and that this Committee had prepared a Report, stating, that Plans had been presented, by which *if Forgery could not be rendered impossible, it could at least be rendered extremely difficult.*"

Q.—By what *Interest* has the temptation to commit Forgery been encouraged? and to what *Interest* have wretched Beings been sacrificed for twenty years, when their crime might have been rendered *difficult, if not impossible?*"

LONDON:—PUBLISHED BY WILLIAM HONE, 45, LUDGATE HILL; *with the* "BANK RESTRICTION NOTE," *an Engraved Specimen of a Bank Note not to be imitated. Submitted to the consideration of the Bank Directors, and the inspection of the Public.*
PRICE (the "*Bank Restriction Barometer*" and the "*Bank Restriction Note*" together) ONE SHILLING.

Printed by Hurdenelle and Son, 40, Cloth Fair, London.

Attacking the problem of forgery was not enough for Hone and Cruikshank; they also attacked paper money itself.

This note was imitated in 1825, after the Restriction period. This imitation was also signed by Ketch, the infamous hangman. The sum block is a pound sign made from rope worth "for one" and a faceless victim hangs in the vignette.[42] A literary satire, *Satan's Bank Note*, also describes the fate of forgers:

> The Imitators were hung up
> Some seven in a row.
> And every Monday morning you
> With such sights might be treated,
> And if you went on Wednesday
> The same would be repeated.

Its cover depicts Foreign Secretary Viscount Castlereagh (Robert Stewart) and Home Secretary Henry Addington, 1st Viscount Sidmouth, being led by the devil, who prepares to hang five forgers with their faces covered. These prominent politicians are represented as murderers, deservedly hanged by the devil, for executing forgers and those who passed forged notes. The last section of the satire refers to the Bank of "Hangland" instead of England:

> Then let us sing, Got save the Queen,
> And grant us she may long live,
> And grant the Bank of Hangland may,
> Soon Golden guineas give.[43]

Similarly, *A peep into the old rag shop in Threadneedle Street* shows the Bank of England directors asleep on the job, ascribing to the accused utterer, on his knees before them, a "d——d hanging look." An actual forged note from the bank taken out of circulation is shown in **Figure 31**.

While the *Bank Restriction Note* has been cited in several studies by literature scholars, banknote specialists, and historians, its anti-radical counterpart has not received any attention.[44] The publisher Samuel Knight responded to popular satirical notes with his own imitation note, *House of Correction*, on the subject of radicalism (**Figure 32**). The number 222 appears twice on the note with abbreviations above each number, identifying the bent bodies creating the shapes of these numbers as the three radicals William Hone, Henry Hunt, and William Cobbett, who form the "quintessence of revolution." Mention of Thomas Paine's *Age of Reason* ties them to earlier radical thought. Knight turned the sum block "One" into "Hone" and the devil in the vignette offers a strong binding for a bookseller. This is a comment on Hone's prosecution for publishing parodies, cases in which

Amanda Lahikainen

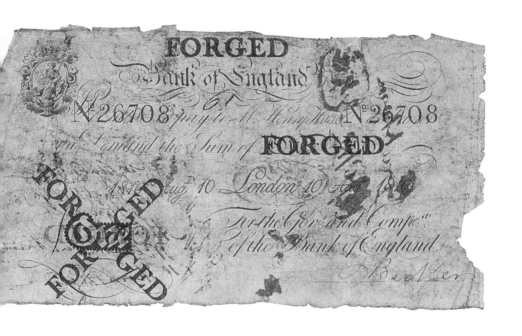

Figure 31. Forged £1 Bank of England note, 1816.

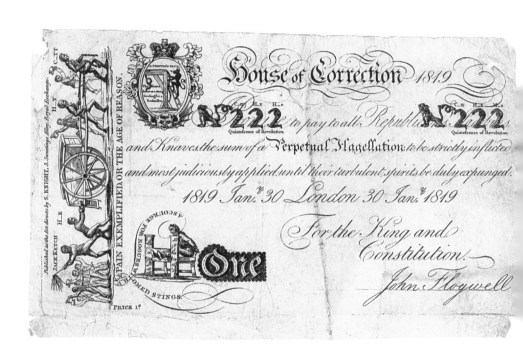

Figure 32. Samuel Knight, *House of Correction*,
satirical banknote, January 30, 1819.

the charges were dismissed when challenged in court. Ketch, the hangman who signed the *Bank Restriction Note*, now actively flogs these three radicals on the left margin. Knight filled the empty sign of paper money with his own grievances, adopting Hone's medium. Unlike the original note, his *House of Correction* note is an imitation of an imitation of a representation, or a sign of a sign of a sign. In the process of this imitation, Knight avoided the original note's complaint about capital punishment, promising instead perpetual flagellation of those who criticized what Cobbett called "the paper money system" and its equivalents in government.[45]

Far more popular than the other satirical notes that preceded it, the *Bank Restriction Note* literalized the idea that the form of money can enact social change against unjust laws. In the case of this satire, forgery laws were obviously tied to paper. In the case of other imitation notes, some printmakers and satirists identified the medium of money as connected to other kinds of problems, including sinecures and taxation, less specifically related to paper money itself. Taken altogether, imitation banknotes demonstrate the divergent directions printmakers took to manipulate the form of money, from crafting inside jokes and political complaints to generating whimsical satire and social protest. When Hone and Knight created opposing satires, one for condemning government murder in the name of forgery and the other for the punishment of radicalism, they proved that paper money could be taken up for a range of diverse political allegiances. In so doing, they created their own followings and challenged the government as the only legitimate maker of social and political capital. Like money itself, paper or otherwise, imitation banknotes tried to create their own spending power and value.

A "black flesh coin"?

Slavery was another social problem taken up by makers of imitation banknotes. The fake bank "Two England" issued a somewhat cryptic anti-slavery note in 1810 (**Figure 33**). The note is now in very poor condition and has been folded repeatedly, as if out of habit, into a small rectangle. The text states:

I Promise to pay Messrs Cambridgeshire, Ryecastle, & Co or Bearer on Demand TWO PENCE when Englishmens grievances be recompensed when Foreigners is Banished from our Land, & Willm Cobbett cease to expound Britons Cause.

For the Govr & Compy of Integrity.

Innocence

This text indicates that the authors of this note associate enslaved people with innocence, abolition with integrity, and foreigners with problems. They also ridicule published writings on slavery in the Caribbean by

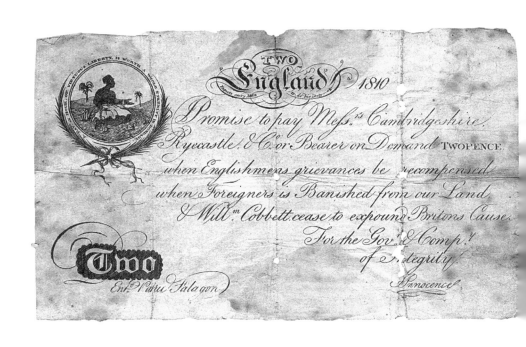

Figure 33. Satirical banknote referencing
slavery, innocence, and William Cobbett, 1810.

William Cobbett, who wrote at length about paper money and race. He wrote within a nationalistic framework focused on the superiority of the British laborer over any foreigner.[46] Marcus Wood refers to him as "the most ingeniously post-Burkean negrophobe."[47] This imitation banknote does not understand Cobbett to further the abolitionist cause. The vignette on this note, however, may advocate for that cause.

The vignette depicts a black woman in chains surrounded by the words "a day an hour of virtuous liberty is worth a whole eternity in bondage." She sits in a position of submission in a West Indian landscape with two palm trees behind her. Her figure looks much like that depicted in the enslaved person medallion produced by Josiah Wedgwood in 1787. Wedgwood formed a company in 1759 that later produced Jasperware, or unglazed stoneware that became most famous later in the eighteenth century in the colors light blue and white. Inspired by pottery in the ancient world, it brought a taste of neoclassicism to British interiors. In a particularly famous image, Wedgwood put his Jasperware to work for the cause of abolition. He designed a medallion of a kneeling black man in chains as part of the anti-slavery campaign in Britain. Underneath this image a banner asked: "Am I not a man and a brother?" This medallion was mass-produced and distributed widely in support of the abolition of slavery. It was reproduced repeatedly in its own time and in later years, and its imagery can be found in a number of different mediums, including print and dinnerware.

Like the enslaved man who prays in the famous cameo medallion, the woman on this imitation banknote presents the palms of her hands up to show she is unarmed and not a threat to society. The shape of this vignette is perfectly round, unlike the oval surrounding Britannia in real Bank of England notes, and likely takes the shape of a coin intentionally. Wood has noted that the Caribbean slave often personified the opposite of British Liberty in radical discourse and this vignette literally displays this inverted relationship.[48] In a sense, the image also recalls the contrast used by William Blake in the engraved plates for John Gabriel Stedman's book *The Narrative of a Five Years Expedition against the Revolted Negroes of Surinam* (1796), which contained unspeakable horrors.[49] For instance, the design of the plate *A Negro hung alive by the Ribs to a Gallows, c. 1773* has a similar picture space, consisting of a centered black body contrasted with simplified surroundings. On this satirical banknote, the representation of the woman's body might also be linked to the limp bodies swinging from the gallows in the *Bank Restriction Note*, where women and men endured violence, terror, and death as victims of the economy.[50]

This imitation, or protest, banknote offers an excellent comparison to the concept of the "black flesh coin" described at length by Michael O'Malley in the context of American money and satire. The phrase "black flesh coin" comes from an anonymous American satire from 1788 describing a fictional

currency based on enslaved Black people.[51] O'Malley uses this phrase as a conceptual tool to suggest that the Black body served as a kind of "gold standard" in America due to the lack of a central bank. In this reading, the enslaved woman on this British imitation banknote represents monetary value in the form of enslaved people labor and carries the connotations of real value, as in coin. Slaves furnished the economy with labor that eventually was transformed into currency.

O'Malley has argued that money hides the centrality of racism in cultural life: "debates about money have always also been debates about the problem of racial difference in a free democratic society."[52] He contends that money is the primary sign that registers what the differences between things, or between people, mean—that money is a way to assign value to difference.[53] In this way, he argues that the logic of racism is rooted in the logic of the free market and that debates about money solidified categories and subjectivities that paradoxically resisted the very freedoms at the heart of these debates.[54] O'Malley's argument is strikingly similar to that of early nineteenth-century currency radicals. They also felt that money was hiding deep structural social problems. Cobbett wrote more on the subject of paper money than any of his contemporaries. He argued that printing paper money masked the increasing national debt and repression of the poor. Money connects people in economic and political relationships and therefore is literally the stuff of politics.[55]

Is the duty referenced under the name of "Two England" the duty to abolish slavery in the colonies? Does the medallion of a black slave attribute the value of this coin to the black woman pictured in terms of her labor, or does it indicate the value of circulating slavery itself? With so many referents, many of which are still obscure, the vehicle of paper money for this commentary falls a bit flat for the modern reader. The note's design lacks coherence in text and image, and remains ambiguous by associating real monetary value with the slave, even if the note was meant to garner sympathy and outrage. This is not to say that in its original context, if "flashed" in front of someone, it might have helped further the cause of abolition. In any case, the printmaker has clearly tied slavery to value by associating the Black body in the vignette with coin, and coin with paper money.

Imitating the Immaterial

Thus far, our discussions of money have indicated that a wide variety of topics were explored by imitation banknotes, including those that directly commented on the dire consequences of money practices and exchange value in paper form. Printmakers understood paper money as a symbol that can grow to mean different things, and as a platform that embodies social relations. As the following chapter on materiality will discuss even

further, the divide between the world of ideas and the material world poses problems that creators of satirical banknotes gleefully took up as a subject. Some of those banknotes play with the fundamental difficulty of representing debt and credit in material form, the problems inherent in representation itself. They imitate things that have no original form, owing to reproductive technologies or because they are in the realm of ideas. In this sense, it comes as no surprise that other compelling treatments of paper credit and works of art with similar semiotic strategies came later in the history of art. Modern artists including John Haberle, Marcel Duchamp, J. S. Boggs, and Akasegawa Genpei took up the theme of paper money in powerful ways.[56] Johanna Drucker compares Haberle, discussed below, with the cubists Picasso and Braque. She argues that the work of late nineteenth-century *trompe l'oeil* artists who painted paper money and coin, especially Haberle, "anticipate the conspicuous and characteristic practices of modern art."[57] This final section will compare the satirical banknote *William Pittachio* with three later works of art. The reason to make this comparison is not to valorize *William Pittachio*, but rather to identify similarities with the later works including economic context and artistic strategies. The artists discussed in this last section play with concepts, surface, medium, sign, value, and ordinary materials.

The first work of art for comparison is Haberle's *Imitation* of 1887 (**Figure 34**). It demonstrates delight in minute, hyper-realistic representations of objects. These objects include fractional paper money worth fifty cents, as well as a dollar bill, a penny, a colonial shilling, a tintype portrait, and several stamps.[58] All of these objects are well-worn and Haberle expresses this tactile quality as a gleefully overcome challenge to representation. The depicted objects have been explained by various authors as a fascination with the bric-a-brac of industrialization, as part of the culture of mass-produced trivia, as an expression of anxiety about monetary policy, and as participation in the art historical tradition of conceptual realism.[59] Drucker finds these explanations helpful for contextualization, but not satisfactory in terms of artistic practice. She argues that the work of *trompe l'oeil* artists, although most especially Haberle, qualifies as a kind of modern art.[60] She explains this in terms of his imitation of both subject and material. The surface on which the image is painted is one with the image, inseparable materially, optically, and conceptually. The material support becomes both image and surface. Thus a work like *Imitation* takes the concept of imitation as both theme and formal device, calling clear attention by its title to the self-reflexive investigation of the imitative activity.[61] According to Drucker, the use of signs, fragments, and ordinary materials by American painters like Haberle puts them in line with Picasso, Braque, Kurt Schwitters, and the "mainstream of modernism."[62] She writes: "Haberle comes very close to their sensibility, his reproductions almost indistinguishable from their originals, participating in the re-presentation of

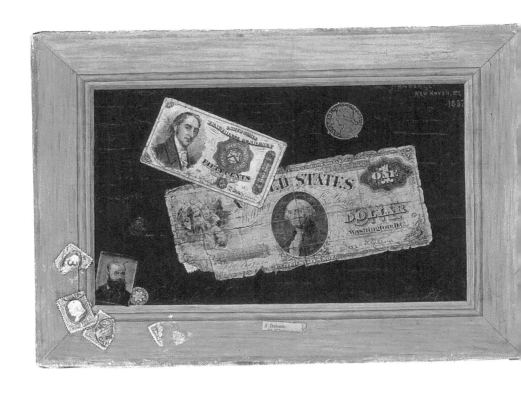

Figure 34. John Haberle, *Imitation*, 1887.

the never original materials of mass production and popular culture as one of the signal features of visual modernity."[63]

Whether one accepts her argument or not, the fascinating point to observe here is how Haberle, John Frederick Peto, and the other American artists Drucker discusses perseverated on objects that build social reality. These painters, and the satirical printmakers discussed above, all use imitation and satire to probe the validity and status of that social reality. Haberle works in degrees of removal from the world, employing signs of things we recognize: we can understand a stamp as just one degree removed from money, for instance, as stamps were in fact used as money for a time in the 1860s. Similarly, the tintype depicted can be seen as being one degree removed from a real person in one moment of time, the painting itself as one degree removed from the actual objects represented, the worn copper 1853 penny as one degree removed from the goods and services it can purchase, and so on. The stamps, tintype, and coins are all objects of exchange, as is the oil painting itself. They are all materials that take up their meaning as institutional facts through collective belief and exchange. Perhaps that is why paper money is the star of *Imitation*. Two examples of paper money in the center take up more picture space than the rest. The questionable value of the notorious shinplaster in the upper left juxtaposes inflation with its embodied object. While the "fifty cents" on the face of this shinplaster was meant to bring mathematical certainty to its value, the reality is that goods cost more when the value of currency goes down. Money is an abstraction and embodies social relations.

By representing stamps and currency that are real only by virtue of human agreement, Haberle questions what is real in the sense of fact and value. Hyperreal representations of things that have claim to both fact and value help to pose questions about the status of those things in the mind of the viewer. Hyperreal representations make objects both more and less real at the same time. In Haberle's case, *Imitation* shows us not just the act of painting and the representations in the painting, but also an acknowledgement of human agreements in the material form of institutional facts. The institutional facts represented on his canvas cannot really be the subject of imitation in and of themselves, only their physical markers in the world can be. In this sense, he represents the unrepresentable and plays with the gap between a sign and its referent. Though in the medium of oil and canvas, Haberle's *Imitation* manages to ask similar questions about money, value, and social relations to those the British graphic satirists working with the medium of paper were able to ask a century earlier.

The second work of art for comparison comes from Marcel Duchamp, who helped form the Dada movement in Europe after World War I. He embraced nonsense and irrationality and is well known for expanding the definition of art to include ideas. Duchamp, like J. S. Boggs after him, engaged money as art beyond engaging paper money as a muse and medium.

Both artists meditated on the creation of value and then created it themselves. Duchamp created many works of art along these lines starting in 1919, including *Tzanck Check*, *Cheque Bruno*, and *Czech Check*.[64] In 1919, Duchamp wrote a check to his dentist Daniel Tzanck for 115 dollars. Handdrawn on paper, this check boasts an invented company name and Duchamp's signature at the bottom. Like Boggs would do for every imitation banknote he used to purchase something, Duchamp later bought the check back from Tzanck for more money than the amount on the line. This piece, *Tzanck Check*, highlights Duchamp as the artist and in so doing delights in a knowable, actual person. It also asks the viewer what it means to have paper represent value and why this object is any different from a real check. It is no coincidence that the decade of the 1910s, when Duchamp created this work of art, saw "the most inflationary period in US history."[65] Duchamp and Boggs literally produced their own market value by setting the base price for what their art was worth. In this, their banknotes have something in common with *William Pittachio*, which would have sold for more money than the two pence listed on its face (likely closer to a shilling). Duchamp and Boggs even have something in common with William Pitt himself, who issued dividends on the national debt that were interest bearing.

There is something to be said about the economic context for eighteenth-century imitation banknotes and the later capitalist successes witnessed by twentieth-century conceptual artists. Ian Baucom and Geoff Quilley have gone well beyond addressing similarities between these centuries. They have theorized the relationship between the late eighteenth century and the late twentieth century in terms of hyper-financialization, or the widespread use of money capital, insurance, speculation, and credit. Quilley writes: "there is a dialectical relation between the structural social and economic forms of the late-eighteenth century and those of the late-twentieth and twenty-first, by which the latent potential of the earlier period is realized in the later."[66] Dialectical relations aside, there are a number of similarities here in regards to how artists of those two periods play with the process of mediating value. In the late eighteenth century, as now, paper money could be conceptualized as a credit instrument that, from a certain perspective, qualifies as a kind of small-scale financialization. Boggs, Duchamp, Haberle, and Luffman were all responding to changes in finance and the immaterial promise of value in new mediums.

Twentieth-century conceptual art shares a lot with *William Pittachio* beyond some aspects of economic context. Consider their shared polemical position, rejection of conventional media, emphasis on language and ideas, and overriding concern with meaning and subject matter.[67] In the third work of art used for comparison here, *One and Three Chairs* (**Figure 35**), Joseph Kosuth presents a mediated representation of a chair (a photograph), a wooden folding chair itself, and the definition of a chair written as

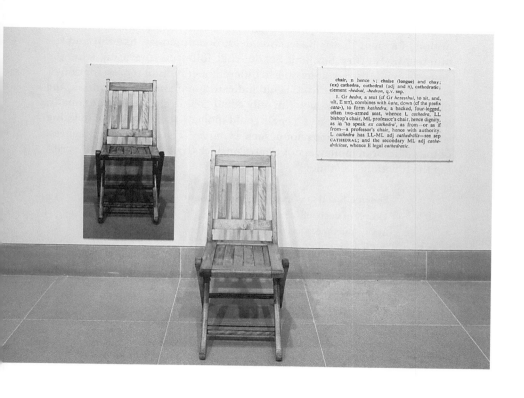

Figure 35. Joseph Kosuth, *One and Three Chairs (Ety.)*, 1965.

a label on the wall. Kosuth's work has a striking resemblance to Plato's allegory of the cave in the *Republic*, which queries the difference between ideas and their manifestation in the material world. Kosuth asks the viewer to reflect on the physical, linguistic, and non-physical iterations of the chair. This work of art, although about a chair, draws attention to the same semiotic system that paper money does. All three parts of his piece are a chair of some kind. As *One and Three Chairs* makes clear, conceptual artists in the twentieth century rejected the traditional mediums of painting and sculpture in favor of visualizing concepts and ideas.

The three parts of Kosuth's project could also be a metaphor for money. A viewer can see how the photograph of a chair could represent a wide definition of a chair that is like a wide definition of money, like Pitt and the nineteenth-century Banking School that followed him used, whereby money can be abstract and come in different mediums of representation or embodiment. The chair itself could indicate a more narrow definition, the Bullionist credo that money can only equal gold in the bank. And, finally, the dictionary definition of a chair could indicate the difficulty of defining a short, seemingly obvious noun, such as money. The realness, or fakeness, of the chair, or of money, is not clear. Consider Glyn Davies's table describing the functions of money:

Specific functions (most micro-economic)

1) Unit of account (abstract)
2) Common measure of value (abstract)
3) Medium of Exchange (concrete)
4) Means of payment (concrete)
5) Standard for differed payments (abstract)
6) Store of value (concrete)

General Functions (mostly macro-economic and abstract)

7) Liquid asset
8) Framework of the market allocative system (prices)
9) A causative factor in the economy
10) Controller of the economy[68]

This extensive list demonstrates not only how the dichotomy of abstract versus concrete breaks down under scrutiny, but also shows the variety of functions money can have, demonstrating too how many connotations a parody or imitation of money might also have. The neat, clean lines and overtly simplified presentation of Kosuth's work of art deliberately contrast with the confusing, vexing, and complex world of ideas, language, semiotics, linguistics, and art that inform it. *William Pittachio* has parallels to the photograph of the chair, the chair itself, and the dictionary definition of the chair as Peirce's index, icon, and symbol.

Amanda Lahikainen

By delighting in semiotic play and intentional fakeness, *William Pitta-chio* demonstrates some aesthetic complexity and plays with several frustrating facts: that the medium of money cannot easily be pinned down, that the divide between abstract and material worlds cannot be easily reconciled, and that we might ask questions about monetary and artistic value. This play provides us with an object that sustains critical attention. In this sense, *William Pittachio* offers up a kind of conceptual art that has something in common with the work of Haberle, Duchamp, and Kosuth.

The very existence of satirical banknotes provokes questions about graphic art quite beyond economic parody. Duchamp prompted his viewers to ask, "Is this art?" and even further, "What is art?" Luffman prompted his viewers to ask, "Is this money?" and even further, "What is money?" Their notes imitate with awareness of medium. They are both fakes, but they are fakes that question in an intentional and artistic way.

According to Jonathon Keats, in his discussion of fake works of art, fakeness makes objects extremely productive: "In other words, art forgeries achieve what legitimate art accomplishes when legitimate art is most effective, provoking us to ask agitating questions about ourselves and our world. By this standard—the standard of modernity—we need to take art forgers seriously as artists and to acknowledge that their fakes are the great art of our age."[69] For us to draw out the semiotic play and intentional fakeness of satirical banknotes recognizes not only their aesthetic complexity but even a kind of incipient modernity. *William Pittachio* provoked questions about institutional facts by mimicking plainly. Imitation of immateriality presented an artistic opportunity to question the value of, the fact of, and the definition of money.

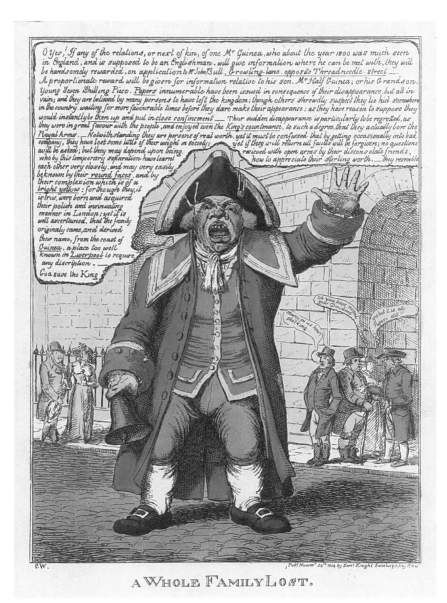

Figure 36. Charles Williams, *A Whole Family Lost*, November 24, 1814.

CHAPTER FIVE

Materiality

WHEN THE TOWN CRIER in Charles Williams and Samuel Knight's boldly colored print *A Whole Family Lost* (**Figure 36**) announces the disappearance of the Englishman Mr. Guinea, he cries out the importance of money's materiality. A whole family has been lost, the viewer is told, and everyone is meant to look for them. A father has lost his son and his grandson; or rather the guinea, half-guinea, and seven-shilling piece have disappeared from circulation. Three important visual and material characteristics distinguish the gentlemen featured: round faces, yellow complexions, and polish. In the case of Mr. Guinea, his relationship to portraiture, patriotism, and the monarch also give him value since he bears the king's countenance (as seen in Figure 37). It is as if a member of the royal family has disappeared. The crier unwittingly announces an instance of Gresham's law, where bad money in poor condition has driven out the good money in mint condition. In this case, people are hoarding the gold and silver coins with attractive material values of being shiny, polished, and yellow.

This satire, and others like it, helped cultivate a taste for money in the form of physical coin with certain qualities of metal. The crier's gaping and grotesque mouth directly contrasts with the beautiful qualities of new metal currency described in the text. His teeth and tongue claim the center of the image, while a full third of the image space is devoted to what he says:

O Yes! If any of the relations, or next of kin, of one Mr Guinea, who about the year 1800 was much seen in England, and is supposed to be an Englishman. will give information where he can be met with, they will be handsomely rewarded, on application to

Mr John Bull, Growling-lane. opposite Threadneedle-street——. A proportionate reward will be given for information relative to his son, Mr Half Guinea; or his Grandson, Young Seven Shilling Piece. Papers innumerable have been issued in consequence of their disappearance, but all in vain; and they are believed by many persons to have left the kingdom; though others shrewdly suspect they lie hid somewhere in the country, waiting for more favourable times before they dare make their appearance; as they have reason to suppose they would instantly be tken up [sic] and put in close confinement——Their sudden disappearance is particularly to be regretted, as they were in great favour with the people, and enjoyed even the King's Countenance, to such a degree that they actually bore the Royal Arms.——Notwithstanding they are persons of real worth, yet it must be confessed that by getting occasionally into bad company, they have lost some little of their weight in society; yet if they will return all faults will be forgiven; no questions will be asked; but they may depend upon being recieved [sic] with open arms by their disconsolate friends, who by this temporary separation have learnt how to appreciate their sterling worth.——they resemble each other very closely, and may very easily be known by their round faces, and by their complexion which is of a bright yellow; for though they, it is true, were born and acquired their polish and insinuating manner in London; yet it is well ascertained, that the family originally came, and derived their name, from the coast of Guinea, a place too well known in Liverpool to require any description.——God save the King.

A good way to give value to coin was to personify it. *A Whole Family Lost* anthropomorphizes its subject on two levels simultaneously by portraying an object that performs as a human does (a town crier in paper form) and by discussing objects that perform as humans do. Money and people share the same qualities. By celebrating coin, this satire draws attention to its own low status as an object printed on paper. It entangles value, medium, and materiality in the same way British users of paper money did. Following the same pattern as other circulation narratives in literature, the values of roundness, shininess, and being brightly colored in this satire ascribe value to youth—newly minted coins embody more value.

Clearly, weight is also a value in addition to youth. Men off to the side complain that their dividends have been paid in paper. The crier has no confidence in paper either, claiming that "Papers innumerable have been issued in consequence of their disappearance, but all in vain." Blame is placed here not on the king, but on the Bank of England, France, and paper money itself, the "papers innumerable." Real money has "left the kingdom" and was very likely spent by Napoleon prior to his exile. Williams and Knight repeatedly engage and perpetuate the false dichotomy of "gold versus paper" so popular in the British press. Their print indicates materiality, of both coin and paper, and the nuanced aesthetic judgments that guided the exchange of money. Apparently the coins the crier speaks of acquired their polish and "insinuating manner" in London. Whether this insinuation implicates gender and sexual activity in its winding and "penetrating" is unclear, but it does indicate slow and stealthy penetration into society.

The crier notes that coins occasionally fall into bad company and lose "their weight in society."

Social values relating to the center and periphery of the British Empire are also indicated. "Sterling worth" draws on many associations, including "genuine English money" and the human characteristics of excellence and capability to stand "every test"—this is likely being contrasted with depreciated currency and people in the colonies.[1] Williams directly acknowledges the slave ships leaving Liverpool for the West Coast of Africa. As in the "black flesh coin" discussed earlier, there is a relationship between gold as a commodity and slavery as a practice.

This satire appeared two years before the Great Recoinage Act of 1816, when the sovereign officially replaced the guinea.[2] By relishing the physical qualities of coin, it actively articulates popular monetary value systems, and potentially reproduced or reinforced this system for its viewers. Aesthetic judgments of visual and material form facilitated the desire for coin. The town crier's announcement indicates, on some level, the value of the fine arts, especially in relation to images of the king. **Figure 37** shows an actual gold guinea as it was minted in 1776. The king's profile is nearly identical on a Royal Academy medal from the same century. Medals engraved with the profile of the reigning monarch were awarded in gold, silver, and bronze yearly for painting, sculpture, architecture, and drawing.[3] The open and grotesque mouth of the town crier, in a satirical reversal of official portraiture etiquette, is quite similar to the satirical medal from 1800 by John Gregory Hancock (**Figure 38**). Hancock's pewter medal also displays teeth in the open mouth of a figure swallowing the whole world.[4] This medal likely satirizes the high price of wheat, or more generally inflation. Satires like this refute simplified claims about materiality, such as those of Mary Poovey in *Genres of the Credit Economy*, who argued that the "aesthetic merits" of money "were inconsequential."[5]

One of the curious features of *A Whole Family Lost* is the dual emphasis on text and image. Like paper money itself, this graphic satire relies on writing for coherence. A speech bubble claims a third of the space and its inflated visual presence is curious. Many of the satires of this period relied heavily on the use of speech bubbles to complete a joke and to provide context and complexity.[6] Given the close connections between literature, theater, and graphic satire in this period, perhaps the inflation of speech bubbles in satire might not come as a surprise. The words in this print have a tangible quality and materiality, much like paper money, and it is tempting to read the top third of the image space as metonymy for a banknote itself. The real money discussed by the town crier is replaced with text in the speech bubble, or the implied written words on a banknote.

Recently, art history has taken a great interest in materiality. Nina Athanassoglou-Kallmyer wrote the editor's introduction to the winter 2019 issue of the *The Art Bulletin*, titled "Materiality, Sign of the Times."[7] As then editor-in-chief of this leading publication, she noted that materiality

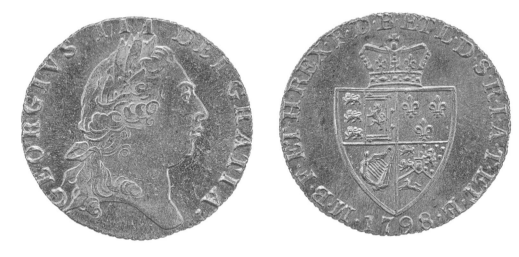

Figure 37. Gold Guinea with the head of George III, 1798.

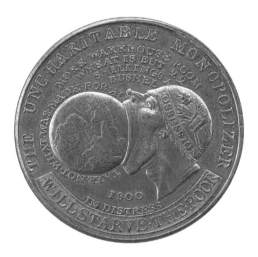

Figure 38. John Gregory Hancock, Satirical medal, 1800.

has increasingly dominated the course of art historical thinking. This might be seen as part of the broader "material turn" in the humanities and social sciences, especially in anthropology and archaeology, that began in the 1980s.[8] Traced back to the late nineteenth century in the scholarship of Aby Warburg, materiality has come and gone as a sustained topic of consideration. For the past ten years or so it has grown in importance. Citing Peter Miller, Michael Ann Holly, and Michal Yonan, as well as the issue of *The Art Bulletin* from 2013 where scholars from the humanities debated the meaning of materiality, Athanassoglou-Kallmyer lists five "metaphoric cognates" for materiality: "close looking," "haptic," "le faire," "the touch," and "embodied object."[9] For her, the exciting aspect of materiality is its egalitarian promise as a line of inquiry that avoids traditional dichotomies and hierarchies. She also identifies the upshot of this material turn in art history: the ability to expand the field to include the study of objects traditionally seen outside its purview, such as those explored in conservation, fashion, and the decorative arts. In this list we might also include graphic art and money. Money has only very recently been a subject of interest to art historians, with the work of Richard Taws deserving special mention.[10]

Satires of money help to further articulate the "vexed relation between aesthetics and economics" as it played out in the long eighteenth century.[11] Ideas like tactility and pleasure, which are traditionally tied to art and aesthetics, matter for circulating currency—especially with respect to the instability of, and need for, representation itself. Debates around paper money have taken many different forms, but they always hinge to some degree on problems of representation and the attendant gap between a sign and its referent.[12] Cultures can assign value to anything, and can store value in equally arbitrary ways. Credit and debt also relate to this definitional problem. For instance, the *Oxford English Dictionary* defines "debt" as both a material and an immaterial thing.[13] Money's location somewhere between a physical object and a fluctuating value presents a constant disconnect. Money not only changes hands quickly, but it is also subject to cultural norms and exchange rates. It changes physical form, such as when a paper note is exchanged for gold, when a bill of exchange is discounted and turned into banknotes, or when a deposit at a bank becomes a number in a ledger.[14]

William Cobbett gleefully drew attention to the insubstantial form of money as it operated in funds or stocks, politicizing its lack of material reality: "money is put into the Funds. . . . These funds, or stock, as we have seen, have no bodily existence, either in the shape of money or of bonds or of certificates or of any thing else that can be seen or touched." Such money, he warned, merely consists of names written in a book kept at Threadneedle Street.[15] Cobbett, like the creators of the *Political Bank* satirical note (Figure 2), was disturbed by this abstraction and placed political corruption at the heart of monetary transactions. Printmakers addressed this problem in a variety of different ways when they mimicked the form of paper money for a variety of ends.

This chapter will suggest that the very materiality of paper money is essential to understanding its near failure, and eventual success, as a standard financial instrument in this period. The last section ends by showing how materiality poses a challenge to the dematerialization principle of modern money.

"All is not Gold that glitters": The Semantic Thickness of Materiality

What is the difference between medium and materiality? Medium is a category, but it is also the substance through which impressions are conveyed to the senses. Materiality is defined as "the quality of being material."[16] Medium is the brute material and its category, while materiality refers to the qualities and values of that material. The difficulty is that both are dependent on context. The term "banknote" accounts for the medium of paper money better than "signed engraving" because it accounts for the use of hand-signed and hand-numbered engravings with specific language. This process of categorizing, labeling, and valuing still stands as the reason today that imitation banknotes are awkwardly divided in the British Museum's collection between "Prints & Drawings" as art, and "Coins & Medals" as part of monetary history. Names can tell us a lot about the social values of materiality: the "rags" that literally make up a banknote became an insult to them, "flash" notes imply the intentional deception of a counterfeit banknote in a fast exchange, while "banknote" implies a very special legal category of hand-signed engraving that carries the legitimacy of a bank and banking system. In the case of the Bank of England note, it is connected to the government, the political party in power, and the king himself. The qualities presented by materiality were continually noted by satirists following financial debates surrounding the Bank Restriction period. Materiality and medium are different, and written and visual records indicate that Britons attended to the difference, but not within a fixed value system. A banknote that was cast as flimsy in one context was later cast as "crisp" and "sharp" in another. In short, Britons distinguished between the material itself and the qualities of that material—the categories of language used to describe money, its semantic thickness.

I use this term, "semantic thickness," as a phrase that helps identify both meaning in an object and the language that describes meaning. The term comes from a book on the French artist Jean-Baptiste-Siméon Chardin by Ewa Lajer-Burcharth in which she cites Chardin's personalized approach to the process of making and argues for the "deep materiality" of his painting. She defines this deep materiality as the "thick material substance of the painting and its semantic thickness, its capacity to produce meaning."[17] In the same sense that painting has long been valued as a medium in the history of Western art, so too has gold been valued as a form of currency in the West. Many cultures have valued gold as currency. Its materiality has a draw that can transcend cultural difference. Yet, it is not universal. A lack of interest in gold by

Africans was used as a marker of their inferiority by Daniel Defoe.[18] If categories that identify a medium can indicate how a culture values something, like a "signed engraving" versus "a banknote," then perhaps the category of medium is also mediated by culture. Walter Benjamin noted that the history of a work of art included the number of its copies and, accounting for materiality, the medium of its reproductions too.[19] Both the medium of an object and its materiality thus carry value. Lajer-Burcharth acknowledges that materiality is an autonomous agent of signification and "the very site where meaning may reside."[20] If medium cannot help us distinguish between signed engraving and banknote, materiality can help us come to terms with the qualities of paper and the ink on its surface, as well as the tactile and visual qualities of coin.

Despite acknowledgement of some kind of material turn in art history, there is disagreement as to the place of materiality in the scholarship. Lisa Pon and Joseph Monteyne list materiality as a standard consideration for print culture studies.[21] Materiality is arguably one of the "un-self-conscious embedded cultural and social signs" that provides a main reward of artifact study.[22] Yet, James Elkins goes so far as to identify a fear of materiality in art history. Materiality is relegated to the "making" of objects, and therefore set "apart from historical, theoretical and critical accounts."[23] Similarly, Michael Yonan has identified what he calls the suppression of materiality in Anglo-American art historical writing. He claims "the work of art's materiality is simplified into its medium, typically formulated as a predecessor to meaning and not a component of it." Noting that the discipline of art history has long prioritized the optic over the haptic, he ultimately blames a Platonic framework: a "distrust of the physical world in favor of a conceptual one."[24] Forced to confront this problem directly, graphic satires of money and several satirical banknotes in the period studied here do account for materiality, adding an interesting aspect to this historiography.

Tactility is one aspect of money's materiality. In addition to its graphic design and issues of trust and forgery, familiarity with the feel of paper posed yet another challenge to the government and banks issuing paper money. Like many of the imitation notes in the British Museum's collection, the *Scale de Cross* banknote (Figure 21) has been folded in half vertically, horizontally, and then vertically again. It once formed a small rectangle. This indicates the importance of tactile engagement with the feel of its paper and the audible rustle made by touching it. Paper demanded tactile engagement, but lacked the history of being traded routinely in smaller transactions. The thickness and quality of the paper used for imitation banknotes varied as widely as the subject matter the notes targeted. Another note from the Luffman/Fores run is signed "Zekel Hardbrass" (Figure 27). Referencing the failure of the country banks "Ruin'd by our speculations," the words around the vignette warn "All is not Gold that glitters. Mind yourself!" In this version of the idiom, as in the Shakespearean phrase "all that glisters is not gold," the materiality of gold is separated

from the medium. Gold itself should be valued, it warns, not the quality of glittering itself. Visual spectacle can overpower the medium of gold. Several imitation notes reference this type of aesthetic consideration. As the satirical banknote signed by Zekel Hardbrass shows, imitation banknotes contributed new evidence for the variety of meanings that get attached to money.

Materiality beyond the medium was unavoidable—for instance, in detecting forgeries. Most people were adept at handling coin and developed ways to spot a forgery. For the M'Guire forgery case involving a Bank of England note in 1801, aesthetic considerations took precedence over signatures and the reputation of banking houses. The cashier's testimony was not needed to disprove the handwriting. Rather, the forgery, said the judge, was evinced by "the texture of the paper, the watermark, the engraving, the ink, and the written date of the year."[25] Another case from 1784, that of Joseph Dunbar, was settled when a cashier from the Bank of England stated that the paper of his note was clearly wrong; it was "of a thinner consistence."[26] The satire *Dandies Sans Souci* (**Figure 39**) refers to a banknote as "a flimsy," remarking on the limp tactile quality of well-worn paper money. A courtesan reaches into the pocket of a dandy searching for money saying, "Curse ye don't make such a noise! I feel something like a flimsy." The satire delights in the confusion of flimsy paper with what is no doubt the flaccid member between this dandy's legs. A dandy is someone vain of appearance and foolish. Thus, these dandies have no worries, even as they are robbed in plain sight. Although this banknote's gender is clearly male, as discussed previously, the main association is still with weakness due to its limp and slender materiality and inability to get "hard" like coin. Later, in 1850, the same term, "flimsy," was used to describe paper money from the Bank of England but without the negative connotations: "Although her [the Old Lady of Threadneedle Street or the Bank of England] works are the reverse of heavy or erudite—'flimsy' to a proverb—yet the eagerness with which they are sought by the public, surpasses that displayed for the productions of the greatest geniuses who ever enlightened the world."[27]

The satirical banknote *William Pittachio* (Figure 25) is signed "Self Silvertouch & Lovegold Brass Hatepaper," drawing attention to the importance of touching metal, and consequently not wanting to touch paper. As this note indicates, the disappearance of coins also became a subject in many satires, especially after banknotes depreciated in 1809. Cobbett popularized the disappearing coin and the depreciation of paper money that accompanied it in a series of articles called "Jacobin Guineas."[28] Like John Luffman and many others, George Cruikshank blamed the high price of bullion and depreciated currency on the overissue of paper money by the Bank of England, an idea circulated by the first Bullion Commission Report.[29] He shows Lord Stanhope and Prime Minister Perceval shoving paper money down John Bull's throat in *The Blessings of Paper Money, or King a Bad Subject* (**Figure 40**), repeating the theme used by Richard Newton in 1797 in his *A Paper Meal with Spanish Sauce* (**Figure 41**).[30]

Amanda Lahikainen

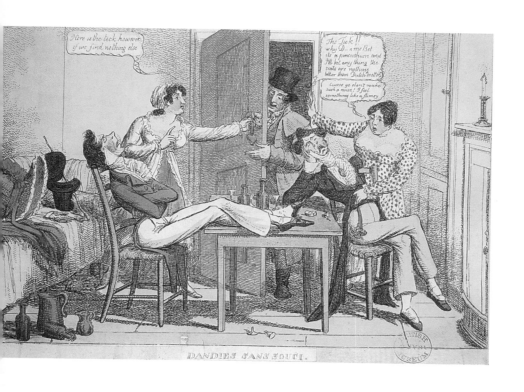

Figure 39. Charles Williams, *Dandies Sans Souci*, 1819.

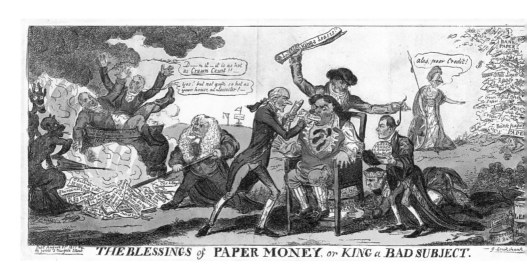

Figure 40. George Cruikshank,
The Blessings of Paper Money, or King a Bad Subject, 1811.

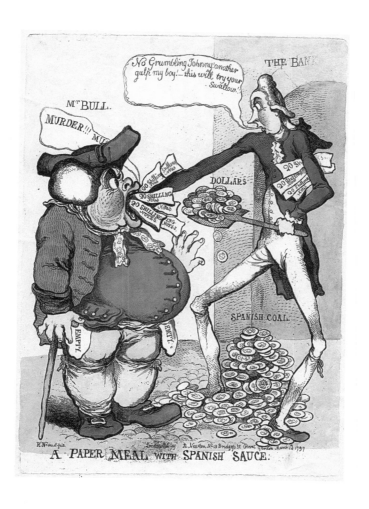

Figure 41. Richard Newton,
A Paper Meal with Spanish Sauce, March 14, 1797.

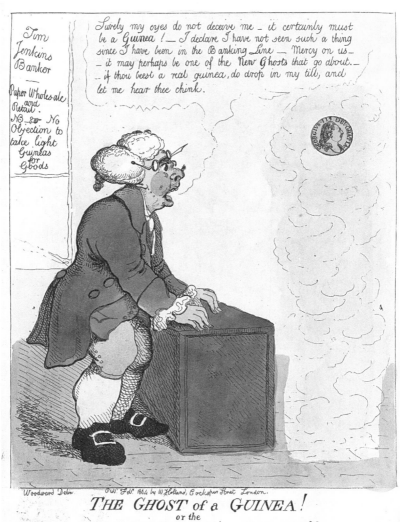

Figure 42. William Holland after George Woodward,
The Ghost of a Guinea! or the Country Banker's Surprise!!, 1804.

Both of these satires delight in the grotesque notion of swallowing dry, rolled-up rags, but also provide the image of "eating words" (which means "to swallow back" and "retreat" in Samuel Johnson's *Dictionary of the English Language*). Presumably the humorous implication is that the government, not John Bull, should really be eating its words on paper money as a carrier of value. In *The Blessings of Paper Money*, Napoleon steals all the specie from the country while human-headed leeches crawl on Bull's chest, and Lord Peter King (of the Lord King affair) stands above as a mischievous interloper in the affairs of the country's money. The stockades and a gibbet stand just left of the center of the print, indicating prosecutions for forgery. Britannia laments the poor state of Lady Credit, who ironically lies under a pile of "white linen rags," "bank paper," and "crown tissue paper" morally heavy enough to crush her.

George Woodward and William Holland's *The Ghost of a Guinea! or the Country Banker's Surprise!!* (**Figure 42**) circulated in three versions between 1804 and 1810, with a fourth published in America as *The Ghost of a Dollar or the Country Bankers Surprize* around 1813.[31] J. Sidebotham pirated the 1804 version for sale in Dublin. Such was the novelty of a banker looking on actual specie. The second version by Woodward and Holland in 1810 improves upon their first version. The country banker, Tim Jenkins, stands with both hands on his desk staring at four coins arising from a cloud of smoke. The title of the later version, *The Ghost of a Guinea, and little Pitt's. or the Country Banker's Surprise!!*, indicates that the three small coins, seven-shilling pieces or third-guineas according to Dorothy George, were known as Pitts.[32] As with "Abraham Newlands," this evidence suggests that real, knowable people gave value to metal and paper money. It remains a mystery as to why these coins were added to the 1810 version, other than to draw William Pitt into the image even after his death in 1806. The banker's wide open mouth and hairy wart contrast with the regal profile of George III on the coin. He stares in awe at the gold, saying: "Surly [sic] my eyes do not deceive me—it certainly must be a *Guinea*! I declare I have not seen such a thing since I have been in the Banking Line—Mercy on us—it may perhaps be one of the *New Ghosts* that go about—if thou beest a real guinea do drop in my till, and let me hear the chink." Jenkins, wary of counterfeit coins, yearns for the material and aesthetic qualities of gold, eager for the sound gold coins make when knocked together.[33] Here, sound is made part of the description of coin and with it comes the connotation of wealth. If one can have a pile of coins, and hear them "chink" together, then one has wealth.

Sound, coolness, warmth, weight—these were qualities with which the materiality of paper could not initially compete. Coins were perceived to carry more value, as referenced previously in the Lord King affair. Cobbett noted that in 1811 "many persons in London have written upon their shop windows notifications that they will take the coin at a higher than the nominal value; in numerous cases a distinction is made in prices paid in coin

and prices paid in paper."[34] In the print, Jenkins posts a sign in his bank window. He would prefer clipped coins to paper money: "NB.—No Objection to take light Guineas for Goods."

———

While the value of paper money continually fluctuated, paper's ability as a medium to carry value was far less controversial in 1847 than it was in the late eighteenth and early nineteenth centuries. Deborah Valenze cites money's involvement "in social relations" as a reason for "its authorization as a normative aspect of culture."[35] Yet, imitation banknotes never lost their controversial appeal, it seems, or their problematic disposition. In 1832, for instance, *The Observer* published this: "the emigrant, on showing his note to the landlady, found it was worth nothing, being a note from the Bank of Elegance."[36] The British Museum has several such imitation notes starting from 1821 that advertise a barber.[37] In 1847, the *Stamford Mercury* drew attention to the punishment of banishment for fourteen years to a penal colony for the crime of printing mock banknotes: "Many respectable tradesmen illegally and ignorantly issue announcements in their business by means of such notes."[38] The notes referenced here were probably quite similar to the "Bank of Elegance" or "Bank of Fashion" advertisement notes from the 1820s and 1830s, or the "Bank of True Love" valentine that takes the idea of paper money more seriously than do earlier imitation banknotes.[39] Several imitation banknote valentines followed closely after the Bank Charter Act of 1844, which limited the distribution of private-issue notes and established note issuance in relation to securities.[40] By establishing the supremacy of the Bank of England note, this act helped to make the medium of paper money increasingly invisible to Britons. This, combined with the development of the railroad, meant the death knell of local banks, which enjoyed their heyday between 1789 and 1815, leaving the Bank of England and the London money market as the main centers in a formerly three-tiered banking system.[41]

With naturalization comes a changed appreciation for materiality. W. H. Wills's review "The Bank Note" in *Household Worlds* (1850) takes pride in the uniformity of the Bank of England note, and claims its form helped to dispel all doubts and relieve all objections surrounding credit. He found "pithy terseness in the construction of the sentences" and the note's text "boldly graphic." Such form served to convince the reader of the note that the payer "meant honestly and instantly to keep his word." Several aesthetic qualities, including tactility, are highlighted in his essay: he finds Britannia proud and "inimitable," the color of ink a "brilliant jet-black," and the sound of banknotes irresistible. He writes: "tested by the touch," they give "a crisp, crackling, sharp sound—a note essentially its own—a music which resounds from no other quires."[42] Wills expresses delight and excitement in relation to touching a banknote. The only sensory effects missing

from his discussion are smell and taste; he can only complain about the illegibility of the signatures on the notes. There is no mention of limp or flimsy paper.

It is certainly worth mentioning here how objects held were read and how they relate to the history of reading. Banknotes are "passed," "accepted," and "felt," sometimes even "appreciated" for their aesthetic qualities, but we rarely think of them as being read. And yet they were read and interpreted. As such, paper money deserves a place in the history of reading as well as material culture. Reading is a practice and the circulation of printed texts in a culture is the circulation of different readings of those texts.[43] One could even say that representations and imitations of money gesture toward a "taxonomy of literate practices" that affected the networks of trust surrounding paper money and the development of knowledge that made them function in society.[44] One magazine even recognized the circulation of paper through the Bank of England in this way in 1850: "This great house is, therefore, a huge circulating library."[45]

This way of thinking poses questions fundamental to the study of print culture that is inclusive of paper money, including how readers of money decided who to believe and how they came to trust paper money. Elizabeth Eisenstein famously claimed that print endowed culture with the traits of standardization, dissemination, and fixity, thereby rendering possible the establishment of veracious knowledge in modern society.[46] Applied to money, this claim would indicate that paper money endowed culture with a stable financial system. Of course, that could not be further from the case. Adrian Johns, in *The Nature of the Book*, offers a compelling and well-accepted criticism of this narrative, demonstrating that Eisenstein and related scholars overlooked the historical complexity of print and related cultural consequences. Johns argues that the reliability and veracity of print are contingent and extrinsic, not part of the print itself but of the culture surrounding it. The identity of print had to be made. In other words, the present identity of print culture, inclusive of paper money, was created by hard work. Johns highlights the cultural work that went into establishing trust in early modern scientific texts: "That modern writers have been able to refer to the press's ability to impose a 'logic' of cultural behavior is, in fact, a consequence of its very inability to do so: proponents had to propagandize extensively in such terms to establish fixity as plausible."[47] In the context of money, the concept of fixity refers to the ability of a currency to carry a permanent or unchanging value—something that is not possible. Yet, cultures of paper money, like other Western institutions, value the idea of fixity and seek to maintain it.

Clearly, questions about trust are central to understanding cultures of print. Manifold representations, practices, conflicts, laws, punishments, and other factors build trust in print. Noting the recognized trust in paper money by the mid-nineteenth century, Frances Robertson has argued that

by virtue of their "*appearance* [my emphasis] as a product of mechanical reproduction," the uniformity of British banknotes themselves played an essential role in the establishment of trust.[48] Before the technology existed to make banknotes indistinguishable, the Bank of England worked hard to establish this uniformity of appearance, despite political pressure to change the design and improve the production of their notes. The history of the Bank of England note thus suggests that the process of naturalization was tied to visual and material form.

Hopefully, these examples suggest that materiality reveals semantic thickness in both coin and paper, as materiality has the capacity to produce meaning beyond the medium of a material object and the images or pictures a material object may depict. If Yonan is right that art historians' distrust of the material in favor of the conceptual has suppressed materiality in art historical discourse, then the history of paper money in early nineteenth-century Britain demonstrates that the opposite position was popularly held and represented by satirists. Materiality affected the conceptual basis of trust; in fact for some it was the basis of trust in the face of forgery. People wanted to hear the "chink" of metal money, see the shine of a newly minted coin, and feel crisp paper in their hands. Thickness may be subject to semantics, but it was also subject to aesthetics.

Theory and the Problem of Dematerialization

As Yonan's observation indicates, debates about art—and I will add money as well—have the tendency to filter out the idealists from the realists. In the history of British art, there has been a long-standing tension between commercial culture and the fine arts. Embodying ideas like the political republic, the republic of taste, and the general good, history painting in eighteenth-century Britain, as elsewhere, was considered the highest form of art. Painting in this sense was noble, good, and to some extent abstract, quite separate from the material stuff of its making or the means to buy and sell it.[49] Part of the problem faced by artists like William Hogarth and Joseph Wright of Derby was separating art from money in terms of the need to make a living and of imagining and representing an audience for art outside of a burgeoning commercial society.[50] By the golden age of graphic satire, satirical printmakers were less concerned with this problem and had embraced themselves as their own best advertisers in a commercial world.

Philosophers from at least Plato onward have acknowledged the limits of human knowledge and the fundamental tension between the world of ideas and sensed reality. This was perhaps most famously articulated in Britain when Samuel Johnson kicked a rock, yelling "I refute it thus!" in response to the Reverend George Berkeley's theory of immaterialism. Money is a metaphor for, and exemplar of, the problem of the relationship between ideal and real, sign and substance, thought and matter, and abstract value

and its instantiation in physical form.[51] While convenient and useful, these dichotomies—fact and value, material and immaterial, paper and gold—break down under scrutiny.

In terms of the history of money, it is worth noting that one of these dichotomies—ideal versus real or immaterial versus material—has given much credence to the so-called dematerialization principle.[52] This dematerialization principle informs Georg Simmel's famous work of sociology *The Philosophy of Money*, first published in 1900.[53] Simmel's paradigm links money with depersonalized interactions, alienation, and social dissolution as part of a teleological linear progression. In a way, Simmel reflected on materiality by attaching value to its absence. Simmel, whose contribution to scholarship on money does not include tracing its history, compared leather money in the unspecified "Middle Ages" to paper money: "If paper money signifies the progressive dissolution of money value into purely functional value, then leather money may be regarded as symbolizing the first step towards it."[54] Simmel attached the progress of a society to the dematerialization of its currency. In assigning purely "functional" value to paper money, he overlooked its materiality and the aesthetic considerations and tastes that developed around it.

One recent compelling treatment of the history of money is Rebecca Spang's *Stuff and Money in the Time of the French Revolution*. Her book makes many important contributions to the study of money in France during the late eighteenth century, with three claims especially worthy of note here. First, Spang recognizes that the quality of currency remained as important as its quantity, and puts the two on equal footing.[55] She even goes a step beyond this to criticize the theoretical foundation of classical economic thought: William Reddy's "liberal illusion," which treats money as universal, "substituting and substitutable, as a quantity without qualities."[56] Second, she criticizes the modernist interpretation of money as fundamentally ahistorical, as a narrative that moves from material to abstract without much thought given to plot construction.[57] Linear treatments of money's history obscure the dialectical process of currency creation; new forms of money arise alongside and often in conflict with old forms of money. In Spang's view, neoconservatives and left-leaning critics like Niall Ferguson and Mary Poovey "share a sense that over the centuries currency has been dematerialized (that the coins of the past were somehow more physical than the debit cards of the present)."[58] Third, Spang argues that the quantity theory of money gets treated as a naturalized idea in the scholarship of the French Revolution—omnipresent and unchallenged now and during its own time.[59] This raises an important question: is hyperinflation always the same, escaping any historical particulars of its own context? In this sense, she "leaves open the possibility" that the quantity theory of money is wrong (printing more money need not always lead to inflation).[60] Spang acknowledges that this theory motivated human action in both France and Britain.

One example in her work directly confronts Simmel's dematerialization argument. She explains that while networks of paper credit circulated amongst known individuals who could be accounted for if necessary, the value of coin was subject to many considerations, including war, coin clipping, the overproduction of silver, and the rule of the king in the context of Old Regime France. Louis XIV had the right as monarch to set the exchange rate between coins and "the money of account." He changed the value of an *écu*, a silver coin worth around six *livres tournois*, forty-three times between 1689 and 1715.[61] The *écu* is just one example of money value and functional value being entwined. In other words, paper, or any other "dematerializing" medium for money, cannot lay sole claim to abstraction.

Yet, many scholars argue that money is becoming less and less material and that this dematerialization distances and alienates members of a given community. A few examples include sociologist Viviana Zelizer, who, citing James Coleman, indicates that a cashless society, where people pay with credit cards, inevitably makes "interpersonal ties and trust" irrelevant to that society.[62] Her prediction rests on the observation that a buyer is no longer one member in an exchange between buyer and seller, but rather a member in an exchange that connects the seller with an impersonal clearinghouse of credits and debts, a mediator of sorts that offers no sense of community to the consumer—and therefore no sense of self. Historian Dario Castiglione is another author for whom the perceived dematerialization of money equals linear progress. He explains the principle succinctly in this way:

"Forms of money" and "means of payment" have multiplied, diversified and become more sophisticated. Through progressive conventions, their continuous refinement and their unintended consequences, we have created a credit system that is by its very nature unstable and increasingly reliant upon the intangible qualities of confidence and trust; and we probably have no other way to go. As Simmel rightly perceived, money has progressively, and under our very eyes, lost the characteristics of a substance and become no more, but no less, than a function and web of relationships.[63]

Castiglione attributes intrinsic value to material money and some kind of "progress" to its history. When Poovey states that all systems of money "tend towards abstraction," she may also fall into this trap.[64] Marc Shell engages the dematerialization principle in the introduction to *Money, Language, and Thought*, discussing electrum from Ancient Lydia and "electricity" in today's modern record-keeping, arguing that with "the advent of electronic fund-transfers the link between inscription and substance was broken. The matter of electric money does not matter."[65]

Turning to a modern example of so-called dematerialized money will help illustrate the complex factors hidden by the dematerialization principle. Shell published his book before a modern iteration of electrum

became a beautifully designed website in 2011 that verifies and stores the crypto-currency Bitcoin in a simplified payment verification wallet, essentially storing the digital credentials proving the ownership of and transactions made with the currency.[66] The language on the website electrum.org indicates it exists for "freedom and independence." The founder, Thomas Voegtlin, is listed clearly by name and the website offers a link to a "community" offering various forms of support on such social media forums as Reddit and Twitter. The website asks that users trust in the designer of the software, while at the same time offering the slogan "Do not trust. Verify."[67] Information about redundant servers existing in the real world is clearly posted. Trust in people and institutions matters even for monetary software. Knowable people, along with the design, font, and presence of brand logos, still mediate and affect the perception of value for the software's users. On this last point, Shell might agree. He also wrote: "Credit, or belief, involves the very ground of aesthetic experience."[68]

Money has always been about mediated human relationships. While the ways a culture perceives, accepts, embodies, and handles money may change, the need for negotiating and changing the medium of money will not. The idea that gold has some kind of unassailable value is the real deceptive trick, or humbug as Americans called it in the early nineteenth century. Gold, by way of its seductive qualities, such as hardness and shine, fools its users into attributing hard, intrinsic value to it, and even creeps into the scholarship meant to treat it more critically. For instance, Jennifer Baker, who compares paper to "hard money" in the eighteenth-century transatlantic fashion, claimed that coins "obtained currency through metal's market value," while paper money relied purely on faith. Metallism, the idea that the value of money comes from the commodity on which it is based, still lingers.[69] In actuality, the value of both coin and paper fluctuate; it just so happens that the value of coin has been even more naturalized as a vehicle for wealth than the newer mediator of paper. Henry Thornton, the economist and Member of Parliament who recognized the fiction of inherent value in metal money, wrote in 1807: "The precious metal, when uncoined (or in the state of bullion), are themselves commodities; but when converted into money they are to be considered merely as a measure of the value of other articles. They may, indeed, be converted back into commodities; and it is one recommendation of their use as coin, that they are capable of this conversion."[70] Recall that paper is also a commodity. There was a critical shortage of paper during the American Revolution, for instance, that forced the Continental Congress to pass a resolution preventing papermakers in Pennsylvania from joining the armed forces.[71]

There is nothing intrinsic about any store of value for money. Consider the primary source quotes discussed earlier describing paper money as "flimsy" in every negative way in 1819, and then as "terse" and "crisp" in 1850. The aesthetics of the medium will always have an effect on value in strange

cultural ways, and money will always require some kind of record. Its value, after all, is tied to goods and services in the real world, to the facts that brought such a relationship and its value into existence. The de-materialization principle seems to misconstrue what money is. Although credit is now recorded electronically, and some currencies like Bitcoin are controlled by an algorithm, material and aesthetic considerations still affect these forms of money. People still need credit cards or websites to move numbers in the virtual world. As indicated in the example of electrum.org, website design and authorship serve as means to trust in cryptocurrencies quite beyond the algorithms meant to guard them against inflation.

A model explanation of money's need for continual representation can be found in the writing of Peirce, who accounted for this mediation in his study of semiotics. There are signs, objects, and interpretants. Someone has to make connections between the world of ideas and the material world; this is understood as the very process of culture itself. The process of inter-preting signs requires something real acting on the body, if only through vision or language. Some kind of representation needs to occur in order for a sign to become a store or measure of value, a medium of exchange, or means of payment. Only then can at least two people exchange it—only then can it be an institutional fact.

The dematerialization principle authorizes us to mistakenly think about money in terms of progressive, linear evolution. Recent authors to acknowledge this as a problem in addition to Spang are Bill Maurer and Geoffrey Ingham. Maurer writes: "money is also a system of relationships, a chain of promises, and a record of people's transactions with one another." He recognizes the effects of ascribing a linear progression to the history of money: "if we buy the evolution story, we might lose sight of the infrastructures that support each new form of money . . . [money] comes into being by convention, agreement, and a set of relationships and obli-gations among people inside of complex organizations like states."[72] Maurer's quote leads us right back to institutional facts, and how the language of paper versus gold does not actually structure money in the way that some historical discourses would have us believe. Ingham describes the difficulty economics has accounting for the existence and role of money. In one example, he writes: "the most mathematically sophisti-cated and therefore most revered theories in neoclassical economics— broadly speaking, neo-Walrasian general equilibrium theories—have had great difficulty in actually finding a place for money in their schemes." He argues that money itself *is* a social relation, but it can only be sensibly seen as being *constituted by* social relations.[73] Economics has trouble accounting for the relationships and institutional facts that structure money's value. One example of this is John Searle's identification of how the fact/value dichotomy in ethics has failed to account for institutional facts.[74] There is also a parallel with the discipline of art history and how it sometimes has

trouble accounting for the relationships and institutional facts that structure art's value. Binaries like "high" and "low" art are the product of long-standing human agreement and have prevented discussion of, for instance, the cultural material discussed in this book.

Imitation banknotes demonstrate the unfolding of old and new forms of money, commenting on the cultural unease and novelty of paper money as it worked its way into smaller-scale transactions. Study of paper money in the context of late eighteenth- and early nineteenth-century Britain reveals that materiality affected the perception of currency, and crises reveal the semiotic incongruity or vulnerability of money that persists even during stable economic times. Graphic satirists bridged the gap created by this tension in new and visually explosive ways in the Georgian period. They knew money was tied to actions and abstract ideas—to the debt of the nation, its credit, its printing press, authorship, collective intentionality, the series of relationships that sustain local and national economic stability, and the problem of embodiment in a material. Some satirists exposed the instability of the fact/value dichotomy as they criticized and commented on human ethical and financial agreements.

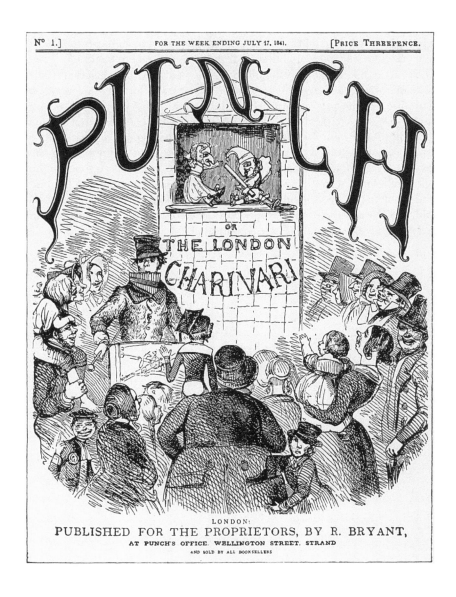

Figure 43. A. S. Henning, *Punch*, no. 1, July 17, 1841.

The Deflation of Georgian Graphic Satire

BOTH GRAPHIC ART AND MONEY are subject to inflation. As we have seen, graphic art underwent a metaphorical inflation during its so-called golden age, at a time when the producers and consumers of graphic art experienced literal monetary inflation. Although explaining inflation is particularly vexing, the correlation between a stabilizing economy and the deflation of Georgian graphic satire deserves attention in discussions of the genre's supposed demise. Inflation and deflation contextualize the golden age of graphic satire.

Even before the arrival of *Punch* in July of 1841 (**Figure 43**), lively satirical prints in "the Gillray manner" were no longer being produced. Bradford Mudge summarizes the early nineteenth-century critic Henry Angelo, who lamented the "unfortunate change in English culture from the lively and lascivious 1770s and 1780s to the rather prim and proper 1810s and 1820s."[1] Dorothy George argued that satirical prints had virtually disappeared after 1830, despite the popularity of William Heath and his imitators in 1827.[2] Diana Donald refers to the end of the Georgian tradition in satire by analyzing several representations of the Peterloo Massacre, which she understands to have "set in train the process of transformation." She lists several reasons that help to explain this demise, such as the March of Mind, the idealism of the Victorian age, the decline in comedy noted by William Hazlitt, and the importance of reaching the

lower classes, which led to a simplification of references in images.[3] Andrew Benjamin Bricker discusses the death of visual satire and claims the market for single-sheet political caricature "simply dried up" in the 1830s due to market forces.[4] Christina Smylitopoulos identifies the accelerating Victorian eclipse of satire early in George Cruikshank's career, claiming he abandoned graphic satire in favor of illustrated text and the comic as early as 1814.[5]

Imitation banknotes followed the same visual trends as satire and drifted away from the Georgian tradition by embracing other forms, such as advertisement and novelty imitations.[6] These forms suggest that later imitation banknotes changed in accordance with other trends in print culture, mainly the decline of graphic satire and the ascent of paper as money. Ian Haywood refers to this as the "final irony of the relationship between caricature and forgery"; the restoration of "real value" in 1821 served as a marker for the decline of the golden age of British caricature.[7] As noted earlier in the Introduction, Lothar Müller has commented on Thomas Carlyle's "Paper Age," which thrived during the French Revolution. Müller notes that the early nineteenth-century Scottish luminary had "coupled the inflation of the intellect to the inflation of money."[8] Edmund Burke would likely have agreed with this correlation, that creative intellect led to the worst form of money imaginable—and certainly imaginary—and thus that assignats marked a broader decline in late eighteenth-century France. The relationship discussed throughout this book returns in inverted form: it seems that, by the mid-nineteenth century, reactions to the two types of engravings covered here were switched. Paper money was the more naturalized form, while graphic satire in the eighteenth-century fashion declined.

The end of the Bank Restriction in 1821 saw a negative inflation rate of 12 percent; 1822 saw a negative inflation rate of 13.5 percent.[9] While the year 1825 saw a 17.4 percent increase in prices, the percentage changes following that year were largely uniformly deflated for decades until a marked increase during World War I. Perhaps economic models of inflation could help explain the change in satire alongside political context, in relation to the inflationary gap or changes in supply and demand.[10] Here, I suggest that metaphorical deflation serves as an apt model, one that nuances the death or demise paradigm. While that paradigm has some truth to it, it does a disservice to the influence of James Gillray and Thomas Rowlandson in *Punch* and elsewhere. A metaphorical model of deflation fits the visual evidence: graphic satire had puffed up with political vitriol, incongruity, violence, and swollen lines beyond available limits. The very limits of representation and exaggeration meant that structurally satires could only deflate. And they did so along the lines of the economy and the stabilizing prices of everyday goods, including the increasingly cheaper and cheaper price of paper.

The Laughing Audience[11]

The question of audience has long preoccupied historians of caricature, from those making the more democratic argument that everyone engaged with such images on the street (Donald and Sheila O'Connell) to those far more skeptical of their reach and intent (Eirwen Nicholson and David Francis Taylor).[12] One of the most fraught battlegrounds of this debate has been analysis of printshop window scenes, or satires showing an audience viewing caricatures on the streets of London. Scenes of this kind appeared in British graphic satire from the 1770s and continued well into the nineteenth century. This final section gives an extended comparison of two printshop window scenes. It compares the issue of *Punch* dating July 17, 1841 (Figure 43), priced at threepence, with George Woodward and William Holland's *Caricature Curiosity* (Figure 22). The latter would have likely sold for at least a shilling, probably two. This comparison demonstrates metaphorical deflation in terms of the quality of the images' exaggerated lines, incongruity humor, and conceptual force. It allows for the examination of two different imagined laughing audiences.

As a mechanism for producing humor, incongruity offers another metric for understanding the decline in production of Georgian satire and what Vic Gatrell calls their "bawdy and angry irreverence."[13] Incongruity has been linked to humor since the ancient world, although William Hogarth said it particularly well in the eighteenth century: "When improper, or incompatible excesses meet, they always cause laughter . . . [the] joining of opposite ideas."[14] Recent work in the philosophy of humor has shown how even Thomas Hobbes, seemingly bound to the superiority theory of humor, actually engaged the incongruity theory of humor as well.[15] Its importance as a structural component of Georgian satire has not been stressed enough, especially in relation to the logical limits of inflation and deflation. The very practice of caricature, as the exaggeration or loading of the features of an individual, deliberately contrasts the actual features of a person with the incongruous exaggeration of those features. Caricature itself requires incongruity. And caricature as a practice deflates in the early nineteenth century.

The *Punch* image, as the cover of a magazine, was no longer a single-sheet intaglio print. It was more widely available for purchase and used cheaper paper. James Baker stresses this difference, and points out the error of treating Georgian satirical prints as reproductions in this modern sense. In other words, *Punch* was not the product of a craft.[16] By one estimate, the print run for 1844 indicates that *Punch* had over 22,795 copies printed and 113,975 readers. By 1850, it had 33,180 copies printed and 165,900 total readers.[17] These circulation numbers—far higher than those of any Georgian print—invite economic explanations in terms of supply and demand. This cover of *Punch* owes a great debt to the printshop window scenes of the eighteenth century, and to the long history of the Punch and Judy show

The Deflation of Georgian Graphic Satire **143**

in culture and as print culture, what Henry Fielding called "that excellent Old English Entertainment" seen in graphic prints from Hogarth's *Southwark Fair* (1734) to Gillray's *State-Jugglers* (1788).[18]

Caricature Curiosity and the *Punch* cover both share the theme of people gathering to watch a spectacle in the street. Londoners gather to look at the Punch and Judy puppet show in one, and at satires of their own image and behavior in the other. Woodward carefully indicates texture and shadow with line, while the rhythmic squiggles of line flanking the stage on the *Punch* cover indicate a quick sketch and flatness, not an actual city block with pavers, brick, wood paneling, and blue sky as in *Caricature Curiosity*. Both satires advertise their own product by depicting an eager audience. *Punch* even indicates its own popularity, despite not actually achieving it until 1842. Two of the most compelling differences between these street scenes pertain to the mechanics of humor—incongruity—as well as to how they engage the notion of critical reflexivity.

In *Caricature Curiosity*, the tall and slender volunteer stands next to the short and rotund pastor. Even hats and noses continue the parallel construction as they each gaze at their own caricatured representation. The tall man has a tall hat, the short man has a short hat, the rotund pastor has a round nose, and so on. Their professions of war and peace are also contrasted. Even the position of the dogs indicates incongruity. Yet, there is not an obvious way that incongruity pervades the *Punch* cover. Although the large man in the center of the *Punch* cover appears tall and wide next to the boy who picks his pocket, this contrast does not appear important for the operation of the image. Further, *Caricature Curiosity* records direct commentary on self-reflection, as the pastor and volunteer reflect on how their society sees them, and respond to their own image in angry resignation. In turn, they reflect on society itself. The *Punch* cover, however, offers a glimpse of a jovial society receiving a spectacle, happy to be entertained—critical reflexivity is absent.

For all these differences, the *Punch* cover retains the pickpockets who turned London's streets into a prime location to rob distracted lovers of satire in the Georgian era. A pickpocket lifts a wallet out of a man's coat pocket in the bottom center of the print while the people smile and look at the puppet stage framed by the title "Punch." A boy stares out at the viewer of this cover as a tribute to an earlier era. The *Punch* cover also erases the physical violence so visceral and dominant in the graphic satires from the 1790s. It suggests pleasant laughter at implied violence; the magazine is named for the Punch and Judy puppet show, which performed hitting in the context of a male and female relationship, if not in marriage.[19] The imaginary viewers of the printshop satire are happy to watch and clap at the abusive husband-and-wife drama unfolding before them, but in terms not nearly as visceral as in Rowlandson's grotesque and sadistic satire *The Coblers Cure for a Scolding Wife* (**Figure 44**). Rowlandson shows a wife's physiognomy

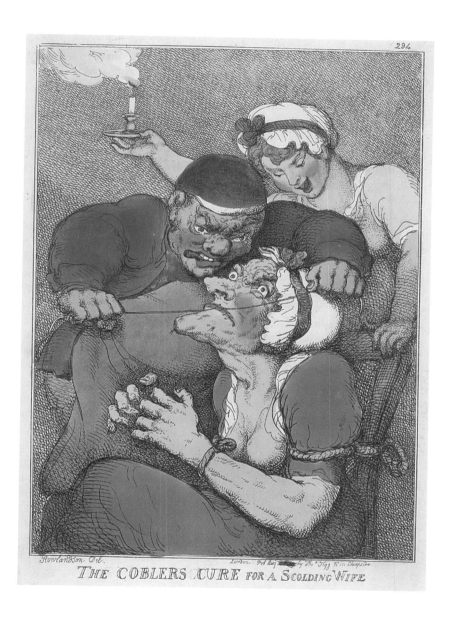

THE COBLERS CURE FOR A SCOLDING WIFE

Figure 44. Thomas Rowlandson, *The Coblers Cure
for a Scolding Wife*, August 1813.

swelled up to indicate manly features, while her mouth is literally sewn shut by her husband. Such inflated bodies, distorted physiognomies, obvious incongruity, visualized violence, and the satirist's maverick imagination have no place in the *Punch* cover.

Asking who had the dexterity and expertise to decipher graphic satire, Taylor argues that satires of the printshop windows policed rather than effaced class boundaries, adjudicated high and low culture, and prescribed rather than described audience.[20] He writes: "I'm deeply uncomfortable with any reading that assumes political caricatures—then or now—to be a necessarily radically inclusive or democratic form . . . literary parody in these images is largely aimed at, and can be seen as a means of imagining, an elite political public."[21] Sophisticated references to literature, in his view, define graphic satire's true audience. For Taylor, literariness and the superiority theory of humor mark the important boundaries of these graphic satires.

A similar skeptic of caricature's laughing audience is Baker, whose interest is in the production of late Georgian satirical prints. Similarly to Taylor, he argues that graphic satire's audience was elite: "The real story . . . was of a diverse trade whose core consumer derived not from the 'multitude' but from the very same polite classes who sought to moralize over and constrain the actions of the 'multitude.'"[22] Study of the "realities" of selling prints leads Baker to a contradiction sometimes avoided by historians, that of the "non-purchasing" consumer. Many printshops sold more than satirical prints, but endeavored to be known for the satires they sold, such as in Laurie & Whittle's 1795 catalog emphasizing "the greatest of Humorous and Entertaining Prints."[23] He uncovers the market realities for these sellers: "the late-Georgian shops that sold satirical prints were flexible businesses, chameleons who shifted from 'Book shops' to 'Print shops,' from 'Print shops' to 'Stationers,' and back again, to best exploit a given situation, time or audience."[24]

Altogether, I am not arguing against the quite admirable scholarship of Taylor and Baker per se, or the idea that the imagined audiences of these graphic satires indicate a kind of elite ability to see as part of a cultural practice. In addition to the perspectives they offer, however, another account might take gawking and elite snickering together as part of the vortex created by printshop windows, both on the street and imagined in graphic satire. We do not know what unfolded in the minds of viewing audiences. We know that records from the Old Bailey, London's central criminal court, show the pickpockets who robbed people as they pushed their way toward the printshop windows.[25] Those who "just gawped" at the satires, and were not able to appreciate nuance in some intended way or appreciate the elite audience the satirists imagined, still feature prominently in these scenes and served to indicate some kind of Britishness.[26] To turn Taylor's phrase about his discomfort with certain readings of

caricature, I am deeply skeptical of anyone who claims that a myriad of semiotic strategies did not unfold on the streets or that such strategies are not relevant to the history of graphic satire. Elusive sophistication, which Georgian graphic satire certainly had, need not preclude more simple kinds of pleasure or engagement. I suggested earlier that scholarship could benefit from knowing more about how banknotes were read. We also need a history of viewing practices for graphic satire and caricature, an account of how they were seen and read. This might never be possible, but as Carlo Ginzburg has shown in a different context, individual contemporary readings of cultural artifacts can show how objects and images inspire polysemic interpretations.[27] The mutual reliance between high and low, as between fact and value, seem to me central for a fuller account of caricature's audience.[28]

According to Brian Maidment, looking at Regency and early Victorian caricatures of printshop windows suggests how far "these depictions of the street are constructed by ideas concerning social order."[29] By the Regency, in his view, there was a change in the act of spectatorship. When describing the level of absorption that viewers of satires in these images exhibit, he argues that such absorption threatened the social fabric and made viewers irresponsible targets of pickpockets.[30] Similar to Taylor and Baker, Maidment finds that passersby of these printshop windows "may well look but may not necessarily *see*."[31] Comments of this kind seem to provide evidence for and argument against a "low" and inclusive audience for caricature. He argues that "early Victorian images of printshops, despite a declared participation in a comic graphic tradition, manifestly served the social purpose of divesting caricature of its associations with the carnivalesque, the disorderly and the potentially transgressive."[32] Consistent with this claim, the *Punch* cover of 1841 represents an orderly and tame audience of smiling, content individuals.

A similar satiric deflation can be seen by comparing a graphic satire from the early 1830s to an imitation banknote from the 1820s. William Cobbett famously said he would happily be broiled alive on a gridiron if inflation and government debt subsided. John Doyle's satire from 1833, *The Gridiron*, literalizes this threat (**Figure 45**). In this lithograph, chancellor of the Exchequer John Charles Spencer and soon-to-be chancellor and Prime Minister Sir Robert Peel lead Cobbett toward Secretary of the Treasury Thomas Spring Rice and a hot oven. They have a gridiron ready to roast him. It reads below: "The honorable member solemnly declared in writing that when this country returned to cash payments he would suffer himself to be broiled upon a gridiron, now the country has returned to cash payments and I think the hon. member bound to undergo the consequences." With inflation at negative 6.1 percent in 1833, and negative 7.4 percent the previous year, Cobbett had been proven wrong when the government restored the convertibility of paper into gold, maintained the

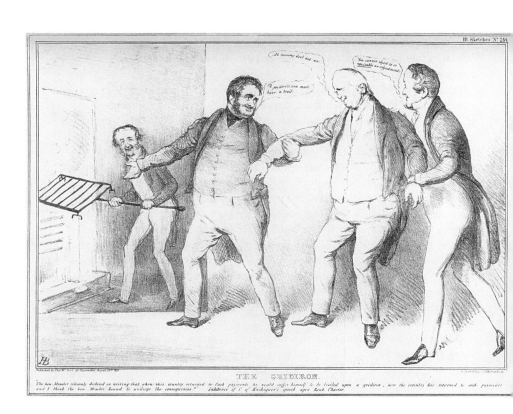

Figure 45. John Doyle, *The Gridiron*, 1833.

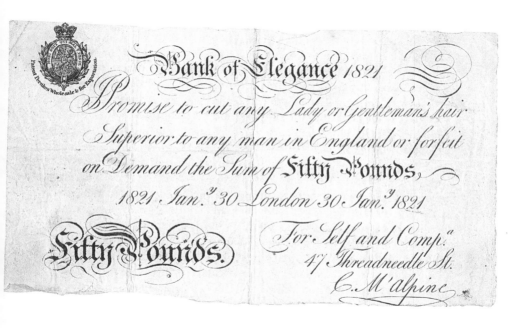

Figure 46. Anonymous, *Bank of Elegance*,
advertisement in the form of a mock banknote, 1821.

national debt at a steady level, and kept on printing small-denomination paper notes.[33] While the gallows humor presented here may have had comedic value for those annoyed by Cobbett's radical journalism or happy that inflation had subsided, the visual quality of the satire has been reduced to awkward figures and speech bubbles. Especially awkward is the articulation of Cobbett's neck and the perspective of his knocked knees. Caricature has little place here. All of the figures smile politely as if going to dinner, and not to an execution. The satire hides all of the factors that would have been visually explosive during the Georgian period. This type of deflated visual choice dominated many of the graphic satires in the early nineteenth century.

Reflection on the process and medium of Georgian graphic satires allows for good comparison with *The Gridiron* as well. *The Gridiron* is a lithograph, as opposed to the other types of prints that dominated in Gillray, Cruikshank, and Rowlandson's time. As Baker reminds us, the Georgian satirists used engraving, etching, aquatint, mezzotint, and stipple to enrich, texture, layer, and give depth and tone to their scenes.[34] Lithography, as a process involving stone, water, and oil, could allow for endless reproduction without loss of quality to the printed image. In contrast to this, the soft copper plate carved by the engraver's burin wore out under the stress of repeated printing.

The same kind of deflation also appears in imitation banknotes, such as the *Bank of Elegance* (**Figure 46**) and the *Bank of Fashion* (1826). Far from providing criticism of culture, capitalism, or the medium of money—or deploying humor, biting irony, or other characteristics from the Georgian period—in these examples, the platform of paper money is a rather droll and insignificant way to advertise. In the first advertisement, drawn on the "Bank of Elegance" a satiric metonym for the Bank of England, C. M. Alpine offers to forfeit fifty pounds if anyone can find a superior haircut to his own in England. The latter note advertises a shop located at 30 Upper Temple Street in Birmingham. Along with London, Birmingham was a center of financial forgery during this period. The date on this note of April 1 might indicate that it is an April Fool's Day joke, and for the careful reader the note is not worth anything, just the promise to forfeit one hundred pounds if the hair of a lady or gentleman is not done in the best style of elegance.

With some hesitation, Richard Altick characterizes *Punch* as further deflated, "innocuous indeed, the very soul of decorum and fair play."[35] As pointed out by Gatrell, albeit without extended visual evidence, "[c]ompare *Punch*'s jokes with those from half a century earlier, and the change needn't be labored further."[36] Haywood, who brings the work of Charles Jameson Grant, Robert Seymour, and "serial offenders" (a pun on cheap serial publication) into focus in *The Rise of Victorian Caricature*,[37] abandons the close reading of single images he used in his previous book *Romanticism and Caricature*. His methodology alone seems to admit deflation in these images.

These observations need not be confused with the devaluation of this material. Recent work by Maidment, Henry Miller, and Haywood demonstrates the great potential of Victorian graphic satires to teach us about the politics of reform, the role of political likeness in modernization, the continuity of satire in the 1820s and 1830s with the eighteenth-century tradition, and the emergence of a mass readership for comic images.[38] Baker uses the adjectives "fascinating" and "glorious" to describe this material: "comic art c. 1820–50 may not have produced work as memorable or of as consistently high quality as either the late-Georgian single-sheet caricature that proceeded it or the *Punch* cartoons that would follow, but . . . this period is no lull in the history of British comic art but rather a fascinating, turbulent, and glorious period unto itself."[39]

The terms Baker uses indicate changes not only in how humor was structurally produced on the page or in an image, but also in how the broader culture reacted to those changes, especially related to the act of laughter. David Bindman has suggested that two different interpretations of laughter were demarcated in eighteenth-century Britain: laughter as derision and laughter as physical act.[40] Laughter of the more physical, low kind that inflates the belly during convulsions was reserved for those of the lower classes, who had poor control over their bodies, namely their sexual desires and bodily functions, and engaged in emotional and physical violence. This is the kind of laughter attributed to *sans-culottes* in the 1790s, who smile with wide open mouths bearing their teeth, seen in several of Hogarth's prints, such as *The Laughing Audience*.[41] Gatrell writes about a watershed in the public history of English humor after the 1850s, where the "bawdy carnivalesque of the old laughter was replaced by a humor that was domesticated and tamer" and "Squeamishness about unseemliness and disorder combined with a deepened fastidiousness about those sights and functions of the lower bodily parts in which eighteenth-century humor had delighted."[42] Clearly, the smiling men and women in the 1841 cover of *Punch* do not signify laughter as a physical act. Their polite smiles seem to demonstrate pleasure, at least until the top half of the image comes into focus. On this mini-stage, we see laughter as derision, where Judy is brought to life by a puppeteer in order to smack her husband. Taken as a case study, this comparison of *Caricature Curiosity* to the first *Punch* cover indicates that graphic satire had deflated like the laughless, smiling bodies on the *Punch* cover itself. Biting, critical satire of the eighteenth-century Georgian kind was not absent in Victorian Britain, just less inflated.

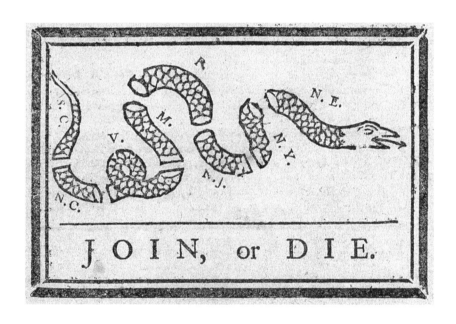

Figure 47. Benjamin Franklin, *Join, or Die*, 1754.

Beyond Britain

BRITAIN WAS BY NO MEANS UNIQUE in its struggles against inflation or its reliance on new monetary mediums in the eighteenth and nineteenth centuries. Nor was it the only society to use satire to comment upon and criticize paper money. Richard Taws discusses a German copy of a James Gillray print from 1793 depicting a starving Frenchman surrounded by paper money and coins, noting that this image of the French was mediated via the work of a British artist for a German audience: "this print speaks to the confluence of caricature and paper money across international borders."[1] The Germans were particularly enamored with Gillray, as their republication and lengthy explanations of his satires in the journal *London und Paris* demonstrate.[2] It is well known that the British tradition of graphic satire provided a foundation for what became a distinct tradition of graphic satire in the United States. This line of satirical influence, discussed in some detail in the first part of this epilogue, was not limited to this former British colony. Another example from the edges of the British Empire, in the second section, demonstrates how one of the nations also influenced was, quite surprisingly, Japan.

The United States

The British tradition of printmaking came to the American colonies as early as the seventeenth century. Early examples of political satires blatantly copied English prints. For instance, *A Warm Place—Hell* (1768) by Paul Revere copies an English print from 1765 with few modifications.

The long-standing authority on American cartoons, Frank Weitenkampf, claimed that celebrated satirists William Charles and David Claypoole Johnston were mere shadows of their British predecessors: "As [William] Charles had been a rough reflex of Gillray, so David Claypoole Johnston (1797–1865) was a weak dilution of [George] Cruikshank."[3] Johnston was even known as the American Cruikshank and modeled his "comic sense" and "style" after George Cruikshank in the 1820s and 1830s. Johnston was also referred to as the American Hogarth.[4]

Many scholars have even proposed that the confluence and contrast of the British and American traditions suggests that Americans did not produce innovative graphic satire until after the Civil War: Stephen Hess and Milton Kaplan referred to early American graphic satire as a "weak carbon copy of European model" and listed James Albert Wales (b. 1852) as the first "home-bred political cartoonist of the first order."[5] The art historian David Tatham is one of the few to reclaim Johnston's distinctly original contributions to American art, especially when compared to Michael Lewis, who, even after highlighting the achievements of William Birch (1755–1834) as a printmaker, plainly states in the context of early American printmakers: "It would be unkind but truthful to say that when they [printmakers] sailed from England to America, the artistic quality of both places increased."[6] Claims of the latter kind overlook the most famous American satire, considered the first American cartoon, Benjamin Franklin's *Join, or Die* design (**Figure 47**)—of a serpent cut into eight pieces, each representing a colony— which was published in 1754 and reproduced for decades to come. In the case of this print, influence went in the direction of the colony to the center of empire. Gillray adopted Franklin's famous satire in *The American Rattle Snake* (1782) in order to ridicule British military losses.

By 1837, in addition to advancing this shared tradition of graphic satire, the binary of "paper versus gold" structured American discourse on money in ways similar to how it shaped British satires during the Bank Restriction period. The dichotomies of paper versus gold and material versus ideal— owing much to the fact versus value dichotomy that still corrupts our thinking about money and art—flourished in satire produced in the United States. Weitenkampf indicated an uptick in the production of satire with Andrew Jackson's administration. This was related to several factors including the popularity of lithography, the prevalence of political dichotomies at the time, and influence from the British tradition—Cruikshank was, after all, copying his father, who thrived as a graphic satirist along with Gillray in the 1790s.[7] The dichotomy of paper versus gold persisted despite the multitude of existing carriers of financial value, including stocks, bonds, checks, bills of exchange, and so forth. This false dichotomy was particularly vibrant in British satires from the 1790s, as already discussed in regard to *Political Hocus Pocus!* and *Midas*. Crisis provokes contrast, and contrast makes for obvious incongruity humor and easily understood propaganda.

One of the winning dichotomies exercised by the satirists is the problematic of gold as "a fact" and paper as "a value," and the corollary of gold as material and paper as a mere abstraction or belief. These dichotomies could be seen in responses to the Panic of 1837, which included the failure to recharter the Second Bank of the United States, Jackson's redistribution of government funds from Philadelphia to state banks, the growth of local banks (over seven hundred newly created banks were printing their own paper money by 1836), a rise in commodity prices nationwide, the suspension of trade due to lack of cash, the failure of many businesses, the filing of lawsuits by foreign debtors (especially in London), and the suspension of payments in specie from many banks.[8] Jessica Lepler has broadened the understanding of the period to include multiple transatlantic and local panics in New York, New Orleans, and London, complicating the history of the term "panic" and its effect on historical interpretations of the 1837 crisis.[9] Analogies of the event were similar, yet slightly different to those made to the specie crisis of 1797 in Britain, including references to contagious disease, technological disaster, epidemic, biblical punishment, fantastical horror, unpredictable weather, an out-of-control machine, and a godly test of human morality.[10]

During the Panic of 1837, Johnston imitated a fractional paper banknote worth twelve-and-a-half cents. He gave a lengthy name to the satire: *Great Locofoco Juggernaut, a New Console-a-tory Sub-Treasury Rag-Monster* (**Figure 48**).[11] Clearly both the title and the image itself rely heavily on context and demand extensive explanation for viewers then and now. The terms in need of the most explanation here are "Locofoco" and "Console-a-tory." Locofoco references a political party in the United States that was active for about a decade beginning in 1835. Centered in New York City, this subfaction of the Democratic Party advocated specie payment and the separation of government from banking. Its members asserted, like this cartoon, that only the rich were paid in gold hoarded by the bank. They believed that the form of money itself contributed to class inequality. On occasion, the term "Locofoco" was used as an insult. Johnston takes the word consolatory, meaning to bring comfort, and breaks it up to reference conservative politics, so "Tory" in this sense does not indicate a strict political party, but likely an insult to those disagreeing with hard money policy. Generally speaking, Johnston's satire likens the Democrats to a radical subfaction of their own party and blames them for the problem of worthless paper money.[12] Analysis of this American satire can reveal unique responses to inflation and materiality, as well as exemplify an important legacy of the British satirical tradition.

Johnston's satire gleefully takes up the form of a shinplaster. Shinplasters were the low-denomination, near worthless units of paper money that circulated in places across the United States that were low on small change. They were issued during the Free Banking era, a period lasting twenty-six

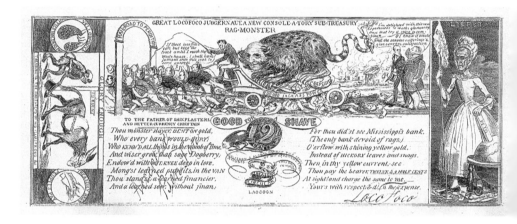

Figure 48. D. C. Johnston, *Great Locofoco Juggernaut,
a New Console-a-tory Sub-Treasury Rag-Monster*, 1837.

years between 1837 and 1863.[13] As the economists Arthur Rolnick and Warren Weber describe, this era was known as the wildcat banking era for many reasons: "The Free Banking Era was a time when entry into banking was nearly unrestrained, when banks could issue their own currency, when the government did not insure banks, and when there was little supervision and regulation of bank activity. It was also a time when many banks closed and many noteholders reportedly suffered. The conventional view of this period is that wildcat bankers were roaming the countryside taking advantage of an unsuspecting public by issuing bank notes they had no intention of redeeming."[14] Shinplasters were the paper promises of this era. This satire on Martin Van Buren and Andrew Jackson appeared, along with many other satires, after the specie crisis of 1837 and the start of the Free Banking era.

Van Buren in the image is the sub-treasury rag monster vaguely resembling a cat. As discussed in earlier chapters, the derogatory term "rags" was used in several different cultures in the Anglophone world to reference paper money. Van Buren hoards deposits while riding in a wagon labeled "200,000 jackass power" toward the "rail-road to perdition," trampling "the people" underneath. At right, liberty personified as Jackson stands in women's clothing holding a "veto" and a pole with a tattered "constitution." At left, Van Buren (an ape) and Jackson (an ass with gold deposits on his back) follow a sign reading "to ruin." In other words, the Democrats, symbolized by the donkey, are leading the country to ruin and associated with a subfaction of the party that they did not actually belong to. The price for this shinplaster, as Jessica Lepler has noted, matches the price of what the caricature might actually have cost.[15] Johnston asserts the equivalency of the value of money as paper with the value of satirical art on paper.

On the left-hand side, two incongruous seals are juxtaposed: "Yellow-boys" for "office holders' pay" against the "treasury rags" for "people's pay." This section delights in two dichotomies: rich versus poor and gold versus paper. We are meant to associate politicians, or office holders, with gold, and regular people with worthless paper money. On the left-hand side is also a vignette. Despite his long-standing distrust of paper money, politician Thomas Hart Benton has signed the note "Ben Ton" as cashier for this shinplaster. Benton's nickname was "Old Bullion," so this introduces a bit of humor.

It is likely that Johnston also imagined a new Laocoön in the center of his engraved satirical treasury note. The shortened name of a famous sculptural group from antiquity (dating to the first century BCE or CE in Rhodes), *Laocoön* is now in the Vatican Museums after rediscovery in 1506. This caricature of Van Buren might liken him to Laocoön, a Trojan priest in Greek mythology, referencing his position on the Independent Treasury. A snake labeled "treasury circular" with an arrow for a tongue wraps around him,

ready to strike. This "treasury circular" could be the predecessor to the Treasury Act of 1846 that Van Buren supported. The Independent Treasury, or subtreasury, generally references the history of banking and federal oversight of the money supply in the United States. In response to the Panic of 1837, Van Buren suggested the government set up a number of subtreasuries, or banks, to hold federal funds in vaults so cash could not circulate. This system was put into place later in the 1840s and was eventually replaced by the Federal Reserve System. The circular could also reference the specie circular, an executive order issued by President Jackson in 1836 requiring that the payment for public lands be made in gold or silver.

Above the priest, words from Benton in the form of a beetle state, "Solitary & alone amidst the seers & taunts of my opponents put this ball in motion," as he kicks a coin. This ball is likely the "golden ball," a symbol of hard money Democrats and early hard money policies of the Jackson Administrations (1829–37).[16] Van Buren is being consumed by his own policy here, even if the Independent Treasury was too new to have a great effect and even if the specie circular was signed by Jackson. Putting "the ball in motion" is akin to sending in a Trojan horse. That is, hard money policy will eventually lead to destruction at the hands of a trick, or humbug. Yet, the paper rag forming the very platform for this caricature is clearly not a solution to the specie crisis either. This American example contrasts hard with soft, rich with poor, politicians with the people, and gold with paper.

As a printed image from a plate, *Great Locofoco Juggernaut* measures only about seven-and-a-half-inches long. The version of it in the American Antiquarian Society's collection has a substantial margin and does not imitate the size and form of paper money. Another printing of it from the National Museum of American History, however, does not have this margin and comes much closer to imitating the form of a fractional paper banknote. In the terms discussed above in relation to British satires, then, this printing makes for a more compelling challenge to the value of paper money and the political relationships that govern the agreement of monetary value.

The deeper history of failed Continental paper currency haunted debates over paper money in the United States during the specie crisis of 1837. The post–Revolutionary War generation had carried deep skepticism about the backing of paper money and this had a real effect on the production of satire.[17] One literary satire that has escaped scholarly attention, *The History of a little Frenchman and his bank notes. "Rags! Rags! Rags!,"* was published for an anonymous author in Philadelphia in 1815. In a lengthy text, it describes "a little Frenchman of rather singular appearance and dress" who is routinely frustrated by the act of spending paper money in the United States. This satirical account provides tremendous insight into the handling of paper money in the early nineteenth-century United States. While some rare book catalogs identify *The History of a little Frenchman*

and his bank notes. "*Rags! Rags! Rags!*" as merely associated with James Kirke Paulding, he was likely the author of the pamphlet.[18] Paulding served time in debtor's prison after his father backed failed Continental currency with his family property. Paulding probably disguised his satire as a travel narrative in order to rant against paper money. The travel narrative is also very likely based on that of Stephen Girard, who in 1813 had led a group of wealthy bankers, like himself, to help finance the War of 1812. This literary satire superbly captures the lived details and frustrations of the paper money system along the East Coast of the United States in the early nineteenth century and approaches the problem in a similar way to that of the British graphic satirists, including paying due attention to the handling and materiality of paper money.

At the outset, the author draws the reader in by describing "this Frenchman" as "animated by an inveterate propensity to grumble at every thing." Girard, who had lost an eye in his youth, was born in France and routinely traded in the Caribbean before settling in Philadelphia. Both "the Frenchman" and the real Girard, then, traveled north from the West Indies, arriving from Cuba in Savannah. The Frenchman deposited eight thousand dollars in gold at a local bank and from this point forward he "never paid or received money without a vast deal of shrugging up of his shoulders and other tokens of dissatisfaction, and whenever he handled a banknote, eyed it with a look of most sovereign contempt."[19] Paulding's use of caricature heightens the central problem of the story: this Frenchman is as ridiculous as paper money. His long hair apparently hung like a rat's tail under his high-crowned hat and he wore large earrings. When he returned to withdraw some of the money deposited for his journey from Savannah to Boston, the bank refused to give him any specie. He was forced to take paper money, which depreciated at each stage of the journey. At one point the author, traveling with this gentleman, explains that one note had depreciated four percent within the distance of one mile from its issuing source. This inspired the man to drink as much wine as possible at dinner to maximize the value of his remaining notes.

What begins as a story ends as a tract arguing against the "occult mysteries of the present banking system." It demands resumption of redeeming all notes in specie.[20] Paper money is reduced to mere "rags" and "pretty pictures engraved on fine paper."[21] The Frenchman complains of the erection of an infinite number of petty banks in every obscure village, each of which props up "modern financiers of bad character."[22] Credit for this Frenchman is mutual trust indicated by character. The main point clearly remains: chartered banks, farmers, and everyone else should only accept payment in specie.

This early satire sets up the cultural context nicely for the late 1830s when the medium of money became crucial to political affiliation. It was not until the specie crisis of 1837 in the United States that satirical banknotes appeared.

Beyond Britain

An imitation banknote satire from this context, *Fifty Cents/Shin Plaster* (**Figure 49**), a lithograph published by Henry R. Robinson, was backdated to May 10, 1837, the day specie payments were suspended in New York banks (from June 10, 1837, when it was registered for copyright). It takes up the graphic design of a banknote with humorous modifications. Robinson was a self-identifying Whig who, according to Peter Welsh, "was a consistent and sympathetic backer of the Bank of the United States and depicted Nicholas Biddle as the recipient of Jackson's fury and abuse."[23] He blamed Jackson for the depression of 1837 and characterized the event as a moral and financial failure. One blacksmith says in the satire: "Gold & Silver have their value, Industry & Integrity should have their value also."[24]

The printseller promises to pay "Thomas H. Benton or bearer, FIFTY CENTS, in Counterfeit Caricatures at my Store," making direct comparison between a printed satire and paper money. The satire references hard money with two coin medallions, as so many imitation banknotes did, on its upper right- and left-hand sides. President Jackson rides the back of a breast-feeding sow off a cliff toward the United States Bank (that had just stopped issuing specie). Nicknamed "Old Bullion," Benton was an advocate of hard money and rides a donkey behind Jackson off the same cliff. Van Buren rides a fox down a different path. Jackson and Benton are chasing "Gold Humbug," a butterfly with golden wings symbolizing the scarcity of specie— its "flight" to other places—during the financial crisis and, possibly, according to the Library of Congress catalog, "their efforts to restrict the ratio of paper money in circulation to gold and silver supplies."[25] Use of the eighteenth-century term "humbug" is particularly telling. It appears here as a criticism of both gold and paper money by Robinson and the American Democrat Samuel Young. Edgar Allan Poe's famous short story "The Gold-Bug" (1843) puns on both the term's literal and figurative meanings.[26] This print has much in common with the British satire discussed in the Introduction to this book, *Political Hocus Pocus!* (Figure 1). As previously described, in this satire, William Pitt issues paper banknotes out of a sack as if performing a magic trick. Like Pitt, Jackson imposed a new medium for circulating money, and his creation of a new currency was also likened to a trick.

Fifty Cents/Shin Plaster measures ten-by-seventeen inches, the size of a small painting. Other imitation banknotes, as in the British context, took up the actual size of money in the service of advertisement. Robert H. Elton, who published several comic almanacs in the 1830s in New York (1834, 1835, 1836, 1837, and 1840), dreamed up the *Eltonian Komick Bank* (1837) and issued a six-cent shinplaster from it. It reads: "Promise to give SIX CENTS, in Plays, Songs, Books, Prints or Stationery, on this, their Shin Plaster, being presented at 134 Division, or 68 Chatham-Sts. N.Y. 1837."[27] The makers of this advertisement identify Nicholas Biddle, the president of the Second Bank of the United States, by playing with Latin phrases. He is a king making false promises: "Vivat Rex Biddleum! Non habit cash diddleum! CAPITAL!

Amanda Lahikainen

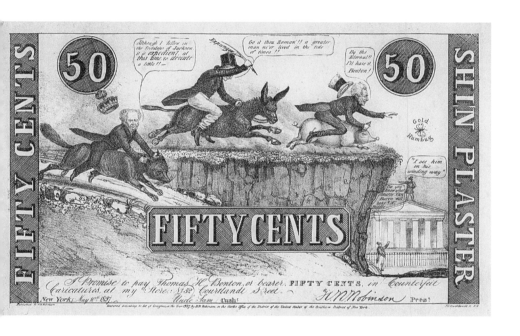

Figure 49. Henry R. Robinson, *Fifty Cents/Shin Plaster*, 1837.

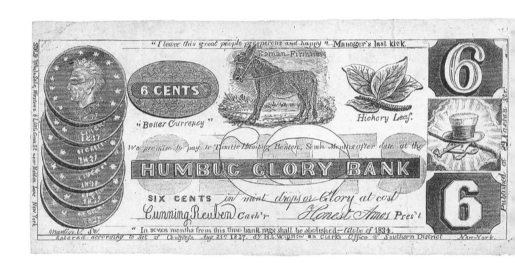

Figure 50. Anthony Fleetwood, *6 Cents/Humbug Glory Bank*, 1837.

Loans on Real Estate, $000,000,000! Stock paid in $000,000,000! SPECIE, $0!!!" There is also the *Humbug Glory Bank* (**Figure 50**), showing six coins on the left-hand side. It references Jackson and "Tom Humbug Benton," and promises to pay "six cents in mint drops or glory at cost." This satirical banknote could be an advertisement, but it is certainly humorous. It has a number of striking similarities to British imitation banknotes from the end of the eighteenth century. It uses coin to reference real wealth, it is signed by fake individuals such as "Honest Amos," and it engages vague abstraction with its offer of "glory."

Jackson, referenced by the "Hickory Leaf" here, was often represented as a hoarder of cash. This hoarding was exemplified by a hard-times token showing Jackson holding a sack of gold while sitting in a treasure chest. Such copper tokens were used as unofficial currency in the United States from about 1833 to 1843. With only two sides, coins and tokens made an excellent vehicle for incongruities and dichotomies. This token parallels the political propaganda coins made by Thomas Spence in the 1790s. Spence designed a token with a guillotine on one side, and the decapitated head of Pitt on the other. He also took up the standard contrast of the decade on a copper half-penny, showing both English slavery and French Liberty contrasted with a sheaf of wheat indicating peace and plenty.[28] Pictured here are two further examples of contrast tokens, showing the long-standing comparison between Britain and France (**Figures 51** and **52**). Contrast prints were not necessarily humorous and have a longer history outside of graphic satire. Gillray's *French Liberty/British Slavery* (**Figure 53**) exemplifies this type of print that so readily enabled the use of irony, contrast, and incongruity humor, albeit with far more sophisticated use of form and line. The crisis of the French Revolution helped force its contrasts: thin versus fat, hungry versus full, snails versus roast beef, poor versus rich, nearly naked versus well-clothed, long hair versus no hair, imaginary wealth versus material wealth, and liberty versus slavery (ironically mislabeled). Britannia holds a large sack of sterling above John Bull, while paper assignats and *sous* issue from the pocket of the utterly ruined French *sans-culotte*. Gillray reinforces the message spatially by having the small gold statue of Britannia high up on the wall in contrast to the French paper money, which falls well below the bottom half of the picture plane.

The tradition of skepticism toward paper money seen with the shin-plasters of the Free Banking Era continued well into the nineteenth century, and is especially compelling in the satires of Thomas Nast in the 1870s. Such satires, like *Ideal Money* (1878), problematized money and its status as an institutional fact.[29] In this wood engraving, Nast labels a barrel of soap as a kind of money: "By an act of Congress this is money."[30] He satirizes the problems of defining money and identifying its value. By challenging the idea that the government has the power to define the medium of money, he identifies its liminal status between the social and material worlds, as we have seen

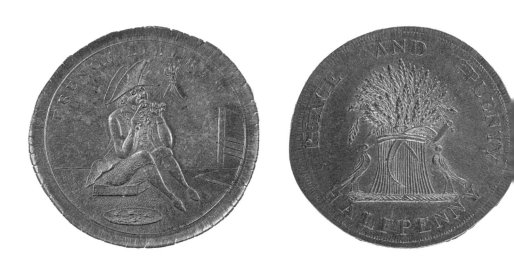

Figure 51. Eighteenth-century token with French man.

Figure 52. Eighteenth-century token with British man.

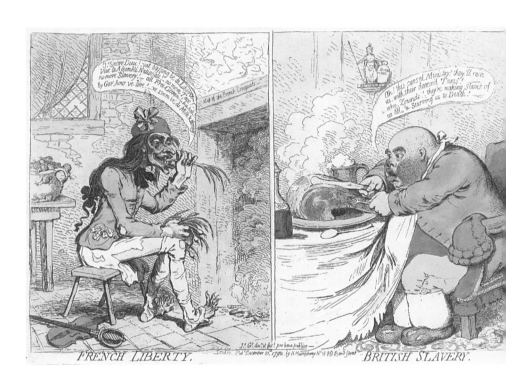

Figure 53. James Gillray, *French Liberty/British Slavery*, December 21, 1792.

so many satirists probe in previous examples. Representations of money, however, have an even longer tradition in the paintings of late nineteenth-century *trompe l'oeil* still-life painters, including Charles Alfred Meurer, John Peto, John Haberle, and William Harnett. Harnett is the first known artist to have painted American paper currency. As the story goes, two of his oil paintings in a popular Manhattan venue had caught the attention of the government. Harnett was approached by the United States Secret Service in 1886 about possible violations of counterfeiting law and stopped painting currency after the encounter.[31] In this genre of paintings, money becomes entwined with questions of medium, surface, and the art historical tradition of still life. Haberle's *Imitation* of 1887 (Figure 34), another example of this genre, was discussed in much greater detail in Chapter Four.

These American *trompe l'oeil* painters from the late nineteenth-century extend the discussion well beyond the start of American satire during the Revolutionary War, where this epilogue began. Satires on paper that preceded them, such as *Great Locofoco Juggernaut* and the *Humbug Glory Bank*, also engaged with questions about value and institutional facts. They challenged how and why paper could be money, and challenged ethical ramifications about the form of money. These later painters lived in a world more familiar with reproductive technologies, but the social reality of institutional facts was no different. Questions of satire and medium aside, objects like money and other things that reveal the construction of social reality received continued interest by artists in America over time. These artists therefore gave form to a kind of engagement with modernism.

Japan

The Anglo-Japanese Treaty of Amity and Commerce of 1858 opened Britain's reach to Japan in unprecedented ways. While not a British colony like the United States, Japan became what has been called "a variant of informal empire" in the context of relations with Britain.[32] The tradition of British graphic satire became known to artists in Japan after the treaty went into effect. For instance, referred to as "Manga's British ancestor," the British expatriate Charles Wirgman (1832–1891) arrived in Japan as a sketch artist for the *London Illustrated News* in 1861.[33] He started a version of *Punch* magazine there called *Japan Punch* containing satires of culture and the government known as "ponchi-e," or Punch pictures, which he published between 1862 and 1887.[34] As a mentor teaching Western fine art and cartooning techniques to artists such as Goseda Hōryū, Goseda Yoshimatsu, Takahashi Yūichi and Yamamoto Hōsui, he furthered Western-influenced art in Japan.[35] One of the few Western scholars to discuss this influence, Peter Duus traces "the cartoon's introduction into Japan" to Charles Wirgman and states that his jokes and caricatures of prominent residents "soon found their way into the hands of curious Japanese readers, as did other caricatures,

Beyond Britain **167**

satirical prints, and humor magazines imported from the West."[36] He discusses several Japanese publications in this vein that reflected the "hybrid nature of early Meiji culture," such as *Marumaru chinbun*, the humor magazine started in 1877, or the first political cartoon magazine in Japan, *Nipponchi*.[37] Duus speculates that Gillray influenced a monstrous and crude cartoon in *Marumaru chinbun* during the political crisis of 1881.[38]

While the phenomenon of Japonism and the influence of Japanese art, especially *ukiyo-e* woodblock prints, on modernism in the West are well known, the reverse influence has received less scholarly attention in relation to satire. Writing about the eighteenth-century tradition of *kibyoshi*, Adam Kern asserts that Western artists did indeed look toward Tokyo's visual tradition for inspiration, but that the "first comic-strip *manga* to be published in Japanese newspapers certainly were inspired by foreign caricature, not the native tradition."[39] One of the most famous Japanese artists to Westerners, Katsushika Hokusai, used many techniques to create humor in his woodblock prints, *manga*, and *kibyoshi* including: random juxtaposition, burlesque, exaggeration, fantasy, grotesqueness, anthropomorphism, play with scale, parody, and even a few instances of satire.[40] Certainly, Hokusai is known to have been influenced by Western natural histories and publications imported by the Dutch East India Company in the semi-open port of Nagasaki, including natural history prints by English naturalist Francis Willughby.[41] A late eighteenth-century local tradition already suited to this type of art, the *Toba-ehon*, "spoofed drunken, pompous, and posturing samurai," the ruling class at the time.[42] Indeed, Duus indicates that a robust market for visual satire flourished before the United States Commodore Matthew C. Perry's expedition to open up Japan to trade. Although, this market was subject to censorship and encouraged elaborate techniques to obscure the identity of real people, such as the use of hints, clues, and bricolage.[43]

This hybrid nature of Japanese graphic art produced commentary on a monetary crisis after the Seinan Civil War of 1877 in Japan, which has many parallels to the specie crisis of 1797 in Britain and the Panic of 1837 in America. Japanese artists also challenged value and the medium of money with symbolism, anthropomorphism, contrast, and dichotomies. For instance, Kodama Matashichi's *Paper Money Struggles in a Tug of War with Rice, Symbolizing High Inflation* (**Figure 54**) responds to a paper money crisis.[44] The explanation at the bottom of the print translates roughly to "Greed at Play: A Strength Contest."[45] To fund a war against samurai rebels during the Seinan Civil War, the Meiji government of Japan was forced to issue fiat currency in paper form. Private issues of paper money had been common in Japan since the seventeenth century.[46] This paper money was not convertible into bullion and lost value dramatically due to inflation.

In Matashichi's woodblock print, the central struggle unfolds between paper money and a bag of rice. Both are personified as having human bodies, sitting on the ground in the center. They are joined by a red band around their necks.

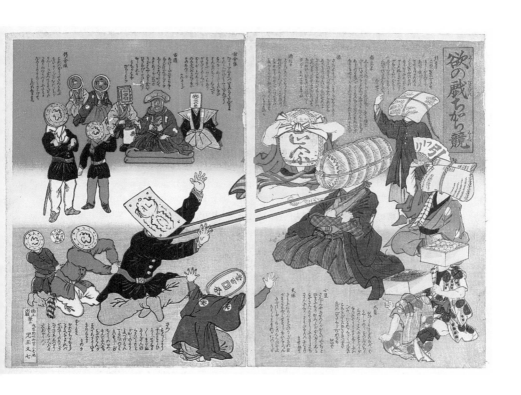

Figure 54. Kodama Matashichi, *Paper Money Struggles in a Tug of War with Rice, Symbolizing High Inflation*, 1880.

The personification of paper money leans off-balance, losing the tug of war against the personified bag of rice, whose body has firmly crossed arms and a stable triangular composition. Coins issued during the Meiji period hold the belt of paper money hoping to stabilize him, but fail. All the new currency has adopted Western dress, while coins and paper money issued during the Edo period wear traditional dress and passively watch inflation take over. The print is divided with all money on the left and commodities, including beans and sake, on the right. This creates a set of prints dividing the symbolic world of politics and money from the real world of material goods. They are hopelessly divided, yet joined by the red band in the center.

This representation of money draws on oversimplified dichotomies that would have been familiar to viewers of British satires, such as William Dent's heavily dichotomized satire *Money Lent. An Accommodating Pawnbroker* (1793),[47] which contrasts commodities (on the left) with paper money (on the right). Men with fishhooks pulled through their noses are led out the door by paper money. Five-pound notes were first introduced in the year of this satire's publication,[48] and it likely comments on a loan proposed by Pitt on March 27 for £4.5 million in 3 percent annuities. Paper money serves as the cause of the frenzy in the upper left of the satire, and the spurious cure in the bottom right. On the upper left, a knight made of paper money kneels on a base labeled "cause," his body composed of banknotes reading the names of banks, among them Hull, Bath, Liverpool, and Bristol. His elbow reads, "I Promise to pay 20." On the upper right, the exchequer holds a bag of coins (real wealth) and sits upon the base labeled "cure." He asks, reasonably, "Won't [St]ocking Goods up in a Warehouse make the Market high?" The center of the print shows the origin of this paper money solution: Pitt aggressively grabs the forehead of his fellow Tory and pulls a hook through his nose, saying "There's Fifty for your Hundred at 5 per Cent and be sure you redeem them in time, or we knock them down to the best Bidder." For one hundred pounds of jewelry, he gets a banknote labeled "Duplicate X Chequer 50£." His government is the accommodating pawnbroker indicated in the title of the satire. The sign of a pawnbroker's shop, three balls, float just above the arms of the government. Two individuals, one of whom is Whig opposition leader Charles James Fox with his gambling cards and dice, lack noses and therefore will not be hooked by Pitt.

The elite cultural associations of paper money are directly identified; the men with paper money state, "We have got rid of our Goods and now we are Gentlemen." The irony of this statement, of course, is that the dominant association of paper money for satirists was with the lower classes driving the Revolution in France and their sympathizers, but in terms of Britain's own history, the opposite was true. Behind the counter, a man, likely Scottish politician Henry Dundas, whispers to another with no nose, "Your Plate may be French—besides your Security wants Substance—we can take no hold—a little more Nose and less Wig if you please." Apparently Dent knew that Whigs had a narrower definition of paper money.

Amanda Lahikainen

As Dent and Matashichi's satires from over a century apart demonstrate, satirists in many contexts have relied on the use of incongruity humor to politicize their images targeting inflation, whether effective and humorous or not. Both these artists associated old and new with good and bad, abstract and concrete with unstable and stable. Matashichi also contrasted East and West by depicting reliable traditional Japanese kimonos and suspect Western dress. Both artists' works were mired in dichotomies, strong satirical traditions, monetary inflation, skepticism of paper money, and problems of medium, value, and representation.

Into the twentieth century, the topic of paper money continued to meet with some popularity in Japanese satire and art. In 1963, the artist Genpei printed one-sided replicas of one thousand-yen notes, which he mailed out, like Hogarth did in his many subscription tickets used as advertisements for his solo exhibition, as discussed in Chapter Two.[49] Genpei then printed more notes to use in his work in various ways. He was eventually sentenced to three months hard labor by the Japanese government in 1970 under a law forbidding the imitation of currency and bond certificates. The artist suspected he was targeted under these laws as part of a crackdown on leftist activism. Partly in response to this legal situation, he created the *Great Japan Zero-Yen Banknote* in 1967 as a "worthless" work of art on a large scale. Its reverse depicts his patron, his assistant, and Johannes Gutenberg in homage to the history of printing. Genpei wrote of the initial notes that earned him a criminal record: "my printed matter that became a legal matter of sorts, contrary to my intentions, is not a counterfeit but a model of the 1,000-yen note. It differs from a counterfeit or a real 1,000-yen note in that in my intention and in its actuality it is 'unusable,' and thus a model of the 1,000-yen note stripped of the function of paper currency."[50] Genpei sought to isolate the value of currency from the object of currency itself, to play with its form and materiality. This became a more formal kind of political protest after his indictment, which is why the Japanese statesman Iwakura Tomomi's face was erased in his later *Great Japan Zero-Yen Banknote*. Tomomi was a Japanese statesman credited with modernizing Japan, including its financial systems, in a Western style. Tomomi's portrait had been on the obverse of the five hundred-yen banknote between 1951 and 1954.

Money and its representation pose a challenge to culture. That challenge appeared in the context of late nineteenth-century Japan, with likely inspiration from British satirists, as well as in the mid-twentieth century in Japanese avant-garde art. It proved productive for Japanese artists interested in interrogating money and related ideas, such as value, institutional facts, and inflation in ways quite similar to how it was productive for J. S. Boggs, Duchamp, and others. Incongruity humor, binaries, and a willful challenge to forgery laws all motivated artists of graphic satire across Europe, America, and Japan as they explored human relationships and tested the construction of social reality.

NOTES

Introduction: The Inflation of Georgian Graphic Satire

1. When the Bank of England stopped cash payments, it challenged the very definition of paper money, which was understood as a promise to pay in specie or metal. This temporary measure lasted until 1819, but in practice until 1821. Paper money issued during this time was fiat currency, or money that was established by the government in the sense of "order" or "decree." For a broad history of currency and related legal developments, see the classic work Sir Albert Feavearyear, *The Pound Sterling: A History of English Money*, 2nd ed. (Oxford: Clarendon Press, 1963). For a history of paper money, see R. D. Richards, "The Evolution of Paper Money in England," *The Quarterly Journal of Economics* 41, no. 3 (May 1927): 361–404. For an excellent article on this crisis, see Hiroki Shin, "Paper Money, the Nation, and the Suspension of Cash Payments in 1797," *The Historical Journal* 58, issue 2 (June 2015): 415–42.

2. Simon Dickie, *Cruelty and Laughter: Forgotten Comic Literature and the Unsentimental Eighteenth Century* (Chicago: University Of Chicago Press, 2011), 1.

3. Thomas Paine, *Prospects on the War and Paper Currency* (London, 1793), 34. Originally published in 1787.

4. Thomas Carlyle, *The French Revolution*, vol. 1, revised edition (New York: The Colonial Press, 1900), 26–27.

5. See the *Oxford English Dictionary* (*OED*) *Online*, s.v. "succedaneum," https://www .oed.com/view/Entry/193288.

6. See also Amanda Lahikainen, "Currency from Opinion: Imitation Banknotes and the Materiality of Paper Currency in Britain, 1782–1847," *Art History* 40, no. 1 (February 2017): 105–31. I follow the logic of Kevin McLaughlin in *Paperwork: Fiction and Mass Mediacy in the Paper Age* (Philadelphia: University of Pennsylvania Press, 2005), 5.

7. Lothar Müller, *White Magic: The Age of Paper*, trans. Jessica Spengler (Malden, MA: Polity, 2014), 148.

8. See Müller's introduction to *White Magic*.

9. *Punch, or the London Charivari* was a British weekly humor and satire publication started in 1841 and famous for coining the term "cartoon." It was inspired by its French counterpart, *Le Charivari*, which featured the work of H. Daumier. As printshops declined and weekly magazines and newspapers took their place, the single-sheet graphic satires of the eighteenth and early nineteenth centuries were replaced by lithography and woodcuts.

10. Diana Donald, *The Age of Caricature: Satirical Prints in the Reign of George III* (New Haven, CT: Yale University Press, 1996), 47, 60; Amelia Rauser, *Caricature Unmasked: Irony, Authenticity, and Individualism in Eighteenth-Century English Prints* (Newark: University of Delaware Press, 2008), 15. See also Eirwen E. C. Nicholson, "Emblem v. Caricature: A Tenacious Conceptual Framework," in *Emblems and Art History: Nine Essays*, ed. Alison Adams (Glasgow: University of Glasgow, 1996), 141–67.

11. In the 1770s, macaroni prints dominated the satirical art market in London and elsewhere in Britain following the cultural trend that started largely in reaction to the Grand Tour. Fashionable men and women returning from Italy had new styles of dress and hair easily mocked in fake fashion print plates amusing their viewers that were named for the pasta dish "macaroni." Publishers Matthew and Mary Darly were especially successful selling these macaroni prints.

12. Cited in Donald, *The Age of Caricature*, 147.

13. Peter J. Cook, "Flash Money and Old-England's Agent in the Early 19th Century," *Cambrian Law Review* 24, vol. 12 (1993): 37. See also Sir Francis Baring, "Observations on the Establishment of the Bank of England and on the Paper in Circulation of the Country" (London, 1797).

14. Derrick Byatt, *Promises to Pay: The First Three Hundred Years of Bank of England Notes* (London: Spink, 1994), 53–56. See also Cook, "Flash Money," 12–44.

15. Spurrier is discussed at length by Peter Cook in "Flash Money," 18.

16. *OED*, s.v. "inflation."

17. Robert D. Hume, "The Value of Money in Eighteenth-Century England: Incomes, Prices, Buying Power—and Some Problems in Cultural Economics," *Huntington Library Quarterly* 77, no. 4 (2014).

18. Jim O'Donoghue, Louise Goulding, and Grahame Allen, "Consumer Price Inflation since 1750," *Economic Trends* 604 (March 2004): 38–46.

19. For recent work on art markets, see Susanna Avery-Quash and Christian Huemer, eds., *London and the Emergence of a European Art Market, 1780-1820* (Los Angeles: Getty Research Institute, 2019). Several broad studies of these graphic satires, from scholars in the fields of history, literature, and art history—perhaps no one more than Dorothy George, who wrote the original catalog entries for the British Museum—help to draw out the richness of these objects. Dorothy George and F. G. Stephens, eds., *Catalogue of Political and Personal Satires in the British Museum*, 11 Volumes (London: Trustees of the British Museum, 1870–1954). Their descriptions of these satires have been reproduced online at the British Museum and are referenced hereafter as BMC followed by their number. This website will allow any satire referenced in this book as BMC to be viewed at: https://www.britishmuseum.org/collection. I am indebted to George in particular. See also work by David Bindman, *Shadow of the Guillotine: Britain and the French Revolution* (London: British Museum Press, 1982); Douglas Fordham, "On Bended Knee: James Gillray's View of Courtly Encounter" in *Efflorescence of Caricature, 1759-1838*, ed. Todd Porterfield (Routledge, 2016); Vic Gatrell, *City of Laughter: Sex and Satire in Eighteenth-Century London* (New York: Walker & Company, 2006); Richard Godfrey and Mark Hallett, *James Gillray and the Art of Caricature* (London: Tate, 2002); Tamara Hunt, *Defining John Bull: Political Caricature and National Identity* (Burlington, VT: Ashgate, 2003); John Moores, *Representations of France in English Satirical Prints, 1740-1832* (London: Palgrave MacMillan, 2015); Ronald Paulson, *Representations of Revolution* (New Haven, CT: Yale University Press, 1983); and David Francis Taylor, *The Politics of Parody, A Literary History of Caricature, 1760–1830* (New Haven, CT: Yale University Press, 2018). See also Amanda Lahikainen, review of *Representations of France in English Satirical Prints*, by John Richard Moores, *The BARS Review* (British Association for Romantic Studies) no. 47 (Spring 2016).

20. James Baker, *The Business of Satirical Prints in Late-Georgian England* (London: Palgrave Macmillan, 2017), 9, 13–15. Baker cites scholars who have written about Georgian prints as a medium of trade, including Tim Clayton, Antony Griffiths, and John Ford: Clayton, *The English Print 1688-1802* (New Haven, CT: Yale University

Press, 1997); Griffiths, *Prints and Printmaking: An Introduction to the History and Techniques* (London: British Museum Press, 1980); Ford, *Ackermann 1783–1983: The Business of Art* (London: Ackermann, 1983).

21. James Peller Malcolm, *An Historical Sketch of the Art of Caricaturing* (London: Printed for Longman, Hurst, Rees, Orme, and Brown, Paternoster-Row, 1813), 157.

22. Richard Taws, *Politics of the Provisional: Art and Ephemera in Revolutionary France* (University Park: Pennsylvania State University Press, 2013), 4, 10. See also Kay Dian Kriz, *Slavery, Sugar, and the Culture of Refinement* (New Haven, CT: Yale University Press, 2008), 5.

23. Mark Hallett, *The Spectacle of Difference: Graphic Satire in the Age of Hogarth* (New Haven, CT: Yale University Press, 1999), 2.

24. Hiroki Shin, "The Culture of Paper Money in Britain: The Bank of England Note during the Bank Restriction Period, 1797–1821" (PhD diss., St. Catharine's College, University of Cambridge, 2008), 159. See also Draper Hill, *Mr. Gillray, the Caricaturist, a Biography* (London: Phaidon, 1965).

26. Another print in this reduced extreme, and an excellent example of incongruity humor, is Gillray's *A Sphere, projecting against a Plane* (1792).

26. Donald, *Age of Caricature*, 47, 60–65.

27. Ibid., 7.

28. Baker, *Business*, 191.

29. Between 1797 and 1801, Gillray received a secret annual pension of two hundred pounds. See Richard Godfrey, *James Gillray: the Art of Caricature* (London: Tate Publishing, 2001), 35. Exhibition catalog.

30. Carl Wennerlind argues that the Scientific Revolution, particularly alchemy and Baconian thinking, developed the intellectual framework necessary for credit currency. Wennerlind, *Casualties of Credit: The English Financial Revolution, 1620–1720* (Cambridge, MA: Harvard University Press, 2011), 4. See also P. G. M. Dickson, *The Financial Revolution in England: A Study in the Development of Public Credit, 1688–1756* (New York: Routledge, 1967); Joyce Appleby, *Economic Thought and Ideology in Seventeenth-Century England* (Princeton, NJ: Princeton University Press, 1978); Catherine Ingrassia, *Authorship, Commerce, and Gender in Early Eighteenth-Century England: A Culture of Paper Credit* (Cambridge: Cambridge University Press, 1998).

31. Patrick Karl O'Brien, "Mercantilist Institutions for the Pursuit of Power with Profit: The Management of Britain's National Debt, 1756–1815," *Government Debts and Financial Markets in Europe*, ed. Fausto Piola Caselli (London: Pickering & Chatto, 2008), 179. See also Dickson's *The Financial Revolution in England*, and James Steven Rogers, *The Early History of the Law of Bills and Notes: A Study of the Origins of Anglo-American Commercial Law* (Cambridge: Cambridge University Press, 2004). See also Angela Redish, "The Evolution of the Gold Standard in England," *The Journal of Economic History* 50, no. 4 (Dec. 1990): 789–805. For lengthy discussion of the gold standard and entwined cultural developments, see Alexander Dick, *Romanticism and the Gold Standard: Money, Literature, and Economic Debate in Britain 1790–1830* (London: Palgrave Studies in the Enlightenment, Romanticism and Cultures of Print, 2013).

32. Richard Taws, *Politics of the Provisional*, and Nina Dubin, *Futures and Ruins: Eighteenth-Century Paris and the Art of Hubert Robert* (Los Angeles: Getty Research Institute, 2010). For the notion that art and money share an internal logic in contemporary art, see Natasha Degen, ed., *The Market (Whitechapel: Documents of Contemporary Art)* (Cambridge, MA: MIT Press, 2013).

33. Taws, *Politics of the Provisional*, 6.

34. Tamara Hunt, *Defining John Bull: Political Caricature and National Identity in Late Georgian England* (Oxfordshire: Routledge, 2003), 1.

35. Hallett, *The Spectacle of Difference*; Kriz, *Slavery, Sugar, and the Culture of Refinement*; Joseph Monteyne, *From Still Life to the Screen: Print Culture, Display and the Materiality of the Image in Eighteenth-Century London* (New Haven, CT: Yale University Press, 2013); Todd Porterfield, ed., *The Efflorescence of Caricature, 1759–1838* (New York: Routledge, 2011).

36. Ian Haywood, "Paper Promises: Restriction, Caricature, and the Ghost of Gold," *Romantic Circles Praxis Series* (February 2012); Haywood, *Romanticism and Caricature* (Cambridge: Cambridge University Press, 2013), 8.

37. Lahikainen, Review of *Representations of France in English Satirical Prints*.

38. Donald, *Age of Caricature*, 144, 142.

39. Ibid., 32. One of the three major theories of humor as discussed primarily in the field of philosophy, the incongruity theory holds that the juxtaposition of things that are dissimilar creates humor. The other two theories are the superiority theory (that humor is a response to feeling better than someone or something else) and the relief theory (that humor arises to alleviate social tension).

40. See the text to image ratio in Gatrell, *City of Laughter*, 5.

41. Eirwen Nicholson, review of *The Age of Caricature* by Diana Donald, *EHR* (April 1998): 485–86.

42. Gatrell, *City of Laughter*, 9–11.

43. Dick, *Romanticism and the Gold Standard*, 13. Dick summarizes the primary assumptions of the "economic turn" in literary criticism as: that money and language, both systems of signs, are structurally similar or "homologous"; that the same problems of representation and alienation affecting language are evident in money; and that literature's and especially Romanticism's investment in sincerity, authenticity, nature, and individuality was a reaction against the malaise apparently caused by these homologous representational systems. My approach to money has something in common with these assumptions, but I offer a framework for thinking about money based on the philosophy of John Searle and the fact/value dichotomy. This is discussed in the first chapter on money, fact, and value.

44. Nathaniel Popper, "How China Took Center Stage in Bitcoin's Civil War," *New York Times*, June 29, 2016.

45. This is also one of the observations made by Rebecca Spang in *Stuff and Money in the Time of the French Revolution* (Cambridge, MA: Harvard University Press, 2015), esp. Chapter 5. She traces the politics of money in France from 1789 into the 1840s; money is always both economic and political.

Chapter One: Money, Fact, and Value

1. Mary Poovey offers a summary of nineteenth-century British writers on money in *Genres of the Credit Economy: Mediating Value in Eighteenth- and Nineteenth-Century Britain* (Chicago: University of Chicago Press, 2008), 201. Geoffrey Ingham has an excellent summary of these debates in Part I of his book *The Nature of Money* (Cambridge: Polity, 2004), especially 41–46.

2. Andrew B. Abel, Ben S. Bernanke, and Dean Croushore, *Macroeconomics*, Seventh Edition (New York: Addison-Wesley/Pearson, 2011), 239. To this could be added several additional definitions, including means of exchange, commodity, medium of exchange, IOU, debt-token, method of payment, standard of value, and store of

wealth. Bill Maurer lists money as having "three to five" functions in "The Anthropology of Money," *Annual Rev. Anthropology* 35 (2006): 21. *The Economist* asked if the recent digital currency Bitcoin could be counted as money at all, noting that it falls short in providing a reliable medium of exchange or a stable store of value, or in having a good measure of broader value in the economy. Free Exchange, "Money from nothing," *The Economist*, March 15, 2014, 72. See also Glyn Davies for the ten functions of money. Davies, *A History of Money: From Ancient Times to the Present Day* (Cardiff: University of Wales Press, 1994), 27.

3. The introduction and first two chapters of Ingham's *The Nature of Money* offers a complex and comprehensive analysis of the history of money, in part due to his ability to engage sociology, history, and economics.

4. The economist Joseph Schumpeter argued that there are "only two theories of money which deserved the name . . . the commodity theory and the claim theory," and he went on to cite the incompatibility of these theories. Cited in Ingham, *The Nature of Money*, 6–7.

5. The title of Matthew Rowlinson's book references this: *Real Money and Romanticism* (Cambridge: Cambridge University Press, 2010). Rowlinson engages both Marx and followers of Keynes. See Brett Mobley, review of *Real Money and Romanticism*, by Matthew Rowlinson, *Romantic Circles*, March 2011.

6. Abel, Bernanke, and Croushore, *Macroeconomics*, 335–36. Ingham discusses how money "is not a 'neutral veil.'" *Nature of Money*, 71.

7. Abel, Bernanke, Croushore, *Macroeconomics*, 379–83.

8. He put forward a famous argument in his book *The General Theory of Employment, Interest and Money* (1936; San Diego, CA: Harcourt, Brace & World, 2016) that economic strength is influenced by spending. See also Ingham's summary of Keynes in *The Nature of Money*, 50–55.

9. Abel, Bernanke, and Croushore, *Macroeconomics*, 336, 434.

10. See pages 510 and 515 in Geoffrey Ingham, "Money Is a Social Relation," *Review of Social Economy* 54, no. 4 (Winter 1996): 507–29. See also Deborah Valenze, *The Social Life of Money in the English Past* (Cambridge: Cambridge University Press, 2006), 19.

11. Carl Wennerlind, "Money Talks, but What Is It Saying? Semiotics of Money and Social Control," *Journal of Economic Issues* 35, no. 3 (September 2001): 557, 563. See also the geographer Peter North, *Money and Liberation: The Micropolitics of Alternative Currency Movements* (Minneapolis: University of Minnesota Press, 2007), 13–17.

12. See, for instance, Niall Ferguson, *The Ascent of Money: A Financial History of the World* (London: Penguin, 2009); Ingham, "Money Is a Social Relation"; John Searle, *The Construction of Social Reality* (New York: The Free Press, 1995). In *Debt: The First 5,000 Years* (Brooklyn, NY: Melville House, 2011), anthropologist David Graeber describes debt as "the essence of society itself" (56). Valenze sought to "extend our grasp of the subject by presenting a series of interwoven investigations into what might be called the social life of money, its propensity to become involved in relations between people in ways that move beyond what we understand as its purely economic functions," *The Social Life of Money in the English Past*, 2.

13. This view has been criticized as a problematic "reduction" in the literature theorizing things, not specifically money. See Christopher Pinney, "Things Happen: Or, From Which Moment Does That Object Come?" in Daniel Miller, ed., *Materiality* (Durham, NC: Duke University Press, 2005), 256–72. Pinney seeks to account for the inseparability of subjects and objects, and humans and nonhumans (257).

14. Rowlinson, *Real Money and Romanticism*, 13. Rowlinson mentions money's origins as a social relation. Ibid., 5, 12.

15. Ingham, *The Nature of Money*, 70; Ingham, "Money Is a Social Relation," 510.

16. Narayana R. Kocherlakota, "Money Is Memory," *Research Department Staff Report* 218 (Minneapolis, MN: Federal Reserve Bank of Minneapolis, October 1996).

17. Ingham, "Money Is a Social Relation," 510, 515.

18. Davies, *History of Money*, xviii.

19. "For some, money is *not* a cooperative but a contested social relation. Force, fear and death are equally important meanings attached to money." Wennerlind, "Money Talks," 563. For portraiture and the invisibility of money, see also Marcia Pointon, "Money and Nationalism," in *Imagining Nations*, ed. Geoffery Cubitt (Manchester: Manchester University Press, 1998), 229–54.

20. Ferguson, *The Ascent of Money*, 31; Ingham, "Money Is a Social Relation," 517; Searle, *The Construction of Social Reality*, 1.

21. Cora Lee C. Gilliland, "The Stone Money of Yap: A Numismatic Survey," *Smithsonian Studies in History and Technology* 23 (1975). Yap was almost designated a UNESCO world heritage site.

22. Kevin Gilmartin, *Print Politics: The Press and Radical Opposition in Early Nineteenth-Century England* (Cambridge: Cambridge University Press, 1996), 164.

23. William Reid, *The Life and Adventures of the Old Lady of Threadneedle Street* (London, 1832), 8.

24. "Paper, owing its currency to opinion, has only a local and imaginary value. It can stand no shock." Richard Price, *Two Tracts on Civil Liberty* (London, 1778), 75.

25. The *Oxford English Dictionary* lists the first mention of this in 1616: "Second sight: a supposed power by which occurrences in the future or things at a distance are perceived as though they were actually present." Marc Shell discusses the "many poets' and economists' association of paper money with ghostliness." Shell, *Money, Language, and Thought: Literary and Philosophical Economies from the Medieval to the Modern Era* (Los Angeles: University of California Press, 1982), 6.

26. The distinction between analytical versus continental philosophy is imperfect. The former term generally means breaking problems down into simple ideas (logical clarity), as well as examination of things through the means in which they are expressed (evidence in language and visual knowledge). See A. P. Martinich, "Introduction," *A Companion to Analytic Philosophy* (Hoboken, NJ: Blackwell, 2001), 1–5.

27. In *A Treatise of Human Nature* (III.1), he asks how such a feat could be accomplished, and clearly denies its possibility. In fact, his reductionist epistemology, which *a priori* excludes the principles of form and function, would make deriving value claims from facts impossible, if it were true. See David Hume, *A Treatise of Human Nature*, ed. L. A. Selby-Bigge (New York: Oxford University Press, 1988), and David Hume, *An Enquiry Concerning Human Understanding*, ed. Tom L. Beauchamp (New York: Oxford University Press, 2000), especially sections IV and XII.

28. The claim has something in common with the post-structuralist rejection of binaries. Hilary Putnam, *Collapse of the Fact/Value Dichotomy and Other Essays* (Cambridge, MA: Harvard University Press, 2004), 3. Searle formulated this as "factual premises can entail evaluative conclusions" in "How to Derive 'Ought' from 'Is,'" *The Philosophical Review* 73, no. 1 (January 1964): 58. See Satya P. Mohanty, "Can Our Values Be Objective?" in *The Art of Art History*, ed. Donald Preziosi (Oxford: Oxford University Press, 2009), 443–45. Mohanty writes "values often refer to facts and properties that exist independently of our beliefs" (443).

29. There is a distinction here between institutional facts and nationalism, which is ably discussed by Benedict Anderson in *Imagined Communities: Reflections on the Origin and Spread of Nationalism* (Brooklyn, NY: Verso, 1983). Nationalism's imagined communities are different from money's imagined communities; the distinction merits further discussion.

30. Searle, *The Construction of Social Reality*, 1. He writes "all and only cases of collective intentional facts are social facts. Institutional facts are then a special subject of social facts" (122). Banknotes were the debts of the Bank of England and not legal tender. See R. G. Hawtrey, "The Bank Restriction of 1797," *The Economic Journal* 28, no. 109 (March 1918): 61. See also Poovey, *Genres*, 57.

31. Georg Simmel, *The Philosophy of Money*, trans. Tom Bottomore and David Frisby (London: Routledge & Kegan Paul, 1978), 62. For criticism of Searle by a broad range of scholars, see Ernest Lepore and Robert Van Gluick, eds., *John Searle and His Critics* (Malden, MA: Blackwell, 1993).

32. Searle, *Construction of Social Reality*, 121. "Mental" indicates that the fact is thought, not external in the world (like observing snow on Everest). "Intentional" indicates that the fact is desired, and "collective" that many people hold the belief (one could imagine a world where art is expressed merely by individuals, and certainly different groups hold different definitions of art). The fact is then assigned a function and agency (what it is and does, or should do), labeled, and then its embodiment as an object changed within that cultural context.

33. Ibid., 26. This model works against the claim that collective intentionality is reducible to individual intentionality.

34. *OED*, s.v. "value." Another definition of value in the *OED* is "worth based on esteem; quality viewed in terms of importance, usefulness, desirability."

35. The term "speech act," associated with J. L. Austin, indicates instances when saying something is actually doing something, such 0as saying "I do" in the context of a wedding makes one "married." Language can be divided into different types of speech acts or "performative utterances" (illocutionary and perlocutionary, for example).

36. See A. P. Martinich, "John R. Searle," *A Companion to Analytic Philosophy*, A. P. Martinich and David Sosa, eds. (Malden, MA: Blackwell, 2001), 449. Searle, *The Construction of Social Reality*, 43–51 and 111.

37. For an overview of Searle's work and thought, see A. P. Martinich, "John R. Searle," *A Companion to Analytic Philosophy*, 434–50.

38. For an overview, see the introduction to Roy Porter, *The Creation of the Modern World: The Untold Story of the British Enlightenment* (New York: W. W. Norton & Co., 2001). While he acknowledges that print culture and a pre-figuration of the "electric information explosion" furthered the Enlightenment, Porter admittedly does not discuss art and material culture (xxiv). For a more recent popular treatment, see Steven Pinker, *Enlightenment Now: The Case for Reason, Science, Humanism and Progress* (London: Allen Lane, 2018).

39. Marc Shell, *Art & Money* (Chicago: University Of Chicago Press, 1995); Peter Stupples, ed., *Art and Money* (Newcastle upon Tyne: Cambridge Scholars Publishing, 2015); Peter Knight, Nicky Marsh, and Paul Crosthwaite, eds., *Show Me the Money: The Image of Finance, 1700 to the Present* (Manchester: Manchester University Press, 2014).

40. Knight, et al., *Show Me the Money*, 1.

41. Peter Stupples, *Art and Money*, xiii.

42. Haywood, "Paper Promises," paragraph 12.

43. Malcolm, *An Historical Sketch of the Art of Caricaturing*, 157.

44. William Makepeace Thackeray, "George Cruikshank," *Westminster Review* 66 (June 1840); Viceimus Knox, *Winter Evening: Or Lucubrations on Life and Letters* (London, 1788), 127.

45. *London und Paris* VII: 333–48. Cited in Donald, *Age of Caricature*, 37.

46. According to David Taylor, the status function of graphic satire was to imagine its own elite public. Taylor, *The Politics of Parody*. Taylor is discussed more in the final chapter.

47. Phillip Harling, *The Waning of "Old Corruption": The Politics of Economical Reform in Britain, 1779–1846* (Oxford: Oxford University Press, 1996).

48. Ferguson, *The Ascent of Money*, 30.

Chapter Two: Crisis

1. Much like our current debates about financial crises, fiscal cliffs, and quantitative easing, debt was frequently the subject of heated debate throughout the eighteenth century, notably during the South Sea Bubble crisis in 1720 and over the Bank Restriction Act of 1797. Some authors have listed as many as thirteen financial crises during the eighteenth century. See Julian Hoppit, "Financial Crises in Eighteenth-Century England," *The Economic History Review*, New Series 39, no. 1 (Feb. 1986): 44.

2. [London] *Times*, Friday, February 3, 1797; Issue 3810.

3. Adrienne Todd, "The Infinite Grotesque: Paper Money and Aesthetics in Edmund Burke's Reflections on the Revolution in France," *Eighteenth-Century Studies* 53, no. 1 (2019): 80.

4. [London] *Telegraph*, Wednesday, March 1, 1797, page 2, column 2.

5. "William Pitt," *Oxford Dictionary of National Biography*, eds. H. C. G. Matthew and Brian Harrison (New York: Macmillan, 1895), 44, 483–84. In *Bank Notes*, discussed below, government officials carry bags of notes in satirically small denominations designed to replace all metal currency, such as a one-shilling note.

6. Peter Isaac, "Sir John Swinburne and the Forged *Assignats* from Haughton Mill," *Archaeologia Aeliana* 5, vol. 18 (1990): 158–63. See also Peter Bower, "Sir John Swinburne's Memorandum on the English Forgery of French Assignats at Haughton Castle Paper Mill, Northumberland, in the 1790s," *The Quarterly, The Journal of the British Association of Paper Historians*, no. 106 (April 2018).

7. T. C. Hansard and William Cobbett, eds., *The Parliamentary History of England from the Earliest Period to the Year 1803* (London: T. C. Hansard, 1806), 1518–19; Hawtrey, "The Bank Restriction," 60. Having the treasury dispense bills that were payable at the Bank of England in specie—especially given the bad exchange rates at the time for foreign markets—made the bank's outstanding commitments difficult to meet in cash. See also Sir Albert Feavearyear, *The Pound Sterling*.

8. *St. James Chronicle or the British Evening Post*, March 9–11, 1797, Issue 6119, page 4, column 2.

9. Harden Sidney Melville and Thomas Shepherd, *London Interiors: A Grand National Exhibition of the Religious, Regal, and Civic Solemnities, Public Amusements, Scientific Meetings, and Commercial Scenes of the British Capital* (London, 1841), 71.

10. Ibid., 72. The authors even point to how the opposite was true in France, where, citing Baron Dupin, "The administration of a French *bureau*, with all its inaccessibilities, would be started at the view of this Hall!"

11. William Dent, *Two to One, an attempt to Outwit the Young Pawnbroker* (1793). BMC 8326.

12. Haywood, "Paper Promises," paragraph 6.

13. *OED*, s.v. "crisis."

14. This is the earliest one I have found. These early banknotes are in the National Museums Scotland collection. Hugh Rockoff, "Upon Daedalian Wings of Paper Money," *Adam Smith Review*, ed. Fonna Forman-Barzilai (New York: Routledge, 2011), 6: 245.

15. Other examples include those reproduced in *The Scottish Antiquary, or, Northern Notes & Queries* 12 (1898): 68–73.

16. C. W. Boase, *A Century of Banking in Dundee*, 2nd edition (Edinburgh: R. Grant & Son., Prince Street, 1867), 57.

17. George Selgin and Lawrence H. White, "The Option Clause in Scottish Banking," *Journal of Money, Credit, and Banking* 29, no. 2 (May 1997): 270–73. Relating to the problematic definition of money and how it acts in an economy or society, see the debates between Selgin, White, and James A. Gherity on the purpose and effectiveness of the option clause in the *Journal of Money, Credit, and Banking*.

18. J. H. S., "Old Scots Bank-Notes," *Scottish Antiquary or Northern Notes and Queries* 12 (1898): 71.

19. Selgin and White, "The Option Clause in Scottish Banking," 270–73.

20. A sheet in the department of coins and medals explains, "Skit notes as a name . . . was in fact the invention of Maberley Phillips the donor of the Institute's [probably chartered Institute of Bankers] collection." Misc. folder in the Coins and Medals Department of the British Museum, January 2012.

21. *OED*, s.v. "puff." This describes "puff" as both a noun and adjective.

22. Silver medal. Christian Wermuth, 1720. BM 1905, 1206.9. The South Sea Bubble was an economic bubble created by inflated shares of the British joint-stock company the South Sea Company (created in 1711 to help ease the national debt). While the price of shares rose to an apogee in 1720, the company itself did not produce comparable value and the stock price collapsed, ruining thousands of investors. See Helen Paul, *The South Sea Bubble: An Economic History of its Origins and Consequences* (Oxfordshire: Routledge, 2011).

23. *OED*, s.v "puff." This describes "puff" as a verb. Johnson's dictionary indicates these meanings of the word too, see "blast," "bluster," and "elate." Samuel Johnson, *A Dictionary of the English Language* (1755) digital edition, ed. Beth Rapp Young, Jack Lynch, William Dorner, Amy Larner Giroux, Carmen Faye Mathes, and Abigail Moreshead, 2021, https://johnsonsdictionaryonline.com.

24. Roger Outing, *The Standard Catalogue of the Provincial Banknotes of England and Wales* (Devon: Token Pub., 2010), 409–15. Several skits in the British Museum department of coins and medals do not appear on his list and vice versa. Other collections include: the Library of Congress Prints and Photographs Division, the Bodleian Library at Oxford, the Ashmolean Museum of Art and Archaeology at Oxford, the Society of Antiquaries in London, and the Winterthur Library in Delaware.

25. Eirwen E. C. Nicholson, "Consumers and Spectators: The Public of the Political Print in Eighteenth-Century England," *History* 81, no. 261 (January 1996): 10–11.

26. Shin, *Culture of Paper Money*, 77.

27. James Gregory, "Parody Playbills: The Politics of the Playbill in Britain in the Eighteenth and Nineteenth Centuries," *eBLJ* (2018): 7.

28. Ibid., 2.

29. Outing, *The Standard Catalogue of the Provincial Banknotes of England and Wales*, 409.

30. John Casey, "The Fort Montague Bank," *Journal of the Institute of Bankers* (December 1962): 408–10. For the actual note, see the coins and medals department at the British Museum, CIB9813. This note was also passed as real money. The British Museum catalog dates it between 1800 and 1820; its design indicates that it is from before 1800, likely the 1790s.

31. S. J. Butlin, *Foundations of the Australian Monetary System 1788–1851* (Sydney, Australia: University of Sydney Library, 2002), 249.

32. Viviana Zelizer, *The Social Meaning of Money* (New York: Basic Books, 1995), 204, 216.

33. Ronald Paulson, *Hogarth: His Life, Art, and Times* (New Haven, CT: Yale University Press, 1971), 22.

34. Ingrassia, *Authorship*, 10.

35. Taws, *Politics of the Provisional*, 28.

36. Colin Nicholson, *Writing and the Rise of Finance: Capital Satires of the Early Eighteenth Century* (Cambridge: Cambridge University Press, 1994). Nicholson focuses on Pope, Swift, and Gay, noting that "readings of *Gulliver's Travels*, *The Beggar's Opera* and *The Dunciad* . . . bring into debate the conflict between traditional forms of civic personality grounded in real property and endowed with classical virtue, and market-oriented perceptions of individuality where passion and fantasy are encouraged to operate in constant flux" (xii).

37. Richard Hayes, *Ireland and Irishmen in the French Revolution* (London: Ernest Benn Limited, 1932), 14. Cited from the Haliday Pamphlet and Tract Collection, 1789–93, Royal Irish Academy.

38. Baker, *Business*, 67.

39. Ibid., 69.

40. *Manchester Mercury*, Tuesday, May 5, 1812, 2.

41. William Cobbett, "Jubilee Dollars," *Political Register* 19 (Jan.–June 1811): 1063–64, column 1.

42. William Newmarch, *On the Loans Raised by Mr. Pitt During the First French War, 1793–1801* (London: Effingham Wilson, Royal Exchange: 1855), 2. See also Hawtrey, "The Bank Restriction," 54. Pitt actually favored lowering the national debt and, following the ideas of Richard Price, established a number of sinking funds aimed at this objective. See Patrick Karl O'Brien, "Mercantilist Institutions for the Pursuit of Power with Profit: The Management of Britain's National Debt, 1756–1815," in *Government Debts and Financial Markets in Europe*, ed. Fausto Piola Caselli (London: Pickering & Chatto, 2008).

43. James Aitken, *Billys Hobby Horse or John Bull Loaded with Mischief*. BMC 8664.

44. See BMC 8669, 8672 and 8707.

45. See for instance BMC 8477, 8687, and 9017. Richard Newton applies the digestive metaphor to Bull rather than Pitt in *A Paper Meal with Spanish Sauce* (1797) and *The New Paper Mill or Mr Bull Ground into 20 Shilling Notes* (1797).

46. See the anniversary issue "The South Sea Bubble, Mississippi Bubble, and Financial Revolution" of *Eighteenth-Century Studies* 54, no. 1 (Fall 2020).

47. The print had been "raided" and brought to England by Thomas Bowles as *The Bubblers Mirrour: or Englands Folly* (1720). According to the British Museum entry, "The plate was first issued by Thomas Bowles in 1720 and re-issued by his successor Henry Carington Bowles, who traded with Samuel Carver between 1793 and 1832." Registration number 1935,0522.1.4. Hallett, *The Spectacle of Difference*, 67.

48. Inflation of the Mississippi Company's shares led to the Mississippi Bubble. Much like the contemporaneous South Sea Bubble, this overvaluation led to stock in the

company collapsing. BMC1651. Notably, Thomas Paine's *Rights of Man* was also represented as wind.

49. Pitt's father had been accused of war mongering in the print *The Great Financier, or British Oeconomy for the Years 1763, 1764, 1765* (1765).

50. *Parliamentary History*, 1528.

51. Natasha Glaisyer, "'A due Circulation in the Veins of the Publick': Imagining Credit in Late Seventeenth- and Early Eighteenth-Century England," *The Eighteenth Century* 46, no. 3 (2005): 278, 281.

52. *Parliamentary History*, 1539.

53. Ibid., 1567.

54. *Morning Chronicle* (London), Thursday, March 9, 1797; Issue 8553.

55. Ibid.

56. Pitt carries the entire Bank of England on his shoulder in the satire *Bank Transfer, Or, A New Way of Supporting Public Credit* (1791).

57. *Parliamentary History*, 1520.

58. Ibid., 1527.

59. Donald, *Age of Caricature*, 160.

60. *Oracle and Public Advertiser* (London), Tuesday, February 28, 1797; Issue 19, 558.

61. Hiroki Shin, "Paper Money, the Nation, and the Suspension of Cash Payments in 1797," 415–42.

62. *Times*, Tuesday, February 28, 1797; Issue 3830.

63. *Morning Chronicle*, Tuesday, February 28, 1797; Issue 8545.

64. *Oracle and Public Advertiser*, Wednesday, March 8, 1797; Issue 19,565; *Observer* (London), Sunday, March 5, 1797; Issue 274.

65. *True Briton* (London), Tuesday, February 28, 1797; Issue 1304.

66. Paper credit "haunted" literature up through the 1990s. Patrick Brantlinger ties money to maintenance of the modern nation-state: "Money and its corollary public credit (or public debt), which is all that legitimates money to begin with, are thus even more fundamental to the fictional or ideological creation and maintenance of the imagined communities of modern nation-states than are more explicitly nationalistic cultural forms including both literary canons and competing political ideologies." Brantlinger, *Fictions of State: Culture and Credit in Britain, 1694–1994* (Ithaca, NY: Cornell University Press, 1996), 22.

67. *Parliamentary History*, 344.

68. Thomas Paine, *Prospects on the War and Paper Currency* (London: James Ridgway, 1793), 33. This pamphlet was written in 1787 and republished.

69. Thomas Paine, *The Decline and Fall of the English System of Finance* (London, 1796), 5.

70. *Parliamentary History*, 53.

71. The Jacobins were members of a political party associated with Maximilien Robespierre during the French Revolution. The term became a pejorative descriptor for people with republican sympathies in Britain and the satirists used it gleefully to imply sedition and radicalism. The term is loaded, loosely deployed, and dependent on context.

72. Gillray, *The Dagger Scene: or The Plot discover'd* (1792). BMC 8147.

73. Edmund Burke, *Reflections on the Revolution in France* (London, 1790), 163, 340.

74. J. G. A. Pocock, *Virtue, Commerce, and History: Essays on Political Thought and History, Chiefly in the Eighteenth Century* (Cambridge: Cambridge University Press, 1985), 197.

75. *Parliamentary History*, 1542.

76. Ibid., 327.

77. Ibid., 37–38.

78. Feavearyear, *Pound Sterling*, 222. He writes: "Between February and May 1810 the Bullion Committee held thirty-one meetings and examined twenty-nine witnesses. Their Report, which was presented to the House on 9 June 1810, is one of the most important documents in English currency history" (195).

79. See Gillray's *Effusions of a Pot of Porter* (1799). BMC 9430.

80. Tom Furniss, "Burke, Paine, and the Language of Assignats," *The Yearbook of English Studies* 19 (1989): 241.

81. For precedents, see Ian Haywood, "Paper Promises," paragraph 24ff. See Barrie Cooke's entry in Sheila O'Connell, ed., *Britain Meets the World: 1714–1830* (Beijing: Palace Museum, 2007). John Law said, "I have discovered the secret of the philosopher's stone . . . it is to make gold out of paper." Ferguson, *Ascent of Money*, 138. Cited from H. Montgomery, *John Law: The History of an Honest Adventurer* (London: Home & Van Thal, 1969), 83.

82. Natasha Glaisyer writes that "from its earliest days the Bank of England was characterized, and caricatured, as a Whig institution." Glaisyer, "A Due Circulation," 280.

83. Burke, *Reflections*, 346.

84. Ibid., 336.

85. *Morning Chronicle*, Thursday, March 9, 1797; Issue 8553.

86. Fox quoted in the *Telegraph*, Wednesday, March 1, 1797.

87. Haywood, "Paper Promises," paragraph 10.

88. Taylor, *Politics of Parody*, 248.

89. Furniss, "Burke, Paine, and the Language of Assignats," 62.

90. Henry Thornton, "An Inquiry Into the Nature and Effects of the Paper Credit of Great Britain" (Philadelphia, 1807), 4. First published in 1802.

91. John Keyworth, *Amusing, Shocking, Informing: The Bank of England's Cartoons & Caricatures* (London: The Bank of England Museum, 2000), 9. See also Wilfred Marston Acres, "On the Name 'Old Lady of Threadneedle Street,'" *The Old Lady of Threadneedle Street* 4 (1927): 6–7. Acres ties the idea of the lady to Richard Brinsley Sheridan but the name to Gillray (a conclusion supported by Parliamentary records), and Hiroki Shin looks toward iconographic precedents of Lady Credit and gambling culture, in particular Lady Archer. See his discussion in Chapter 3 of his dissertation, "The Culture of Paper Money in Britain."

92. BMC 9287. Reproduced in the German journal *London und Paris*. Lewis Walpole Library, Yale University. This satire is possibly a pirated copy of William Holland's work.

Chapter Three: Subjectivity and Trust

1. Peter King, *A Selection from the Speeches and Writings of the Late Lord King* (London, 1844), 234.

2. Ibid., 336.

3. Searle, *The Construction of Social Reality*, 43–51.

4. Joseph Roach, "Gossip Girls: Lady Teazle, Nora Helmer, and Invisible-Hand Drama," *Modern Drama* 53, no. 3 (Fall 2010): 297.

5. Ibid., 297.

6. Cook, "Flash Money," 30.

7. The Gold Coin and Bank Note Bill in 1811, supported by Stanhope, and the Prevention of Frauds Bill in 1812. Poovey, *Genres*, 198.

8. The definitive volume on theories of humor is still John Morreall, *Taking Laughter Seriously* (New York: SUNY Press, 1983).

9. John King was born Jacob Rey (1780–1820). See Todd Endelman, "The Chequered Career of 'Jew' King: a Study in Anglo-Jewish Social History," in *Profiles in Diversity: Jews in a Changing Europe 1750–1870*, ed. Frances Milino and David Sorkin (Detroit, MI: Wayne State University Press, 1991).

10. Adam Mendelsohn, "The Rag Race," *Capitalism by Gaslight: Illuminating the Economy of Nineteenth-Century America*, ed. Brian P. Luskey and Wendy A. Woloson, (Philadelphia: University of Pennsylvania Press, 2015), 76–92.

11. Frank Felsenstein, *Anti-Semitic Stereotypes: A Paradigm of Otherness in English Popular Culture, 1660–1830* (Baltimore, MD: Johns Hopkins University Press, 1995), 2.

12. Ann Louise Kibbie notes in *Secret Life of Things* that "The 'character' that allows money to pass as currency is, first and foremost, the stamp of a national identity." Ann Louise Kibbie, "Circulating Anti-Semitism: Charles Johnstone's Chrysal," in *The Secret Life of Things: Animals, Objects, and It-Narratives in Eighteenth-Century England*, ed. Mark Blackwell (Lewisburg, PA: Bucknell University Press, 2007), 244.

13. For additional research on this subject, see Frank Felsenstein, "'If you tickle us, do we not laugh?': Stereotypes of Jews in English Graphic Humor of the Georgian Era," in *No Laughing Matter: Visual Humor in Ideas of Race, Nationality, and Ethnicity*, eds. Angela Rosenthal, David Bindman and Adrian Randolph (Hanover, NH: Dartmouth College Press, 2016). Also Michael Ragussis, "Jews and Other 'Outlandish Englishmen': Ethnic Performance and the Invention of British Identity under the Georges," *Critical Inquiry* 26.4 (2000); Sheila Spector, ed., *The Jews and British Romanticism: Politics, Religion, Culture* (New York: Palgrave Macmillan, 2005); Iain McCalman, "New Jerusalems: Prophecy, Dissent and Radical Culture in England, 1786–1830," in *Enlightenment and Religion: Rational Dissent in Eighteenth-Century Britain*, ed. Knud Haakonssen (Cambridge: Cambridge University Press, 1996). See also the associated term Jew-bail (insufficient bail) explored by Rowlandson in *Kitty Careless in Quod, or Waiting for Jew Bail* (1811).

14. Felsenstein, *Anti-Semitic Stereotypes*, 3.

15. *OED*, s.v. "subjectivity."

16. Burke, *Reflections*, xx. He writes: "[T]o love the little platoon we belong to in society, is the first principle (the germ as it were) of public affections. It is the first link in the series by which we proceed towards a love to our country, and to mankind. The interest of that portion of social arrangement is a trust in the hands of all those who compose it; and as none but bad men would justify it in abuse, none but traitors would barter it away for their own personal advantage."

17. G.W. F. Hegel, *Hegel's Phenomenology of Spirit*, trans. A.V. Miller (Oxford: Oxford University Press, 1977), 111.

18. Richard Taws successfully takes this as a framework in "The Currency of Caricature in Revolutionary France" in *The Efflorescence of Caricature*.

19. Rauser, *Caricature Unmasked*, 87.

20. Philip Connell, *Romanticism, Economics and the Question of 'Culture'* (Oxford: Oxford University Press, 2001), 228. Connell mentions "Pitt's apparent partiality to the commercial and manufacturing interests at the expense of the both farmers and the rural poor" (195).

21. Charles Williams and S.W. Fores, *The Card Party or the Utility of Paper* (1808), BMC11124.

22. Many thanks to Philip Timmons for confirming this interpretation of the satire.

23. This observation dates back to at least Aristophanes, but is named for Thomas Gresham, who wrote it in a letter to Queen Elizabeth in 1558. See "law, n." in the *OED*.

24. A paper on the floor below references the German monk Gregor von Feinaigle, a known mnemonist, and indicates that no worse times than the present can be remembered.

25. Shell, *Money, Language, and Thought*, 19.

26. Haywood, "Paper Promises," paragraph 21.

27. Donald, *Age of Caricature*, 79–80.

28. Roach, "Gossip Girls," 297.

29. Felsenstein, "'If you tickle us, do we not laugh?,'" 67–68.

30. Kibbie, "Circulating Anti-Semitism: Charles Johnstone's *Chrysal*," in *The Secret Life of Things*, 244, 259. I combined her list with Christopher Flint's list in "Speaking Objects: The Circulation of Stories in Eighteenth-Century Prose Fiction," *The Secret Life of Things*, 174.

31. Jennifer J. Baker, "Paper Money Gets Personal: Reading Credit and Character in Early America," *Common Place* 6, no. 3 (April 2006). Baker lists eight examples of these American it-narratives, including: Joseph Green, "The *Dying Speech* of Old Tenor" (Boston, 1750), "The Adventures of a Continental Dollar," *United States Magazine* (June 1779), and "Paper Money once more speaketh for itself!," *Worcester Magazine* (November, 1786). American writers stressed the analogy between personal and national credibility.

32. Glaisyer, "'A due circulation," 277–97.

33. Thomas Bridges, *Adventures of a Bank-Note* (London, 1770–71), 2, 25.

34. Deidre Lynch, "Personal Effects and Sentimental Fictions," *The Secret Life of Things*, 75; Liz Bellamy, "It-Narrators and Circulation: Defining a Subgenre," *The Secret Life of Things*, 124–25.

35. Liz Bellamy, "It-Narrators," 118. In *Adventures of a Rupee* (1782) the rupee circulates as a sentimental keepsake or fetish across class lines, not as money. See also Lynch, "Personal Effects and Sentimental Fictions," 78.

36. Cited in Bonnie Blackwell, "Corkscrews and Courtesans," *The Secret Life of Things*, 279.

37. Ibid., 287.

38. Ibid., 289.

39. Newland beats Napoleon into submission in a satire by Piercy Roberts, *Buonaparte and Abraham Newland!!* (1803), BMC10131. Published by William Holland.

40. Byatt, *Promises to Pay*, 84.

41. I borrow the phrase from Richard Taws, who gestures toward this idea: "Indeed, the vast majority of visual materials that conveyed the Revolution's symbolic message around France, whether issued by the state of private interests, were mobile, ephemeral, and multiple." Taws, *Politics of the Provisional*, 4. Complexity theory focuses on systems of many interacting, uneven groups that produce emergent phenomena. Authors of it-narratives and satirists were clearly fascinated by an object entering into so many—irreconcilably—different contexts and performing the same and different tasks. R. Alexander Bentley and Herbert D. G. Maschner, *Complex Systems and Archaeology: Empirical and Theoretical Applications* (Salt Lake City: The University of Utah Press, 2003). In economics, for example, Richard Bookstaber has called for the use of agent-based modeling in order to deal more precisely with complexity and scale in predicting financial crises. Bookstaber, *The End of Theory: Financial Crises, the Failure of Economics, and the Sweep of Human Interaction* (Princeton, NJ: Princeton University Press, 2017). See also Shin, *The Culture of Paper Money in Britain*.

42. Elinor Harris Solomon, *Virtual Money: Understanding the Power and Risks of Money's High-Speed Journey into Electric Space* (Oxford: Oxford University Press, 1997), 10, 244–45.

43. Bill Maurer, *How Would You Like to Pay? How Technology Is Changing the Future of Money* (Durham, NC: Duke University Press, 2015), 68.

44. Peter de Bolla, *The Discourse of the Sublime: Readings in History, Aesthetics and the Subject* (New York: Blackwell, 1989), 135.

45. Flint, "Speaking Objects," 175.

46. Liz Bellamy identifies these in her essay "It-Narrators and Circulation," 125.

47. Monteyne, *From Still Life to the Screen*, 180.

48. Ibid., 181.

49. Ingham, *The Nature of Money*, 83.

50. Shin, "Cultures of Paper Money," 134–36.

51. Randall McGowen, "Knowing the Hand: Forgery and the Proof of Writing in Eighteenth-Century England," *Historical Reflections/Réflexions Historiques* 24, no. 3 (1998): 385–414. See page 412.

52. Ibid., 386.

53. Ibid., 402.

54. Natasha Glaisyer, "Calculating Credibility: Print Culture, Trust and Economic Figures in Early Eighteenth-Century England," *Economic History Review* 60, 4 (2007): 685–711.

55. McGowen, "Knowing the Hand," 404.

56. Ibid., 405, 412. See also an early eighteenth-century example of this in Glaisyer, "Calculating Credibility."

57. See, for instance: Ian Hodder, *An Archaeology of the Relationships between Humans and Things* (Hoboken, NJ: Wiley and Blackwell, 2012); Richard Taws, *Politics of the Provisional*; Natasha Eaton, *Mimesis across Empires: Artworks and Networks in India, 1765-1860* (Durham, NC: Duke University Press, 2013); Joseph Monteyne, *From Still Life to the Screen*; or Mihaly Csikszentmihalyi and Eugene Rochberg-Halton, *The Meaning of Things: Domestic Symbols and the Self* (Cambridge: Cambridge University Press, 1981).

58. Outing, *Standard Catalogue*, 409.

59. Ibid.

60. McGowen, "Knowing the Hand," 407–8, 412.

61. *Emetic Court Bank Dublin* (1794), BMC8564.

62. Phillips, *History of Banks*, 44.

63. Marcus Wood, *Radical Satire and Print Culture, 1790-1822* (Oxford: Clarendon Press, 1994), 38, 20.

64. Haywood, "Paper Promises," paragraph 23.

65. British Museum SSB D3 183. The sum block matching "teas" with "teas" in the text (in the same font) and blind Lady Justice in the vignette lend an air of trustworthiness to this advertisement.

66. John Strachan, *Advertising and Satirical Culture in the Romantic Period* (Cambridge: Cambridge University Press, 2007), 5.

67. *Canterbury Bank* (1791), BMC 7839.

68. BMC7839, https://www.britishmuseum.org/collection/object/P_J-4-368.

69. See, for instance, Ian Baucom, *Specters of the Atlantic: Finance Capital, Slavery, and the Philosophy of History* (Durham, NC: Duke University Press, 2005); Pocock, *Virtue, Commerce, and History*; Collin Nicholson, *Writing and the Rise of Finance: Capital Satires of the Early Eighteenth Century* (Cambridge: Cambridge University Press, 1994), xii.

70. This references the tradition of scholarship stemming from Durkheim, Marx, and Simmel.

71. Müller, *White Magic*, 151.

72. Baucom, *Specters of the Atlantic*, 67. He writes, "To accept a multiply circulated bill of exchange was not only to accept a form of paper money but to express trust in one's own ability to read character and trust in the capacity of one's fellow citizens to do likewise" (64).

73. Emphasis in original. Slavoj Žižek, *Tarrying with the Negative: Kant, Hegel, and the Critique of Ideology* (Durham, NC: Duke University Press, 1993), 29.

74. Eaton, *Mimesis*, 9. Girard's concept of "mimetic desire" is especially compelling—the idea that we want what someone else desires and in that sense imitation demands a self, an other, and mediation.

75. Monteyne, *From Still Life to the Screen*, 159–60.

76. Ibid., 161.

77. Hopefully more examples of imitation bank notes will be discovered.

78. "At a local level, wherever possible, reciprocal debts contracted between as many interested parties as possible over a number of months, or even years, would be 'reckoned' and cancelled against each other, and then only the remaining balance would be paid in money, and since most people were innumerate this was usually done orally." Craig Muldrew, "'Hard Food for Midas': Cash and its Social Value in Early Modern England," *Past and Present* 170, no. 1 (2001): 84.

79. Shin, *Culture of Paper Money*, 134–36.

80. Amanda Lahikainen, "'British Assignats': Debt, Caricature and Romantic Subjectivity in 1797," *Studies in Romanticism* 53 (Winter 2014): 534–35.

81. [W. H. Wills], "Review of a Popular Publication, in the Searching Style," *Household Worlds* 1, no. 18 (July 27, 1850): 429.

82. Haywood, "Paper Promises," paragraph 9.

83. William Holland, *John Bull swearing to his Property!!* (1798), BMC9363.

84. A similar gaze can also be seen in *Alecto and her Train*, when the Fury Alecto tries to hand Bull assignats. See Figure 13.

Chapter Four: Imitation and Immateriality

1. Such scholars include Roger Outing, Ian Haywood, Hiroki Shin, and Alexander Merick Broadley (his *Napoleon in Caricature 1795-1821* was published in 1904). William Hone and George Cruikshank's *Bank Restriction Note* is an exception in the scholarship. For Scottish satirical banknotes, see Rockoff, "Upon Daedalian Wings of Paper Money."

2. Country banknotes were less susceptible to forgery and often boasted a higher-quality engraving than Bank of England notes. Other paper credit instruments circulated as well. For an early history of paper credit in the seventeenth century, see R. D. Richards, "The Evolution of Paper Money in England," *The Quarterly Journal of Economics* 41, no. 3 (May 1927): 361–404. See also Mary Poovey's discussion of the three major types of money, what she calls monetary genres: bills of exchange, bank paper, and checks. Stocks, lottery tickets, insurance certificates, etc. also circulated (*Genres*, 35–55).

3. Byatt, *Promises to Pay*, 42.

4. Charles Sanders Peirce, "What Is a Sign?" *The Essential Peirce*, The Peirce Edition Project, vol. 2 (Bloomington: Indiana University Press, 1998), 5. Other categories related to signs include qualisign, sinsign, legisign (how the sign itself works) and rheme, dicisign, and argument (how the sign is interpreted by the interpretant).

5. Emphasis in original. Richard Price, *Two Tracts on Civil Liberty* (London, 1778), 75. This is also a definition of theatricality. Performance theorist Erika Fischer-Lichte defined theatricality as the production of "signs of signs" in "Theatricality: A Key Concept in Theatre and Cultural Studies," *Theatre Research International* 20, no. 2 (1995): 85.

6. Peirce, "What Is a Sign?" 10.

7. Jennifer Roberts, *Transporting Visions: The Movement of Images in Early America* (Berkeley: University of California Press, 2014), 122.

8. He writes of "an uninterrupted circuit without reference or circumference" and "the liquidation of all referentials." Jean Baudrillard, *Simulacra and Simulation* (Ann Arbor: University of Michigan Press, 1994), 2, 6.

9. Monteyne, *From Still Life to the Screen*, 223.

10. It is worth noting here that symbols and values have this in common, as Searle stated clearly, "values cannot lie in the world, for if they did they would cease to be values and would just be another part of the world." Searle, "How to Derive 'Ought' from 'Is,'" 53.

11. Cobbett, *Paper against Gold*, 67.

12. Dorothy George has dated the S.W. Fores run by the date of the Luffman issue in the BMC.

13. Poovey, *Genres*, 196, 199.

14. He writes: "caricature was, like the assignat itself, a form of representation that occupied an uncertain middle ground between authenticity and falsehood, playing with the categories of similarity and difference." Taws, *The Politics of the Provisional*, 37.

15. Marcus Wood, *Radical Satire*, 172; S.W. Fores, *Nouveau guide des étrangers* (London, 1789/90).

16. *The Ministers* (1800), BMC 9518, and *The Shops round The 'Change* (1800), https://www.britishmuseum.org/collection/object/P_1880-1113-5939. The latter advertises Luffman as an engraver.

17. Shin, *Culture of Paper Money*, 295. More important legislation helped to strengthen and naturalize the Bank of England note in 1826, 1833, and 1844.

18. V. H. Hewitt and J. M. Keyworth, *As Good as Gold: 300 Years of British Bank Note Design* (London: British Museum Press, 1987), 32.

19. Ibid., 111. This note also displayed a new Britannia, was payable to the bearer only, eliminated the chief cashier's name, and had a shaded watermark. An electrotype enabled the same form to be used for all metal printing plates.

20. Ibid., 113.

21. Ibid., 36–37, 48, 74.

22. Isaac Robert Cruikshank and S.W. Fores, *Symptoms of Crim Con!!! or a Political visit to the Heiress in Threadneedle Street* (Figure 20); Hewitt and Keyworth, *As Good as Gold*, 55.

23. George Cruikshank, *Johnny Bull and his Forged Notes!! or Rags & Ruin in the Paper Currency!!!* (1819), BMC13197.

24. *Monthly Magazine*, November 1797, 337. Cited in Shin, *Culture of Paper Money*, 279.

25. Sir Joshua Reynolds, *Discourses* (London: Penguin, 1992). The first discourse was originally delivered in 1769: "[I]t is difficult to give any other reason, why an empire like that of BRITAIN should so long have wanted an ornament so suitable to its greatness, than that slow progression of things, which naturally makes elegance and refinement the last effect of opulence and power" (79).

26. Holger Hoock, *The King's Artists: The Royal Academy of Arts and the Politics of British Culture 1760–1840* (Oxford: Clarendon, 2003), 30.

27. Society of Arts, *Report of the Committee of the Society of Arts etc . . . relative to the mode of preventing the forgery of bank notes* (London, 1819). Hewitt and Keyworth, *As Good as Gold*, 67, 75. Starting in 1797, nearly four hundred suggestions for banknote designs were sent to the Bank of England, and the Committee of Treasury entertained these options until 1802 and then again in 1817. Ibid., 47, 56.

28. C. W. Williams and R. H. Solly citations taken from Hewitt and Keyworth, *As Good as Gold*, 55–72. American Jacob Perkins made two innovations: he hardened the soft engraving metals to enable runs of thirty thousand rather than five thousand, and he figured out how to transfer images from one plate to another so they were exact copies (not hand-done).

29. Shin, *Culture of Paper Money*, 77, 113–15. Easing wartime cash shortages with an increase in small-denomination notes reveals the strong link between paper money and war, in this case against Revolutionary France between 1793 and 1802. The Napoleonic Wars also overlapped with much of the rest of the Restriction (1803–15).

30. Society of Arts, *Report . . . relative to the mode of preventing the forgery of bank notes*, 1; Hewitt and Keyworth, *As Good as Gold*, 60.

31. BMC 11854.

32. Poovey, *Genres*, 117.

33. Ibid., 177.

34. Stephen Bann, *Parallel Lines: Printmakers, Painters and Photographers in Nineteenth-Century France* (New Haven, CT: Yale University Press, 2001), 41. Bann follows art historian Richard Shiff in the observation that pure original and perfect copy must be situated "very close together."

35. Vic Gatrell, *Hanging Tree*, 402. Thomas Maynard was the last to be hanged in England for forgery on December 30, 1829. Ibid., 413.

36. See Wood, *Radical Satire*.

37. For a short summary of this, see Ian Hislop and Tom Hockenhull, *I Object: Ian Hislop's Search for Dissent* (London: Thames & Hudson, British Museum, 2018), 180–85.

38. For an excerpt from this letter of 1875, see Gatrell, *Hanging Tree*, 187. For this note as a mock submission to the Bank of England, see Haywood, *Romanticism and Caricature*, 39.

39. Nina Athanassoglou-Kallmyer, "Géricault's Severed Heads and Limbs: The Politics and Aesthetics of the Scaffold," *The Art Bulletin* 74:4 (December 1992): 605.

40. Robert L. Patten, *George Cruikshank's Life, Times and Art* (New Brunswick, NJ: Rutgers University Press, 1992), 148.

41. Gatrell, *Hanging Tree*, 187. Thackeray wrote in 1840 that he "remembered the 'grinning mechanics' round the window of Hone's shop 'who spelt the songs, and spoke them out for the benefit of the company,' as they must have done in public houses and reformers' unions throughout the country." Donald, *The Age of Caricature*, 198.

42. Anon., *Bank of England One Pound Note with rope noose*, 1825. Coins and Medals Department, British Museum, Red Folder. This is likely an imitation of the two notes published by Hone and Cruikshank and has accompanying verse. It reads on the side: "Specimen of a bank note not likely to be imitated from" and "Letter in Rhyme by E. Gerard."

43. *Satan's Bank Note* (London: John Lindsay Turner, 1820).

44. Lahikainen, "Currency from Opinion," 117. The following authors discuss the *Bank Restriction Note*: Haywood, *Romanticism and Caricature*, chapter 2; Patten, *George*

Cruikshank's Life, 145–49; Shin, *Culture of Paper Money*, 224; Wood, *Radical Satire*, 4; Gatrell, *City of Laughter*, 211; Outing, *Standard Catalogue*, 500.

45. Cobbett, *Paper against Gold*, xiii.

46. Marcus Wood, "William Cobbett, John Thelwall, Radicalism, Racism and Slavery: A Study in Burkean Parodics," *Romanticism on the Net*, August 15, 1999, paragraph 9.

47. Ibid., paragraph 4.

48. Ibid., paragraph 1.

49. Marcus Rediker and Peter Linebaugh, *The Many-Headed Hydra: Sailors, Slaves, Commoners, and the Hidden History of the Revolutionary Atlantic* (Boston, MA: Beacon Press, 2000), 344–51.

50. For a broader history of "the multiethnic class that was essential to the rise of capitalism and the modern, global economy," see the introduction to ibid.

51. O'Malley discusses this at length in chapter 1 of *Face Value: The Entwined Histories of Money and Race in America* (Chicago: University of Chicago Press, 2012).

52. Ibid., 4–5.

53. Ibid., 5.

54. In this sense, Rebecca Spang's observation that historians are often loath to historicize money might be applied to O'Malley's study.

55. Reviewing an article by Alan Dyer, Carl Wennerlind succinctly summarizes: "money creates the conceptual milieu in which our imagination and behavior are shaped." Wennerlind, "Money Talks," 564. See also Alan Dyer, "Making Semiotic Sense of Money as a Medium of Exchange," *Journal of Economic Issues* 23 (June 1989): 503–10.

56. For a list of contemporary artists who have treated this subject in a variety of ways, see the *Art Works* volume *Money*, eds. Katy Siegel and Paul Mattick (New York: Thames & Hudson, 2004). In this book, Genpei is discussed in the second part of the epilogue.

57. Johanna Drucker, "Harnett, Haberle, and Peto: Visuality and Artifice Among the Proto-Modern Americans," *The Art Bulletin* 74, no. 1 (March 1992): 38.

58. In Haberle's painting, the fractional currency seems to date between 1869 and 1875 (when John Allison was Register of the Treasury, and F. E. Spinner was Treasurer), and the dollar bill dates to 1863 (dated on the left-hand side). National Gallery of Art, Washington, DC, oil on canvas, 10 × 14 in. (254 × 356 mm), New Century Fund, Gift of the Amon G. Carter Foundation, 1998.96.1.

59. See John Wilmerding, *Important Information Inside: The Art of John F. Peto and the Idea of Still-Life Painting in Nineteenth-Century America* (Washington, DC: National Gallery of Art, 1983); William H. Gerdts and Russell Burke, *American Still Life Painting* (New York: Praeger, 1971); and Barbara Novak, *American Painting in the Nineteenth Century: Realism, Idealism, and the American Experience* (New York: Oxford University Press, 1979). Discussed in Drucker, "Harnett, Haberle, and Peto," 37.

60. Drucker, "Harnett, Haberle, and Peto," 38.

61. Ibid., 49.

62. Ibid., 50.

63. Ibid., 49–50.

64. Dalia Judovitz, *Unpacking Duchamp: Art in Transit* (Berkeley: University of California Press, 1995), 167. She writes that the same "institutional markers that define the legal identity of a check also define the institutional parameters of a work of art" (168).

65. Stephen B. Reed, "One Hundred Years of Price Change: The Consumer Price Index and the American Inflation Experience," *Monthly Labor Review*, U.S. Bureau of Labor Statistics, April 2014, https://doi.org/10.21916/mlr.2014.14.

66. Geoff Quilley, "Art History and Double Consciousness: Visual Culture and Eighteenth-Century Maritime Britain," *Eighteenth-Century Studies* 48, no. 1 (2014), 32; Baucom, *Specters of the Atlantic*.

67. Roberta Smith, "Conceptual Art," in *Concepts of Modern Art*, ed. Nikos Stangos (London: Thames & Hudson, 2001), 264.

68. Davies, *A History of Money*, 27.

69. Jonathon Keats, *Forged: Why Fakes Are the Great Art of Our Age* (Oxford: Oxford University Press, 2013), 24.

Chapter Five: Materiality

1. *OED*, s.v. "sterling."

2. Thomas J. Sargent and Francois R. Velde, *The Big Problem of Small Change* (Princeton, NJ: Princeton University Press, 2002). They write: "With the Coinage Act of 1816, the British government began to implement the standard formula not just for small denomination copper or bronze coins, at the lowest end of the denomination scale, but for all of its silver coinage. In doing so, Britain implemented the first full-fledged gold standard. But it did so in a piecemeal fashion, rather than carrying out a preconceived plan" (303).

3. Thanks to Craig Hanson. See Francis Haskell, *History and Its Images: Art and the Interpretation of the Past* (New Haven, CT: Yale University Press, 1995), especially Chapter 1, "The Early Numismatists." See also Arnaldo Momigliano, "Ancient History and the Antiquarian," *Journal of the Warburg and Courtauld Institutes* 13 (1950).

4. John Gregory Hancock, satirical medal, 1800. British Museum 1906, 1103.469.

5. Poovey, *Genres*, 172. See Rebecca Spang, "Money, Money, Money," review of *Genres of the Credit Economy* by Mary Poovey, *History Workshop Journal* 69 (Spring 2010): 225–33.

6. Thanks to an anonymous reviewer for suggesting that speech bubbles and the materiality of text deserve further attention in the scholarship.

7. Nina Athanassoglou-Kallmyer, Editor's Note, "Materiality, Sign of the Times," *The Art Bulletin* 101, no. 4 (December 2019). See also Daniel Miller, *Materiality* (Durham, NC: Duke University Press, 2005); Nicole Boivin, *Material Cultures, Material Minds: The Impact of Things on Human Thoughts, Society, and Evolution* (Cambridge: Cambridge University Press, 2008); Peter Miller, ed., *Cultural Studies of the Material World* (Ann Arbor: University of Michigan Press, 2013).

8. Dan Hicks and Mary C. Beaudry, *The Oxford Handbook of Material Culture Studies* (Oxford: Oxford University Press, 2010). These editors note the "fast-expanding literature in 'material culture studies'" (2). For an excellent review article, see Veerle Thielemans, "Beyond Visuality: Review on Materiality and Affect," *Perspective* [online] 2 (December 7, 2015), http://journals.openedition.org/perspective/5993, DOI: https://doi.org/10.4000/perspective.5993.

9. Athanassoglou-Kallmyer, "Materiality, Sign of the Times," 6. "Le faire" is a French term used to describe the touch of an artist recorded during art-making that is immediately present to a viewer in a work of art, in a technical or stylistic sense. Athanassoglou-Kallmyer has referred to "le faire" as a metaphorical cognate of materiality, meaning it communicates something similar to materiality.

10. Taws, *Politics of the Provisional*. See also Jennifer Roberts, *Transporting Visions*, and "The Currency of Ornament: Machine-Lathed Anticounterfeiting Patterns and the Portability of Value," in *Histories of Ornament: From Global to Local*, ed. Gülru Necipoğlu and Alina Payne (Princeton, NJ: Princeton University Press, 2016), 308–19,

and Laura Anne Kalba, "Beautiful Money: Looking at La Semeuse in Pin-de-Siècle France," *The Art Bulletin* 102, no. 1 (March 2020): 55–78.

11. Shell, *Art & Money*, 5, 139.
12. Poovey, *Genres*, 5–7. The phrase "gap between a sign and its referent" appears in the index to her book.
13. Debt is "n. 1. a. a sum of money or a material thing. b. a thing immaterial." *OED*.
14. Silver was hardly minted in the eighteenth century. Feavearyear, *The Pound Sterling*, 158.
15. Cobbett, *Paper against Gold*, 28–29.
16. *OED*, s.v. "materiality."
17. Ewa Lajer-Burcharth, "Chardin Material," in *Chardin Material*, eds. Daniel Birnbaum and Isabelle Graw (Frankfurt-am-Main: Sternberg Press, 2011), 9–49.
18. O'Malley, *Face Value*, 22.
19. Walter Benjamin, "The Work of Art in the Age of Mechanical Reproduction," in *Illuminations*, ed. Hannah Arendt, trans. Harry Zohn (1935; New York: Schocken Books, 1969), 243.
20. Lajer-Burcharth, *Chardin Material*, 9 n.2.
21. Monteyne, *From Still Life to the Screen*, 14, 229.
22. Lubar and Kingery, *History from Things*, xvi.
23. James Elkins, "On Some Limits of Materiality in Art History," *31: Das Magazin des Instituts für Theorie* 12 (2008): 25–30.
24. Michael Yonan, "The Suppression of Materiality in Anglo-American Art-Historical Writing," in *The Challenge of the Object/Die Herausforderung des Objekts*. Proceedings of the 33rd Congress of the International Committee of the History of Art (CIHA), Nurnberg, July 15–20, 2012, ed. Georg Ulrich Grossmann and Petra Krutisch (Nurnberg: Verlag des Germanischen Nationalmuseums, 2014), I:63–66.
25. Edward Hyde, *A Treatise of the Pleas of the Crown*, vol. 2 (London, 1803), 993; McGowen, "Knowing the Hand," 410.
26. McGowen, "Knowing the Hand," 410.
27. "The Old Lady in Threadneedle Street," *Household Worlds*, Saturday, July 6, 1850, 339.
28. William Cobbett, "Jacobin Guineas," *Political Register*, September 1809–August 1810. Selections from John M. Cobbett and James P. Cobbett, *Cobbett's Political Works: being a complete abridgement of the 100 volumes which comprise the writings of "Porcupine" and the "Weekly political register." With notes, historical and explanatory*, Volume 3 (London, Ann Cobbett, 1835).
29. Poovey, *Genres*, 440 n.45.
30. Richard Newton, *A Paper Meal with Spanish Sauce* (1797). British Museum 1948,0214.362.
31. The American version is in the collection of Colonial Williamsburg and was published by William Charles in Philadelphia.
32. Woodward, *The Ghost of a Guinea and little Pitt's. or the Country Banker's Surprise!!* (1810), BMC 11576.
33. Country banking enabled the development of another group of "financial specialists" during the Restriction period, the bill brokers. They worked against the localizing effects of smaller banks by negotiating bills in the London money market, and eventually led to the booming discount market in nineteenth-century London. L. S. Pressnell, *Country Banking in the Industrial Revolution* (Oxford: Clarendon Press, 1956), 85.
34. Cobbett, *Paper against Gold*, 257.

35. Valenze, *Social Life*, 260.

36. *The Observer*, May 13, 1832, 1.

37. See the Romantic Circles Praxis volume on "Romanticism, Forgery and the Credit Crunch," in particular Ian Haywood's reliance on forgery in "Paper Promises," paragraph 1ff, https://romantic-circles.org/praxis/forgery/index.html.

38. *Stamford Mercury*, Friday, April 9, 1847, 4.

39. I have suggested that a partially naturalized currency serves as a condition of possibility for its printing. Lahikainen, "Currency from Opinion."

40. Poovey, *Genres*, 163; Outing, *Standard Catalogue*, 10.

41. Pressnell, *Country Banking*, 75, 85.

42. Wills, "Review," 426, 427–28.

43. Steven Fischer, *A History of Reading* (London: Reaktion, 2004). For a well-known example of a scholar who was able to excavate an alternative reading of a text in historical context, see Carlo Ginzburg, *The Cheese and the Worms: The Cosmos of a Sixteenth-Century Miller* (Baltimore, MD: Johns Hopkins University Press, 2013).

44. Adrian Johns, *The Nature of the Book: Print and Knowledge in the Making* (Chicago: University of Chicago Press, 1998), 245. Steven Lubar and W. David Kingery wrote that too seldom "do we try to read objects as we read books—to understand the people and times that created them, used them, and discarded them." Lubar and Kingery, *History from Things*, viii.

45. "The Old Lady in Threadneedle Street," 339.

46. Elizabeth Eisenstein, *The Printing Press as an Agent of Change: Communications and Cultural Transformations in Early Modern Europe* (Cambridge: Cambridge University Press, 1979).

47. Johns, *Nature of the Book*, 625.

48. Frances Robertson, "The Aesthetics of Authenticity: Printed Banknotes as Industrial Currency," *Technology and Culture* 6 (January 2005): 31.

49. John Barrell, *The Political Theory of Painting from Reynolds to Hazlitt: "The Body of the Public"* (New Haven, CT: Yale University Press, 1986).

50. See David H. Solkin, *Painting for Money: The Visual Arts and the Public Sphere in Eighteenth-Century England* (New Haven, CT: Yale University Press, 1993), 1–3.

51. Shell, *Money, Language, and Thought* and *Art & Money*. Scholars of material culture have noted the "stark opposition between an idealism that denies the objective status of things, on the one hand, and the crudest empirical account of the mute resistance of matter to subjective manipulation, on the other." Blackwell, *Secret Life of Things*, 9.

52. Georg Simmel and David Frisby, eds., *The Philosophy of Money*, second edition, trans. Tom Bottomore and David Frisby (New York: Routledge, 1990).

53. Mark Coeckelbergh summarizes three main components of Simmel's analysis: in relation to people, money distances, dematerializes, and alienates. See his *Money Machines: Electronic Financial Technologies, Distancing and Responsibility in Global Finance* (New York: Routledge, 2015), 34.

54. Simmel, *Philosophy of Money*, 172. For an excellent summary of Simmel, see Ingham, *The Nature of Money*, 63–66.

55. Spang, *Stuff and Money*, 168.

56. Ibid.

57. See Rebecca Spang, "Money, Money, Money," 226. She groups together Bernd Widdig, Marc Shell, Georg Simmel, and Niall Ferguson as modernist theorists.

58. Spang, *Stuff and Money*, 11.

59. This long-debated economic theory states that the price of goods and services is directly related to the amount of money in circulation.

60. Spang, *Stuff and Money*, 216.

61. Ibid., 11–12.

62. Zelizer, *Social Meaning*, 206.

63. Dario Castiglione, "Blood and Oil: Eighteenth-Century Monetary Anxieties," *Historical Reflections/Réflexions Historiques* 31, no. 1 (Spring 2005): 48.

64. Poovey, *Genres*, 51.

65. Shell, *Money, Language, and Thought*, 1.

66. Electrum.org, https://electrum.org/#home. Accessed August 2017 and December 2021.

67. Ibid. This phrase cycles across the homepage along with other phrases and photographs.

68. Shell, *Money, Language, and Thought*, 7.

69. Baker, "Paper Money Gets Personal: Reading Credit and Character in Early America." 1. *OED*, s.v. "metallism": "b. The theory that all currency should be in the form of metal coins. Also: the theory that any currency should consist of a commodity (usually some metal) so that the exchange value and purchasing power of the commodity (considered independently of its monetary role) determines that of the currency." At issue in the Austrian perspective is the diamond-water paradox: how can a diamond be worth more than water, when water is clearly the more necessary item for survival?

70. Henry Thornton, "An Inquiry Into the Nature and Effects of the Paper Credit of Great Britain" (Philadelphia, 1807), 18.

71. Eugenie Andruss Leonard, "Paper as a Critical Commodity during the American Revolution," *The Pennsylvania Magazine of History and Biography* 74, no. 4 (Oct. 1950): 488–99.

72. Maurer, *How Would You Like to Pay*, 46, 64–71; Ingham, "Money is a Social Relation," 70.

73. Ingham, "Money is a Social Relation," 508, 510.

74. Searle, "How to Derive 'Ought' from 'Is.'"

Chapter Six: The Deflation of Georgian Graphic Satire

1. Bradford Mudge, "'Like as My Profile': Of Monuments, Money, and Political Caricature in Spring 1784," *Eighteenth-Century Life* 35, no. 3 (Fall 2011): 29–59 (30).

2. Dorothy George, *Hogarth to Cruikshank: Social Change in Graphic Satire* (London: Walker & Co., 1967), 220.

3. Donald, *Age of Caricature*, 184, 185. The "March of Mind" or "March of Intellect" was a debate that unfolded in early nineteenth-century Britain in response to social change and new attitudes toward education and knowledge. Two sides developed different attitudes toward progress, seeing it as either working well or as an unhelpful trend.

4. Andrew Benjamin Bricker, "After the Golden Age: Libel, Caricature, and the Deverbalization of Satire," *Eighteenth-Century Studies* 51, no. 3 (2018): 328. Bricker tries to explain the decline of literary satire between 1670 and the 1740s in this article, claiming that rather than vanishing, it migrated to visual media in the mid-eighteenth century as a result of governmental legal tactics, libel law, and trial procedures delimiting verbal ambiguity (306).

5. Christina Smylitopoulos, "Abandoning Graphic Satire and Illustrating Text: Cruikshank's Crowning Himself Emperor of France, 1814," in *Word and Image in the Long Eighteenth Century*, eds. Christina Ionescu and Renata Schellenberg (Newcastle: Cambridge Scholars Publishing, 2008), 325.

6. Lahikainen, "British Assignats," 509–40.

7. Haywood, *Romanticism and Caricature*, 57.

8. Müller, *White Magic*, 148.

9. O'Donoghue, Goulding, Allen, "Consumer Price Inflation," Table 2.

10. Helen MacFarlane and Paul Mortimer-Lee, "Inflation over 300 years," *Bank of England Quarterly Bulletin* (May 1994): 159–60.

11. Donald uses this title of a Hogarth print to label a section in her book as well. See *Age of Caricature*, 1.

12. Ibid.; Sheila O'Connell, *The Popular Print in England* (London: British Museum Press, 1999); Eirwen E. C. Nicholson, "Consumers and Spectators: The Public of the Political Print in Eighteenth-Century England," *History* 81, no. 261 (January 1996): 5–21; Taylor, *Politics of Parody*.

13. Gatrell, *City of Laughter*, 434. The other two general theories of humor are the superiority and relief theories. For a review of these positions, see the foundational work in the philosophy of laughter and humor, John Morreall, *Taking Laughter Seriously*.

14. Hogarth, *Analysis of Beauty*, 1753. Diana Donald and I have discussed the history of this theory in Britain following publications by Akenside, Beattie, Grose, Hartley, Hogarth, Hutchson, Morris, and Priestley in the eighteenth century. Amanda Lahikainen, "'Some Species of Contrasts': British Graphic Satire, the French Revolution and the Humor of Horror," *Humor: International Journal of Humor Studies* 28, no. 1 (February 2015): 99–108; Donald, *Age of Caricature*, 50.

15. L. B. Amir, "Philosophy's Attitude towards the Comic. A Reevaluation," *European Journal of Humor Research* 1 (2013): 6–21, and Amir, "Taking the History of Philosophy on Humor and Laughter Seriously," *The Israeli Journal of Humor Research: An International Journal* 5 (2014): 43–87.

16. Baker, *Business*, 119.

17. Richard D. Altick, *Punch: The Lively Youth of a British Institution, 1841–1851* (Columbus: Ohio State University Press, 1997), 37–38. See the estimates in Altick's first chapter and his discussion of stamped copies and "country" versus "metropolitan" circulation. For an excellent summary of *Punch*'s historiography, see Patrick Leary, *The Punch Brotherhood: Table Talk and Print Culture in Mid-Victorian London* (London: The British Library, 2010), 2–5.

18. Robert Leach, *The Punch & Judy Show: History, Tradition and Meaning* (Athens: The University Of Georgia Press, 1985), 28.

19. Ibid., 174.

20. Taylor, *Politics of Parody*, xi, 48, 248.

21. Ibid., x.

22. Baker, *Business*, 150.

23. Ibid., 162, 154.

24. Ibid., 191.

25. See *The Proceedings of the Old Bailey: London's Central Criminal Court, 1674 to 1913* website: https://www.oldbaileyonline.org/.

26. Taylor, *Politics of Parody*, 68. "Gawping" is key to his argument.

27. Ginzburg, *Cheese and Worms*.

28. Peter Stallybrass and Allon White, *The Politics and Poetics of Transgression* (Ithaca, NY: Cornell University Press, 1986), 43.

29. Brian Maidment, *Comedy, Caricature and the Social Order, 1820–50* (Manchester: Manchester University Press, 2013), 115.

30. Ibid., 121.

31. Ibid., 119.

32. Ibid., 116.

33. See Table I for inflation statistics. See Matthew Roberts, "Satan's Bank Note," *History Today* (September 19, 2017).

34. Baker, *Business*, esp. 60–67.

35. Altick, *Punch*, 11.

36. Gatrell, *City of Laughter*, 427.

37. Ian Haywood, *The Rise of Victorian Caricature* (London: Palgrave Macmillan, 2020).

38. Henry Miller, *Politics Personified: Portraiture, Caricature and Visual Culture in Britain c. 1830–80* (Manchester: Manchester University Press, 2015); Maidment, *Comedy*; Haywood, ibid.

39. Baker, *Business*, 9.

40. David Bindman, "Laughter as Performance: Some Eighteenth-Century Examples," in *No Laughing Matter*, 237.

41. Lahikainen, "'Some Species of Contrasts,'" 108–9; Bindman, "Laughter as Performance," 237.

42. Gatrell, *City of Laughter*, 417, 425. Gatrell points out that literary satire suffered a similar fate, when "light verse, lectures, tracts and fiction" were preferred to satire by Pope, Swift, Byron, and Shelley (431).

Epilogue: Beyond Britain

1. Taws, "The Currency of Caricature in Revolutionary France," 108.

2. Diana Donald and Christine Banerji, *Gillray Observed: The Earliest Account of his Caricatures in London and Paris* (Cambridge: Cambridge University Press, 2009).

3. Frank Weitenkampf, *American Graphic Art* (London: Johnson Reprint Corporation, 1970), 214.

4. John Sullivan, "The Case of 'A Late Student': Pictorial Satire in Jacksonian America," *Proceedings of the American Antiquarian Society* (1974): 280.

5. Stephen Hess and Milton Kaplan, *The Ungentlemanly Art: A History of American Political Cartoons* (New York: The Macmillan Company, 1968), 16–17.

6. David Tatham, "David Claypoole Johnston's 'Militia Muster,'" *American Art Journal* 19, no. 2 (Spring 1987): 6–7. This issue is also addressed by Allison Stagg in "The Art of Wit: American Political Caricature, 1780–1830," (PhD Diss., University College London, 2011). See also Jennifer A. Greenhill, "Playing the Fool: David Claypoole Johnston and the Menial Labor of Caricature," *American Art* 17, no. 3 (Autumn 2003): 33–51; and Judith Brodie, Amy Johnston, and Michael J. Lewis, *Three Centuries of American Prints from the National Gallery of Art* (Washington, DC: Thames and Hudson, 2016), 10.

7. Weitenkampf, *American Graphic Art*, 216. Weitenkampf writes of American satires that "[t]he remarks of the various persons in the pictures are inclosed [sic] in loops issuing from their mouths, in a matter always marking a distinctly lower grade of the art, as in so many of the dreary continuous series drown out through successive issues of our present-day newspapers."

8. Jessica Lepler, "Pictures of Panic: Constructing Hard Times in Worlds and Images," *Common Place* 10, no. 3 (April 2010).

9. Lepler moves beyond the two standard interpretations of the event from the central bank-supporting monetarists who focus on politics and policy, and the economic historians focused on international finance. Jessica M. Lepler, *The Many Panics of 1837: People, Politics, and the Creation of a Transatlantic Financial Crisis* (Cambridge: Cambridge University Press, 2013), 4–6.

10. Lepler, "Pictures of Panic." Discussion of the Panic of 1837 is to say nothing of the paper money experiments in Texas at this time, which would not join the United States until 1845. The first paper interest-bearing promissory notes were issued by the Republic of Texas in 1837; after these lost over fifty percent of their value, the government issued paper money at face value. These also failed as a currency. Recent reproductions of the Republic of Texas currency (1838–41) by the Historical Documents Company still offer a strong sense of local identity and pride. The company advertises the reproduction of a one hundred-dollar bill by appealing to its materiality: "Antiqued Reproductions . . . They LOOK OLD and ACTUALLY FEEL OLD!" The envelope containing the bill highlights "optimism and idealism" and the "artistic qualities" of "banknote engravers of the 19th century." Collection of the author. Purchased at the Alamo in San Antonio, TX, in 2013.

11. Sometimes only attributed to Johnston, the proofs for this print are held in The American Antiquarian Society collection in Worcester, MA, with Johnston's estate papers.

12. Lepler, "Pictures of Panic."

13. Arthur J. Rolnick, and Warren E. Weber, "Free Banking, Wildcat Banking and Shinplasters," *Federal Reserve Bank of Minneapolis Quarterly Review* 6, no. 3 (Fall 1982).

14. Ibid., 18.

15. Lepler, "Pictures of Panic."

16. I follow Lepler's identifications in "Pictures of Panic." Mark Shell suggests the beetle could be Jackson or Thomas Hart Benton. Shell, *Money, Language, and Thought*, 227.

17. For a discussion of this problem as it relates to currency in America as part of the British Atlantic and attempts to implement an imperial paper currency, particularly in the 1760s, see Aaron Graham, *Bills of Union*, Palgrave Studies in the History of Finance (New York: Springer International Publishing, 2021).

18. James Kirke Paulding, *The History of a little Frenchman and his bank notes. "Rags! Rags! Rags!"* (Philadelphia: Edward Earle, 1815), 3. Printed by Joseph M. Sanderson.

19. Ibid., 3.

20. Ibid., 21.

21. Ibid., 27.

22. "[W]ithout charters, without respectability, without responsibility, and without capital, issuing and circulating millions of dollars in rags." Ibid., 14.

23. Peter C. Welsh, "Henry R. Robinson: Printmaker to the Whig Party," *New York History* 53, no. 1 (January 1972): 29, 32.

24. Cited in ibid., 32.

25. Library of Congress, department of prints and photographs online catalog: https://www.loc.gov/pictures/item/2008661307/.

26. Heinz Tschachler, *The Monetary Imagination of Edgar Allan Poe: Banking, Currency and Politics* (Jefferson, NC: McFarland & Company: 2013), 48.

27. National Museum of American History Archives, ROLL/FR 14/10511, Washington, DC.

28. These coins share the same obverse image of "Peace and Plenty."

29. See the Library of Congress prints and drawing catalog. Call number: LOT 14012, no. 225.

30. Thomas Nast, *Ideal Money* (1897), Library of Congress, prints and photographs catalog, https://www.loc.gov/pictures/item/2010644256/.

31. Gertrude Grace Sill, *John Haberle: American Master of Illusion* (New Britain, CT: New Britain Museum of American Art, 2009), 15. One of these paintings is *Five Dollar Bill* (1887, Philadelphia Museum of Art).

32. Michael Auslin, *Negotiating with Imperialism: The Unequal Treaties and the Culture of Japanese Diplomacy* (Cambridge, MA: Harvard University Press, 2004), 30.

33. Helen McCarthy, *A Brief History of Manga: The Essential Pocket Guide to the Japanese Popular* (London: Ilex Press, 2014).

34. John Clark, *Japanese Exchanges in Art, 1850s–1930s with Britain, Continental Europe, and the USA* (Sydney: Power Publications, 2001), 10. *Japan Punch* was published intermittently until 1837, then on a regular monthly basis until March 1887. In December of 1883, Wirgman switched from woodblock prints to lithography.

35. Ibid., 18. Kiyochika Kobayashi, the well-known print artist and main cartoonist for *Marumaru Chinbun*, and Tamura Sōryū are also sometimes mentioned. See Peter Duus, "Presidential Address: Weapons of the Weak, Weapons of the Strong—The Development of the Japanese Political Cartoon," *The Journal of Asian Studies* 60, issue 4 (November 2001): 980.

36. Duus, "Weapons," 968.

37. Ibid., 978.

38. Ibid.

39. Adam L. Kern, *Manga from the Floating World: Comicbook Culture and the Kibyoshi of Edo Japan* (Cambridge, MA: Harvard University Press, 2006), 130–31. Widely considered the first adult comic book genre in Japanese literature, *kibyoshi* picture books were first published in the eighteenth century and were produced into the early nineteenth century.

40. John M. Rosenfield, "The Anatomy of Humor in Hokusai's Instruction Manuals," in *Hokusai and His Age: Ukiyo-e Painting, Printmaking and Book Illustration in Late Edo Japan*, ed. John T. Carpenter (Amsterdam: Hotei Publishing, 2005), 299–327. He lists Hogarth and Daumier as "analogues of Hokusai" (316).

41. Tsuji Nobuo, "The Impact of Western Book Illustration on the Designs of Hokusai—The Key to His Originality," trans. Timon Screech, in *Hokusai and His Age*, 342–43.

42. Duus, "Weapons," 971.

43. Ibid., 972.

44. Stephen Bennett Phillips, Shingo Odaka, and Kaori Sekiguchi, *Japan's Social & Economic Landscape: Nineteenth-Century Woodblock Prints from the Currency Museum, Bank of Japan* (Washington, DC: Board of Governors of the Federal Reserve System, 2014), 28–29.

45. Thanks to Alfred Haft at the British Museum for this translation.

46. Alan M. Stahl, *Money on Paper: Bank Notes and Related Graphic Arts from the Collections of Vsevolod Onyshkevych and Princeton University* (Princeton, NJ: Princeton University Library, 2010), 41.

47. This figure of speech dates back to at least the sixteenth century. There are several prints treating this pawnbroker theme by William Dent and Isaac Cruikshank from 1793, published by James Aitken and S. W. Fores.

48. BMC 8325, 8326, etc.

49. Hislop and Hockenhull, *I Object*, 185–86.

50. Ibid., 185.

BIBLIOGRAPHY

Historical Periodicals

Manchester Mercury
[London] *Morning Chronicle*
[London] *The Observer*
[London] *Oracle and Public Advertiser*
The Scottish Antiquary, or, Northern Notes & Queries
Stamford Mercury
St. James Chronicle or the British Evening Post
[London] *Telegraph*
[London] *Times*
True Briton

Secondary Sources

Abel, Andrew B., Ben S. Bernanke, and Dean Croushore. *Macroeconomics*. Seventh Edition. New York: Addison-Wesley/Pearson, 2011.

Acres, Wilfred Marston. "On the Name 'Old Lady of Threadneedle Street.'" *The Old Lady of Threadneedle Street*, 1927.

Altick, Richard D. *Punch: The Lively Youth of a British Institution, 1841–1851*. Columbus: Ohio State University Press, 1997.

Amir, L. B. "Philosophy's Attitude towards the Comic. A Reevaluation." *European Journal of Humor Research* 1 (2013): 6–21.

———. "Taking the History of Philosophy on Humor and Laughter Seriously." *The Israeli Journal of Humor Research: An International Journal* 5 (2014).

Anderson, Benedict. *Imagined Communities: Reflections on the Origin and Spread of Nationalism*. Brooklyn, NY: Verso, 1983.

Appleby, Joyce. *Economic Thought and Ideology in Seventeenth-Century England*. Princeton, NJ: Princeton University Press, 1978.

Athanassoglou-Kallmyer, Nina. "Géricault's Severed Heads and Limbs: The Politics and Aesthetics of the Scaffold." *The Art Bulletin* 74, no. 4 (December 1992).

———. Editor's Note, "Materiality, Sign of the Times." *The Art Bulletin* 101, no. 4 (December 2019).

Auslin, Michael. *Negotiating with Imperialism: The Unequal Treaties and the Culture of Japanese Diplomacy*. Cambridge, MA: Harvard University Press, 2004.

Avery-Quash, Susanna, and Christian Huemer, eds. *London and the Emergence of a European Art Market, 1780–1820*. Los Angeles: Getty Research Institute, 2019.

Baker, James. *The Business of Satirical Prints in Late-Georgian England*. London: Palgrave Macmillan, 2017.

Baker, Jennifer J. "Paper Money Gets Personal: Reading Credit and Character in Early America." *Common-Place: The Interactive Journal of Early American Life* 6, no. 3 (April 2006).

Bann, Stephen. *Parallel Lines: Printmakers, Painters and Photographers in Nineteenth-Century France*. New Haven, CT: Yale University Press, 2001.

Baring, Sir Francis. *Observations on the Establishment of the Bank of England and on the Paper in Circulation of the Country*. London, 1797.

Barrell, John. *The Political Theory of Painting from Reynolds to Hazlitt: 'The Body of the Public.'* New Haven, CT: Yale University Press, 1986.

Baucom, Ian. *Specters of the Atlantic: Finance Capital, Slavery, and the Philosophy of History*. Durham, NC: Duke University Press, 2005.

Baudrillard, Jean. *Simulacra and Simulation*. Ann Arbor: University of Michigan Press, 1994.

Bellamy, Liz. "It-Narrators and Circulation: Defining a Subgenre." In *The Secret Life of Things: Animals, Objects, and It-Narratives in Eighteenth-Century England*, edited by Mark Blackwell. Lewisburg, PA: Bucknell University Press, 2007.

Benjamin, Walter. "The Work of Art in the Age of Mechanical Reproduction." In *Illuminations*, edited by Hannah Arendt. Translated by Harry Zohn. New York: Schocken Books, 1969.

Bentley, R. Alexander, and Herbert D. G. Maschner. *Complex Systems and Archaeology: Empirical and Theoretical Applications*. Salt Lake City: The University Of Utah Press, 2003.

Bindman, David. "Laughter as Performance: Some Eighteenth-Century Examples." In *No Laughing Matter: Visual Humor in Ideas of Race, Nationality, and Ethnicity*, edited by Angela Rosenthal, David Bindman, and Adrian Randolph. Hanover, NH: Dartmouth College Press, 2016.

———. *Shadow of the Guillotine: Britain and the French Revolution*. London: British Museum Press, 1982.

Blackwell, Bonnie. "Corkscrews and Courtesans." In *The Secret Life of Things: Animals, Objects, and It-Narratives in Eighteenth-Century England*, edited by Mark Blackwell. Lewisburg, PA: Bucknell University Press, 2007.

Boase, C.W. *A Century of Banking in Dundee*. 2nd edition. Edinburgh: R. Grant & Son, Prince Street, 1867.

Boivin, Nicole. *Material Cultures, Material Minds: The Impact of Things on Human Thoughts, Society, and Evolution*. Cambridge: Cambridge University Press, 2008.

Bookstaber, Richard. *The End of Theory: Financial Crises, the Failure of Economics, and the Sweep of Human Interaction*. Princeton, NJ: Princeton University Press, 2017.

Bower, Peter. "Sir John Swinburne's Memorandum on the English Forgery of French Assignats at Haughton Castle Paper Mill, Northumberland, in the 1790s." *The Quarterly, The Journal of the British Association of Paper Historians*, no. 106 (April 2018).

Brantlinger, Patrick. *Fictions of State: Culture and Credit in Britain, 1694–1994*. Ithaca, NY: Cornell University Press, 1996.

Bricker, Andrew Benjamin. "After the Golden Age: Libel, Caricature, and the Deverbalization of Satire." *Eighteenth-Century Studies* 51, no. 3 (2018).

Bridges, Thomas. *Adventures of a Bank-Note*. London, 1770–71.

Broadley, Alexander Merick. *Napoleon in Caricature 1795–1821*. London: John Lane, 1904.

Brodie, Judith, Amy Johnston, and Michael J. Lewis. *Three Centuries of American Prints from the National Gallery of Art*. Washington, DC: Thames and Hudson, 2016.

Burke, Edmund. *Reflections on the Revolution in France*. London, 1790.

Butlin, S. J. *Foundations of the Australian Monetary System 1788–1851*. Sydney, Australia: University of Sydney Library, 2002.

Byatt, Derrick. *Promises to Pay: The First Three Hundred Years of Bank of England Note*. London: Spink, 1994.

Carlyle, Thomas. *The French Revolution*. Vol. 1, revised edition. New York: The Colonial Press, 1900.

Casey, John. "The Fort Montague Bank," *Journal of the Institute of Bankers* (December 1962).

Castiglione, Dario. "Blood and Oil: Eighteenth-Century Monetary Anxieties." *Historical Reflections/Réflexions Historiques* 31, no. 1 (Spring 2005).

Clark, John. *Japanese Exchanges in Art, 1850s–1930s with Britain, Continental Europe, and the USA*. Sydney: Power Publications, 2001.

Clayton, Tim, Antony Griffiths, and John Ford. *The English Print 1688–1802*. New Haven, CT: Yale University Press, 1997.

Cobbett, William. *Political Register*.

Coeckelbergh, Mark. *Money Machines: Electronic Financial Technologies, Distancing and Responsibility in Global Finance*. New York: Routledge, 2015.

Connell, Philip. *Romanticism, Economics and the Question of 'Culture.'* Oxford: Oxford University Press, 2001.

Cook, Peter J. "Flash Money and Old-England's Agent in the Early 19th Century." *Cambrian Law Review* 24, vol. 12 (1993).

Davies, Glyn. *A History of Money: From Ancient Times to the Present Day*. Cardiff: University of Wales Press, 1994.

de Bolla, Peter. *The Discourse of the Sublime: Readings in History, Aesthetics and the Subject*. New York: Blackwell, 1989.

Degen, Natasha, ed. *The Market Whitechapel: Documents of Contemporary Art*. Cambridge, MA: MIT Press, 2013.

Devereaux, Simon. "Promulgation of the Statutes in Late Hanoverian Britain." In *The British and their Laws in the Eighteenth Century*, edited by David Lemmings. Woodbridge, UK: Boydell, 2005.

Dick, Alexander. *Romanticism and the Gold Standard: Money, Literature, and Economic Debate in Britain 1790–1830*. London: Palgrave Studies in the Enlightenment, Romanticism and Cultures of Print, 2013.

Dickie, Simon. *Cruelty and Laughter: Forgotten Comic Literature and the Unsentimental Eighteenth Century*. Chicago: University Of Chicago Press, 2011.

Dickson, P. G. M. *The Financial Revolution in England: A Study in the Development of Public Credit, 1688–1756*. New York: Routledge, 1967.

Donald, Diana. *The Age of Caricature: Satirical Prints in the Reign of George III*. New Haven, CT: Yale University Press, 1996.

—— and Christine Banerji. *Gillray Observed: The Earliest Account of his Caricatures in London und Paris*. Cambridge: Cambridge University Press, 2009.

Doyle, John H. B. *Political Sketches*, vol. 1. London, 1829.

Drucker, Johanna. "Harnett, Haberle, and Peto: Visuality and Artifice Among the Proto-Modern Americans." *The Art Bulletin* 74, no. 1 (March 1992).

Duus, Peter. "Presidential Address: Weapons of the Weak, Weapons of the Strong—The Development of the Japanese Political Cartoon." *The Journal of Asian Studies* 60, issue 4 (November 2001).

Dyer, Alan. "Making Semiotic Sense of Money as a Medium of Exchange." *Journal of Economic Issues* 23 (June 1989).

Eaton, Natasha. *Mimesis across Empires: Artworks and Networks in India, 1765–1860*. Durham, NC: Duke University Press, 2013.

Eisenstein, Elizabeth. *The Printing Press as an Agent of Change: Communications and Cultural Transformations in Early Modern Europe*. Cambridge: Cambridge University Press, 1979.

Elkins, James. "On Some Limits of Materiality in Art History." *31: Das Magazin des Instituts für Theorie* 12 (2008).

Feavearyear, Sir Albert. *The Pound Sterling: A History of English Money*. 2nd Edition. Oxford: Clarendon Press, 1963.

Felsenstein, Frank. "'If you tickle us, do we not laugh?': Stereotypes of Jews in English Graphic Humor of the Georgian Era." In *No Laughing Matter: Visual Humor in Ideas of Race, Nationality, and Ethnicity*, edited by Angela Rosenthal, David Bindman, and Adrian Randolph. Hanover, NH: Dartmouth College Press, 2016.

Ferguson, Niall. *The Ascent of Money: A Financial History of the World*. London: Penguin, 2009.

Fischer, Steven. *A History of Reading*. London: Reaktion, 2004.

Fischer-Lichte, Erika. "Theatricality: A Key Concept in Theatre and Cultural Studies." *Theatre Research International* 20, no. 2 (1995).

Flint, Christopher. "Speaking Objects: The Circulation of Stories in Eighteenth-Century Prose Fiction." In *The Secret Life of Things: Animals, Objects, and It-Narratives in Eighteenth-Century England*, edited by Mark Blackwell. Lewisburg, PA: Bucknell University Press, 2007.

Free Exchange. "Money from Nothing." *The Economist* (March 2014): 72.

Ford, John. *Ackermann 1783–1983: The Business of Art*. London: Ackermann, 1983.

Fordham, Douglas. "On Bended Knee: James Gillray's View of Courtly Encounter." In *Efflorescence of Caricature, 1759–1838*, edited by Todd Porterfield. New York: Routledge, 2016.

Furniss, Tom. "Burke, Paine, and the Language of Assignats." *The Yearbook of English Studies* 19 (1989).

Gatrell, Vic. *City of Laughter: Sex and Satire in Eighteenth-Century London*. New York: Walker & Company, 2006.

———. *The Hanging Tree: Execution and the English People*. Oxford: Oxford University Press, 1996.

George, Dorothy. *Hogarth to Cruikshank: Social Change in Graphic Satire*. London: Walker & Co., 1967.

——— and F. G. Stephens, eds. *Catalogue of Political and Personal Satires in the British Museum*. 11 Volumes. London: Trustees of the British Museum, 1870–1954. Online: https://www.britishmuseum.org/collection.

Gerdts, William H., and Russell Burke. *American Still Life Painting*. New York: Praeger, 1971.

Gilliland, Cora Lee C. "The Stone Money of Yap: A Numismatic Survey." *Smithsonian Studies in History and Technology* 23 (1975).

Gilmartin, Kevin. *Print Politics: The Press and Radical Opposition in Early Nineteenth-Century England*. Cambridge: Cambridge University Press, 1996.

Ginzburg, Carlo. *The Cheese and the Worms: The Cosmos of a Sixteenth-Century Miller*. Baltimore, MD: Johns Hopkins University Press, 2013.

Glaisyer, Natasha. "Calculating Credibility: Print Culture, Trust and Economic Figures in Early Eighteenth-Century England." *Economic History Review* 60, no. 4 (2007).

———. "'A due Circulation in the Veins of the Publick'": Imagining Credit in Late Seventeenth- and Early Eighteenth-Century England." *The Eighteenth Century* 46, no. 3 (2005).

Godfrey, Richard, and Mark Hallett. *James Gillray: The Art of Caricature*. London: Tate Publishing, 2001.

Graeber, David. *Debt: The First 5,000 Years*. Brooklyn, NY: Melville House, 2011.

Graham, Aaron. *Bills of Union*. Palgrave Studies in the History of Finance. New York: Springer International Publishing, 2021.

Greenhill, Jennifer A. "Playing the Fool: David Claypoole Johnston and the Menial Labor of Caricature." *American Art* 17, no. 3 (Autumn 2003).

Gregory, James. "Parody Playbills: The Politics of the Playbill in Britain in the Eighteenth and Nineteenth Centuries." *eBLJ* 6 (2018).

Griffiths, Anthony. *Prints and Printmaking: An Introduction to the History and Techniques*. London: British Museum Press, 1980.

Hallett, Mark. *The Spectacle of Difference: Graphic Satire in the Age of Hogarth*. New Haven, CT: Yale University Press, 1999.

Hansard, T. C., and William Cobbett, eds. *The Parliamentary History of England from the Earliest Period to the Year 1803*. London: T. C. Hansard, 1806.

Harling, Phillip. *The Waning of "Old Corruption": The Politics of Economical Reform in Britain, 1779–1846*. Oxford: Oxford University Press, 1996.

Haskell, Francis. *History and Its Images: Art and the Interpretation of the Past*. New Haven, CT: Yale University Press, 1995.

Hawtrey, R. G. "The Bank Restriction of 1797." *The Economic Journal* 28, no. 109 (March 1918).

Hayes, Richard. *Ireland and Irishmen in the French Revolution*. London: Ernest Benn Limited, 1932.

Haywood, Ian. "Paper Promises: Restriction, Caricature, and the Ghost of Gold." *Romantic Circles Praxis Series* (February 2012).

———. *The Rise of Victorian Caricature*. London: Palgrave Macmillan, 2020.

———. *Romanticism and Caricature*. Cambridge: Cambridge University Press, 2013.

Hegel, G. W. F. *Hegel's Phenomenology of Spirit*. Translated by A. V. Miller. Oxford: Oxford University Press, 1977.

Hess, Stephen, and Milton Kaplan. *The Ungentlemanly Art: A History of American Political Cartoons*. New York: The Macmillan Company, 1968.

Hewitt, V. H., and J. M. Keyworth. *As Good as Gold: 300 Years of British Bank Note Design*. London: British Museum Press, 1987.

Hicks, Dan, and Mary C. Beaudry. *The Oxford Handbook of Material Culture Studies*. Oxford: Oxford University Press, 2010.

Hill, Draper. *Mr. Gillray, the Caricaturist, a Biography*. London: Phaidon, 1965.

Hislop, Ian, and Tom Hockenhull. *I Object: Ian Hislop's Search for Dissent*. London: Thames & Hudson, British Museum, 2018.

Hogarth, William. *Analysis of Beauty*. 1753.

Hoock, Holger. *The King's Artists: The Royal Academy of Arts and the Politics of British Culture 1760–1840*. Oxford: Clarendon, 2003.

Hoppit, Julian. "Financial Crises in Eighteenth-Century England." *The Economic History Review*, New Series 39, no. 1 (Feb. 1986).

Hume, David. *An Enquiry Concerning Human Understanding*, edited by Tom L. Beauchamp. New York: Oxford University Press, 2000.

———. *A Treatise of Human Nature*, edited by L. A. Selby-Bigge. New York: Oxford University Press, 1988.

Hume, Robert D. "The Value of Money in Eighteenth-Century England: Incomes, Prices, Buying Power—and Some Problems in Cultural Economics." *Huntington Library Quarterly* 77, no. 4 (2014).

Hunt, Tamara. *Defining John Bull: Political Caricature and National Identity in Late Georgian England*. Burlington, VT: Ashgate, 2003.

Hyde, Edward. *A Treatise of the Pleas of the Crown*. Vol. 2. London, 1803.

Ingham, Geoffrey. "Money Is a Social Relation." *Review of Social Economy* 54, no. 4 (Winter 1996): 507–29.

———. *The Nature of Money*. Cambridge: Polity, 2004.

Ingrassia, Catherine. *Authorship, Commerce, and Gender in Early Eighteenth-Century England: A Culture of Paper Credit*. Cambridge: Cambridge University Press, 1998.

Isaac, Peter. "Sir John Swinburne and the forged *assignats* from Haughton Mill." *Archaeologia Aeliana* 5, vol. 18 (1990).

Johns, Adrian. *The Nature of the Book: Print and Knowledge in the Making*. Chicago: University of Chicago Press, 1998.

Judovitz, Dalia. *Unpacking Duchamp: Art in Transit*. Berkeley: University of California Press, 1995.

Kalba, Laura Anne. "Beautiful Money: Looking at La Semeuse in Pin-de-Siècle France." *The Art Bulletin* 102, no. 1 (March 2020).

Keats, Jonathon. *Forged: Why Fakes Are the Great Art of Our Age*. Oxford: Oxford University Press, 2013.

Kern, Adam L. *Manga from the Floating World: Comicbook Culture and the Kibyoshi of Edo Japan*. Cambridge, MA: Harvard University Press, 2006.

Keynes, John Maynard. *The General Theory of Employment, Interest and Money*. Originally published in 1936. San Diego, CA: Harcourt, Brace & World, 2016.

Keyworth, John. *Amusing, Shocking, Informing: The Bank of England's Cartoons & Caricatures*. London: The Bank of England Museum, 2000.

Kibbie, Ann Louise. "Circulating Anti-Semitism: Charles Johnstone's *Chrysal*." In *The Secret Life of Things: Animals, Objects, and It-Narratives in Eighteenth-Century England*, edited by Mark Blackwell. Lewisburg, PA: Bucknell University Press, 2007.

King, Peter. *A Selection from the Speeches and Writings of the Late Lord King*. London, 1844.

Knight, Peter, Nicky Marsh, and Paul Crosthwaite, editors. *Show Me the Money: The Image of Finance, 1700 to the Present*. Manchester: Manchester University Press, 2014.

Knox, Viceimus. *Winter Evening: Or Lucubrations on Life and Letters*. London, 1788.

Kocherlakota, Narayana R. "Money Is Memory." *Research Department Staff Report* 218. Minneapolis, MN: Federal Reserve Bank of Minneapolis, October 1996.

Kriz, Kay Dian. *Slavery, Sugar, and the Culture of Refinement*. New Haven, CT: Yale University Press, 2008.

Lahikainen, Amanda. "'British Assignats': Debt, Caricature and Romantic Subjectivity in 1797." *Studies in Romanticism* 53 (Winter 2014).

———. "Currency from Opinion: Imitation Banknotes and the Materiality of Paper Currency in Britain, 1782–1847." *Art History* 40, no. 1 (February 2017).

———. Review of *Representations of France in English Satirical Prints*, by John Richard Moores. *The BARS Review*, British Association for Romantic Studies no. 47 (Spring 2016).

———. "'Some Species of Contrasts': British Graphic Satire, the French Revolution and the Humor of Horror." *Humor: International Journal of Humor Studies* 28, no. 1 (February 2015).

Lajer-Burcharth, Ewa. "Chardin Material." In *Chardin Material*, edited by Daniel Birnbaum and Isabelle Graw. Frankfurt am Main: Sternberg Press, 2011.

Leach, Robert. *The Punch & Judy Show: History, Tradition and Meaning*. Athens: The University of Georgia Press, 1985.

Leary, Patrick. *The Punch Brotherhood: Table Talk and Print Culture in Mid-Victorian London*. London: The British Library, 2010.

Leonard, Eugenie Andruss. "Paper as a Critical Commodity during the American Revolution." *The Pennsylvania Magazine of History and Biography* 74, no. 4 (Oct. 1950).

Lepler, Jessica. *The Many Panics of 1837: People, Politics, and the Creation of a Transatlantic Financial Crisis*. Cambridge: Cambridge University Press, 2013.

———. "Pictures of Panic: Constructing Hard Times in Worlds and Images." *Common Place* 10, no. 3 (April 2010).

Lepore, Ernest, and Robert Van Gluick, editors. *John Searle and His Critics*. Malden, MA: Blackwell, 1993.

Lubar, Stephen, and David W. Kingery. *History from Things*. Washington, DC: Smithsonian, 1995.

Lynch, Deidre. "Personal Effects and Sentimental Fictions." In *The Secret Life of Things: Animals, Objects, and It-Narratives in Eighteenth-Century England*, edited by Mark Blackwell. Lewisburg, PA: Bucknell University Press, 2007.

MacFarlane, Helen, and Paul Mortimer-Lee. "Inflation over 300 years." *Bank of England Quarterly Bulletin* (May 1994).

Maidment, Brian. *Comedy, Caricature and the Social Order, 1820–50*. Manchester: Manchester University Press, 2013.

Malcolm, James Peller. *An Historical Sketch of the Art of Caricaturing*. London: Printed for Longman, Hurst, Rees, Orme, and Brown, Paternoster-Row, 1813.

Martinich, A. P. "Introduction." In *A Companion to Analytic Philosophy*, edited by A. P. Martinich and David Sosa. Hoboken, NJ: Blackwell, 2001.

Matthew, H. C. G., and Brian Harrison, editors. *Oxford Dictionary of National Biography*. New York: Macmillan, 1895.

Maurer, Bill. *How Would You Like To Pay? How Technology Is Changing the Future of Money*. Durham, NC: Duke University Press, 2015.

———. "The Anthropology of Money." *Annual Rev. Anthropology* 35 (2006).

McCarthy, Helen. *A Brief History of Manga: The Essential Pocket Guide to the Japanese Popular*. London: Ilex Press, 2014.

McGowen, Randall. "Knowing the Hand: Forgery and the Proof of Writing in Eighteenth-Century England." *Historical Reflections/Réflexions Historiques* 24, no. 3 (1998).

McLaughlin, Kevin. *Paperwork: Fiction and Mass Mediacy in the Paper Age*. Philadelphia: University of Pennsylvania Press, 2005.

Melville, Harden Sidney, and Thomas Shepherd. *London Interiors: A Grand National Exhibition of the Religious, Regal, and Civic Solemnities, Public Amusements, Scientific Meetings, and Commercial Scenes of the British Capital*. London, 1841.

Miller, Daniel. *Materiality*. Durham, NC: Duke University Press, 2005.

Miller, Henry. *Politics Personified: Portraiture, Caricature and Visual Culture in Britain c. 1830–80*. Manchester: Manchester University Press, 2015.

Miller, Peter, ed. *Cultural Studies of the Material World*. Ann Arbor: University of Michigan Press, 2013.

Mobley, Brett. Review of *Real Money and Romanticism*, by Matthew Rowlinson. *Romantic Circles* (March 2011).

Mohanty, Satya P. "Can Our Values Be Objective?" In *The Art of Art History*, edited by Donald Preziosi. Oxford: Oxford University Press, 2009.

Momigliano, Arnaldo. "Ancient History and the Antiquarian." *Journal of the Warburg and Courtauld Institutes* 13 (1950).

Monteyne, Joseph. *From Still Life to the Screen: Print Culture, Display and the Materiality of the Image in Eighteenth-Century London*. New Haven, CT: Yale University Press, 2013.

Montgomery, H. *John Law: The History of an Honest Adventurer*. London: Home & Van Thal, 1969.

Moores, John. *Representations of France in English Satirical Prints, 1740–1832*. London: Palgrave MacMillan, 2015.

Morreall, John. *Taking Laughter Seriously*. Albany: State University of New York Press,1983.

Mudge, Bradford. "'Like as My Profile': Of Monuments, Money, and Political Caricature in Spring 1784." *Eighteenth-Century Life* 35, no. 3 (Fall 2011).

Muldrew, Craig. "'Hard Food for Midas': Cash and its Social Value in Early Modern England." *Past and Present* 170, no. 1 (2001).

Müller, Lothar. *White Magic: The Age of Paper*, translated by Jessica Spengler. Malden, MA: Polity, 2014.

Newmarch, William. *On the Loans Raised by Mr. Pitt During the First French War, 1793–1801*. London: Effingham Wilson, Royal Exchange, 1855.

Nicholson, Colin. *Writing and the Rise of Finance: Capital Satires of the Early Eighteenth Century*. Cambridge: Cambridge University Press, 1994.

Nicholson, Eirwen E. C. "Consumers and Spectators: The Public of the Political Print in Eighteenth-Century England." *History* 81, no. 261 (January 1996).

———. "Emblem v. Caricature: A Tenacious Conceptual Framework." In *Emblems and Art History: Nine Essays*, edited by Alison Adams. Glasgow: University of Glasgow, 1996.

———. Review of *The Age of Caricature* by Diana Donald. *EHR* (April 1998): 485–86.

Nobuo, Tsuji. "The Impact of Western Book Illustration on the Designs of Hokusai—The Key to His Originality." In *Hokusai and His Age: Ukiyo-e Painting, Printmaking and Book Illustration in Late Edo Japan*, edited by John T. Carpenter. Translated by Timon Screech. Amsterdam: Hotei Publishing, 2005.

North, Peter. *Money and Liberation: The Micropolitics of Alternative Currency Movements*. Minneapolis, MN: University of Minnesota Press, 2007.

Novak, Barbara. *American Painting in the Nineteenth Century*. New York: Westview Press, 1979.

O'Brien, Patrick Karl. "Mercantilist Institutions for the Pursuit of Power with Profit: The Management of Britain's National Debt, 1756–1815." *Government Debts and Financial Markets in Europe*, edited by Fausto Piola Caselli. London: Pickering & Chatto, 2008.

O'Connell, Sheila. *The Popular Print in England*. London: British Museum Press, 1999.

———, ed. *Britain Meets the World: 1714–1830*. Beijing: Palace Museum, 2007.

O'Donoghue, Jim, Louise Goulding, and Grahame Allen. "Consumer Price Inflation since 1750." *Economic Trends* 604 (March 2004).

O'Malley, Michael. *Face Value: The Entwined Histories of Money and Race in America.* Chicago: University of Chicago Press, 2012.

Outing, Roger. *The Standard Catalogue of the Provincial Banknotes of England and Wales.* Devon: Token Pub., 2010.

Paine, Thomas. *The Decline and Fall of the English System of Finance.* London, 1796.

———. *Prospects on the War and Paper Currency.* London, 1787.

Patten, Robert L. *George Cruikshank's Life, Times, and Art.* New Brunswick, NJ: Rutgers University Press, 1992.

Paul, Helen. *The South Sea Bubble: An Economic History of its Origins and Consequences.* Oxfordshire: Routledge, 2011.

Paulding, James Kirke. *The History of a little Frenchman and his bank notes. "Rags! Rags! Rags!"* Philadelphia: Edward Earle, 1815. Printed by Joseph M. Sanderson.

Paulson, Ronald. *Hogarth: His Life, Art, and Times.* New Haven, CT: Yale University Press, 1971.

———. *Representations of Revolution.* New Haven, CT: Yale University Press, 1983.

Peirce, Charles Sanders. "What Is a Sign?" In *The Essential Peirce*, The Peirce Edition Project, vol. 2. Bloomington: Indiana University Press, 1998.

Phillips, Maberly. *History of Banks, Bankers and Banking in Northumberland, Durham, and North Yorkshire, Illustrating the Commercial Development of the North of England, from 1755 to 1894.* London, 1894.

Phillips, Stephen Bennett, Shingo Odaka, and Kaori Sekiguchi. *Japan's Social & Economic Landscape: Nineteenth-Century Woodblock Prints from the Currency Museum, Bank of Japan.* Washington, DC: Board of Governors of the Federal Reserve System, 2014.

Pinker, Steven. *Enlightenment Now: The Case for Reason, Science, Humanism and Progress.* London: Allen Lane, 2018.

Pinney, Christopher. "Things Happen: Or, From Which Moment Does That Object Come?" In *Materiality*, edited by Daniel Miller. Durham, NC: Duke University Press, 2005.

Pocock, J. G. A. *Virtue, Commerce, and History: Essays on Political Thought and History, Chiefly in the Eighteenth Century.* Cambridge: Cambridge University Press, 1985.

Pointon, Marcia. "Money and Nationalism." In *Imagining Nations*, edited by Geoffrey Cubitt. Manchester: Manchester University Press, 1998.

Poovey, Mary. *Genres of the Credit Economy: Mediating Value in Eighteenth- and Nineteenth-Century Britain.* Chicago: University of Chicago Press, 2008.

Popper, Nathaniel. "How China Took Center Stage in Bitcoin's Civil War." *New York Times*, June 29, 2016.

Porter, Roy. *The Creation of the Modern World: The Untold Story of the British Enlightenment.* New York: W.W. Norton & Co., 2001.

Porterfield, Todd, ed. *The Efflorescence of Caricature, 1759–1838.* New York: Routledge, 2011.

Pressnell, L. S. *Country Banking in the Industrial Revolution.* Oxford: Clarendon Press, 1956.

Price, Richard. *Two Tracts on Civil Liberty.* London, 1778.

Proceedings of the Old Bailey, 1674–1913. Online: https://www.oldbaileyonline.org/.

Putnam, Hilary. *Collapse of the Fact/Value Dichotomy and Other Essays.* Cambridge, MA: Harvard University Press, 2004.

Quilley, Geoff. "Art History and Double Consciousness: Visual Culture and Eighteenth-Century Maritime Britain." *Eighteenth-Century Studies* 48, no. 1 (2014).

Rauser, Amelia. *Caricature Unmasked: Irony, Authenticity, and Individualism in Eighteenth-Century English Prints.* Newark: University of Delaware Press, 2008.

Rediker, Marcus, and Peter Linebaugh. *The Many-Headed Hydra: Sailors, Slaves, Commoners, and the Hidden History of the Revolutionary Atlantic.* Boston, MA: Beacon Press, 2000.

Redish, Angela. "The Evolution of the Gold Standard in England." *The Journal of Economic History* 50, no. 4 (Dec. 1990).

Reed, Stephen B. "One Hundred Years of Price Change: The Consumer Price Index and the American Inflation Experience." *Monthly Labor Review*, U.S. Bureau of Labor Statistics (April 2014), https://doi.org/10.21916/mlr.2014.14.

Reid, William. *The Life and Adventures of the Old Lady of Threadneedle Street.* London, 1832.

Reynolds, Sir Joshua. *Discourses.* London: Penguin, 1992.

Richards, R. D. "The Evolution of Paper Money in England." *The Quarterly Journal of Economics* 41, no. 3 (May 1927).

Roach, Joseph. "Gossip Girls: Lady Teazle, Nora Helmer, and Invisible-Hand Drama." *Modern Drama* 53, no. 3 (Fall 2010).

Roberts, Jennifer. "The Currency of Ornament: Machine-Lathed Anticounterfeiting Patterns and the Portability of Value." In *Histories of Ornament: From Global to Local*, edited by Gülru Necipoğlu and Alina Payne. Princeton, NJ: Princeton University Press, 2016.

———. *Transporting Visions: The Movement of Images in Early America.* Berkeley: University of California Press, 2014.

Robertson, Frances. "The Aesthetics of Authenticity: Printed Banknotes as Industrial Currency." *Technology and Culture* 6 (January 2005).

Rockoff, Hugh. "Upon Daedalian Wings of Paper Money." *Adam Smith Review*, edited by Fonna Forman-Barzilai. New York: Routledge, 2011.

Rogers, James Steven. *The Early History of the Law of Bills and Notes: A Study of the Origins of Anglo-American Commercial Law.* Cambridge: Cambridge University Press, 2004.

Rolnick, Arthur J., and Warren E. Weber. "Free Banking, Wildcat Banking and Shin-plasters." *Federal Reserve Bank of Minneapolis Quarterly Review* 6, no. 3 (Fall 1982).

Rosenfield, John M. "The Anatomy of Humor in Hokusai's Instruction Manuals." In *Hokusai and His Age: Ukiyo-e Painting, Printmaking and Book Illustration in Late Edo Japan*, edited by John T. Carpenter. Amsterdam: Hotei Publishing, 2005.

Rowlinson, Matthew. *Real Money and Romanticism.* Cambridge: Cambridge University Press, 2010.

Sargent, Thomas J., and Francois R. Velde. *The Big Problem of Small Change.* Princeton, NJ: Princeton University Press, 2002.

Satan's Bank Note. London: John Lindsay Turner, 1820.

Searle, John. *The Construction of Social Reality.* New York: The Free Press, 1995.

———. "How to Derive 'Ought' from 'Is.'" *The Philosophical Review* 73, no. 1 (January 1964).

Selgin, George, and Lawrence H. White. "The Option Clause in Scottish Banking." *Journal of Money, Credit, and Banking* 29, no. 2 (May 1997).

Shell, Marc. *Art & Money.* Chicago: University Of Chicago Press, 1995.

———. *Money, Language, and Thought: Literary and Philosophical Economies from the Medieval to the Modern Era.* Los Angeles: University of California Press, 1982.

Shin, Hiroki. "The Culture of Paper Money in Britain: The Bank of England Note during the Bank Restriction Period, 1797–1821." PhD dissertation, St. Catharine's College, University of Cambridge, 2008.

———. "Paper Money, the Nation, and the Suspension of Cash Payments in 1797." *The Historical Journal* 58, issue 2 (June 2015).

Siegel, Katy, and Paul Mattick, eds. *Money*. New York: Thames & Hudson, 2004.

Sill, Gertrude Grace. *John Haberle: American Master of Illusion*. New Britain, CT: New Britain Museum of American Art, 2009.

Simmel, Georg. *The Philosophy of Money*. Translated by Tom Bottomore and David Frisby. London: Routledge & Kegan Paul, 1978.

Smith, Roberta. "Conceptual Art." In *Concepts of Modern Art*, edited by Nikos Stangos. London: Thames & Hudson, 2001.

Smylitopoulos, Christina. "Abandoning Graphic Satire and Illustrating Text: Cruikshank's Crowning Himself Emperor of France, 1814." In *Word and Image in the Long Eighteenth Century*, edited by Christina Ionescu and Renata Schellenberg. Newcastle: Cambridge Scholars Publishing, 2008.

Society of Arts. *Report of the Committee of the Society of Arts etc . . . relative to the mode of preventing the forgery of bank notes*. London, 1819.

Solkin, David H. *Painting for Money: The Visual Arts and the Public Sphere in Eighteenth-Century England*. New Haven, CT: Yale University Press, 1993.

Solomon, Elinor Harris. *Virtual Money: Understanding the Power and Risks of Money's High-Speed Journey into Electric Space*. Oxford: Oxford University Press, 1997.

Spang, Rebecca. "Money, Money, Money." Review of *Genres of the Credit Economy* by Mary Poovey. *History Workshop Journal* 69 (Spring 2010): 225–33.

———. *Stuff and Money in the Time of the French Revolution*. Cambridge, MA: Harvard University Press, 2015.

Stagg, Allison. "The Art of Wit: American Political Caricature, 1780–1830." PhD Dissertation, University College London, 2011.

Stahl, Alan M. *Money on Paper: Bank Notes and Related Graphic Arts from the Collections of Vsevolod Onyshkevych and Princeton University*. Princeton, NJ: Princeton University Library, 2010.

Stallybrass, Peter, and Allon White. *The Politics and Poetics of Transgression*. Ithaca, NY: Cornell University Press, 1986.

Strachan, John. *Advertising and Satirical Culture in the Romantic Period*. Cambridge: Cambridge University Press, 2007.

Stupples, Peter, ed. *Art and Money*. Newcastle upon Tyne: Cambridge Scholars Publishing, 2015.

Sullivan, John. "The Case of 'A Late Student': Pictorial Satire in Jacksonian America." *Proceedings of the American Antiquarian Society* (1974).

Tatham, David. "David Claypoole Johnston's 'Militia Muster.'" *American Art Journal* 19, no. 2 (Spring 1987).

Taws, Richard. "The Currency of Caricature in Revolutionary France." In *The Efflorescence of Caricature, 1759–1838*, edited by Todd Porterfield. Farnham, UK: Ashgate, 2010.

———. *Politics of the Provisional: Art and Ephemera in Revolutionary France*. University Park: Pennsylvania State University Press, 2013.

Taylor, David Francis. *The Politics of Parody: A Literary History of Caricature, 1760–1830*. New Haven, CT: Yale University Press, 2018.

Thackeray, William Makepeace. "George Cruikshank." *Westminster Review* 66 (June 1840).

Thielemans, Veerle. "Beyond Visuality: Review on Materiality and Affect." *Perspective* [online] 2 (December 7, 2015), http://journals.openedition.org/perspective/5993, https://doi.org/10.4000/perspective.5993.

Thornton, Henry. *An Inquiry Into the Nature and Effects of the Paper Credit of Great Britain*. Philadelphia, 1807. First published in 1802.

Todd, Adrienne. "The Infinite Grotesque: Paper Money and Aesthetics in Edmund Burke's Reflections on the Revolution in France." *Eighteenth-Century Studies* 53, no. 1 (2019).

Tschachler, Heinz. *The Monetary Imagination of Edgar Allan Poe: Banking, Currency and Politics*. Jefferson, NC: McFarland & Company, 2013.

Valenze, Deborah. *The Social Life of Money in the English Past*. Cambridge: Cambridge University Press, 2006.

Weitenkampf, Frank. *American Graphic Art*. London: Johnson Reprint Corporation, 1970.

Welsh, Peter C. "Henry R. Robinson: Printmaker to the Whig Party." *New York History* 53, no. 1 (January 1972).

Wennerlind, Carl. *Casualties of Credit: The English Financial Revolution, 1620–1720*. Cambridge, MA: Harvard University Press, 2011.

———. "Money Talks, but What Is It Saying? Semiotics of Money and Social Control." *Journal of Economic Issues* 35, no. 3 (September 2001).

[Wills, W. H.]. "Review of a Popular Publication, in the Searching Style." *Household Worlds* 1, no. 18 (July 27, 1850).

Wilmerding, John. *Important Information Inside: The Art of John F. Peto and the Idea of Still-Life Painting in Nineteenth-Century America*. National Gallery of Art, 1983.

Wood, Marcus. *Radical Satire and Print Culture 1790–1822*. Oxford: Clarendon Press, 1994.

———. "William Cobbett, John Thelwall, Radicalism, Racism and Slavery: A Study in Burkean Parodics." *Romanticism on the Net*, August 15, 1999.

Yonan, Michael. "The Suppression of Materiality in Anglo-American Art-Historical Writing." In *The Challenge of the Object/Die Herausforderung des Objekts*, Proceedings of the 33rd Congress of the International Committee of the History of Art (CIHA), Nurnberg, July 15–20, 2012, edited by Georg Ulrich Grossmann and Petra Krutisch. Nurnberg: Verlag des Germanischen Nationalmuseums, 2014.

Zelizer, Viviana. *The Social Meaning of Money*. New York: Basic Books, 1995.

Žižek, Slavoj. *Tarrying with the Negative: Kant, Hegel, and the Critique of Ideology*. Durham, NC: Duke University Press, 1993.

INDEX

Baker, James, 6, 12, 42–43, 143, 146–47, 150–51, 174n20
Baker, Jennifer, 137
Bank Agents, 6
Bank Charter Act of 1844, 132
banking, 36, 155; country, 193n33; of local banks, 132. *See also* Bank of England
banknotes: country, 188n2; definitions of, 52; depreciation of, 60; design of, 96, 190n27; endorsing of, 80; "femininity" of, 15; as "rags," 22; reading of, 147; signatures on the back of, 15; tactile qualities of, 132–33; trust in, 133–34. *See also* Bank of England; British pound; forgery; imitation banknotes; paper money; satirical banknotes
Bank of England, 2, 5, 12, 28–35, 43, 48–56, 73, 76, 87, 95–96, 150; bankers of the, 98; banknotes of the, 14, *18*, 26–32, 38, 42, 56, 61, 69, 89–99, 109, 132–34, 188n2; catalog entries for graphic satires held at the, 80; "circulation" of feminine, 67–73; directors of the, 104; establishment of the, 12; history of the, 22, 132; instability of the, 32. *See also* banking; banknotes; money
Bank of the United States, 155
Bank Restriction (1797–1821), 2–9, 13, 35, 41–44, 48–49, 74, 89, 92, 104, 124, 142, 173n1
Bank Restriction Act (1797), 32, 45, 62, 154, 180n1; and semiotic instability, 44–56
bankruptcy, 52
Baucom, Ian, 81
Baudrillard, Jean, 91
Benjamin, Walter, 125
Benton, Thomas Hart, 157–58, 160
Biddle, Nicholas, 160
Bindman, David, 151
Birmingham, 60, 150
Bitcoin, 17, 28, 137–38, 177n2. *See also* cryptocurrency
Blackwell, Bonnie, 68; *The Secret Life of Things*, 69
Blake, William, 109
Boggs, J. S., 171

bons, 31
Bricker, Andrew Benjamin, 142, 195n4
Bridges, Thomas: *Adventures of a Bank-Note*, 68–69, 72
Bristol, 89
Britain, 95, 134, 153, 163; anti-slavery campaign in, 109; Golden Age of caricature in, 2, 6, 9; John Bull as the embodiment of, 1–2; "papered" century in, 5; relations with Japan of, 167; reliance on public credit and debt of, 13; social change in early nineteenth-century, 195n3. *See also* John Bull; Parliament; Regency age; Victorian age
British Army, 93
British Empire, 121, 153; paper currency of the, 198n17
British Museum, 36, 38, 80, 83, 125, 132, 174n19, 181n24, 182n30
British pound: *Bank of England £1 Note* (1813), *18*, 19; stability of the, 16. *See also* banknotes; money
bullion. *See* gold bullion
Bullion Commission Report, 126
Burdett, Sir Francis, 92–93
Burke, Edmund, 142; *Reflections*, 52–55, 62

Canterbury Bank (satirical banknote, 1791), 76, 80, 84
capitalism: criticism of, 150; exchange of interests in, 72; and prosperity, 55; successes of, 114. *See also* economics
capital punishment, 99
Caribbean, 107, 109, 159
caricature: classification as, 66; decline of the golden age of British, 142; eighteenth-century tradition of, 99; exaggerated representation in, 27; history of, 6, 9, 27, 76, 143; inflation of, 9; in Japan, 167; and paper money, 153, 159; political, 142, 146; use of, 159; viewing of, 80, 147; as visual inflation, 9. *See also* cartoons; graphic satire
cartoons, 9, 151; American, 153; British, 173n9; Japanese, 167. *See also* caricature

Carlyle, Thomas, 3–4; "Paper Age" of, 142
Castiglione, Dario, 136
Castlereagh, Foreign Secretary Viscount (Robert Stewart), 104
Catholicism, 93
censorship, 99
Chancellor of the Exchequer, 49
Charles Haliday manuscript collection, 42
Charles, William, 154
China, 4
Civil War, 154
Cobbett, William, 43, 63, 92, 104–10, 123–26, 131, 147, 150; Satirical Banknote Referencing Slavery, Innocence, and William Cobbett (1810), 107, 108
Coinage Act of 1816, 192n2
coins: circulation of money in, 44; counterfeit, 131; forgery of, 6; gold, 1–2; Gold Guinea with the Head of George III (1798), 121, 122; hoarding of, 59; myth of intrinsic value of, 16; old symbol of, 91; paper, 52; tactile and visual qualities of, 125; value of, 66, 131, 137. See also money
Coleman, James, 136
comedy: decline in, 141–42; of gallows humor, 150. See also humor; laughter
comic almanacs, 160
corruption, 28, 45; parliamentary and political, 63
Courier, 43
Court of Common Pleas, 69
Cowper, Edward, 96
credit: and aesthetic experience, 137; contingent subjects of, 75; and debt, 6, 13, 22; economy of, 13, 27, 42, 84, 97; money and, 21, 139; as mutual trust indicated by character, 159; network of, 72; older system of, 83; paper, 12, 42, 63, 80, 136, 183n66, 188n2; public, 44–45; satirical representations of, 74; stability of, 48; theory of, 20. See also debt; money
crime: forgery as a capital, 5; of uttering, 28. See also forgery; utterance

critical reflexivity, 16
Cruikshank, George, 96, 99, 104, 142, 154; The Bank Restriction Barometer (satirical print, 1819), 103; Bank Restriction Note (satirical banknote, 1819), 5, 28, 91, 99, 102, 104, 107; The Blessings of Paper Money, or King a Bad Subject (satirical print, 1811), 126, 128, 131; Johnny Bull and His Forged Notes!! Or Rags & Ruin in the Paper Currency!!! (satire, 1819), 98, 101
Cruikshank, Isaac, 5, 35, 96, 99, 200n47; Billy a Cock-Horse or the Modern Colossus Amusing Himself (1797), 45, 46, 48; Symptoms of Crim Con!!! or a Political Visit to the Heiress in Threadneedle Street (1819), 69, 71
cryptocurrency, 17, 137–38. See also Bitcoin; currency
Cuba, 159
currency: Continental paper, 158–59; copper tokens as unofficial, 163; credit, 175n30; debasement of, 61, 170; dematerialization of, 135–36; digital, 17; fiat, 48, 168, 173n1; imperial paper, 198n17; law forbidding the imitation of, 171; local, 17; new metal, 119; painting of American paper, 167; paper, 31, 75; partially naturalized, 194n39; quality of, 135; quantity of, 135; slave labor and, 110. See also money; paper money

Daumier, H., 173n9
Davies, Glyn, 21
death penalty, 28
deBolla, Peter, 72
debt: for the Bank of England, 53; in Britain, 72; credit and, 6, 13, 22; definition of, 123; money and, 5, 139; national, 44, 150, 182n42; public, 63; reciprocal, 188n78; satirical representations of, 74; Tory attitude toward, 52. See also credit; money
deflation, 9, 16, 56; of Georgian graphic satire, 141–51; metaphorical, 142–43

Defoe, Daniel, 125
dematerialization principle, 16, 124, 135–39
Democratic Party, 155, 157–58
Dent, William, 53, 200n47; *Money Lent. An Accommodating Pawnbroker* (1793), 170–71; *Two to One, an Attempt to Outwit the Young Pawnbroker*, 34
Derrida, Jacques, 4
Dian Kriz, K., 13
Dickie, Simon, 2
Donald, Diana, 4, 6, 9, 13–14, 51, 141, 196n14
Doyle, John: *The Gridiron* (1833), 147, *148*, 150
Dubin, Nina, 13
Dublin, 131
Duchamp, Marcel, 117, 171
Dundas, Henry, 3, 33, 55, 170
Dutch East India Company, 168
Duus, Peter, 167–68
Dyer, J. C., 96

early modern period, 83
Eaton, Natasha, 81
economics: criticism of the theoretical foundation of classical, 135; definition of money in, 19; of exchange, 81; of the free market, 110; Gresham's law in, 66; Keynesian, 21; macro-, 20–21, 116; micro-, 21, 116; neoclassical, 20, 138; real versus nominal value in, 20. *See also* capitalism; money
Eisenstein, Elizabeth, 133
Elkins, James, 125
Elton, Robert H.: *Eltonian Komick Bank* (1837), 160
English Financial Revolution, 12
English literature, 17
engravings, 98; fine art, 96; handsigned, 26; single-sheet, 43. *See also* prints
Enlightenment, 26
etchings, 44. *See also* prints
Examiner, 99

facts: institutional, 24, 26–28, 138–39; and values, 27, 147
fact/value dichotomy, 23, 26–27, 138–39, 176n43; satire and the, 139
Feavearyear, Albert, 53.
Federal Reserve System, 158
Felsenstein, Frank, 61
Ferguson, Niall, 22, 135
Fielding, Henry, 144
finance capital, 81
Fischer-Lichte, Erika, 189n5
Fleet Prison, 43
Fleetwood, Anthony: *Six Cents/ Humbug Glory Bank* (1837), *162*, 163, 167
Flint, Christopher, 72
Fores, Samuel William, 15, 59–60, 92; *Bankers Stopping Payment* (1805), 63, *64*; *The Card Party or the Utility of Paper*, 63, 66; *Fores's New Guide for Foreigners*, 92; *I Promise to Pay to Messrs. Fudge, Swindle and Nocash* (satirical banknote, 1818), *100*; *I Promise to Pay to Monsieur Bonaparte* (satirical banknote, 1818), *94*
forgery, 5–6, 60, 104; banknotes as subject to, 28, 75–76, 96, 98, 99; coins as subject to, 6; defense against, 89; Forged 1£ Bank of England Note (1816), *105*; hanging for, 190n35; punishment of banishment to a penal colony for, 132; and state injustice, 15; three possible solutions to the problem of, 99. *See also* banknotes; crime; money
Fort Montague Bank in Yorkshire, 41
Four-in-Hand Club, 93
Fox, Charles James, 32, 49, 51–52, 55, 63, 170
Fox-North coalition, 12
France, 4, 31, 44, 48–49, 93–95, 163; fear of invasion of Britain by, 32; finances of, 55; late eighteenth-century, 142; Old Regime, 136; Republican, 32; Revolutionary, 4, 13, 48, 59, 190n29; study of money in, 135

Haywood, Ian, 55, 67, 76, 142, 151; "Paper Promises: Restriction, Caricature, and the Ghost of Gold," 13, 27, 35; *Rise of Victorian Caricature*, 150; *Romanticism and Caricature*, 13, 150

Hazlitt, William, 141

Heath, William, 141

Hegel, Georg Wilhelm Friedrich, 62

Henning, A. S.: Cover of the First Volume of *Punch* (1841), *140*, 144, 146–47, 151

Hess, Stephen, 154

Het Groote Tafereel der Dwaasheid (The Great Picture of Folly), 44

Hewitt, V. H., 95

historiography, 125, 196n17

history of art. *See* art history

Hobbes, Thomas, 143

Hoche, General Louis Lazare, 9

Hogarth, William, 4, 134, 143, 171; *The Laughing Audience*, 151; *Mask and Pallet* (1745), *40*, *41*; *Southwark Fair*, 144

Hokusai, Katsushika, 168

Holland, William: *Caricature Curiosity*, 143–44, 151; *The Ghost of a Guinea! or the Country Banker's Surprise!!* (1804), *130*, *131*; *John Bull Swearing to His Property!!* (1798), 84, *85*, 86; *Political Hocus Pocus! or John Bull Brought to Believe Anything!!* (1802), *xvi*, 1–4, 6, 22, 29, 67, 154, 160

Holly, Michael Ann, 123

Hone, William, 92, 104; *Bank Restriction Note* (satirical banknote, 1819), 5, 28, 91, 99, *102*, 104, 107

Hōryū, Goseda, 167

Hōsui, Yamamoto, 167

Hume, David, 23, 178n27

Hume, Robert, 6

humor, 52, 157; gallows, 150; history of, 14, 151; incongruity theory of, 9, 14, 79, 143–44, 171, 175n23, 176n39; in Japanese woodblock prints, 168; philosophy of, 61, 143, 196n13; relief theory of, 176n39; satire's construction of, 61; superiority theory of, 143, 146, 176n39; theories of, 61, 176n39, 185n8, 196n13. *See also* comedy; laughter

Humphrey, Hannah, 32

Hunt, Henry, 104

Hunt, Tamara, 13

idealism, 9

identity: British, 13; personal, 45

imagination, 54

imitation, 91; of an imitation of a representation, 107; of the immaterial, 110–17; novelty, 142

imitation banknotes, 5–9, 27, 35–43, 62, 75–84, 104–10, 126, 150, 155, 160; British, 163; circulation of, 12; and graphic satire, 9, 89, 139, 142; Imitation Banknote in the Form of an Advertisement for Maredent's Drops (1784), *40*, *41*, 84; late, 142, 147; and the unfolding of old and new forms of money, 139; as valentines, 132. *See also* banknotes

imitation theory, 81

immateriality, 110–17; imitation of, 117

inflation, 6, 9, 31, 135, 142, 168, 171; analysis of consumer price, 6; Consumer Price Inflation from 1751–1850, 8; economic models of, 142; graphic art and money as subject to, 141; in Revolutionary France, 59. *See also* money; paper money

Ingham, Geoffrey, 20–22, 138

inscriptions, 31

institutional facts: collective intentionality and, 81; and nationalism, 179n29; web of, 86, 90

Insulanus, Theophilus: *A Treatise on Second Sight: Dreams and Apparitions*, 3

intentionality: collective, 14–16, 24, 60–62, 81, 84, 139, 179n33; individual, 179n33; subjective, 14

Ireland, 14, 42, 66, 93

irony, 2, 31–33, 36, 150

it-narrative, 15, 68, 186n41. *See also* novel

Jackson, President Andrew, 154–55, 157–58, 160, 163

James II, King, 13, 66

Meurer, Charles Alfred, 167
microeconomics. *See* economics
Miller, Peter, 123, 151
modernism, 167–68
money: abstract nature of, 53, 138–39; art and,26, 89, 154, 175n32; art history and, 123; ascent of paper as, 142; claim theory of, 51–52; commodity theory of, 20, 51–52; credit theory of, 20; definition of, 14–22, 117, 163, 181n17; English, 121; ethical and political nature of, 28; exchange of, 72, 80; fiat, 5; fiction of inherent value in metal, 137; gold coin as, 1–2; and graphic art, 16–17, 62; graphic satire of, 14, 27, 125; grounding of the value of, 19, 26; history of, 20, 89, 135, 138; institutional value of, 26, 66, 117, 138; lethal, 20; material culture of, 72; materiality of, 15, 119; modernist interpretation of, 135; neoclassical understanding of, 21; networks of exchange and, 72; new medium for the circulation of, 160; and paintings, 167; politics and, 17, 170; power of, 1–2; as a primitive form of, 21; quantity theory of, 135; real stuff of, 91; representation of, 167, 170–71, 176n43; satire of, 15, 20, 123; "scrip" as substitute for, 35; as social reality, 26–29; as social relation, 21–29, 62–67, 110, 178n19; state theory of, 20; supply of, 41; three basic functions or definitions of, 20; veil theory of, 20. *See also* banknotes; Bank of England; British pound; coins; credit; cryptocurrency; currency; debt; economics; forgery; imitation banknotes; inflation; paper money
Monteyne, Joseph, 13, 72, 91, 125; *From Still Life to the Screen*, 81
Monthly Magazine, 96
Morning Chronicle, 48–49, 51, 54
Mudge, Bradford, 141
Muldrew, Craig, 83
Müller, Lothar, 4, 80–81, 142; *White Magic*, 4
myth: Greek, 157; of intrinsic value, 16, 67; Midas, 31

Napoleonic era, 6, 13, 38, 44; real money in the, 120
Nast, Thomas: *Ideal Money* (1878), 163
National Assembly (Paris), 42
nationalism, 26; institutional facts and, 179n29
National Museum of American History, 158
National Museums Scotland, 35–36, 181n14
Newgate Prison, 43
Newland, Abraham, 69, 80
New Orleans, 155
Newton, Richard: *The Inexhaustable Mine*, 72; *Men of Pleasure in Their Varieties* (1794), 69, 70; *A Paper Meal with Spanish Sauce* (1797), 126, *129*
New York, 155
Nicholson, Eirwen, 16, 38, 143
Nipponchi (political cartoon magazine), 168
novel: of circulation, 68; eighteenth century, 15. *See also* it-narrative

O'Brien, Patrick, 13
Observer, The, 51, 132
O'Connell, Donald, 143
O'Connell, Sheila, 143
Old Bailey, 146
O'Malley, Michael, 109–10, 191n54
Oracle and Public Advertiser, 51
ordonnances, 31
Ovid: *Metamorphoses*, 55
Oxford English Dictionary, 35, 123, 178n25

Paine, Thomas, 3, 42, 52; *Age of Reason*, 104; *The Decline and Fall of the English System of Finance*, 51–52; *Rights of Man*, 183n48
Panic of 1837 (United States), 16, 155, 158, 168, 198n10
paper: as a commodity, 137; gold and, 44, 89, 154–55, 158; high cost of, 42–43; mechanized production of, 42; rag trade and, 61; as a religious text, 84; satirical art on, 157; tactile engagement of, 125; value of, 79–80, 157. *See also* paper money

paper money, 1–6, 32, 42, 49–56, 61–68, 80–84, 89–91, 97, 167; anthropomorphization of, 16; attack on, 104; British users of, 120; caricature and, 153, 159; circulation of, 72; crisis of, 168; criticism of, 16, 43; cultures of, 133–34; definition of, 44–45, 51–52, 170, 173n1; depreciation of, 67, 126; exchanges of, 62, 80; feminization of, 67–68, 72; as fictitious capital and false credit, 99, 104; French, 32; graphic art and, 16–17; history of, 76, 157; imitation of, 87; inconvertible, 31; literal and metaphorical inflation of, 6, 9; materiality of, 16; personal, 41; political and economic relations supporting, 28–29, 110; printing of, 110; private issues of, 168; and race, 109–10; and satire, 42, 160; semiotic instability of, 79; as a social practice, 81; as a social relation, 32, 86; softness of, 86; users of, 15–16, 159; value of, 27, 60–62, 137–38, 157–58. *See also* banknotes; currency; Great Paper Manufactory; inflation; money; paper

Parliament, 31–32, 49, 51, 60–61, 73. *See also* Britain

Paulding, James Kirke, 159

Paulson, Ronald, 41

Peel, Hugh, 76

Peel, Robert, 53, 147

Peel's Act (1819), 53, 92

Peirce, Charles Sanders, 15, 72, 89–91, 116, 138; "What Is a Sign?," 90

Perceval, Prime Minister Spencer, 60–61, 126

Perkins, Jacob, 96, 190n28

Perry, Commodore Matthew C., 168

Peterloo Massacre, 141

Peto, John, 167

Philadelphia, 155, 158–59

Phillips, Maberley, 37

philosophy, 23; analytic, 89, 178n26; continental, 178n26

physiognomy, 144, 146

Pitt, Prime Minister William, 1–6, 27–35, 44–56, 62, 66, 73, 76, 80, 84–89, 131, 160, 163, 170, 182n42, 185n20

Plato, 134; *Republic*, 116

Pocock, John G. A., 53

Poe, Edgar Allan: "The Gold-Bug," 160

Political House that Jack Built, The (Cruikshank and Hone), 99

Pon, Lisa, 125

Poovey, Mary, 135–36, 176n1, 188n2; *Genres of the Credit Economy*, 121

popular culture, 61, 67, 72; English, 141

Porterfield, Todd, 13

poverty, 63, 110

precious metals, 52

Price, Richard, 22, 90, 182n42

print culture, 4, 16–17, 62, 98, 143–44, 179n38; printmakers and, 110; study of, 133; trends in, 142. *See also* prints

prints: bawdy and licentious, 72; contrast, 163; Japanese woodblock, 167–71; macaroni, 174n11; natural history, 168; political, 9, 147; satirical, 12, 141, 146–47; two types of, 76. *See also* engravings; etchings; graphic art; lithography; print culture; printshops

printshops, 12, 27; genre of viewing scenes of, 16, 81, 143–44, 146–47. *See also* prints

prostitution, 67–69, 72; and the circulation of paper money, 72

Pulteney, William, 53

Punch (satirical publication), 4–5, 16, 140, 141–50, 173n9; circulation numbers of, 143; historiography of, 196n17; Japanese version of, 167. See also *Japan Punch*

Punch and Judy show, 16, 143–44

Putnam, Hilary, 23

race: black bodies and, 109–10; paper money and, 109–10

radicalism, 104; early nineteenth-century, 110; punishment of, 107; sedition and, 183n71

rape, 73

Rauser, Amelia, 4, 6, 14

reading, history of, 133

realism, 9

Reddit, 137

Reddy, William, 135